Exploring and explaining the role of arts therapists in dismantling assumptions based in biological determinism and psychoanalytic theory makes for fascinating reading in this text. Authors of diverse backgrounds carefully consider how and why they see individuals as active agents who engage with creative methods in order to reconceive themselves during times of distress and pain. This text draws on critical theory to demonstrate how the arts can provide conditions in which we are able to thrive as the unique individuals that we are by transcending the systems of domination and oppression that might otherwise shape our lives.

– **Professor Katrina McFerran,** The University of Melbourne, Australia

A short endorsement cannot do justice to this very important book. The theme of "Gender and Difference in the Arts Therapies" allows the authors to dig deep into the soil and landscape of the arts therapies. Much of it has not been excavated before, and there are rich gems to be found. There are crucial discoveries, such as that body-movement can create changes in the brain, art therapy can include crafts and making of objects, and costume and dramatic play can support a transgender teenager discover his role in life. The editor obviously has skills in choosing and balancing the chapters which include the highly academic as well as the practice-based. This remarkable book should be required reading for teachers, clinicians, therapists and all the rest.

– **Professor Sue Jennings,** PhD, visiting Professor of Dramatherapy, University of Derby, UK Professor of Play (EFD) and specialist in Neuro-Dramatic-Play

This important book provides a wide variety of perspectives that explore gender as a multifaceted social construct that is affected by sex, class, and cultural mores. It provides theoretical and research perspectives along with case studies that illustrate the use of a broad range of creative arts and arts interventions from those theoretical perspectives to support exploration and challenge of these constructs and perspectives via image and metaphor.

– **Christianne Strang,** PhD, ATR-BC, President of the American Art Therapy Association

'*Gender and Difference in the Arts Therapies*' addresses the complex relationships between gender and the arts therapies in ways that are illuminating and challenging. Historic positive developments in attitude and resistances to change are examined through lucid debate in ways that create insight into life inside and outside the therapy room. Rich and varied clinical material provides access to practice covering a range of international contexts, presented and interrogated with verve and critical energy. Concepts such as gender, sexual identity, sexual orientation and intersectionality are brought alive in ways that avoid generalisation and take the reader into very particular contexts to reveal how they are present in visible and invisible ways within arts therapy practice. Essential in understanding arts therapy work with all clients, and in developing thinking and practical responses to complex areas, this book is both accessible and deeply provocative.

– **Professor Phil Jones,** University College London, UK Institute of Education, author of *The Arts Therapies* and *Drama As Therapy*

This timely book representing the insights of leading creative arts therapies scholars and the diverse range of people with whom they work is a welcome addition to the literature. Hogan has amassed a comprehensive collection of chapters critically examining the most pertinent questions and concepts related to gender and difference impacting marginalized groups and society at large today. With topics addressed including gender politics, identity politics, power and privilege, economic and social justice, and more – it holds immense appeal and relevance for scholars, clinicians and students alike.

– **Donna Betts,** PhD, ATR-BC, Past President, the American Art Therapy Association; Clinical Research Advisor, Creative Forces, National Endowment for the Arts Military Healing Arts Network; Adjunct Associate Professor of Art Therapy, George Washington University, USA

At last we have a definitive book that takes a deep dive into the therapeutic issues imbued in gender, culture, identity, and the body. Written by arts therapies clinicians, this book takes on these crucial constructs in an inclusive and representative way. Gender, like the body itself, is often the unexamined elephant in the treatment room, when it actually strongly affects every interaction, in every moment. By situating gender in a strong clinical spotlight, these authors advance our understanding and our skills in using the arts to help us all embody our genders, our identities, and our cultures in a conscious and honest way.

– **Christine Caldwell,** PhD, Professor Emeritus, Graduate School of Counseling and Psychology, Somatic Counseling, Naropa University, USA

This fantastic book offers a welcome international overview of issues which, although central to arts therapies practice, are often not given the prominence they deserve. Authors share their considerable experience and knowledge and contribute to extending ours. It is also expertly edited and collated by Professor Susan Hogan and gathers perspectives from all the arts therapies which makes it a gripping read. I recommend it to all practitioners, from trainees to experienced arts therapists, as a source of information and knowledge that will be useful in everyday clinical work.

– **Dr Val Huet,** PhD, Chief Executive Officer, British Association of Art Therapists

GENDER AND DIFFERENCE IN THE ARTS THERAPIES

Gender and Difference in the Arts Therapies: Inscribed on the Body offers worldwide perspectives on gender in arts therapies practice and provides understandings of gender and arts therapies in a variety of global contexts. Bringing together leading researchers and lesser-known voices, it contains an eclectic mix of viewpoints, and includes detailed case studies of arts therapies practice in an array of social settings and with different populations.

In addition to themes of gender identification, body politics and gender fluidity, this title discusses gender and arts therapies across the life-course, encompassing in its scope, art, music, dance and dramatic play therapy.

Gender and Difference in the Arts Therapies demonstrates clinical applications of the arts therapies in relation to gender, along with ideas about best practice. It will be of great interest to academics and practitioners in the field of arts therapies globally.

Susan Hogan is Professor of Arts and Health at the University of Derby, UK. She has written extensively on the relationship between the arts and insanity, and the role of the arts in rehabilitation, particularly in relation to women.

GENDER AND DIFFERENCE IN THE ARTS THERAPIES

Inscribed on the Body

Edited by Susan Hogan

LONDON AND NEW YORK

First published 2020
by Routledge
2 Park Square, Milton Park, Abingdon, Oxon OX14 4RN

and by Routledge
52 Vanderbilt Avenue, New York, NY 10017

Routledge is an imprint of the Taylor & Francis Group, an informa business

© 2020 selection and editorial matter, Susan Hogan; individual chapters, the contributors

The right of Susan Hogan to be identified as the author of the editorial material, and of the authors for their individual chapters, has been asserted in accordance with sections 77 and 78 of the Copyright, Designs and Patents Act 1988.

All rights reserved. No part of this book may be reprinted or reproduced or utilised in any form or by any electronic, mechanical, or other means, now known or hereafter invented, including photocopying and recording, or in any information storage or retrieval system, without permission in writing from the publishers.

Trademark notice: Product or corporate names may be trademarks or registered trademarks, and are used only for identification and explanation without intent to infringe.

British Library Cataloguing-in-Publication Data
A catalogue record for this book is available from the British Library

Library of Congress Cataloging-in-Publication Data
Names: Hogan, Susan, 1961– editor.
Title: Gender and difference in the arts therapies : inscribed on the body / edited by Susan Hogan.
Description: Milton Park, Abingdon, Oxon ; New York, NY : Routledge, 2019. | Includes bibliographical references and index.
Identifiers: LCCN 2019005594 (print) | LCCN 2019018250 (ebook) | ISBN 9781351105361 (Master E-Book) | ISBN 9781138477148 (hardback : alk. paper) | ISBN 9781138477186 (pbk. : alk. paper) | ISBN 9781351105361 (ebk)
Subjects: LCSH: Art therapy. | Gender identity. | Sex role—Psychological aspects.
Classification: LCC RC489.A7 (ebook) | LCC RC489.A7 G45 2019 (print) | DDC 615.8/5156—dc23
LC record available at https://lccn.loc.gov/2019005594

ISBN: 978-1-138-47714-8 (hbk)
ISBN: 978-1-138-47718-6 (pbk)
ISBN: 978-1-351-10536-1 (ebk)

Typeset in Bembo
by Apex CoVantage, LLC

CONTENTS

Dedication ix
About the editor x
Notes on contributors xiii
Foreword xviii

1 Introduction: inscribed on the body: gender
 and difference in the arts therapies 1
 Susan Hogan

2 Feminism as practice: crafting and the politics of art therapy 13
 Savneet Talwar

3 Under the skin: barriers and opportunities for dance
 movement therapy and art psychotherapy with LGBT+ clients 24
 Thania Acarón and Alison Wren

4 Breaking and entering: wounded masculinity
 and sexual offending 36
 Emma Allen

5 Body politics and performance of gender in music therapy 53
 Randi Rolvsjord and Jill Halstead

6 Mask and gender: from concealment to revelation, from pain
 to relief. Arts therapies with masks. A journey through art therapy 69
 Irina Katz-Mazilu

7	Mediating the cultural boundaries: the rise of Lion Rock Spirit in Hong Kong women *Bianca Ling Cheun Lee and Regina Wai Yin Au*	84
8	Gender differences expressed in costuming and dramatic play: Warrior Cat boy *Jeanne Sutherland*	99
9	On being a male dramatherapist *Clive Holmwood*	111
10	The perilous house *Silvia Wyder*	123
11	Gender fluidity through Dance Movement Therapy *Julia Hall*	137
12	Gender research in Dance Movement Therapy *Katharina Forstreuter and Sabine C. Koch*	151
13	Art therapy and motherhood as a rite of passage *Evelina Jagminaite*	163
14	Gender identity, sexual identity and sexual orientation in a drama-therapeutic context: an attachment perspective *Craig Flickinger*	181
15	Dismantling the gender binary in elder care: creativity instead of craft *Erin Partridge*	196
16	Beyond masculine and feminine: responding to real expressions of gender identity and the effect on our own gender identity in psychotherapy practice *Mark Wheeler*	207
17	Beyond the binaries: negotiating gender and sex in music therapy *Susan Hadley and Maevon Gumble*	218
Index		*229*

*This book is dedicated to Neil
(affectionately known as "Puggy")
who enlivens my life.*

When liberal whites fail to understand how they can and/or do embody white supremacist values and beliefs even though they may not embrace racism as prejudice or domination (especially domination that involves coercive control), they cannot recognize the ways their actions support and affirm the very structure of racist domination and oppression that they wish to see eradicated.
— *bell hooks*, Talking Back: Thinking Feminist, Thinking Black

ABOUT THE EDITOR

Susan Hogan has a BA Degree in fine art, a post-graduate diploma in art therapy, a Master's Degree in Arts Administration (Arts Policy and Management), and a further Master's Degree in Social Science Research Methods (Social Policy and Sociology, specialising in visual methods). Her PhD, in Cultural History from Aberdeen University, Scotland, looked at the history of ideas on madness and the use of the arts, especially within psychiatry. Susan has also studied art history at Sydney University. Additionally, Susan undertook further training in group-psychoanalytic psychotherapy. She served for six years as a Health Professions Council (U.K.) "visitor" (now HCPC). She is a former Vice-President of ANATA (Australian National Art Therapy Association, now ANZATA), and has twice served as a regional co-ordinator for the British Association of Art Therapists (BAAT). She has been instrumental in setting up, or helping to set up, several art therapy-training courses (Perth, Sydney, Edinburgh, Derby) and also courses in dance movement and drama therapy (Derby).

Professor Hogan qualified as an art therapist in 1985. She has a particular interest in group-work and experiential learning, following early employment with Peter Edwards, MD, an exceptional psychiatrist who had worked with Maxwell Jones, a psychiatrist who is associated with the "therapeutic community movement" in Britain. Susan Hogan has worked mainly in academia since 1983 for a number of institutions, including The University of New South Wales, College of Fine Art; The University of Technology, Sydney; Macquarie University and the National Art School, Sydney.

She is currently Professor in Cultural Studies and Art Therapy in which role for many years she facilitated experiential workshops and the closed-group component of the art therapy training. This closed-group training has been based on the group-interactive approach described by Professor Diane Waller. Now most of her

time is spent supervising research at MA and PhD levels, research management and conducting research.

Susan has also undertaken work with pregnant women and women who have recently given birth, offering art therapy groups to give support to women, and an opportunity for them to explore their changed sense of self-identity and sexuality as a result of pregnancy and motherhood. She has published extensively on this subject. Professor Hogan has been conducting research with several partner institutions, including co-researching women's experience of ageing with sociologists from the University of Sheffield using visual research methods. She is a Professorial Fellow of the Institute of Mental Health of the University of Nottingham where she is co-researching health humanities. Additional to all the above, she has also published a number of both scholarly and polemical papers on women and theories of insanity.

She is a steering-group member of the Arts Health and Wellbeing Special Interest Group at the Royal Society of Public Health, England, and a member of the International Advisory Board for the International Health Humanities Network. She was a recent contributor to the All Party Parliamentary Group inquiry on Arts, Health and Wellbeing being led by Lord Howarth. Particularly influenced by the anthropological work of her late mother-in-law, Professor Dame Mary Douglas, Hogan's work has been innovative in its application of social anthropological and sociological ideas to art therapy; also distinctive is her unwavering challenge to reductive psychological theorising.

Her books are:

- *Feminist Approaches to Art Therapy* (as editor, 1997);
- *Healing Arts: The History of Art Therapy* (2001);
- *Gender Issues in Art Therapy* (as editor, 2003);
- *Conception Diary: Thinking About Pregnancy & Motherhood* (2006);
- *Revisiting Feminist Approaches to Art Therapy* (as editor, 2012);
- *The Introductory Guide to Art Therapy* (with Coulter, 2014);
- *Art Therapy Theories. A Critical Introduction* (2016);
- *Maternal Ambivalence* (co-editor, in-press due 2019);
- Gender Issues in International Arts Therapies Research (concurrent to this book).

Endorsements for *Art Therapy Theories* (the editor's last book):

- "Hogan masterfully explores various theories. . . . My own approach to teaching is changed because of this book . . . a must-read for students, educators and practitioners alike" (**Donna Betts, President of the American Art Therapy Association)**;
- "I found this book really enlightening and strongly recommend it" **(Diane Waller OBE, President of the British Association of Art Therapists)**;

- "*Art Therapy Theories* by Susan Hogan is the book that I, as the executive director of an art therapy training programme and a professor, have been waiting for...." **(Helene Burt, former President of the Canadian Art Therapy Association)**;
- "... this is an essential read for a new generation of art therapists" **(Annette Coulter, former President of the Australian and New Zealand Art Therapy Association)**.

CONTRIBUTORS

Thania Acarón is a lecturer, performer, choreographer and dance movement psychotherapist from Puerto Rico. She obtained her PhD on the role of dance in violence prevention at the University of Aberdeen and holds a master's degree in Dance Education from New York University. She is certified as a clinical supervisor and dance movement psychotherapist in the UK and US. Thania currently works as a lecturer at the Dance Programme at the University of South Wales in Cardiff and co-directs two artist collectives. She offers international workshops on movement and wellbeing and interdisciplinary practice.

Emma Allen is a HCPC Registered Art Psychotherapist, clinical supervisor, lecturer, and a sandplay therapist. She has been working as an art psychotherapist at Rampton Hospital, one of the three high secure hospitals in the UK since 2009; specialising her work in assessment and treatment with adult men and offender populations with personality disorders and psychopathy. She has also recently set up an art psychotherapy and sandplay service with the only residential service providing assessment and treatment to young adult offenders aged 18–25, who are likely to be diagnosed with a personality disorder in prison, at HMP YOI Swinfen Hall, on the Delta Enabling Environment (DEE) service that is provided in partnership between Northamptonshire Healthcare Foundation NHS Trust (NHFT) and Her Majesty's Prison and Probation Service (HMPPS) on the Offender Personality Disorder pathway. She has previously been a Senior Lecturer in Art Psychotherapy at the University of South Wales (2016–2017), and a treatment manager for the Aurora Project, the first project to be set up to prevent sexual offending, with the Safer Living Foundation (a charity in partnership with HMP Whatton and Nottingham Trent University). Along with her work in both high secure, and prison, she is a visiting lecturer at Nottingham Trent University, and a peer reviewer for a number of journals, e.g. *Personality and Mental Health Journal*. She is an author of

works about both art psychotherapy and sandplay therapy, and is the founder, and pioneer, of forensic sandplay therapy.

Craig Flickinger is a Licensed Creative Arts Therapist, a Registered Drama Therapist and holds his MA in Creative Arts Therapies from Concordia University. He currently lives in New York. Attachment theory is a specialty area of interest and Craig is an advocate for the LGBTQQIAP2S community and for gender equality and equity.

Katharina Forstreuter first worked in the field of sports management, before her own experience of the close connection between body and mind brought her to study Dance/Movement Therapy (DMT) at the SRH Hochschule Heidelberg, Germany. For her Master's thesis, she researched the influence of sex and gender on the efficacy and active factors of DMT.

Maevon Gumble is a board-certified music therapist and currently works with youth in long-term residential placement for a nonprofit organization, Familylinks, Inc. (Pittsburgh, Pennsylvania, USA). They have recently graduated with their Master of Music Therapy Degree from Slippery Rock University (Slippery Rock, Pennsylvania, USA) and is a guest editor on *Voices: A World Forum for Music Therapy* for a special issue on queering music therapy. Maevon's professional interests include gender affirming voicework, working with LGBTQ+ persons, and community-based work.

Susan Hadley is professor and director of music therapy at Slippery Rock University, Pennsylvania, USA. Dr Hadley is author of *Experiencing Race as a Music Therapist: Personal Narratives* (Barcelona, 2013), editor of *Feminist Perspectives in Music Therapy* (Barcelona, 2006), *Psychodynamic Music Therapy: Case Studies* (Barcelona, 2003), and co-editor of *Our Black Sons Matter: Mothers Talk about their Fears, Sorrows, and Hopes* (Rowman & Littlefield, 2016) and *Therapeutic Uses of Rap and Hip Hop* (Routledge, 2012). She has also published numerous articles, chapters, and reviews in a wide variety of scholarly journals and books in music therapy and related fields.

Julia Hall is an ADMP UK registered dance movement psychotherapist, clinical supervisor, lecturer, choreographer and performer. She works in private and public practice with children and adults, specialising in gender dysphoria, trauma, anxiety and problems associated with sensory integration and sensory attachment. She has developed and delivers wellbeing packages for education staff in primary schools. Julia regularly presents and delivers workshops and training related to her clinical practice and research. Julia is currently a lecturer across undergraduate and postgraduate university programmes.

Jill Halstead is professor at the Grieg Academy – Department of Music, University of Bergen, Norway. Jill gained a PhD in music from Liverpool University, UK,

in 1995 and has published in the field of gender and music and popular music in addition to practice-led research disseminated through performance and film. She is currently the director of the Grieg Research School in Interdisciplinary Music Studies, a regional research consortium on the west coast of Norway.

Clive Holmwood is a dramatherapist with more than 23 years of experience working with children and adults in the public, private, and voluntary sectors. He is currently a Senior Lecturer in Dramatherapy and Admissions Tutor for Creative Expressive Therapies, at the University of Derby, and a Director of Creative Solutions Therapy Ltd. He gained his PhD from the University of Warwick, and his thesis was published by Routledge in 2014 as *Drama Education and Dramatherapy – Exploring the Space between Disciplines*. He is also the co-editor of *The International Handbook of Dramatherapy*, published by Routledge in 2016.

Evelina Jagminaite, MA, PLPC, is an Art Therapist/Clinical Counsellor at Children's Bureau of New Orleans, Louisiana, USA, working with children, adults, and families. She was an Artist in Residence for Social Action, WINGS/Art Corps Guatemala – a nongovernmental organisation providing reproductive health care, education, and family planning.

Irina Katz-Mazilu is a trained art therapist. She graduated with the Diplôme d'université (DU) from the Université René Descartes Paris V in 1998 and since then has worked as an art therapist in clinical and social settings and on a private basis in her workshop. She is also active as an art therapy educator and supervisor in social work schools, university settings, and post-graduate art therapy training. She is the President of the Fédération Française des Art-Thérapeutes since 2008. Irina Katz-Mazilu is also a visual artist. She graduated from the Fine Arts Institute of Bucharest and the Ecole Nationale Supérieure des Arts Décoratifs of Paris. She is a member of the Maison des Artistes in Paris. She regularly exhibits her art work in solo and group exhibitions.

Sabine C. Koch did her doctorate in the field of psychological gender research. Today her research focus is on artistic therapies, in particular on Embodiment and Dance/Movement Therapy (DMT). In addition to the professorship for the study program DMT at the SRH Heidelberg University, which has been founded by her, she is the director of the Research Institute for Artistic Therapies at Alanus College Alfter.

Bianca Ling Cheun Lee is an artist, advocate, registered art therapist, and licensed professional clinical counsellor. She received her Master of Art in Art Therapy from the School of the Art Institute of Chicago. Since returning to Hong Kong in 2015, Bianca's focus has been on researching, learning, and lecturing on healing locally and internationally. www.BiancaLeeArts.com

Erin Partridge is an artist and board certified, registered art therapist. Her clinical experience includes work in community, paediatric, forensic, and geriatric settings. Erin has a PhD in art therapy from Notre Dame de Namur, and works as a professor and researcher in the elder care field.

Randi Rolvsjord is Head of department at the Grieg Academy – Department of Music, University of Bergen, Norway. She is also professor in music therapy. She holds a PhD from Aalborg University. She has published extensively on resource-oriented perspectives on music therapy in mental health, highlighted user-perspectives, and contributed to the development of critical and feminist perspectives in music therapy.

Jeanne Sutherland is trained with degrees in fine art, creative arts therapy, special education, and the social psychology of leadership. She is interested in clinical applications using the arts with individuals and with groups towards social development through empowerment arts. She has further interests in applied theatre and therapeutic enrichment groups. She currently teaches as an adjunct professor and as a continuing education specialist in the arts therapies for allied professionals (in Vermont, New Hampshire, and Massachusetts, USA).

Savneet Talwar is an Associate Professor, Art Therapy, School of the Art Institute of Chicago. Dr. Talwar's current research examines feminist politics, critical theories of difference, social justice, and questions of resistance. Using an interdisciplinary approach, she is interested in community-based art practices, cultural trauma, performance art, and public cultures as they relate to art therapy theory, practice, and pedagogy. Her current projects are: *Wandering Uterus Project: A DIY Movement for Reproductive Justice* and *CEW (Creatively Empowered Women) Design Studio*, a craft, sewing, and fabrication enterprise for Bosnian and South Asian women at the Hamdard Center in Chicago. She is the Associate Editor for *Art Therapy: Journal of the American Art Therapy Association*.

Regina Wai Yin Au is a HCPC Registered Art Therapist and BACP Registered Counsellor and Psychotherapist (MBACP). She received her Master of Arts in Art Therapy from the University of Derby. She worked extensively in Hong Kong's public school system with at-risk adolescents since returning to Hong Kong in 2014. www.arttherapyedu.com

Mark Wheeler is a HCPC Registered Art Psychotherapist and supervisor working in NHS child and family therapy and in private practice. Mark is listed on the Department of Health National Clinical Expert Database, selected to provide advice at the national level. Mark used therapeutic photography with adolescents at a therapeutic community and subsequently became the first British photography graduate to undertake post-graduate art therapy training. Mark's qualifying dissertation (1992) was *Phototherapy: The Use of Photographs in Art Therapy*. Mark's

publications include book chapters and journal articles. He also teaches. He has appeared on BBC radio and been interviewed and quoted in magazines, and in 2018 he was awarded the Diamond Phototherapy Award at the Royal Society. Mark continues to make and exhibit artworks including photographs.

Alison Wren is an integrative Art Psychotherapist based in Scotland. She works in the voluntary sector and in private practice, specialising in working affirmatively with clients around issues of sexuality, gender, and relationship diversities. She regularly delivers training to mental health professionals and teaches Master's level arts therapy trainees on LGBT awareness. She has developed an award-winning mental health and wellbeing service for LGBT people, produced two educational films and published a creative writing anthology co-created with LGBT people with lived experience of mental ill health. www.arttherapywithalison.com

Silvia Wyder is currently carrying out a research PhD in art therapy and cultural studies at the University of Derby, UK. She is looking at the house as a metaphor of the self through house drawings and paintings by participants in clinics from (mostly) European and Japanese cultures, additionally focusing on possible appearances of post-traumatic stress disorder phenomena. Further material is obtained via architects' and artists' interview narratives and artworks in the same cultures. Her interdisciplinary research involves art, art therapy, architecture theory, anthropology, and phenomenology. Her former training spans the fields of the arts, art therapy, and mental health. She lives in France close to Geneva.

FOREWORD

Gender and madness: written on the body

For centuries, women have occupied a unique place in the annals of insanity. Women outnumber men in diagnoses of madness, whether this be the "hysteria" of the eighteenth and nineteenth century, or the "neurotic" and mood disorders of the twentieth and twenty-first. Women are also more likely to receive psychiatric "treatment", whether this is hospitalisation in an asylum, accompanied by restraint, electro-convulsive therapy (ECT) and psycho-surgery, or the psychological therapy and psychotropic drug treatments of today (Ussher 2011). The body is central to this process.

If we look to accounts of hysteria, the most commonly diagnosed "female malady" of the eighteenth and nineteenth century, we can trace the genealogy of the "regimes of truth" which define and regulate women's madness today (Ussher 2011). Whilst hysteria was first described by the ancient Greeks, appearing in the writings of Plato and Hippocrates, it was in the seventeenth century that it emerged as one of the most common diseases treated by medics. The British physician Edward Tilt argued in 1881 that "mutability is characteristic of hysteria because it is characteristic of women", a sentiment echoed in 1883 by the French physician Auguste Fabre, who declared "all women are hysterical and . . . every woman carries with her the seeds of hysteria. Hysteria . . . is a temperament, and what constitutes the temperament of a woman is rudimentary hysteria" (Showalter 1993, pp. 286–287).

Whilst the causes of this nebulous disorder were widened to include the nervous system in the late eighteenth century, allowing men to receive a diagnosis of hysteria (Showalter 1997), it was always considered to be "woman's disease", a disorder linked to the essence of femininity itself. Indeed, Thomas Laycock (Laycock 1840), in 1840, described hysteria as a woman's "natural state", whereas it was deemed a "morbid state" in a man (Smith-Rosenberg 1986, p. 206).

By the late nineteenth century, as Carol Smith Rosenberg has argued, "every known human ill" (Smith-Rosenberg 1986, p. 202) was attributed to hysteria, meaning that the diagnosis ceased to mean anything at all (Micale 1995, p. 220). Women diagnosed with hysteria could exhibit symptoms of depression, rage, nervousness, the tendency to tears and chronic tiredness, eating disorders, speech disturbances, paralysis, palsies, and limps, or complain of disabling pain. Many women also exhibited a hysterical "fit", which could either come on gradually, or could occur suddenly, mimicking an epileptic seizure (Smith-Rosenberg 1986, p. 201). Indeed, hysteria has been described by Roy Porter as a "veritable joker in the taxonomic pack" (Porter 1993, p. 226), and by Lesegne as the "wastebasket of medicine" (Bronfen 1998, p. xi) largely because of its nebulous and multifarious nature. Hysteria has also been described as a "mimetic disorder" because it mimics culturally permissible expressions of distress – hysterical limps, paralyses, and palsies were accepted symptoms of illness in the nineteenth century, but have virtually disappeared today, as they no longer stand as a "sickness stylistics for expressing inner pain" (Porter 1993, p. 229). As Edward Shorter argues the symptoms that are accepted as legitimate signs of illness or madness, the "symptom pool", are particular and peculiar to a specific culture, at a particular point in time. By deeming certain symptoms "illegitimate", culture encourages patients not to develop them in order to avoid being positioned as "undeserving", as not having a "real" medical problem. There is thus, Shorter declares, "great pressure on the unconscious mind to produce only legitimate symptoms" (Shorter 1992, p. x; Showalter 1997, p. 15).

At the beginning of the twenty-first century the "legitimate" symptoms of madness are laid out for all to see in the *Diagnostic and Statistical Manual of the American Psychiatric Association* (DSM), (American Psychiatric Association 2013). As new diagnoses are added with each edition (and others, such as hysteria or homosexuality, removed), details of the necessary symptoms for diagnosis are circulated through interactions with the psy-professions, or through pharmaceutical company advertising, media discussion of madness, and "self-help" diagnostic websites. Is it surprising that so many women self-diagnose with these disorders, and then come forward for professional confirmation of their pathological state? Their distress is no less real than that of the women diagnosed as hysterics in the nineteenth century. However, the myriad disorders with which we are now diagnosed are no less mimetic than hysteria was then – we signal our psychic pain, our deep distress, through culturally sanctioned "symptoms", which allows our distress to be positioned as "real". Or we are told by others that we have a problem, and are then effectively positioned within the realm of psychiatric diagnosis and treatment, with all the regulation and subjugation that this entails.

The reproductive "disorders" premenstrual syndrome, post-natal depression, and menopausal depression have taken over from hysteria as "women's problems" associated with the reproductive body – manifestations of the "monstrous feminine" that mark women as mad, bad or dangerous (Ussher 2006). At the same time, higher rates of anxiety and depression reported by women are often attributed to the reproductive body (Ussher 2010). In my own writing and research, I have focussed on women's

regulation and resistance in relation to bio-medical and cultural discourse associated with madness (Ussher 1989, 2006, 2011). However, madness is not solely a "woman's problem". All of the emotions and behaviour that serve as signifiers of madness – including distress, anger, and misery – are experienced by both women and men, and psychiatric diagnosis is also applied to both. Madness is a gendered experience, with "symptoms" judged differently in women and men, and certain diagnostic categories more likely to be applied to women. Indeed, madness is still signified by femininity, whether it occurs in women or men, which is one of the reasons why many distressed men eschew psychological diagnosis or treatment, as they don't want to be seen to be "like a woman" (Batty 2006). I thus agree with Susan Hogan, and the contributing authors within this volume, that it is important to look at *gender* and madness. I also agree that it important to acknowledge the interaction and mutually constitutive nature of gender, sexual identity, age, cultural identity, and other categories of difference in individual lives and social practices, and the association of these arrangements with health and wellbeing. This intersectional framework recognises that individuals are characterised simultaneously by multiple and interconnected social categories, and that these categories are properties of the individual in terms of their identity, as well as characteristics of social structures (Crenshaw 1991).

This book contains ground-breaking contributions on gender and the body in the context of art therapies. It will challenge and inform the practice of those engaged in the many rich varieties of art therapy examined within the chapters. However, it is also of key relevance to scholars, researchers, and clinicians interested in gendered embodiment in the context of madness. I commend the editor and the authors for their insightful and fascinating work, and recommend the book wholeheartedly to prospective readers.

Jane M Ussher, Western Sydney University
Author of *The Madness of Women: Myth*
and Experience **(Routledge, 2011)**

References

American Psychiatric Association. (2013). *Diagnostic and statistical manual of mental disorders*, Edition V. Washington, DC: American Psychiatric Association.

Batty, Z. (2006). *Masculinity and depression: Men's subjective experience of depression, coping and preferences for therapy and gender role conflict*. School of Psychology, University of Western Sydney.

Bronfen, E. (1998). *The knotted subject: Hysteria and its discontents*. Princeton, NJ: Princeton University Press.

Crenshaw, K. (1991). Mapping the margins: Intersectionality, identity politics, and violence against women of color. *Stanford Law Review* **43**(6): 1241–1299.

Laycock, T. (1840). *An essay on hysteria*. Philadelphia: Haswell, Barrington and Haswell.

Micale, M. S. (1995). *Approaching hysteria. Disease and its interpretations*. Princeton, NJ: Princeton University Press.

Porter, R. (1993). The body and the mind, the doctor and the patient: Negotiating hysteria. *Hysteria Beyond Freud*. S. L. Gilman, H. King, R. Porter, G. S. Rousseau and E. Showalter. Berkeley: University of California Press: 225–285.

Shorter, E. (1992). *From paralysis to fatigue*. New York: The Free Press.
Showalter, E. (1993). Hysteria, feminism and gender. *Hysteria Beyond Freud*. S. L. Gilman, H. King, R. Porter, G. S. Rousseau and E. Showalter. Berkeley: University of California Press: 286–344.
Showalter, E. (1997). *Hystories: Hysterical epidemics and modern culture*. New York: Columbia University Press.
Smith-Rosenberg, C. (1986). *Disorderly conduct: Visions of gender in Victorian America*. Oxford: Oxford University Press.
Ussher, J. M. (1989). *The psychology of the female body*. New York: Routledge.
Ussher, J. M. (2006). *Managing the monstrous feminine: Regulating the reproductive body*. London: Routledge.
Ussher, J. M. (2010). Are we medicalizing women's misery? A critical review of women's higher rates of reported depression. *Feminism & Psychology* **20**(1): 9–35.
Ussher, J. M. (2011). *The madness of women: Myth and experience*. London: Routledge.

1
INTRODUCTION

Inscribed on the body: gender and difference in the arts therapies

Susan Hogan

Bodies and difference

In a bizarre TV programme, *Naked Attraction*, 'blind-dating' is done incrementally by revealing a row of nude bodies bit by bit: first the legs and genitals are seen of a row of contestants; then the competitors are asked to turn so the buttocks can be appreciated. Following that, the person doing the choosing eliminates one person, based on his or her appreciation of the physiques on offer. The bodies are objectified and the chooser may make personal remarks about the bodies on view. Next the torsos are revealed and a further contestant is eliminated. Next the screen is further raised so the whole body including the face is seen. In this final round, the two remaining contestants on display are invited to say something they like and dislike about their own bodies, so that their voice can be heard. They get to speak briefly, as instructed. Then a person (or I should say body) is chosen for the date.

A bisexual woman has both men and women in her purview and rejects a young black man because his penis is too big. 'I'm sorry man, it's just too intimidating' she says as he walks out, but then he talks to the camera off-stage, incredulous and sounding slightly hurt that he has been rejected because of the size of his tool:

> My penis was too big for her? If she got to know me she'd know I'm the kindest and most gentle-ist person there is, so that wouldn't really be much of an issue. . . .

We are all judged by the appearance of our bodies. A penis can be an object of intimidation, an instrument of rape, of brutalising sex, or a gentle plaything in the expression of mutual tenderness. A kind gentle man couldn't see his largeness as a problem, because he would be kindly and gentle.

Our bodies are all signifiers of meanings beyond our control. *Our bodies are imbued with the values of our particular culture and historical moment.* The body is not a 'natural thing' beyond culture. It is helpful to think of bodies as 'symbols' – '*the medium through which social relations are constructed*' (Shilling 2016, p. 10). The body as a symbol 'helps people to think, classify, and even engage in discriminatory practices based on physical markers. . . .' (Shilling 2016, p. 7). These meanings are constantly contested. They are in a state of flux, so the meanings ascribed to the body are unstable and we are subject to multiple and conflicting messages about our bodies and what gender means. This instability, I'll call it 'field instability' is affecting.[1] These conflicting messages are potentially destabilising and can lead to mental distress (Hogan 2016b).

Women and men have different bodies and so there is a cultural presumption of difference. However, there is significant variation *between* women, and *between* men, regarding attributes associated with femininity and masculinity – more variation in fact than *between women and men overall* (Kimmel 2011, p. 14).[2] Stereotypes often ignore the similarities and emphasise differences between male and female bodies, and supposed attributes (Richardson 2013). Shilling 2016 highlights the study of hormones (endocrinology) as providing an account of bodies that challenges assumptions of biological opposition, 'Endocrinologists suggested that the chemicals responsible for sex differences meant that there was no such thing as *the* male or *the* female body: it was more accurate to speak of a continuum of sexed bodies' (p. 35). So men and women are not from Mars and Venus respectively. . . .[3] R. W. Connell notes, of sex differences between men and women, that,

> Sex differences, on almost every psychological trait measured, are either non-existent or fairly small. Certainly they are smaller than the differences in social situations that are commonly justified by the belief in psychological difference – such as unequal incomes, unequal responsibilities for child care and drastic differences in access to social power.
>
> *(Connell 1995, p. 21)*

Nonetheless, gender appears important; there is a cultural insistence on knowing sex. Many who have held a new-born infant in a public place will know that, 'Is it a girl or a boy?' is a popular conversational gambit. Knowing the sex determines the gender rules: in this case what adjectives are appropriate to use to describe the baby's behaviour. . . . Gender ambiguity is culturally disconcerting (probably because so many cultural 'rules' rely on gender categorisation). Braithwaite and Orr suggest that 'gender nonconformity is often viewed as threatening to social institutions' (2017, p. 181).

So there are tensions at play here. Gender differences between men and women appear to be fewer and less pronounced than some might suppose when researched, but notions about gender lead to cultural practices, which also create difference. Cultural practices do shape our physical and neurological make-up

(Shilling 2016, p. 32). Indeed, to speak of a male or female sex is reductive, as it compresses an enormous variety of different cultural ideals into one entity. Fine (2010, p. 3) makes this point,

> Every person is unique, multifaceted, sometimes even contradictory individual, and with an astonishing range of personality traits within each sex, and across contexts, social class, age, experience, educational level, sexuality and ethnicity, it would be pointless and meaningless to attempt to pigeonhole such rich complexity and variability into two crude stereotypes....

An important concept to introduce here is that our experiences are also constituted by many other factors, which *intersect* with our having an ostensibly male or female body, such as colour, age, sexual orientation, and so forth. Thinking about intersectional aspects also allows a critical questioning of medical diagnostic classificatory tools used by mainstream psychiatry, for example, that, 'capitalist, white, heteropatriarchal norms dictate the ways in which people are diagnosed, and therefore treated' (and some of these classificatory norms have an underpinning in theories which are fundamentally sexist and racist, Hogan 1997). 'This also means access [to treatment] differs depending on these intersecting aspects of identity' (Jensen 2015, np), as do diagnostic and treatment predilections (Hogan 1997).

Our identities are created by our cultural context, intersecting with many other elements. However, to say there may be different elements, such as ethnicity, which intersect with one's body is potentially problematic, as such a formulation might imply a separation of elements; it is more helpful to see intersectional elements as unified aspects of selfhood, which are more or less operational depending on context. Scholars have highlighted simultaneous and multiple forms of oppression. Brah warns that 'structures of class, racism, gender and sexuality cannot be treated as "independent variables" because the oppression of each is described in the other – is constituted by and is constitutive of the other' (1996, p. 12). O'Reilly (2017) argues that motherhood should also be acknowledged in intersectional discourse as an important and often overlooked subject position.

Gendered subjects (us) are constituted through social relations. One might then go a step further and challenge the notion of us as having a fixed steady identity, though we seemingly have this – a 'core' sense of self, but close analysis reveals that actually we are all distinctive in different situations; we all have different repertoires of being. Context makes us different people. If I am engaging with my dog, I am likely to feel very different things compared to when I am engaging with my vice-chancellor, or a best friend. Different contexts bring out different potentialities and in so doing we are changed, often imperceptibly, moment by moment. Fine (2010, p. 7) puts it like this, 'The active self is a dynamic chameleon from moment to moment in response to its social environment'. Ethnographers have articulated a sense of a *self in process*. Rather than a fixed self that is determined by our biology coupled with early formative childhood experiences (as some psychologists would have it) a more fluid approach to identity is adopted. We are formed and reformed,

made and making simultaneously through our interactions with others.[4] However, we should not think of this as a passive process, as we enact or perform 'gender' identity more or less self-consciously within certain discursive and conceptual limits (Butler 1993). The 'self' is a work in progress, not something fixed. Moreover, we should not assume an essential sameness of human subjectivity across cultures, or even within subject positions. Furthermore, genetic theories are also potentially very reductive when deterministically applied to ideas about identity,

> ... gendered identities of masculinity and femininity cannot be reduced to any 'logic' of genetic influence. The significance of genes and groups of genes, indeed, is *codetermined* by interactions within the human organism as well as by interactions that people have with the social and material environment in which they live.
>
> *(Shilling 2016, p. 36)*

Inequality

Ideology is ideas and concepts about men and women, masculinity and femininity, appropriate roles, capacities or innate ability, ethnic characteristics, and sexuality, which are culturally and historically specific and subject to change. Ideological ideas are located in a particular moment in time, within a particular set of social practices. The body is not a *tabula rasa* (a clean slate) as, even at birth, it is subject to notions about masculinity and femininity and their relative value within particular cultures, because of ideas about the value of roles, dowries, primogeniture, or other inheritance rules. A female baby may be bottle-fed and a male child breast-fed, because he is considered more valuable. In many cultures women join their in-law's families upon marriage and may be in some senses 'lost' to their original family. Large dowries can set up resentments, with negative repercussions for women, their husbands potentially aggrieved about acquired debts. A particularly detrimental cultural practice is called *Baad*, an Afghan custom of giving a girl or women away to a wronged family for the resolution of conflicts involving a murder or a serious affront to honour. Women given in marriage in this way are often subjected to ongoing maltreatment: treated like servants, housed in barns with the animals and beaten as a form of revenge against her family (Gagnon 2012). In cultures where extended families co-operate together the son, who stays with his parents, possibly accumulating a wife's bride's price or dowry along the way, is considered more valuable. In some cultures women have very circumscribed roles, or are kept in *purdah* (a practice of screening women from the sight of men or strangers), and therefore are unable to contribute directly to certain sorts of family business, or enter into a wide variety of roles that require independence of movement. In many contexts *freedom of movement for women is simply unthinkable*, 'In Lagos, I cannot go alone into many reputable clubs and bars. They just don't let you in if you are a woman *alone*. You must be accompanied by a man', notes Nigerian writer Chimamand Ngozi Adichie (2014, p. 20). Cultural norms vary tremendously, but the economist Amarta

Sen suggests that millions of women have deaths 'directly attributable to gender inequality in healthcare' (2001, pp. 35–40). He calculates that there are 100 million 'missing women' globally.[5] Women receive less good health care or nutrition in many parts of the world than their male counterparts. 'As a result of this gender bias' explains Sen, 'the mortality rates of females often exceed those of males in these countries. The concept of the "missing women" was devised to give some idea of the enormity of the phenomenon' (2001, p. 470).

Mortality inequality had been documented in Asia and North Africa, including China (Sen 2001, p. 466). Female foeticide, the selective abortion of female foetuses, is prevalent in China, East and South Asia, South Korea, and India. Sen calls this 'high-tech sexism' (p. 467) as it relies on foetal scanning technologies. Fewer girls than males get educational opportunities globally and lower levels of education are in turn linked to higher rates of reproduction with attendant health risks and health inequalities for women; educated women are less likely to actually die in childbirth (UNESCO Report 2013). Lower rates of childbirth are associated with lower rates of maternal mortality, reduction of poverty, empowerment of women, and environmental sustainability (World Health Organisation, Cleland et al. 2006). Sexual violence and sexual slavery is still rife globally, with rape of women without nationality documentation and migrating women at border controls being on-going, including at the USA border (Human Rights Watch Reports 2017). There is also huge inequality in property ownership globally between men and women (Sen 2001, p. 468). To conclude,

> Globally, many women do not have equal access to resources, and in many cultures have little autonomy outside male control, or are regarded as of lesser value than males, or face male resistance to independent action. Structural inequality in so-called developed countries is still rife, and women are more likely than men to suffer from poverty in later life, lack of opportunity and unequal access to public resources as they age.
>
> *(Hogan & Warren 2013, p. 6)*

Same-sex relations are still illegal in many parts of the world and carry heavy penalties. Even in countries where gay marriage is legal, discrimination continues. Half a century after homosexuality was partially decriminalised in England and Wales, following the Sexual Offences Act (1967), a YouGov poll of 1,609 adults undertaken in 2017 found that high levels of prejudice still remain. Age appeared to be a factor in the responses, as over three in four (78 per cent) of people aged 18–24 believing that gay sex is natural. However, many of the over 60s held negative views. Commenting on the survey, Pink News Chief Executive Benjamin Cohen said: 'It is depressing that 50 years on from the Sexual Offences Act that so many people still think that gay sex is unnatural and that a third oppose gay couples having children' (Nissim 2017).

Men and women who are 'straight' but do not confirm to particular time-and-place specific ideals of masculinity and femininity can also face problems and can

be subjected to bullying, ostracism, or worse because they are perceived as different (see Bichovsky 2003, for an example of this). Gender ambiguity, for example, can rouse strong responses. 'People', notes Bancroft & Fevre (2016), 'can feel themselves trapped by the weight of traditions, institutions, laws, and expectations...' (p. 1). Difference can create punitive and bullying responses, with the majority of transsexual people reporting having been subject to harassment, discrimination, violence, or even forced sex (Carmell, Hopwood & Dickey 2014, p. 310). Furthermore, trans elders often have lower wages and fewer assets than peers, due to discrimination in the workplace and thus experience the same problems of late-in-life poverty, as do many women (Ippolito & Witten 2014).

Inscribed on the body: on the 'discursive limits of sex'

This chapter will think about the concept of gender in further depth. It will then 'unpack' the title of the book. The word 'gender' may be used as a synonym for 'sex', but more often in sociological and other literature refers to male or female with regard to social and cultural ideas and beliefs acquired through enculturation. Attempts to separate 'biological sex' from 'gender' have been queried, as notions about gender colour even how biological processes are interpreted and described and bodies do not exist outside of culture (Jordan-Young 2010). Recent writers on gender have acknowledged the body as a 'text': 'We inscribe our bodies with a wide range of cultural signs and symbols. . . . Our bodies become social "texts" that we construct to be read by others' (Kimmel 2011, p. 339).

Inscribed on the Body is a reference to a corpus of scholarly activity that addresses how bodies are 'inscribed' or imbued with cultural meaning with regard to gender norms, and how in turn assumptions about gender difference lead to practices of inequality. The notion of the material inscription of the ideological comes from Marxist theory, but it also refers to French post-structuralist thought and a move towards linguistic analysis, which seeks to reveal the operations of power in gendered and racial discourses, which may not be immediately evident, or which may appear 'natural' – something we take as axiomatic, unquestioned (Hogan 1997). This is a move away from biological determinism, a mode of thinking which sees behaviours and psychological traits as inborn and instinctive. In effect, biological determinism has sought to justify inequality through theories, which also served to regulate social relations (Hogan 1997). Regulatory frameworks have been called *dispositive apparatus*, defined by Foucault as 'a thoroughly heterogeneous ensemble consisting of discourses, institutions, architectural forms, regulatory decisions, laws, administrative measures, scientific statements, philosophical, moral and philanthropic propositions – in short, the said as much as the unsaid. Such are the elements of the apparatus. The apparatus itself is the system of relations that can be established between these elements' (1977, p. 194). Bourdieu refers to 'doxa' to signify what is taken for granted in any particular society.

Examining the operations of power through discursive analysis has been an important strategy in feminist scholarship, revealing incongruities and absurdities

in the claims made about women. For example, arguments make in the 19th and early 20th centuries preventing women from entering higher education included the popular assertion that women would become infertile through too much study (Showalter 1985). In 1879, Le Bon illustrated commonly held ideas about hierarchy when he wrote that women represent an inferior form of evolution and that they were 'closer to children and savages than to an adult civilised man'. Confronted with impressive women, who did not fit his schema, he wrote them off as freaks:

> They excel in fickleness, inconsistency, absence of thought and logic, and incapacity to reason. Without doubt, there exist some distinguished women, very superior to the average man, but they are as exceptional as the birth of any monstrosity, as, for example, of a gorilla with two heads.
>
> *(cited in Gould 1981, pp. 104–105)*

The notion of 'inscription' comes from an understanding that ideological ideas are attributed to physical bodies in ways not always obvious: meanings are taken for granted, seen as self-evident, or as 'common sense' as conceptualised in the work of Antonio Gramsci (Althusser 1971). They are implicit in ways that render them unnoticed. There is an imprinting of the ideological onto the body, as though it were a parchment, which absorbs meaning; it is inscribed and this constitutes our subjectivity: 'experience is unknowable outside of language' (Rose 2010). On the other hand, this is an active process. We do not simply *absorb* gender; it is learnt and performed (Butler 1993). We are inculcated with the particular gender ideas of our time and place (within Foucault's *dispositive apparatus*, if you like). Gender is actively reproduced and reiterated; through the constant repetition of acts comes the illusion of an underlying gendered nature, Butler suggests – through this reiteration gender behaviour is seen as immanent.

Bourdieu puts it slightly differently. Gender is performed and enacted both knowingly and unknowingly, as 'second nature' as part of our being – our 'habitus' (Bourdieu 1979; 1984). This is an idea that we acquire a set of dispositions that are not necessarily knowingly enacted. Johnson (1993, p. 2) outlines Bourdieu's approach: 'Like Foucault, Bourdieu sees power as defuse and often concealed in broadly accepted, and often unquestioned, ways of seeing and describing the world. . . .'. Habitus is concerned with the way that social classifications can appear 'natural' and 'given', but habitus is more than an unconscious assimilation of classificatory norms and ways of being. Habitus has been described as a *sens pratique* – a 'practical sense' almost intuitive, that:

> inclines agents to act and react in specific situations in a manner that is not always calculated but that is not simply a question of conscious obedience to rules. Rather, it is a set of dispositions which generates practices and perceptions.
>
> *(Johnson 1993, p. 5)*

Habitus is the physical embodiment of our dispositions, skills, and habits. The *habitus* is described by Bourdieu as an 'embodied history, internalised as a second nature and so forgotten as history – is the active presence of the whole part of which it is the product' (Bourdieu 1990, p. 56). Thus habitus becomes a 'second sense' or second nature – or one's subconscious. This is a more cultural explanation for how we are brought into being and embody self-knowledge.

These ideas, which see the subject as constituted through reiterations of gendered practices, are a move away from biological determinism and deterministic psychology, including the universalising of psychic experience provided by early psychoanalysis, to a model of seeing selves in process. They move away from fixed ideas about the hierarchy of the 'races' and notions of man's 'natural' superiority over woman.

> The chief distinction in the intellectual powers of the two sexes is shown by man attaining to a higher eminence, in whatever he takes up, than can women – whether requiring deep thought, reason, or imagination, or merely the use of the senses and hands . . . the average of mental power in man must be above that of women.
>
> *(Darwin 1896, p. 564)*

These ideas about performatively constituted gender move away from universalising psychological theories, which are potentially oppressive. Though psychoanalysis was established 'in opposition to a certain kind of psychiatry, the psychiatry of degeneracy, eugenics and heredity' (Foucault 1980a, p. 60), the generalisations of psychoanalysis are also queried: that a pathological sexual desire should be posited as a norm may now seem strange to us. In Freud's Oedipus Complex, for example, 'a desire organised around the incest taboo, is universalized, reified' (Floyde 2009, p. 57).[6]

Rather, postmodernist ideas see gender as enacted, reiterated, as fluid and mutable (Butler 1993). Butler suggests that Bourdieu's notion of habitus might well be read as a 'reformulation of Althusser's ideology' that 'Bourdieu underscores the place of the body, its gestures, its stylistics' (1997, p. 210); Bourdieu's notion of 'embodied history, internalised as a second nature and so forgotten as history – is the active presence of the whole part of which it is the product' is perhaps a very useful concept for arts therapists, particularly when thinking about trauma and how it is embodied and often inchoate (Bourdieu 1990, p. 56).

Habitus is a helpful formulation allowing us to see women as not merely oppressed, having internalised negative discourses, but as being active agents in reproducing social norms, as having the 'ability to generate practices adjusted to specific situations'; thus this agency is active, and potentially, creative and transformative within a field of action. The notion of the body, brought about into its gender through performance, does suggest some malleability. Art making allows for a *reconceptualising* of experiences in the moment. Deleuze and Guattari suggest that the art encounter can challenge habitual ways of being and acting in the

world, ways which are potentially undermined and questioned. They suggest that our systems of thought can be disrupted and that we may be jolted into thought (O'Sullivan 2007).

Arts therapy

This introduction has talked in fairly general terms about practices of inequality. These practices are wide-ranging and culturally specific. The practitioners in this book will be working with many different groups of people with various concerns, or 'presenting issues'. Grogan and Wainwright (1996) argued that girls as young as eight recognise and internalise dominant cultural pressures to be thin. We are bombarded in the UK, for example, with highly idealised and sexual digitally manipulated ('airbrushed') images of women, leading to astonishing levels of body dissatisfaction among women and girls and to epidemics of self-mutilation, or self-starvation (Grogan 1999). Louis Theroux's 'Talking to Anorexia' (2017) noted the pervasiveness of perceived feelings of 'powerlessness and lack of self-worth' amongst those young women he spoke to, pointing to wider societal influences. So-called free-market capitalistic systems seem disinclined to intervene to curb the ubiquity of pornographic and idealised images of women, which are surely contributing to collective distress? These images, after all, are part of the *dispositive apparatus*: they partly constitute us, our esteem, our conceptual parameters.

What women, men, and non-binary individuals are experiencing is a cultural artefact; it is culturally produced. *It is not the result of their genetic inheritance or faulty object-relations*; to locate the 'problem' purely within the psychopathology of the individual is to potentially compound a problem of society. Yet, arts therapists work with the individual and her or his distress. Women can reframe their culturally induced feelings of impotence and self-loathing through artistic engagement and increased awareness (what earlier feminists have called 'consciousness raising'). As arts therapists we navigate a difficult course between seeking to help the individual by fully acknowledging her distress and pain, at the same time not wishing to exacerbate the situation by consolidating unhelpful notions of personal inadequacy or pathology. In arts therapy new perspectives on issues can be initiated through the composition and content of images, which also have the power to destabilise existing social narratives (Hogan 1997; Huss 2013). Cultural awareness is key, otherwise we run the risk of strengthening structures of domination and oppression (Hamrick & Byma 2017). This book is part of raising cultural awareness. All of the contributors to this book have thought carefully about gender in relation to their practice: their own gender in relation to the therapeutic relationship, or the societal implications of gender in relation to their participants' experience. Theoretical frameworks will vary, as there are several different approaches to practice in operation today (Hogan 2016). Some of the contributors are working within a feminist, cultural theory informed perspective, others with other paradigms, such as a critical psychoanalytically informed orientation. Overall, this book intends to keep gender issues to the fore in art therapies theory and practice and training.

Acknowledgement

Thanks to Phil Douglas and my daughter Eilish Hogan-Douglas for their thoughts about this introduction. I was very pleased that it was accessible to my 21-year-old daughter, so particular thanks to her for reading it. It's a hard balance to examine complex phenomena and also produce work that is fundamentally accessible, which is my aim.

Notes

1 From physics, a theory that explains physical phenomena in terms of a field or area and the manner in which it interacts with matter or with other fields, but useful to cultural theory in encouraging thought which examines the relationship between social actors and various social orders. Put more simply, individual distress can be seen as generated by disturbance in the field. I explore this with respect to the conflicting images and messages that women are subjected to during pregnancy and new motherhood (Hogan 2016).
2 In statistical analysis mean differences in the average scores between men and women are often compared, but say little about the distributions themselves – the differences *among* men, or *among* women. Kimmel makes the point that men and women are not 'opposite' sexes but have much in common. His question is why do we want to assert differences?
3 A very misleading pop psychology book called *Men Are from Mars, Women Are from Venus* by John Gray exaggerates differences between men and women.
4 The French have a word and a concept for this, which almost works – *assujettir*. Henriques et al. (1984 p. 1) suggest that it captures an active and complex way of understanding subjectivity as a process of becoming through a process of *assujetissement*; the reflexive verb means 'to make subject' or to 'produce subjectivity' as well as to 'submit' and encapsulates our coming into being – being made and making simultaneously, although we have discussed the 'submission' element as conceptually problematic (Hogan & Pink 2010, p. 171).
5 'He compared the ratios of women to men in Europe (1.06) and North America (1.05) with those in South Asia (0.93), West Asia (0.94) and China (0.94) and argued that the lower rates in Asia were due to excessive female mortality' (Sen, 1990, pp. 61–66). Female mortality was excessive because considerable research had shown that if men and women receive similar nutritional and medical attention and good health care then females, more resistant to disease, have better survival rates before birth, during birth, and after 40 years of age. To estimate the number of women missing from populations, he calculated the proportions of extra women who would have survived in that society if it had the same ratio of women to men as obtains in other regions of the world where they receive similar care. If equal proportions of females and males could be expected then the low ratio of 0.94 women to men in South Asia, West Asia, and China would indicate a de cit amounting to 6% of their women. However, since in countries where women and men receive similar care the ratio is about 1.05, he argued that the real shortfall is 11%. As a result of these calculations, Sen concluded that a 'great many more than 100 million women are missing' from the populations of South and West Asia, North Africa, and China and that the numbers 'tell us, quietly a terrible story of inequality and neglect leading to excessive mortality of women' (Sen 1990, p. 61). Croll 2001, p. 225.
6 Based on a Greek Legend, Oedipus, King of Thebes, unknowingly, as separated at birth, kills his father and sleeps with his mother. In a well-known version of the story, an oracle warned Laius that his son would slay him, so when his wife Jocasta bore a son, he had the baby exposed. Instead of dying, the infant was found and rescued and lived to carry out the prophecy. The Oedipus complex in psychoanalytic theory is a desire for sex with the parent of the opposite sex and a simultaneous sense of rivalry with the parent of the same sex; it is regarded as an important stage in the normal developmental process.

References

Adichie, C. N. 2014. *We should all be feminists*. London: Fourth Estate.
Althusser, L. 1971. *Ideology and ideological state apparatuses*. Translated from the French by Ben Brewster. London and New York: Verso.
Bancroft, A. & Fevre, R. 2016. *Dead white men & other important people*. London: Palgrave Macmillan.
Bichovsky, H. 2003. Just a Stage I'm Going Through. In Hogan, S. (ed.) *Gender issues in art therapy*. London: Routledge. pp. 46–53.
Bourdieu, P. 1984. *Distinction. A social critique of the judgement of taste*. Translated from the French by Richard Nice. London: Routledge. First published in 1979.
Bourdieu, P. 1990. *The logic of practice*. Stanford: Stanford University Press.
Brah, A. 1996. Difference, Diversity and Differentiation. In Bhavani, K. (ed.) *Feminism and 'Race'*, 2001. Oxford: Oxford University Press.
Braithwaite, A. & Orr, C. A. 2017. *Everyday women's & gender studies. Introductory concepts*. Oxon: Routledge.
Butler, J. 1993. *Bodies that matter: On the discursive limits of 'sex'*. London and New York: Routledge.
Butler, J. 1997. *The psychic life of power. Theories in subjection*. Stanford, CA: Stanford University Press.
Carmell, T., Hopwood, R., & Dickey, L. M. 2014. Mental Health Concerns. In Erickson-Schroth, L. (ed.) *Trans bodies, trans selves. A resource for the transgender community*. Oxford: Oxford University Press. pp. 305–335.
Cleland, J., Bernstein, S., Ezeh, A., Faundes, A., Glasier, A., & Innis, J. 2006. *Family planning: The unfinished agenda*. WHO: Sexual & Reproductive Health 3. Department of Reproductive Health and Research World Health Organisation. Geneva, Switzerland. Journal Paper. pp. 1–18.
Connell, Raewyn. 1995. *Masculinities*. Cambridge, Polity Press; Sydney, Allen & Unwin; Berkeley, University of California Press.
Croll, E. 2001. Amartya Sen's 100 Million Missing Women. *Oxford Development Studies*, vol. 29, no. 3. ISSN 1360–0818, doi:10.1080/13600810120088840.
Fine, C. 2010. *Delusions of gender*. London: Icon.
Floyde, K. 2009. *The reification of desire. Towards queer marxism*. Minneapolis: University of Minnesota Press.
Foucault, M. 1980a. Body/Power. In Gordon, C. (ed.) *Power/knowledge selected interviews and other writings 1971–1977*. New York: Harvester Press Edition, Pantheon Books.
Foucault, M. 1980b. The Confession of the Flesh (1977) Interview. In Gordon, C. (ed.) *Power/knowledge selected interviews and other writings*. New York: Harvester Press Edition, Pantheon Books. pp. 194–228.
Gagnon, G. 2012.'I was Sold Twice': Harmful Traditional Practices in Afghanistan. In Worden, M. (ed.) *The unfinished revolution. Voices from the global fight for women's rights*. Bristol: Polity Press. pp. 139–147.
Gould, S. J. 1981. *The mismeasurement of man*. New York: W.W. Norton & Company, Inc.
Grogan, S. 1999. *Body image: Understanding body dissatisfaction in men, women and children*. London and New York: Routledge.
Grogan, S. & Wainwright, N. 1996. Growing Up in the Culture of Slenderness: Girls' Experiences of Body Dissatisfaction. *Women's Studies International Forum*, vol. 19, no. 6, pp. 665–673.
Hamrick, C. & Byma, C. 2017. Know History, Know Self: Art Therapists' Responsibility to Dismantle White Supremacy. *Art Therapy*, vol. 34, no. 3, pp. 106–111.

Henriques, J., Holloway, W., Urwin, C., Venn, C., & Walkerdine, V. 1984. *Changing the subject: Psychology, social regulation and subjectivity*. London: Routledge.

Hogan, S. 1997. Problems of Identity. Deconstructing Gender in Art Therapy. In Hogan, S. (ed.) *Feminist approaches to art therapy*. London: Routledge. pp. 21–48.

Hogan, S. 2016a. *Art therapy theories. A critical introduction*. London: Routledge.

Hogan, S. 2016b. The Tyranny of Expectations of Post-Natal Delight: Gendering Happiness. *Journal of Gender Studies*. Special Issue: *Gendering Happiness*, vol. 26, no. 1, pp. 45–55.

Hogan, S. & Pink, S. 2010. Routes to Interiorities: Art Therapy, Anthropology & Knowing in Anthropology. *Visual Anthropology*, vol. 23, no. 2, pp. 158–174. Routledge.

Hogan, S. & Warren, L. 2013. Women's Inequality: A Global Problem Explored in Participatory Arts. *International Perspectives on Research-Guided Practice in Community-Based Arts in Health*. Special Issue, *UNESCO Observatory*, vol. 3, no. 3. pp. 1–27.

Human Rights Watch Report. 2017. *Burma: Security Forces Raped Rohingya Women, Girls New Eyewitness Accounts Show Systematic Attacks Based on Ethnicity, Religion*. February 6. www.hrw.org/news/2017/02/06/burma-security-forces-raped-rohingya-women-girls. Rights Abuses Along the U.S. Border with Mexico Persist Amid Climate of Impunity. April, vol. 7, no. 4. www.hrw.org/legacy/reports/1995/Us1.htm

Huss, E. 2013. *What we see and what we say*. New York: Routledge.

Ippolito, J. & Witten, T. M. 2014. Aging. In Erickson-Schroth, L. (ed.) *Trans bodies, trans selves. A resource for the transgender community*. Oxford: Oxford University Press. pp. 476–501.

Jensen, L. 2015. 4 Reasons Why Mental Health Is a Feminist Issue. *Feminist Campus*. July. http://feministcampus.org/4-reasons-why-mental-health-is-a-feminist-issue/

Johnson, R. 1993. Introduction in Bourdieu, P. 1993 *The Field of Cultural Production*. New York: Columbia University Press.

Jordan-Young, R. M. 2010. *Brain storm. The flaws in the science of sex differences*. Cambridge, MA: Harvard University Press.

Kimmel, M. 2011. *The gendered society*. Fourth Edition. Oxford: Oxford University Press.

Nissim, M. 2017. Exclusive: 50 Years After Decriminalisation, Over 40% of Brits Believe Gay Sex Is Unnatural. *Pink News*. July 26, 10:30 PM. www.pinknews.co.uk/2017/07/26/exclusive-50-years-after-decriminalisation-over-40-of-brits-believe-gay-sex-is-unnatural/

O'Reilly, A. 2017. Baby Out With The Bathwater . . . Public lecture given by Professor Andrea O'Reilly at the Australian National University. Wednesday November 29. www.youtube.com/watch?v=Zl6sJcHGjSo&feature=youtu.be

O'Sullivan, S. 2007. *Art encounters Deleuze and Guattari: Thought beyond representation*. Basingstoke: Palgrave Macmillan.

Richardson, S. S. 2013. *Sex itself. The search for male and female in the human genome*. Chicago and London: University of Chicago Press.

Rose, S. 2010. *What is gender history?* Cambridge: Polity Press.

Sen, A. 2001. The Many Faces of Inequality. In Kimmel, M., et al. (eds.) *The gendered society reader*. Oxford: Oxford University Press. pp. 466–477.

Sen, A. 1990. More than 100 million women are missing. *New York Review of Books*, 37 (20).

Shilling, C. 2016. *The body. A very short introduction*. Oxford: Oxford University Press.

Showalter, E. 1985. *The female malady: Women, madness and English culture 1830–1980*. London: Virago.

Smith, B. (ed.). 2000. *Home girls: A black feminist anthology*. New Brunswick: Rutgers University Press.

Theroux, L. 2017. *Talking to anorexia*. BBC Documentary. First shown October 29.

UNESCO Report. 2013. *Education transforms lives*. Paris, France: United Nations Educational. (n.p.). http://unesdoc.unesco.org/images/0022/002231/223115E.pdf (consulted July 2017).

2
FEMINISM AS PRACTICE
Crafting and the politics of art therapy

Savneet Talwar

Over the past six years, since I began my collaboration with *CEW (Creatively Empowered Women) Design Studio*, I have had several passionate conversations with art therapists about craft and art therapy. Many have shared their stories of knitting, crocheting, or other forms of fiber craft in their personal art practice, accounts that have received little attention in the field of art therapy. These stories of "coming out" as crafters, identifying with domestic crafts or "so called feminine work" (Robertson, 2011, p. 184), implicitly ask that art therapy reposition its historical narrative of the separation between art and craft and that it do so from a feminist standpoint. In this chapter, I reflect on the politics of art therapy from a historical perspective and argue that by reclaiming abandoned gendered labor practices (knitting, crocheting, embroidery, and other fiber crafts) art therapists can begin to reposition the role of fiber crafts in art therapy.

The art vs. craft debates have also dominated the art world. Parker (1984), in her book *The Subversive Stitch*, argued that the craft of needlework, embroidery, knitting, and crocheting, were cast out of the artistic canon for being a gendered form of practice. The posture of the needleworker – hunched over shoulders, head bowed – may have appeared to be one of submission, but it also embodied autonomy and commitment to labor. The term *craft* and the German word *Kraft* mean "power" or "strength" (Richards, 1962). Over the last two decades, artists and cultural workers have pushed to reposition craft, domesticity, and gender, offering alternative narratives about the crafting body. As Jefferies (2011) argues, "The idea of making by hand, drawing on learned and tacit skills, is providing a rich stream of intervention and play, ritual and performance" (p. 222). Nevertheless, craft, art, and labour are concepts that bear in different ways on the substance of this chapter.

The importance of "labor" or "work" to social change coincided with several movements in the early twentieth century, among them are vocational training and occupational therapy. Vocational counseling was concerned with issues of economic

and social equity and had a commitment to addressing social problems. Frank Parsons (1854–1908), an American social justice activist, advocated for addressing the institutional and systemic forces that contributed to oppression as part of the counseling process. Leona Tyler (1906–93) worked with conscientious objectors and founded the veterans counseling services after World War II to promote personal meaning through life review and work. Over the course of the past century, vocational/career counseling has advocated for social justice and the advancement of society (Toporek & Chope, 2006). In similar ways, occupational therapy (OT) was influenced by the Moral Treatments Movement (MTM). Pioneered by the Quakers, the MTM focused on social welfare and human rights and sought to improve the treatment of those who were institutionalized for mental illness (Hussey et al., 2007). The MTM sought to reimagine psychiatric care by bringing compassion into the lives of the people with mental illness and creating a welcoming environment; they focused on engaging patients in creative activities, such as sewing, gardening, games, and music. Treating patients with respect and dignity were critical elements of the curative process in the MTM (Hogan, 2001; Talwar, 2019; Whitaker, 2002). The use of art and crafts in psychiatric settings played a significant role in the inception of OT as a profession. The foundation and the development of OT was founded on the notion that "occupation, or doing with the hands," was an "integral part of experiencing a meaningful life" (Harris, 2008, p. 133). OT focused on the several therapeutic benefits of art and craft, improvement of motor control, sensory and perceptual stimulation, cognitive challenges, and the enhancement of self-esteem and sense of purpose (Drake, 1999; Harris, 2008).

The roots of art therapy reach to the popularization of psychoanalytic theory in the early twentieth century (Hogan, 2001; Talwar, 2019), combined with a fascination with the art of the mentally ill; the latter can be traced to Cesare Lombroso (1835–1909), who collected drawings from mentally ill patients as "providing a visual evidence for mental pathology" (McGregor, 1989, p. 93). The German psychiatrist Hans Prinzhorn's (1922) whose book *Bildnerei der Geisteskranken* (*The Artistry of the Mentally Ill*), had a significant impact on the field of art therapy, which was formalized as a profession in the 1940s (Vick, 2003). The rise of the art movements Expressionism and Surrealism also had an impact, especially in the UK (Hogan, 2001). The early practitioners in the US such as Margret Naumburg, Florence Cane, Edith Kramer, and Elinor Ulman believed in the psychoanalytic concepts of free association and self-expression as key components to evoke regression and engage with the unconscious as "symbolic speech" (Vick, 2003). It is well known that Naumburg and Kramer vehemently argued from their perspectives about the definition of art therapy – art psychotherapy vs. art as therapy – thus creating a false dichotomy for the future of the profession (Talwar, 2016). Several art therapists, Ulman, Rubin, Levick, and Wilson, developed their models of art therapy using psychoanalytic language and concepts (Vick, 2003). The Expressive Therapies Continuum, first developed by Kagin and Lusebrink (1978) and further refined by Hinz (2009), focuses on the relationship between materials to developmental aspects of human development. But Hinz does not identify fiber crafting (embroidery, knitting, crocheting) on the continuum of materials.

Among the early art therapists, who were mostly white, highly educated, middle- to upper-class women, several had a conflicted relationship with craft, since they valued intellectual over manual labor. In addition, Ulman et al. (1977) viewed craft as requiring a level of skill that, when exercised, masked pure, unconscious expression. For them, true art therapy was about self-confrontation and the ability of the patient to engage in self-exploration to induce regression and tolerate compulsive defenses. Kramer (1966) wrote at length about the difference between art therapy and arts and crafts, advocating for a separation between the two since the "art" in art therapy was a much more demanding and challenging process. It is highly likely that drawing boundaries and defining what art therapy "is" and "is not" was influenced by the politics of legitimizing art therapy as a profession. Its association with psychiatry, projective testing, developmental approaches, and psychological assessment led to the medicalization of art therapy (Talwar, 2019). By centering the potential of art as a tool for diagnosis, assessment, and evaluation, art therapists took on the role of the expert on clinical teams, superseding occupational and activity therapists who just kept the patients busy. The move to define art therapy as a separate field resulted in debates over art, crafts, and activities that continue to dominate the field. Similar debates about the difference between art and craft have taken place in the contemporary art world (Moon, 2010). Although craft was primarily associated with manual labor, by the end of the 20th century a new interdisciplinarity was recognized between art, craft, and design in the art world. Several feminist artists in the 1980s used crafting as a means to critique issues of gender, class, materiality, memory, history, and the everyday and to confront the hegemony inherent in the world of museums and galleries (see Judy Chicago, Faith Wilding, Janet Morten, among others). While Judy Chicago's installation, *Dinner Party* used traditional crafts to symbolize and memorialize the erasure of women in Western civilization, Faith Wilding's 1972 *Crotched Environments*, also referred to as "womb rooms," represented the contradictions of labor, whether as domestic pursuit or reproduction. Janet Morton covers furniture and objects with her knitted fabric or old sweaters, drawing attention to the "home as a site of comfort, as well as of excess and misplaced sentimentality" (Turney, 2009, p. 22). In covering lamps, tables, telephones, vacuum cleaners, etc. with knitted fabric, Morten connects the home with the ceaseless labor of women.

As the debate in art therapy continues over establishing boundaries, several art therapists have advocated for broadening the scope of art therapy practice to include frameworks that are both critical and culturally sensitive. Drawing on social models, these art therapists are increasingly focused on the definition and role of materials in art therapy practice (Houpt, 2016; Ottermiller & Awais, 2016; Bucciarelli, 2016; Talwar, 2015; among others). Where much of the goal of early art therapists was to uncover "symbolic language" and tap into the unconscious, contemporary practitioners working in marginalized communities are examining the value and role of art production in a context of wellbeing, advocacy, economic, and social justice to advocate for new paradigms of care in dealing with trauma (Yi, 2019; Ravichandran, 2019; Talwar, 2019; Tillet & Tillet, 2019).

Within the social context art therapy engages with critical methodologies that impact not only the personal, but also the cultural and political dimensions of social change. A social model of art therapy informed by feminist theory embraces the tacit knowledge of individuals and communities, especially the therapeutic potential of art and labor. A feminist model of art therapy considers the art in art therapy as a collaborative and socially conscious process that is committed to social change (Hogan, 1997; Talwar, 2019). As Frostig (2011) argues, when we locate the therapeutic in social praxis that encourages collective participation, art is no longer an object of contemplation; instead it becomes a critical and communal process.

Feminist pedagogy, crafting, and creative literacy

Feminism is a social and collective movement that is concerned with issues of political, social, economic, and personal equality. Feminism asks how globalization, capitalism, and neoliberalism have impacted women, their labor practices, as well as mainstream conceptions of work (Ahmed, 2017; Talwar, 2019). Several feminist artists and craftivists have critiqued the art vs. craft binary, actively embracing crafting practices to challenge issues that shape the everyday, domestic, and professional lives of women (Bratich & Brush, 2011; Buzek, 2011; Han Sifuentes, n.d.).

The craft movement hinges on "new forms of feminist sensibility and collectivity" (Cvetkovich, 2012, p. 117) that trouble the relationship between feminists who repudiate the home and working with the hands and ones who embrace the home and domesticity. Third wave feminism has moved to reclaim the domestic as a space for creativity and contesting political structures (Chansky, 2010). Embracing knitting, sewing, and crocheting, the "younger generation of artists are reclaiming craft practices to inflect the contemporary by using traditional forms of making" (Talwar, 2019, p. 181). Cvetkovich (2012) writes that

> Crafting emerges from the domestic spaces that are at the heart of women's culture to provide a model for ways of living that acknowledge forms of structural inequity while also practicing modes of bodily and sensory life that incorporate or weave them into the fabric of a daily life that literally includes texture, color, and sensory pleasure.
>
> *(p. 168)*

For her, crafting is a way of being in the world that requires both practice and knowledge as a form of slow living associated with manual labor, so that crafting is now thought of as being more grounded in the body than in the mind. Stevens (2011) posits that consumer culture has created a crisis of lifestyle as a condition of modernity. Craft traditions strive to work against the social conditions that promote consumer culture. Craft cultures are often self-organizing systems in communities that have a shared vision around materials and processes. Drawing on crafting as a source of creative agency, the CEW Design Studio uses a feminist pedagogy as a means of promoting crafting as a form of "creative economic literacy." A feminist

pedagogy leans on three main principles: "hospitality and creating restorative spaces for wellbeing; empowerment through crafting; and community and social transformation" (Talwar, 2019, p. 185).

CEW (Creatively Empowered Women) Design Studio

Location and collaboration

The CEW (Creatively Empowered Women) Design Studio began, in 2012, as a grass-roots project to explore the role craft, fabriculture, and labor practices could play in addressing trauma in the lives of South Asian immigrants and Bosnian refugee women.

The program began in collaboration with Hamdard Healthcare, a non-profit organization whose mission is "to promote the physical and emotional health and psychological well-being of individuals and families by offering hope, help, and healing" (www.hamdardcenter.org). Hamdard was founded in 1992 by two Pakistani psychiatrists to address the critical mental health needs of the South Asian, Middle Eastern, and Bosnian American communities in Chicago. Located in the West Rogers Park neighborhood of Chicago, specifically on Devon Avenue, Hamdard has been instrumental in providing multilingual and culturally sensitive psychiatric case management, therapy, health care, and adult day services (ADS) to several ethnic communities. In addition, with the influx of Bosnian refugees resettling in Chicago between 1992–1995, Hamdard became a refuge for meeting the mental health needs of the Bosnian community, many of whom suffered from Post-traumatic Stress Disorder (PTSD) as a result of witnessing the violence of war and genocide.

Locating Hamdard Healthcare on Devon Avenue was a strategic move made by the organizers in order to provide easy access for services to the various South Asian and Middle Eastern communities. Devon Avenue is located in the West Rogers Park community known as "little India." A vibrant neighborhood catering to many South Asian communities – Indian, Pakistani, Bangladeshi, Sri Lankan, Nepalese, among others – the two-mile-long ethnic corridor is visited by people of all backgrounds from the Chicago metro area. A large number of Bosnians also live on the north side of Chicago and have easy access to the Hamdard Healthcare.

Reflections: six years at CEW

The *CEW Design Studio* began as a pilot project in 2012 and had a focus on traditional crafts: sewing, embroidery, knitting, and crocheting. The impetus for the project came from my own multilingual background (Hindi, Punjabi, Urdu, and English) and interest in exploring how Western therapeutic concepts translated across cultures and languages. I was also interested in the relationship between economic empowerment, social capital, and the therapeutic. After years of witnessing poor therapeutic outcomes in clients that I had served (in community mental

health and psychiatric hospital settings), I became interested in how social stratification impacts life outcomes, especially for refugees and immigrants. I was also interested in investigating the role critical craft can play in promoting economic literacy with women who, due to various social factors, had been relegated to the margins. Sociologist Pierre Bourdieu (1986) argued for the concept of cultural capital as something that is acquired as a result of one's position in society, being (or not) part of the dominant culture, having (or not) language proficiency to effectively communicate and negotiate everyday life. The agency and resources available as a result of the cultural capital one possesses directly relate to the power and privilege exercised in everyday life. The CEW Design Studio raised questions such as: What are the consequences of losing cultural capital in the form of homeland, language, friends, and family? What is the relationship between social and economic capital in gaining a sense of agency and wellbeing?

Apart from the gender and social empowerment focus, I was also interested in troubling individualized frameworks of art therapy practice to understand more collective or community-based forms of practice (Talwar, 2015). The sheer absence of craft in art therapy, in fact a total rejection of craft as a lower art form, has dominated the field. I was interested in interrogating the domestic arts that once gave women an outlet for their creativity. It is important to question, therefore, when craft and labor are focused both on process and product for economic welfare, what are its benefits for health and wellbeing? Like any researcher and project leader, I entered the space with good intentions, but the evolution of CEW has been shaped by its participants and their meeting the challenges that have emerged in the studio. Over the course of the past six years the studio members have created their own rituals and expectations, but there have also been lessons around decentering power, which lies at the heart of a feminist pedagogy. At CEW, just like at other organizations and institutions, power hierarchies exist. To understand power relationships the discussion at CEW has been about negotiating power rather than leveling power hierarchies, because power is an ever-present fact in all spaces.

Using a participatory approach, the studio operates through a membership concept. All participants are considered to be "members," including the organizers and the artisans who participate in making the major decisions for running the studio. Each person, be it the program coordinator, the fashion designer, or the artisan, signs a contract that outlines the program and what is expected of its members and what the members can expect of it. "The contract outlines the importance of meeting weekly, being open to developing new skills, sharing skills and knowledge, maintaining communication with the staff, being open to conflict resolution, and maintaining a cooperative and supportive space in the studio" (Talwar, 2019, p. 187). The very fact that I am an educator at a major university, a middle-class, highly educated woman of color who can communicate in English, gives me tremendous power and agency in this group. The members of CEW – mostly immigrant and refugee women who have little to no proficiency in English – express their power by deciding the design of their products, discussing the price of their products, participating in the various decisions about sales, and attending craft fairs. CEW is thus

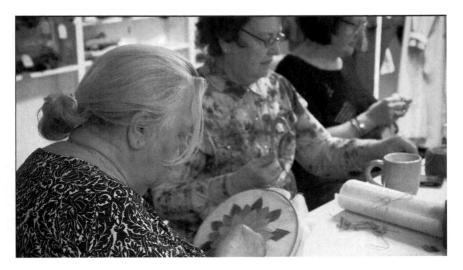

FIGURE 2.1 CEW Design Studio, left to right – Emina, Harija, and Vera, 2006.

envisioned as a collaboration in which each member brings skills and knowledge to the table. While I bring organizational skills and contacts in the community for sales, the main resource is the artisans who bring their crafting skills. CEW functions on the expert knowledge of each member, be it the fashion designer, the program coordinator, the translator, or the artisans. Conversations around materials like yarn, color, and design happen weekly. At CEW we embrace the domestic, gendered, and abandoned practice of crafting as a way to complicate the value of objects, work, and labor. The power of capitalism has defined the value of our lives and material objects that we embrace. By refocusing art therapy practice on creative labor, process, and product, the studio members consistently express their renewed sense of self, social power, and self-efficacy.

Collectively, the CEW members try to keep the concept of "negotiating power" central to the three core principles drawn from feminist pedagogy, craft, theories of touch, and empowerment. But first and foremost, "hospitality and creating restorative spaces for wellbeing" (Talwar, 2019, p. 187) remains central to each meeting at CEW. Feminists of color, especially black feminists, have advocated for womanism to contextualize the lived experiences that focus on hospitality (Phillips, 2006; Walker, 1983). They argue for cultivating spaces that center on relationship building as a necessary factor in promoting psychological wellbeing. Phillips (2006) states,

> hospitality is a practice that facilitates a positive encounter between people who are strangers or "others" to one another, setting the stage for possible friendship or collaboration. Hospitality is the fundamental to managing differences . . . providing a means of connection . . . to mediate and reduce conflict through the heartening effect of care, pleasure, and festivity.
>
> *(p. xxviii)*

Tillet and Tillet (2019) offer a radical perspective to art therapy practice with black high school girls in Chicago by centralizing the concept of "self-care" in their Girl/Friends Leadership Institute. The program draws on art therapy, social justice, and a community development to argue for the concept of self-care as central to healing and wellbeing. Similarly, Ravichandran (2019) writes about "radical caring" in her work with immigrant communities dealing with issues of gender violence. For her, activism, advocacy, and art therapy directly intersect with wellbeing. Providing community spaces that focus on hospitality have a direct impact on health and wellbeing.

At CEW each session beings with the ritual of greeting that demonstrates the hospitality of the space. The sheer joy of greeting each other with enthusiasm sets the stage for the meeting. It is not uncommon for the women to bring some snacks to share while tea is served as they begin, one by one, to show their creations. Most of the women have made something during the week and they enthusiastically share it with the other members of the group. The show and tell along with the making and doing of craft lend themselves to the second principle of feminist pedagogy, "empowerment through crafting" (Talwar, 2019, p. 187). By valuing the life experiences, memories, and knowledge of each member, crafting and "fabriculture" become a means of claiming power in new ways. "Fabriculture refers to the broader practices (meaning-making, communicative, community building) intertwined with immaterial labor" (Bratich & Brush, 2011, p. 234). At CEW drawing on the life experiences of its members through the process of creative encounter provides art therapy a new platform to consider alternative processes of meaning making that are grounded in emancipatory frameworks that connects to the third principle of feminist pedagogy that is about "community and transformative learning" (Talwar, 2019, p. 189). Crafting and labor are a form of creative economic literacy approach that tap into the imagination. As Clover (2005) states, art-based pedagogies create spaces "to educate, empower and demand visibility and justice" (Clover, 2005, p. 631). In this sense crafting spaces informed by a feminist pedagogy can be transformative (Clover, 2005; Greene, 1995; Talwar, 2019).

Conclusion

I want to end by stating that as much as I wanted to resist the urge to romanticize community-based art therapy, it is difficult to write about a project that has been an intimate part of my life. By no means is CEW an ideal and harmonious space. Each of the members brings her cultural histories and forms of interpersonal engagement. The long-term engagement of the members (between two to six years) has provided an avenue for building relationships and opportunities for leadership that are generally not possible in art therapy programs. Due to the time the members have spent they have established relationships where conflict is not seen as something bad. Conflict – about products, whom a pattern belongs to, or about money – emerges on a regular basis.

Over the course of the several years, the project members have spoken of the benefits of the project, which directly relate to addressing trauma, reducing the

stigma surrounding mental health, and providing a space for social engagement, support, and empowerment (Shefsky, 2016). Several members report the benefits of their long-term commitment to the studio, sharing their skills and socializing on a weekly basis as the antidote to dealing with their depression. As Cvetkovich (2012) argues in her book *Depression*, crafting and spaces like CEW can "produce a reparative experience for depression by literally engaging the senses in a way that makes things feel different" (p. 177). Thus, CEW expands the focus of art therapy and wellbeing through crafting to increase the social capital and self-efficacy of its members.

In conclusion, CEW Design Studio offers art therapy an alternative model of care that is focused on the social and economic lives of its members to ensure wellbeing and support. It also offers the concept of labor – manual, affective, and emotional – that is often missing from the literature of art therapy. The term *labor* is used in various ways to describe the work and energy involved in everyday tasks. Some tasks are done for economic gains, some for pleasure (labor of love), and others simply as everyday chores. In art therapy, the act of making is essential to our practice and as such a form of manual labor with emotional and affective dimensions (Hardt, 1999). CEW Design Studio rests on the emotional and affective dimensions of labor in the formation of new subjectivities.

CEW contextualizes abandoned labor practices like crafting, once enacted for no economic gains and done as a means of affective labor for the family. By drawing on the tacit knowledge of the CEW members, knowledge gained from their mothers, grandmothers, and family members, the affective and immaterial labor takes on a new meaning in the life of the members. In this sense, crafting becomes a transformative experience to enact a framework of "touch and relationality." Thus crafting, touch, and materials can be a powerful means to reclaim emotions and memory and find meaning in everyday life.

Finally, CEW's mission is to promote the holistic wellbeing using the crafts to enhance life skills and cultivate a sense of community. At CEW we believe that people thrive when they feel a sense of agency and social capital, which is directly related to economic and social justice. As bell hooks (1989) argues, naming one's pain and suffering is insufficient. In order to enact social change, it has to be linked to transformative learning and experiences that generate a sense of self-efficacy and agency (Talwar, 2015).

References

Ahmed, S. (2017). *Living a feminist life*. Durham, NC: Duke University Press.
Bourdieu, P. (1986). The forms of capital. In J. Richardson (Ed.) *Handbook of theory and research for the sociology of education* (pp. 241–258). Westport, CT: Greenwood.
Bratich, J. & Brush, H. (2011). Fabricating activism: Craft-work, popular culture, gender. *Utopian Studies*, 22 (2), 232–260.
Bucciarelli, A. (2016). Art therapy: A transdisciplinary approach. *Art Therapy: Journal of the American Art Therapy Association*, 33 (3), 151–155.
Buzek, M. E. (Ed.) (2011). *Extra/ordinary: Craft and contemporary* (pp. 175–240). Durham, NC: Duke University Press.

Chansky, R. A. (2010). A stitch in time: Third-wave feminist reclamation of needle imagery. *The Journal of Popular Culture, 43* (4), 681–700.

Clover, D. (2005). Sewing stories and acting activism: Women's leadership and learning through drama and craft. *Ephemera, 5* (4), 629–642. CEW (Creatively Empowered Women) Design Studio. www.creativelyempoweredwomen.com/

Cvetkovich, A. (2012). *Depression: A public feeling.* Durham, NC: Duke University Press.

Drake, M. (1999). *Crafts in therapy and rehabilitation* (2nd ed.). Thorofare, NJ: Slack Incorporated.

Frostig, K. (2011). Arts activism. Praxis in social justice, critical discourse, and radical modes of engagement. *Art Therapy: Journal of the American Art Therapy Association, 28* (2), 50–56.

Greene, M. (1995). *Releasing the imagination. Essays on education, the arts and social change.* San Francisco, CA: Jossey-Bass Publishers.

Han Sifuentes, A. (n.d.). Steps towards decolonizing craft. *Textile Society of America.* https://textilesocietyofamerica.org/6728/steps-towards-decolonizing-craft/

Hardt, M. (1999). Affective labor. *Boundary, 2* (26), 89–100.

Harris, E. (2008). The meanings of craft to an occupational therapist. *Australian Occupational Therapy Journal, 55* (2), 133–142.

Hinz, L. (2009). *Expressive therapies continuum.* New York: Taylor & Francis Group.

Hogan, S. (Ed.) (1997). *Feminist approaches to art therapy.* London: Jessica Kingsley Publishers.

Hogan, S. (2001). *Healing arts: The history of art therapy.* London: Jessica Kinsley Publishers.

Hooks, B. (1989). *Talking back: Thinking feminist, thinking black.* Boston, MA: South End Press.

Houpt, K., et al. (2016). Anti-memoir: Creating alternate nursing home narratives through zine making. *Art Therapy: Journal of the American Art Therapy Association, 33* (3), 128–137.

Hussey, S. M., Sabonis-Chafee, B., & O'Brien, J. C. (2007). *Introduction to occupational therapy* (3rd ed.). St. Louis, MO: Mosby.

Jefferies, J. (2011). Loving attention: An outburst of craft on contemporary art. In M. E. Buzek (Ed.) *Extra/ordinary: Craft and contemporary* (pp. 222–242). Durham, NC: Duke University Press.

Jones, S.L. (2012). Visual voice: Abusive relationships, Women's art and visceral healing. In S. Hogan's (2nd ed.), *Revisiting feminist approaches to art therapy* (pp.173-209). New York, NY: Berghahn Books.

Kagin, S. & Lusebrink, V. (1978). The expressive therapies continuum. *Art Psychotherapy, 5,* 171–180.

Kramer, E. (1966). Art and craft. *Bulletin of Art Therapy, 5* (4), 149–152.

Landes, J. (2012). Hanging by a thread: Articulating women's experience via art textiles: Art therapy group for South Asian women with severe and enduring mental health difficulties. In S. Hogan's (2nd ed.), *Revisiting feminist approaches to art therapy* (pp.224-236). New York, NY: Berghahn Books

McGregor, J. M. (1989). *The discovery of the art of the insane.* Princeton, NJ: Princeton University Press.

Moon, C. (2010). *Materials and media in art therapy: Critical understanding of diverse artistic vocabularies.* New York, NY: Routledge.

Ottermiller, D. & Awais, Y. (2016). A model for art therapists in community based practice. *Art Therapy: Journal of the American Art Therapy Association, 33* (3), 144–150.

Parker, R. (1984). *The subversive stitch.* Padstow, Cornwall: TJ International.

Phillips, L. (2006). *The womanist reader: The first quarter of a century of womanist thought.* New York: Routledge. Prinzhorn, H. (1922). Bildnerei der Geisteskranken (The artistry of the mentally ill). University of Heidelberg Digital Library https://digi.ub.uni-heidelberg.de/diglit/prinzhorn1922.

Ravichandran, S. (2019). Radical caring and art therapy: Decolonizing immigration and gender violence services. In S. K. Talwar's (Ed.) *Art therapy for social justice: Radical intersections* (pp. 144–160). New York: Routledge.

Richards, M. C. (1962). *Centering: In pottery, poetry and the person*. Hanover, NH: Wesleyan University Press.
Robertson, K. (2011). Rebellious dollies and subversive stitches: Writing a craftivist history. In M. E. Buzek (Ed.) *Extra/ordinary: Craft and contemporary* (pp. 184–203). Durham, NC: Duke University Press.
Shefsky, J. (May 5, 2016). Local crafting group knits refugees, immigrants together. Retrieved from http://chicagotonight.wttw.com/2016/05/05/local-crafting-group-knits-refugees-immigrants-together.
Stevens, D. (2011). Validity is in the eye of the beholder: Mapping craft communities of practice. In M. E. Buszek's (Ed.) *Extra/Ordinary craft and contemporary art*. Durham, NC: Duke University Press.
Talwar, S. K. (2015). Culture, diversity and identity: From margins to center. *Art Therapy: Journal of the American Art Therapy Association, 32* (3), 100–103. doi:10.1080/07421656.2015.1060563
Talwar, S. K. (2016). Is there a need to redefine art therapy? *Art Therapy: Journal of the American Art Therapy Association, 32* (3), 116–118. http://doi.org/10.1080/07421656.2016.1202001
Talwar, S. K. (2019). "The sweetness of money": The creatively empowered women (CEW) design studio, feminist pedagogy and art therapy. In S. K. Talwar (Ed.) *Art therapy for social justice: Radical intersections* (pp. 178–193). New York: Routledge.
Tillet, S. & Tillet, S. (2019). "You want to be well?" Self-care as a black feminist intervention in art therapy. In S. K. Talwar (Ed.) *Art therapy for social justice: Radical intersections* (pp. 123–143). New York: Routledge.
Timm-Bottos, J. (2016). Beyond counseling and psychotherapy, there is a field. I'll meet you there. *Art Therapy: Journal of the American Art Therapy Association, 33* (3), 160-162.
Toporek, R. L. & Chope, R. C. (2006). Individual, programmatic and entrepreneurial approaches to social justice: Counseling psychologists in vocational and career counseling. In R. L. Toporek, L. H. Gerstein, N. A. Fouad, G. Roysircar, & T. Israel (Eds.) *Handbook for social justice in counseling psychology: Leadership, vision, and action* (pp. 276–293). Thousand Oaks, CA: Sage.
Turney, J. (2009). *The culture of knitting*. London: Bloomsbury.
Ulman, E. (1975). Art therapy: Problems of definition. In E. Ulman & P. Dachinger (Eds.) *Art therapy in theory and practice* (pp. 3–13). New York: Schocken Books.
Ulman, E., Kramer, E., & Kwiatowska, H. (1977). *Art therapy in the United States*. Craftsbury Commons, VT: Art Therapy.
Vick, R. (2003). A brief history of art therapy. In C. A. Malchiodi (Ed.) *Handbook of art therapy* (pp. 5–15). New York: Guilford Press.
Walker, A. (1983). *In search of our mothers' gardens: Womanist prose*. New York: Houghton Mifflin Harcourt.
Whitaker, R. (2002). *Mad in America: Bad science, bad medicine, and the enduring mistreatment of the mentally ill*. New York: Basic Books.
Yi, S. (2019). Res(crip)ting art therapy: Disability culture as a social justice intervention. In S. K. Talwar's (Ed.) *Art therapy for social justice: Radical intersections* (pp. 161–177). New York: Routledge.

3

UNDER THE SKIN

Barriers and opportunities for dance movement therapy and art psychotherapy with LGBT+ clients

Thania Acarón and Alison Wren

Introduction

This chapter provides an introduction to collaborative creative arts therapies practice with clients who identify as lesbian, gay, bisexual, transgender, or related identities (LGBT+). Its objective is to analyse how gender identity and sexual orientation are manifested through felt experience, and attest to the potential of art therapy (AT) and dance movement therapy (DMT) to foster their expression in a group setting. We aim to expand the repertoire of relevant themes for therapeutic work with gender and sexually diverse identities, thus contributing to an underdeveloped area in creative arts therapies research. This chapter represents an affirmative stance in creating constructive experiences of therapy for LGBT+ clients, and the opportunities offered by an integration of movement and art.

Gender and sexuality are universal to *all* human beings. They have an early influence in how our sense of identity develops and how we build relationships with others. Identity comprises the facets of human development that determine who we are and what make us unique, which stem from a combination of biological, psychological, social, and cultural factors. *Gender identity* refers to an individual's identification with societal denominations of female, male, a combination or neither binary gender. *Sexual orientation* regards the degree of attraction, including non-attraction,[1] towards a person of particular gender(s),[2] which is felt emotionally, sexually, and/or romantically (HGSE QueerEd 2010; Amnesty International 2014), and may remain dynamic or stable throughout a person's life. Gender identity and sexual orientation are aspects that contribute to an individual's sense of self, lived experience, and ultimately to physical and mental health; thus, it is an issue needing attention by the therapeutic community and within therapeutic spaces.

This chapter presents an example of interdisciplinary arts therapies practice with a client group which has been historically marginalised and which has had limited

representation in creative arts therapy research. We will first review the literature in the fields of DMT and AT relevant to LGBT+ clients. Then we will explore key themes based on our work, which highlight the opportunities art- and movement-based creative work offers to improving participants' mental health. We will particularly focus on exploring the themes of the internal/external selves, LGBT+ visibility and identity that emerged from our workshops. We will examine these themes through a case example of a collaborative creative arts workshop focusing on the theme of skin, as a barrier that serves to protect, expose, and transform internal and external aspects of our identity.

The community setting

We deliver workshops and therapeutic sessions as part of a non-profit, community-based LGBT+ organisation in Edinburgh, Scotland. Alison Wren is a Scottish art therapist who works as a Mental Health Development Worker, and Dr. Thania Acarón is a Puerto Rican dance movement therapist working as a sessional workshop facilitator and professional development consultant. The organisation offers counselling services, social events, mental health courses (including AT), arts workshops, helpline support, and information sessions. Creative arts therapy workshops are offered within their mental health programme, which includes individual and group sessions. Adults self-refer to the services, which can be accessed flexibly through regular or drop-in sessions. Those who access the mental health programme vary in age, gender, sexual orientation, ethnicity, faith, socioeconomic status, (dis)ability, and familiarity with the creative arts therapies. People who refer do not need to have experienced mental ill health, though a significant amount of people who do refer have lived experience of mental illness. This is in keeping with the recorded higher rates of mental ill health for LGBT+ people compared to the general population (Fish and UK Department of Health 2007; National Alliance for Mental Illness 2017; The Shaw Mind Foundation 2016).

After introducing our key concepts and setting, the next sections present a review of DMT and AT research pertinent to work with LGBT+ clients.

DMT and work with LGBT+ clients

DMT and the creative arts therapies have much research work to do on sexual minorities, an area that music therapist Hadley (2013) reiterates holds great promise. Allegranti (2009, 2011) argues for an embodied approach to addressing gender and sexuality within dance and DMT, exploring gender perspectives, feminist frameworks, and sexuality as expressed in performance (dance and film) and therapeutic work. Her integration of body politics and gender theory with therapeutic approaches, and the inclusion of sexually diverse narratives in her case analysis of a performance lab, brings to light issues of LGBT+ visibility and heteronormativity within group work (2011). Hanan's (2010) master's thesis is currently one of the few, if not the only, case study explicitly working with LGBT+ clients. Hanan

(2010) focuses on body image through DMT sessions with six transgender clients, exposing emergent themes of self-acceptance, isolation, bodily discrimination, and societal norms regarding body and identity, which we have also encountered as salient themes in our work.

There is an emerging interest in the LGBT+ community, which has sparked a focus on therapist competencies. For example, a questionnaire specifically directed towards dance movement therapists' knowledge of best practices with LGBT+ clients has been published (Kawano et al. 2018). Additionally, Acarón led a webinar for the American Dance Therapy Association (2015), addressing key 'body questions' regarding gender identity and sexual orientation, with an aim for more professional development training opportunities in this area. However, new research needs to be developed on therapeutic competencies, and non-verbal aspects of gender identity and sexual orientation.

Art therapy with LGBT+ clients

Art therapy literature reinforces there is a lack of research in the field in relation to gender and sexuality, and the impact of AT interventions on LGBT+ clients (Addison 2003; Hogan 2003; Pelton-Sweet and Sherry 2008). Pelton-Sweet and Sherry's review of current art therapy LGBT+ research addresses some common themes: the coming out process, client feelings of safety, the need for training in therapist competencies, and explorations of identity. Pelton-Sweet and Sherry (2008) claim that AT interventions are well placed for exploring identity issues and contribute to the development of an evidence base for the value of creative arts therapies with this client group. Ellis (2007) argues from a phenomenological perspective that the subjectivity of sexuality can be embodied in the AT experience and the possibilities of expression that a range of art media can provide are of value when communicating conscious and unconscious lived experiences of sexuality. This provides a rationale for examining interventions that integrate movement experientials with visual art.

One of the challenging areas found in the literature with LGBT+ clients is the developing nature of the appropriate terms and concepts. Addison (2003) attempted an introduction to working with LGBT+ clients specifically in AT settings; however, due to the nature of the evolution of the language LGBT+ communities are using to self-identify, some of the language in her chapter now appears dated or inaccurate. In addition to recommending on-going training on terminology and staying current with shifting political, social and cultural needs, we agree with Pelton-Sweet and Sherry (2008)'s appeal for culturally competent effective care for this community. They specifically recommend that art therapists require 'knowledge of the social, cultural and health issues facing this population, a non judgemental attitude and skill in counselling LGBT clients' (Pelton-Sweet and Sherry 2008, 175). While Whitehead-Pleaux et al. (2012, 2013) have compiled a best practice survey for music therapists supporting LGBT+ clients, no AT (and DMT) specific guidelines for best practice exist.

Although there have been some advances in the way creative arts therapies address sexual orientation and gender identity, AT and DMT interventions need to be analysed according to current changes in LGBT+ legislation, policies, treatment options and remain current within the evolving nature of the community. The next sections will describe the context of our work and present our case example.

Case example: *the skin and boundaries workshop*

A highlighted feature of our work with the LGBT+ community, which has transpired for over six years is a series of collaborative creative arts therapy workshops as part of the Scottish Mental Health Arts and Film Festival [3]. We have led these workshops together for two consecutive years and have chosen an intensive workshop as our case example. The 20 participants of this group comprised cisgender[4] and transgender[5] women, aged 20–50, identifying with a range of sexual orientations. Three quarters of the participants were from the UK with an international make-up of people from Ireland, Nigeria, Poland, Spain, and United States. One of the participants was seeking asylum in the UK on the grounds of being LGBT+. In this intensive workshop, we used a combination of movement and art-based interventions on the topic of the skin as the boundary of the body, and also as protector. Here we will provide a selection of key interventions in this workshop to elucidate our themes: the 'skin layer' art/movement activity and the use of the folk tale 'The Selkie Bride' as a platform to work on the theme of internal/external selves. Movement-based warm-up interventions included sensory play, visualisations, structured improvisations, tableau[6] work, and group devising. Somatic attention to the body and with the body (Csordas 1993; Tantia 2012) was exemplified by body scanning, body tracing, and movement exploration of interpersonal spatial boundaries. These exercises encouraged participants to engage with their own rituals of renewal and cleansing after the workshop.

> I will do some of the exercises, especially the one we run our hands over our body without actually touching it to feel the energy then pushing out all negative energy. Actually makes me feel like I'm cleansing myself.
> *(Anonymous participant, post-workshop evaluation, personal communication 2016)*

The sensory play provided the participants with an encounter with the workshop space and the art materials, in order to cultivate the client's presence at a somatic level and providing a multidimensional experience integrating all senses. We chose materials that had drastically differing perceptual qualities in terms of size, texture, weight, and malleability (i.e. rolls of aluminium wire, soft modelling materials, marbles, large rolls of paper, feathers, among other objects chosen for representational capacity). Another consideration of our choices of materials related to the immediacy of their qualities, therefore not requiring drying time or more complex construction.

Interdisciplinary working

A key aspect of the work is the embodied articulation of AT, and the visual, tangible aspect of DMT. Incorporating somatic techniques in art-making and laying out objects across the space allowed an active engagement with the materials and deeper body awareness. The interventions alternated between art and movement to suit the objectives and needs of the participants, and aid in the flow of the workshop, which is key to collaborative work. The workshop took place in a dance studio, away from a more traditional AT room setting (Case and Dalley 2014), which encouraged participants to move more and to actively engage with the art materials distributed around the room. There were no tables or chairs, as objects were laid out on the floor as an art-making surface, a shift from the 'sitting down', chair-and-table-focused traditional set-up of AT, which invites new possibilities[7]. This is an atypical set-up for AT, but an ideal layout for collaborative art and movement sessions. The participants crawled, rolled on the floor, and used their whole bodies in their art-making. Alternatively, having movement interventions represented visually aided in the reflection and revisiting of the workshop themes, which we will address more in depth in subsequent sections. There was a dynamic flow between art-making and movement, and dual interventions proposed which did not suggest a segregation of each art form.

The next sections will outline the key interventions and themes that arose from this workshop.

Skin layer activity

Projective work is at the heart of creative arts therapies. 'In projective art groups, themes are introduced to provide a common framework to which each individual in the group relates his or her own personal meaning' (Dalley 2008, xvii). This was the case with one of the main movement interventions, which involved the participants in outlining an imagined layer (1–2 inches) external to the skin. This was described as an imaginary 'covering' of the whole body.

Fraenkel (2010) theorises that imagining and sensing this body boundary, and ascribing a metaphoric visualisation can aid in the understanding of one's own personal and spatial awareness, and the spatial relationships established with others. The participants could choose any material to symbolise this boundary, which led to many different types of ideas of materials the skin boundary could be composed of, some examples being cork, foam, plastic, rubber, tar, dishwashing sponge, plush, velvet, and more. This materiality gave us, as creative arts therapists, not only some indications as to the type of boundaries that were emerging during the workshop, but also suggested a materiality of the boundaries the participants engaged with in their everyday lives. This echoes Moon's (2010) reflections on a social constructivist theory of materiality in art therapy, whereby personal artistic expressions are rooted in social schemas, here examined in terms of gender and sexuality. In the case of LGBT+ clients, materials might be used to celebrate self-acceptance, in addition to constructing creative means to be resilient against societal oppression.

In the workshop, we expanded on the skin layer exercise by asking participants to move around the space in closer proximity to others, noticing if there were potential changes in their skin layer visualisations. This exercise was offered to stimulate a shift from individual experience to fostering group awareness and interaction. In post-activity discussions, some participants struggled with visualising and maintaining body boundaries while engaging with others in the space. For several participants, their imagined skin layer became more solid when encountering others in space, while others reported their visualised body boundary disappearing or melding with others. One of the participants said she felt surrounded by rubber and connected it to her inability to adapt to social situations or in relationships with others. She stated things seemed to 'bounce off of her'. In Newman's (2010) case study exhibiting installation art in response to the needs of young LGBT+ people within an AT group, she describes one piece, 'I'm Rubber', which explores the resilience required to experience life as part of a stigmatised population. The workshop participant's feeling of being surrounded by rubber can be hence analysed not as a barrier to connection, but as a source of strength to survive situations perceived as unsafe. Another participant reiterated the connection between material and experience:

> The art activities were particularly poignant for me as they helped me to realise that the 'skin' I was enveloping myself in, saying I was fine when I wasn't, was stopping me from really processing my emotions and asking for help from those close to me.
>
> *(Anonymous participant, personal communication 2016)*

In this participant's case, representing this boundary evoked an awareness of guarding and masking difficult feelings, and the challenge in trusting others and welcoming support.

Art-making offered an opportunity to take the movement interventions into a visual, tangible form, and we proposed a visual representation of an imagined dissected 'slice' of their skin boundary using art materials. We encouraged participants to consider colour, texture, and scale when art-making. Once people had created their individual slice, they were invited to bring their artwork into the centre of the room into a type of 'circle museum' to reconnect with the other participants. We asked them to walk around each of the art objects, being mindful of their presence, and to observe others' artwork and reflect on their own reactions, sensations, and perceptions. The museum exercise was designed to not require verbal explanation in the sharing of the artwork and its associated meanings, encouraging non-verbal reflection.

In both workshop interventions participants connected their own 'skin boundary material' to specific moments where they needed more strength or protection, and described instances where they had felt more vulnerable. This holds relevance to LGBT+ clients and the anticipatory anxiety of coming out, fear of stigmatisation, discrimination, and rejection that can result in increased social isolation (Halpin and

Allen 2004). Herein lies the strength of metaphoric work, as the layers of visual art and movement served as a dual vehicle for alternating modes of somatic experience with projective techniques, adjudicating strength to expressing vulnerability.

'The Selkie Bride'

Another key aspect of the workshop linked movement and art interventions to the folk tale 'The Selkie Bride' (Breslin and Leiper 2012), a popular story in fishing communities in Scotland, Ireland, Portugal, and Scandinavia. The Scottish version of this story (in simplified form) centres around a selkie, a transformative creature that fluctuates between woman and seal by shedding her sealskin, who gets entrapped by a fisherman when she leaves her sealskin unguarded. The fisherman falls in love with the selkie and hides the skin. After many years, her children find her sealskin and she has to choose between her essence, the sea, and her role as mother and wife. Despite the heartbreak inflicted upon her family, she chooses to return to the sea and her true home, thus abdicating her role on land.

As our group was formed by women, this conflict between inner self and outer self, and each of the responsibilities and consequences these entail formed the basis for the design of the interventions. We used the story of the Selkie Bride as inspiration for art-making, bringing in clear latex-free gloves and a wide variety of materials (feathers, buttons, markers, metal, glitter, sequins, etc.) that the participants used to represent their inner self (internal essence) and outer self (external demands). The participants were asked to improvise through movement using their gloves in an exploratory journey through the space. They also created an art-movement dialogue between the boundary slice of skin layer they had created and their glove, fostering connections between interventions. The participants were asked to create short representations of these explorations in group tableaus in a group sharing and discussion.

With these key interventions in mind, we will analyse the symbolic exchange created between external/internal selves and their relationship to work with LGBT+ clients in the following section.

Exploring external and internal selves with LGBT+ clients

Creative arts practice aims to provide an external output to what transpires in an individual's internal world. Inner conflict and transformation are conveyed by making an experience visible, tangible, and present, enabled by the therapeutic relationship. Although not specifically aimed at LGBT+ clients, art therapist Makin (2000) explored themes of 'inside/outside' through self-portraiture interventions. Self-portraiture techniques in AT offer creative opportunity for feelings to be externalised that can be too exposing, frightening, or shameful to express verbally (Addison 1996; Brody 1996; Fraser and Waldman 2004). We chose to portray these by creating the skin boundary visualisation and movement exploration as symbolic internal self-portraits which elicited associations with LGBT+ identity and visibility.

Lasser and Wicker (2008) argue that non-verbal behaviour is a key factor in managing visibility with LGBT+ clients. Many LGBT+ clients' internal world will have aspects of negative external messages about how it is not acceptable to be LGBT+. Some examples of these messages include historical pathologisation in mental health diagnosis, criminalisation, lack of equal rights, societal stigma, over-sexualised identities and lack of positive representation in mainstream media. The internalisation of these powerful messages may result in internalised homophobia/biphobia/transphobia, ultimately impacting on the self-worth of the person and their capacity to live a fulfilling life with flourishing mental health (Fraser and Waldman 2003). This is something unique to LGBT+ clients, as heterosexual and cisgender clients are not usually rejected for their sexual orientation or gender identity.

Since our workshop space was explicitly inclusive of all sexual orientations and gender identities, participants made use of movement and art as tools for visibility of their own personal themes. For example, one of the participants related the weight of external demands being extremely difficult at this particular time when she was seeking asylum in the UK on the grounds of her LGBT+ identity. Her glove boasted vibrant colours which she related to the strength she was gaining in uncovering her own identity, despite the painful memories of her hiding this from her family in her home country and her current lack of acceptance from the United Kingdom Home Office, whom she was having to 'prove' her sexuality to. She repeatedly referred to herself as finding freedom in her artistic expression and hope in the rebuilding of her true identity. Another LGBT+ participant chose to use more stereotypically associated symbols such as rainbow flag colours to externally represent their inner self. This participant chose not to move around the space as much as some others, quietly and carefully making a relatively small piece of artwork, suggesting a connection between notions of safety and visibility within the group. The symbolisation of the rainbow communicated something celebratory about their identity that could have been potentially overlooked. This is consistent with Addison's (2003) and Pelton-Sweet and Sherry's (2008) recommendations that there is symbolisation unique to the LGBT+ community that can be visually expressed but won't necessarily be verbally communicated. However, in contrast to Addison's (2003) descriptions of potential LGBT+ symbols, it is important in our practice to keep current on LGBT+ content but withhold assumptions of associations until disclosed or identified by the client. Not all LGBT+ clients will symbolise their identities in their artwork/movement in this way. Assuming they will can collude with unhelpful dominant beliefs of societal stigma and stereotypes that LGBT+ people already contend with, which can considerably hinder the therapeutic relationship.

In the final group showings and discussions, the external/internal theme generated a construction of new shared meaning amongst participants akin to Moon's (2010) description of a social constructivist stance on the correlation between materiality and shared experience. Some chose to represent their family or close circles and the challenges presented by their external demands. Others chose to focus on the importance of cultivating and nurturing their inner self (expressed

as passions, drives, goals). The transformative elements from the story of the Selkie Bride and the precarious balance between internal and external demands resonated with the participants in deep personal aspects, with opportunities for deconstruction and alternative meanings.

Conclusion

This chapter described the collaborative process between art and dance movement psychotherapists in an intensive workshop format within a mental health festival in Scotland. We claim that a focus on sexual orientation and gender identity, as a fundamental aspect of human life, needs careful attention. The creative arts therapies have a limited trajectory of research in this area, and while there is emerging research in both DMT and AT, further research on relevant themes for this client group are needed. We chose to focus on our work with LGBT+ clients for this chapter, but recommend further research on therapist competencies and current training on terminology and affirmative, inclusive interventions.

The art/movement interventions all related to the theme of internal versus external selves and were rooted in the folk tale 'The Selkie Bride'. Sensory play with a wide range of art materials, movement experientials, and the visual representation of a protective skin boundary helped ground these experiences, enabling inner listening and awareness of self and others in the space. We applied projective techniques through the creation of a skin boundary 'slice' and a glove that represented either external demands or their internal essence, which were shared and discussed.

In terms of our theme, external demands were linked to social pressures, which elicited discussions surrounding the difficulty of LGBT+ visibility amongst family members, and in one strong case, allowed one of the participants to process her current status as someone seeking political asylum. The exploration of internal essence helped participants identify current experiences that seemed to be at a liminal stage: stuck between a crystallisation and identification of the experience, but not able to be externalised and expressed. Visibility, in some respects, may represent a cost, loss, or an opportunity to some LGBT+ clients. For some, though not all clients, being who they are might provoke a loss of their family, loved ones, interfere with work opportunities, or put them at risk of violence. There are also many positives to being visible as an LGBT+ person: affirmation of identity, self-acceptance, experiences of love and support from family/loved ones/work colleagues, which offer positive themes to address through creative arts therapies. Thus, the battle and assuagement between the internal and external worlds, especially in terms of LGBT+ identity was both pertinent and important to this group.

The focus of our work is to allow the somatic experience to become integral to art-making, and also explore visual, tangible manifestations of movement. A group that included heterosexual, LGBT+, cisgender, and transgender women in a community-focussed workshop fostered an inclusive environment, which allowed deep individual exploration and safe group interactions without pressure of disclosure.

In interdisciplinary practice, art-making allows a material representation of one's felt experience which may also contribute a visual recording or reflexive tool for therapeutic movement material. Therapeutic movement material may in turn embody the textures and sensations by allow a "zooming in" to the body through somatic listening (Acarón 2016). The collaborative dialogue between dance/movement and art-making allowed metaphoric connections between materiality and felt experience. Collaborative work between creative arts therapists and integrated movement and art-making interventions can offer multidimensional explorations, perspective-making, and an embodied approach to working with gender and sexuality.

Notes

1 Please note that people who identify as *asexual* are not sexually attracted to any gender and are part of the continuum of sexual orientation.
2 The term *gender(s)* is used to reflect the full spectrum of gender, including people who identify as male, female, non-binary, non-gender, or any combination of male and female.
3 For more information on the festival, see www.mhfestival.com.
4 Cisgender definition: a person whose gender identity corresponds with their sex assigned at birth.
5 Transgender definition: a person whose gender identity does not correspond with their sex assigned at birth.
6 A tableau is a drama-based group exercise, which portrays still shapes (or repetitive movements in some variations) with a common theme, to create what can be described as a live version of a painting.
7 Chairs were available for participants with limited mobility.

References

Acarón, Thania. 2016. "Traversing distance and proximity: the integration of psychodrama and dance movement therapy techniques in supervision." *Body, Movement and Dance in Psychotherapy* 11, no. 1: 4–18.
Acarón, Thania. 2015. "Nonconforming Bodies: The Role of Gender Identity and Sexual Orientation in Dance/Movement Therapy." Webinar Presented at the American Dance Therapy Association. http://adta.bizvision.com/product/adta-webinars/nonconforming bodiestheroleofgenderidentityandsexualorientationindancemovementtherapy(13165)
Addison, Donna. 2003. 'Art Therapy with Gay, Lesbian, Bisexual and Transgendered Clients'. In *Gender Issues in Art Therapy*, edited by Susan Hogan, 53–68. London and Philadelphia: Jessica Kingsley Publishers.
Addison, Donna. 1996. "Message of Acceptance: 'Gay-Friendly' Art Therapy for Homosexual Clients." *Art Therapy* 13 (1): 54–56. doi:10.1080/07421656.1996.10759193
Allegranti, Beatrice. 2009. "Embodied Performances of Sexuality and Gender: A Feminist Approach to Dance Movement Psychotherapy and Performance Practice." *Body, Movement and Dance in Psychotherapy: An International Journal for Theory, Research and Practice* 4 (1): 37–41.
Allegranti, Beatrice. 2011. "Ethics and Body Politics: Interdisciplinary Possibilities for Embodied Psychotherapeutic Practice and Research." *British Journal of Guidance & Counselling* 39 (5): 487–500.
Amnesty International. 2014. "Sexual Orientation and Gender Identity." *LGBTQ Organization. Amnesty International*. www.amnesty.org/en/sexual-orientation-and-gender-identity

Breslin, Theresa and Kate Leiper. 2012. *An Illustrated Treasury of Scottish Folk and Fairy Tales*. Edinburgh: Floris Books. https://wordery.com/an-illustrated-treasury-of-scottish-folk-and-fairy-tales-theresa-breslin-9780863159077

Brody, Rachel. 1996. "Becoming Visible: An Art Therapy Support Group for Isolated Low-Income Lesbians." *Art Therapy* 13 (1): 20–30. doi:10.1080/07421656.1996.10759189

Case, Caroline and Tessa Dalley. 2014. *The Handbook of Art Therapy*. East Sussex and New York: Routledge.

Csordas, Thomas J. 1993. "Somatic Modes of Attention." *Cultural Anthropology* 8 (2): 135–156.

Dalley, Tessa. 2008. *Art as Therapy: An Introduction to the Use of Art as a Therapeutic Technique*. London: Routledge.

Ellis, Mary Lynne. 2007 "Images of sexualities: Language and embodiment in art therapy." *International Journal of Art Therapy* 12, no. 2: 60-68.

Fish, Julie and UK Department of Health Sexual Orientation and Gender Identity Advisory Group. 2007. "Reducing Health Inequalities for Lesbian, Gay, Bisexual and Trans People – Briefings for Health and Social Care Staff." UK Department of Health Sexual Orientation and Gender Identity Advisory Group. http://webarchive.nationalarchives.gov.uk/20130123192422/www.dh.gov.uk/en/Publicationsandstatistics/Publications/PublicationsPolicyAndGuidance/DH_078347

Fraenkel, Danielle L. 2010. "Shape: A Kinesthetic Approach to Building Healthy Boundaries." In *101 Interventions in Group Therapy*, edited by Scott Simon Mehr, 339–344. New York: Routledge. www.amazon.co.uk/101-Interventions-Group-Therapy-Revised/dp/0415882176

Fraser, Jean, and Judith Waldman. 2003. 'Singing with Pleasure and Shouting with Anger: Working with Gay and Lesbian Clients in Art Therapy'. In *Gender Issues in Art Therapy*, edited by Susan Hogan, 69–91. London and Philadelphia: Jessica Kingsley Publishers.

Hadley, Susan. 2013. "Dominant Narratives: Complicity and the Need for Vigilance in the Creative Arts Therapies." *The Arts in Psychotherapy* 40 (4): 373–381. doi:10.1016/j.aip.2013.05.007

Halpin, Sean A. and Michael W. Allen. 2004. "Changes in Psychosocial Well-Being During Stages of Gay Identity Development." *Journal of Homosexuality* 47 (2): 109–126. doi:10.1300/J082v47n02_07

Hanan, M. Eve. 2010. "Embodying Identity: A Qualitative Case Study of Dance Movement Therapy for People Transitioning Genders." Thesis. http://idea.library.drexel.edu/handle/1860/3354

Harvard Graduate School of Education (HGSE) QueerEd. 2006. "Working LGBTQ Definitions." *LGBTQ University Organization. Harvard Graduate School of Education QueerEd*. October. http://isites.harvard.edu/icb/icb.do?keyword=hgse_queer_ed&pageid=icb.page236993

Hogan, Susan. (ed.) 2003. *Gender Issues in Art Therapy*. London and Philadelphia: Routledge.

Kawano, Tomoyo, Robyn Flaum Cruz, and Xueli Tan. "Dance/Movement Therapists' Attitudes and Actions Regarding LGBTQI and Gender Nonconforming Communities." *American Journal of Dance Therapy* 40, no. 2 (2018): 202-223.

Lasser, Jon, and Nichole Wicker. 2008. "Visibility Management and the Body." *Journal of LGBT Youth* 5 (1): 103–117. doi:10.1300/J524v05n01_08

Makin, Susan R. 2000. *Therapeutic Art Directives and Resources: Activities and Initiatives for Individuals and Groups*. London and Philadelphia: Jessica Kingsley Publishers.

Moon, Catherine Hyland. 2010. "Theorizing Materiality in Art Therapy." In *Materials and Media in Art Therapy: Critical Understandings of Diverse Artistic Vocabularies*, 49–88. New York: Routledge.

National Alliance for Mental Illness. 2017. "LGBTQ." *National Alliance for Mental Illness*. www.nami.org/Find-Support/LGBTQ

Newman, Valerie. 2010. "Creating a Safe Place for Lesbian, Gay, Bisexual, and Transgender Youth: Exhibiting Installation Art for Social Change." In *Materials and Media in Art Therapy: Critical Understandings of Diverse Artistic Vocabularies*, edited by Catherine Hyland Moon, 137–153. New York and London: Routledge.

Pelton-Sweet, Laura M. and Alissa Sherry. 2008. "Coming Out Through Art: A Review of Art Therapy with LGBT Clients." *Art Therapy* 25 (4): 170–176. doi:10.1080/07421656.2008.10129546

The Shaw Mind Foundation. 2016. *Mental Health in the LGBT Community*. Newark, Nottinghamshire, UK: The Shaw Mind Foundation. http://shawmindfoundation.org/wp-content/uploads/2016/04/Shaw-Mind-LGBT.pdf

Tantia, Jennifer Frank. 2012. "Mindfulness and Dance/Movement Therapy for Treating Trauma." In *Mindfulness in the Creative Arts Therapies*, edited by L. Rappaport, 96–107. London: Jessica Kingsley Publishers.

Whitehead-Pleaux, Annette, Amy M. Donnenwerth, Beth Robinson, Spencer Hardy, Leah G. Oswanski, Michele Forinash, Maureen C. Hearns, Natasha Anderson, and Xueli Tan. 2013. "Music Therapists' Attitudes and Actions Regarding the LGBTQ Community: A Preliminary Report." *The Arts in Psychotherapy, Gender and the Creative Arts Therapies*, 40 (4): 409–414. doi:10.1016/j.aip.2013.05.006

Whitehead-Pleaux, Annette, Amy Donnenwerth, Beth Robinson, Spencer Hardy, Leah Oswanski, Michele Forinash, Maureen Hearns, Natasha Anderson, and Elizabeth York. 2012. "Lesbian, Gay Bisexual, Transgender, and Questioning: Best Practices in Music Therapy." *Music Therapy Perspectives* 30 (2): 158–166. doi:10.1093/mtp/30.2.158

4

BREAKING AND ENTERING

Wounded masculinity and sexual offending

Emma Allen

When the abused abuse

Sexual manifestations of childhood abuse can sometimes be re-enacted by those who have sexually offended, witnessed by the forensic art psychotherapist (who is often female), and safely contained within the art psychotherapy image. Art psychotherapy gives opportunities for mastering trauma from neglected experiences of, and failures in, past emotional containment and boundaries. Maternal deprivation, along with witnessing domestic sexual violence, may "breed" a damaged hyper-masculinity and intimacy deficits. When the abused abuse, sex can become a weapon (of aggression, power, and control), expressing unconscious acts of hate or blame. Image-making is inherently intimate and affords the additional reparation of relating to the archetypal feminine, which can evoke psychological rebirth. Working with a female therapist in a hyper-masculine forensic setting can be an intimidating prospect, provoking conscious and unconscious reactions to the feminine and engaging with difficult emotions. "Dangerous" to the sexual offender (Polaschek & Gannon, 2004), women are often targets of powerful projections, and not always perceived (nor assumed) to be nurturers, protectors, or carers. Many men with severe personality difficulties have been emotionally, physically, or sexually abused, and thereby traumatised by women, including mothers. Paradoxically, however, female clinicians can often receive a high level of self-disclosure and emotional expressivity from male clients (Scully, 1990). Individualised art psychotherapy with a female therapist can therefore be effective in establishing a consensual alliance, whilst also offering creativity, and a re-socialisation towards women (Gannon, 2015).

Dangerous defence mechanisms often act as a survival tactic for unbearable emotional states where engagement into sex offender (group) treatment programmes (SOTP) can be challenging for the personality-disordered patient in a high secure

setting. This case vignette of "Keith" (pseudonym), a man convicted of serial sexual offences (rape), and diagnosed with anti-social personality disorder (ASPD), who accessed individual art psychotherapy on a *"Dangerous and Severe Personality Disorder"* (DSPD) unit in England and who was able to challenge intimacy and shame deficits in the mixed-gender dyad, along with engaging in victim-empathy and *"consent-scenario"* work before meaningfully re-engaging into a sex offender group (SOG). This chapter hypothesises that image-making in forensic art psychotherapy can evoke compassion for self and others and where joint image-making with the therapist can aim to install gender perspective-taking as a vehicle for change, and a new relationship to the feminine, through empathic-mirroring-transference. In addition, the impact of gender-specific dynamics and their authority upon both the image and therapeutic relationship is examined. Finally, Keith's own perceptions and poignant examples of his, and our, joint imagery illustrate the concept (and my hypothesis of an art psychotherapy process of change) that a symbolic *"surrender"*, *"self-sacrifice"*, and *"confrontation"* takes place pictorially, and psychologically, before reconnecting to an authentic sense of self and a healthier form of masculinity; overcoming denial, and shame.

Breaking consent

Following numerous accounts of rape, burglary, and indecent assault, Keith was sentenced to life imprisonment and referred under a home office transfer to the unit for treatment of his severe form of ASPD and psychopathy, after struggling with his mental state, refusing food, and self-harming in prison. Keith, in his fifties, had witnessed much physical and sexual violence from a young age, and had been sexually abused whilst in care and in boarding school. Although brought up by his mother (due to his father leaving when very young), and a sibling to a sister, Keith found it difficult to *"feel things"* with his depression and described difficulties in sustaining intimate and meaningful relationships with women. Keith had several children from different partners, and had experienced the death of a child.

When I first met Keith, he had withdrawn from SOG and had requested trauma intervention. Art psychotherapy was considered, however, his clinical team reluctantly agreed for him to self-refer, following a difficult time of *"feeling kicked off"* his treatment pathway. Keith had been "caught" disclosing confidential information about his peers, breaking boundaries and any potential trust that had been built. The team were disheartened by his offence-paralleling behaviour and the general consensus was that a referral would be unsuccessful due to past engagement difficulties and resistance to psychological treatment, whereas Keith felt he had *"no control"* over his life or future, but knew he *"needed help"*. There was an expectation to fail, for boundaries to be broken, or that he would need to unconsciously self-validate feelings of low self-worth by proving the team, and himself, right, through a form of sabotage. Nobody, including Keith and I, expected him to meaningfully engage, or enter therapy after assessment.

> *I had very few expectations of what could be achieved, ignorant of what was involved and cynical about what I would get out of it.*
>
> ("*Keith*", Interview, 2011)

"Art therapy is for girls and hippies like you!"

Feminine (maternal) and masculine (paternal) modes of communication exist in forensic environments where the archetypal hyper-masculine, authoritative "father" figure (security) dominates over the "mother" or care-provider (psychotherapy). Hyper-masculine projective identification also exists where patients, staff, and the "system" can become controlling and restrictive or impulsive and threatening. This was particularly the case during my time on the DSPD unit, where the arts were perceived (by both patients and staff) as a "girls only" territory, and that to engage with emotions was "fluffy". The "arts" were sometimes viewed by both patients and staff as a "girls only" territory and that to engage with emotions was "*fluffy*". Psychotherapy requires feminine roles of openness, communication, self-reflection, and intimacy; however, social conditioning influences the wearing of a "mask of masculinity" (for both patient and forensic therapist) that is hard to remove. Gender is a security issue in forensic settings where male staff are protectors (security guards) and female staff are protected; validating an unhealthy gender-specific perception that women are vulnerable.

Men who have sexually offended are not always explicitly aggressive or hostile, but can often be highly articulate and charming, but this can feel superficial, guarded, and manipulative. I often felt suspicious of Keith and I didn't know "where I stood with him". Keith would often mock and belittle art psychotherapy ("*it's girly!*"), me ("*you're a hippy!*") and women ("*they are weak*"), whilst pointing to his watch, critiquing as to whether I was "too early" or "too late" for the session. Keith's degradation of women was downplayed by my use of humour and openness to self-deprecation (aiming to hinder his attempts to dominate through ridicule and humiliation), and a "*breaking and entering*" pattern of relating took place where he often described his relationships with women as feeling like "*two dogs fighting*". Keith was perhaps projecting internalised shame onto me where he later admitted feelings of hatred towards his mother, due to feeling vulnerable to feeling dismissed, forgotten, or abandoned. He described being "dumped" into care, where he was abused, and his overall feelings of rejection were re-validated when he was removed from SOG.

Keith would often tell me about his mother's controlling influence, often needing attention, but also noting she "had power" not only in the hospital, through her carer involvement, but over him. Keith often seemed ambivalent about their relationship. Keith's fears of intimacy with a woman seemed prominent in the transference constellation. I expected him to leave our therapeutic relationship prematurely, in order to avoid intimacy (or perceived criticism or abuse), to separate in order to develop a masculine identity, or indulge in denigration of women in the transference (Schaverien, 1997). As a female therapist, I identified with both Keith's abuser and victims. Warmth and intimacy may have been feared, untrusted, or unfamiliar where Keith was more accustomed to hostility or rejection.

Dangerous personality, hyper-masculinity, and threats of annihilation

Fears of invasion and rejection are common amongst those with ASPD where there is often a lack of empathy, and difficulties with affect (emotional), self, and impulse (behavioural) regulation. Acts of hostility are often an attempt to scare and keep people at a safe distance, validating a low self-worth, and re-stimulating the familiarity of feeling forgotten. Although intimidating, it is important not to be coerced into being punitive or persecutory, particularly as unconscious projections of wishing to be punished are in accordance with internalised guilt. In order to engage with offender-patients, disturbing offence material is often blocked out of mind by staff, which results in a de-sensitisation, and contributes to the forensic setting's unhealthy macho-culture in managing emotions. Although in the majority in the arts psychotherapies profession, women are in the minority, in staffing high secure personality disorder units. Female staff can experience feeling "outsiders", vulnerable and at risk in the male-dominated, and over-powering masculine culture, "characterised by a heterosexist discourse" that reproduces "hegemonic masculinities" (Mercer & Perkins, 2018, p.38 & p.42). For the therapist, there is often a conflictual "split" in the forensic countertransference: feeling warmth and understanding towards the patient, but also mistrustful and suspicious. There is also a toxicity in differentiating between patients and staff as "them" and "us", which can be dehumanising (Murphy & McVey, 2010). Remaining empathically engaged is crucial, but often in conflict with the very nature of having to listen to explicit, graphic material, and in witnessing offence re-enactments (Moulden & Firestone, 2007).

Often, male offenders' unhealthy relationship to "feminine" qualities (such as love and care) alludes to their own inability to nurture themselves and their relationship to their unconscious. Keith's view of women might be thought about as a rejection of a part of himself, and rape, an extreme act of distancing; alienating himself further and symbolically assaulting his victim-self. Keith was encouraged to express genuine emotion through spontaneous expression and play but often experienced this concept as untrustworthy and unfamiliar territory. Keith had experienced childhood victimisation and had acclimatized himself to avoiding vulnerability (and perceived weakness) by using destructive coping strategies. Being suspicious of image-making, therefore, may suggest an awareness of how it might involve a natural breakdown of defences, and where the invitation to let go of control through creativity, would reactivate stress response systems and survival behaviours.

Entering assessment: emotional control

Highly critical, and over-controlled, Keith would make painstaking efforts to draw *"precisely"* what he had in mind, paying great attention to detail, but would quickly conclude upon their meaning, preventing unexpected feedback. Keith was often reassured that it was okay to not know and was encouraged to consider that alternative

perspectives could be therapeutic. Asking for help was difficult due to his perception that he didn't deserve or trust it, *and* that it would make him "*weak*". Conversely, he often set high expectations upon himself and others, which couldn't be sustained; often testing to see if staff knew he needed support. Any failures in his view would confirm and validate his negative self-belief and reinforced feelings of rejection and abandonment. Keith had "raped" his emotionality and relationship to the unconscious, whilst also potentially infantilising (and undermining) image-making as a potential threat of annihilation; to be infantilised would be to feel impotent. His need to degrade feelings paralleled his need to degrade women where expressing emotions were a perceived form of weakness and exposure to vulnerability and victimhood. Men who exhibit denial, minimisation, deviant arousal, and low self-esteem are thought to be at a higher risk of sexual re-offending and less likely to form positive therapeutic relationships (Blasko & Jeglic, 2016); enhancing Keith's self-image and self-worth would be key, along with remaining optimistic.

Instead of being the "out of control" victim, Keith became an "in-control" aggressor. Avoiding victimisation through being an aggressor is not uncommon in children who have been exposed to domestic violence where they often learn to charm and manipulate their perpetrator; switching off their emotions in order to master trauma that eventually manifests into psychopathic personality traits (Dargis & Koenigs, 2017).

Instead of remaining suspicious of Keith, I understood his superficiality and grandiosity to be acts of survival from past maltreatment as a child, masking shame. Keith would ritualistically try to control his expressions and mark-making to begin, often using a ruler, and signing each image. The potential exposure of being asked to "perform" may have evoked a negative transference, or an inferiority complex where I considered his signature on each picture (initially as grandiose, or over-controlling ownership) enabled an improved sense of self through newly found creativity. Putting his name to his work symbolised taking responsibility for himself and his actions. His signature style, although inconsistent, seemed to suggest a fragile sense of self and perhaps in some small way, this process put him at ease, a way of making his true mark and placing himself in the picture. Keith's initial series of escapist landscapes offered an alternative space to his incarceration; an internal retreat into a world without people.

His emotional distancing through intellectualisation in order to avoid confrontation with pain or suffering was an ongoing defence that seemed to reveal itself in the transference. Keith's images repeatedly featured large, burning (phallic) sunrises in the distance, hinting at the start of emotions "coming to light". It would be important to not over-analyse the past, but to remain focused on the present and future in order to prevent repetitive unhelpful patterns of behaviour and to focus upon image-making as an externalisation of different states of mind and emotion (Springham et al., 2012). Those suffering with ASPD often have a severe limited capacity for empathy and trust and so voluntary engagement can be rare and atypical; it would be important to encourage compassion towards self as a place to start. By the end of the assessment, Keith agreed with my recommendations and told his team he wished to continue our work together, and felt "*surprised*".

Using art was something I'd never have considered before.

("Keith", Interview, 2011)

Entering treatment: *avoidance of "victim"*

Keith spoke fluently in *"therapy language"* and so image-making was offered to assist in "not talking over" but engaging in emotions he dismissed through being over-controlled or intellectualised. Keith enjoyed being analytical, trying to make sense of the past, and in "opening himself up" to feedback – a development that astonished us both. His initial over-intellectualisation (a defence and a risk indicator of recidivism) can also be symptomatic of an internalisation of the abandoning mother, where unconscious dynamics of inferiority act as an avoidance of truth and one that plays out in the psychopathic therapeutic relationship. Superficiality can also be viewed as a form of denial and an attempt to *"negate a 'rapist identity' by presenting themselves as 'nice guys'"* (Blagden et al., 2012, p. 189) which presented itself in Keith's first image, that he later would describe as *"picture-perfect"* and *"chocolate box"* and indicative of his need to hide his suffering personality, and trauma.

Keith spoke about his "rising" bitterness and resentment that others had what he didn't have, that offending allowed him to take what they had and give them what he'd experienced: fear, and loss of security, innocence, and dignity. He would also include himself as a minute *"stick man"*; so small that you needed to search for him. Keith often tested to see if I would notice, or be able to find him in his image. He became easily agitated by routine nursing staff observations; feeling *"watched, preyed upon"* and mistrustful of me. His drawings touched upon themes of defensive conflict; isolation vs. seeking attention (and asking for help), feeling threatened vs. being threatening, feeling punished or attacked vs. being punishing, attacking. It is easier for men like Keith to be perpetrator rather than victim as it avoids vulnerability. Keith expressed his desire to victimise and humiliate his victims of rape in the same way that he had been. Emotionally detached, Keith was often fearful of acknowledging his emotions for fear of losing control, being overwhelmed, and hurting himself or others.

"Saving face": the mask of sanity

Masks are often symbolically worn by the offender in the image, alluding to hidden aspects of self, identity disturbance, unstable self-image, denial, and avoidance (e.g. Figure 4.1). His *"mask of sanity"* (Black, 1999) hides vulnerability. Keith would repeatedly tell me that I could say *"anything"* to him; determined to not be affected by feelings, or, a female. Although claiming to be *"tough"* he would also challenge my facial expressions. Keith would ask me abruptly, *"What's that face for?"* expecting criticism from me; it is a phrase I wondered if his mother had used. He found women *"hard to read"*, understand, or trust. Keith was always masked when he committed his offences, violently assaulting women in their home; the mask perhaps served to guard against showing emotions that would be too "in his face". Over-sensitive to my every gesture; the non-verbal was threatening and I was not in his control.

Sexual violence can be thought of as a way of mastering difficulties with masculinity and sexuality; his emotional distancing, through intellectualisation, avoided confrontation with pain. Keith often felt he was an "*observer*" of his own life; dissociated and disconnected. Keith's negative self-perceptions were compounded by the belief that he was "*different*" – "*two people – one good, (caring, intelligent), one bad (a "monster")*". Keith often described feeling "*numb*", "*empty*", and alienated from society where he was often buried, hidden, or camouflaged in his imagery. Keith struggled with his identity of being both a victim and a perpetrator where personality is harmed through severe trauma and powerlessness is avoided or conquered through repetitive re-enactments of the past. In addition to this, Keith's masculinity was damaged through a severe absence of positive male role-models in his life, but also by women who also had the power to emotionally crush him. I often felt an abuser in the transference; seduced to over-intellectualise with him (colluding with emotional avoidance), and sometimes feeling I had facilitated an abusing exposure of the disgust and shame that he had felt about both his violent abuse and abusing.

Breaking and entering dangerous territories:
consent-scenarios, victim-empathy (therapist and self as victim)

Crucial to victim-empathy and victim-harm recognition is the promotion of compassion for self and others. Consent, an important topic in any sexual offender treatment, is one that not only naturally emerges within the therapeutic alliance, but also within imagery. Keith made a series of "entrance" drawings for us to explore. This included drawings of cave and barn entrances, and then much later, an entrance to the vulva emerged (Figure 4.2); all were significant places of hiding or dwelling and could be thought about as an unconscious desire for regressing to an original state of innocence (before crime), and to original, early experiences of security, protection, love and trust. in the unconscious process of transformation; the vulva image is symbolic of the maternal, the womb (the origins of life), and is a place of hiding or dwelling. It also suggests a desire for regression, and relapse into infantalism and to original states of innocence, security, protection, love, and trust. Keith would say to me that it felt safe to enter dark, ruined buildings, but I'd responded to one particular image, saying it felt "*too frightening for a female*" and that I wouldn't want to "enter" it as a woman; focusing upon my gender in the transference. Perhaps there was also some fear in the counter transference of accompanying him into his repressed, avoided aspects of self (his dark shadow). Keith may have, however, suggested it would be safe for us both; indicating his trust in me to go there, together, which needed to feel mutual. The theme of "breaking and entering" continued into imagery as well as our dialogue; entering the unconscious realm would need to feel consensual and safe. Offering genuine responses to his artwork, whilst actively exploring potential expressions of risk of harm to self or others are important guidelines for those with personality disorders (Springham et al., 2012), but it was also important to be honest to show how women can be trustworthy, to make the victim's voice be heard, and to reduce the risk of violent re-enactments.

Joint-viewing highlights different perspectives where it is important to mutually consider problematic affects and attitudes (Springham et al., 2012). Keith often presented a stark contrast between what felt safe or dangerous, reflecting his tendencies to suppress true feelings, particularly, anger. Keith could not understand why we couldn't agree, which influenced our explorations and perspective comparisons, exploring symbolically and metaphorically how he can seem too dangerous to go near. Offering a different perspective upon "unsafe" territories sought to install victim-empathy and help alleviate violent views towards women, but also to symbolically repair maternal deprivation, where gender-specific countertransference assists in eliciting transferential issues that focus upon interpersonal relationships with women who are often "victim" (Pietz & Mann, 1989). The therapist is able to challenge belief systems and degradation of women where perceptions are a vehicle for change (Blasko & Jeglic, 2016). In a collaborative approach, the power imbalance of "staff verses patient" can also be explored; evidencing that integral to any treatment outcome is the therapeutic relationship. If experienced as *"boundaried yet positive"*, *"highly transparent"*, warm and honest, female therapists can contradict past experiences of women (Gannon, 2015, p. 97). Considering my perspective allowed Keith to understand what his victims might have felt, and thereby gaining insight into his impact upon others. After a series of images that were deemed unsafe, he eventually expressed anger at himself for *"turning into an abuser"*, and the additional, re-occurring symbolism of fire (e.g. Figure 4.1) was explored to represent an inner need for cleansing and purification.

It is not only the victim-gender-dyad that offers potential for victim-empathy. Joint attention skills require an inter-affective experience, enabled by the therapist's sensitivity and attunement, exploring what his image might reflect or mirror back to him, supported in the triangular relationship (*patient-therapist-image*) (Isserow, 2008). Victim identification emerges where the female therapist can become "as if" the female victim and can also attune to the offender's stereotyped, prejudiced, or "wounded" views towards women that have hurt women in the past. Fears of rape and intrusion are considered in a symbolic, psychological way where a confrontation *and* surrender to the victim is required exploring his sexual offending and violent impulses. Keith's view of women, heavily influenced by his mother, and "mother-wound", involved a rejection of his own feminine qualities or characteristics; assaulting and alienating his victim-self. Gradually, in the image, both victim and perpetrator identities revealed themselves.

Sacrifice and surrender to the self

Psychopathic, superficial charm was eventually abandoned and images of self-punishment and self-hatred followed into drawings of being set on fire and burning on a crucifix (Figure 4.1), or drowning in the sea. Although he was opening up in his expressions, his face was always hidden or masked in the artwork. Keith felt his sexuality and offending were exposed to shame and punishment, and judged as hopeless to redemption or change. Images altered over time from facial close-ups, to his hands

FIGURE 4.1 Sacrifice and Surrender, 2010.

covering his face, and then eventually, the mask was removed to reveal his true self. Gradually, over time, he began to place himself *in* the picture, but still hidden from view (turning his back to the viewer (and himself), or hiding his face with his hands).

The position of surrender and sacrifice often occurs within offender imagery; symbolic of hidden immorality, but also a passive position, and psychologically, connecting to a release of the grip of the ego towards the acceptance of powers and authority greater than oneself. Figure 4.1 references a "see no evil" symbolism, and a blinding rage, and the crucifixion, a compliance to suffering; alluding to avoidance, and denial. Images such as these illustrate a dichotomy between wanting to persecute and feeling persecuted. It also illustrates a "self-sacrifice" schema; avoiding close relationships, leading to over-compensation. This over-compensation involves a pattern of surrendering to self-denial, doing too much for others and not for oneself, being then left feeling angry at the lack of reciprocal appreciation from others and deciding to no longer care again (Young et al., 2003). Self-portraits depicted him as a martyr, suffering self-inflicted wounds. These images hint towards a subservient, passive, way of relating to a powerful authoritative figure, where the victim must surrender to abuse and control that is sado-masochistic in nature. Keith had certainly described experiencing a sadistic, abusive childhood where he had been put down and "castrated" psychologically, expressing his learned helplessness and loss of control over his life, body, and sexuality. Control must be relinquished, and a new sense of powerlessness felt, in order to trust; this influenced my "provoking"

him to paint. His isolation, a predominant feature in depression, was illustrated in many images; showing how cut-off, and disconnected he was from the experience of feelings, and the fear they might be the death of him – a complete annihilation. For the sexually abused, a state of surrender or freeze can be experienced, symptomatic of dissociation, depersonalisation, and a detached state from the body. Keith felt he had committed sexual offences as a way of overcoming trauma:

> *I never felt part of life – rejected, not good enough; alienated. I was playing with people, not really feeling – detached.*
>
> ("*Keith*", Interview, 2011)

Unmasking trauma may lead to a form of redemption, reconciliation, and rehabilitation. Art, violence, and sex are all expressive acts of feeling and creativity, a "by-product" of the sublimation of instinctual, libidinal impulses (Gussak, 1997). Keith's series of images of hiding may have referred to his secrecy and manipulation but also "exposed" his past childhood sexual abuse, and having been tortured, and "silenced". Whilst encouraging Keith to be spontaneous and to paint (to "free" the suppressed and engage with his rejected femininity), he often became irritated with me for pursuing this and felt I was "forcing this on him" and being the "abuser". Gradually, over time, his images became more personal, authentic, and "up-close", overcoming feelings of inadequacy and impotency.

> *Being somebody who is very over-controlled, it allowed me to let go of some of that control and to explore emotions I'd kept out of sight – it was very liberating to draw images that came into my head without the fear of ridicule.*
>
> ("*Keith*", Interview, 2011)

Confronting violence, entering the feminine ("*everyone is a victim*")

Images of suffering are an important part of the process in order to undergo a ritual confrontation with violent impulses. Feelings connected with this change towards consciousness can be potentially humiliating. Childhood sexual trauma provokes aggression and "wounds" the image of masculinity through being a "victim", and the image of the perpetrator is further damaged by fear and judgements of society. Although embarrassed, and vulnerable to humiliation by his drawing (Figure 4.2), the image evoked an inadvertent unconscious disclosure (Gussak & Virshup, 1997), and evoked a transference of shame, where Keith announced he had witnessed his mother being raped by his step-father when he was seven years old. Keith also began to disclose his frustration at being "*de-sensitised*" and accustomed to violence, almost numb or disconnected ("*not feeling anything*"). He told me he wanted to feel empathy and that self-harming had been an attempt to try and "*feel something*". Keith depicted himself as both a child and an adult (Figure 4.2), along with his mother (depicted as a sexual organ, suggesting depersonalisation). We explored how this traumatic experience had not only affected his view of sex, and sexuality, but his feelings towards

women. Keith spoke of how angry he still was towards his mother, blaming her for the abuse that he and his sister suffered when children. The image also evoked a sense of his desire to have protected his mother, feeling both guilty at not being capable of doing so, but also overwhelmed by maternal deprivation. Keith disclosed how he had never felt loved by her but dismissed, ignored, and undermined. He was angry with his need to seek acceptance from her. Keith often gave the example that his mother dismissed his childhood abuse, had been in denial, and told him that "*everyone is a victim*". He felt she focused too much on her own abuse history, invalidating his experience. In retrospect, I may have also invalidated his own suffering, trauma, and abuse, where I was guilty (along with SOTP programmes) of focusing upon victim-empathy, which is no longer considered to reduce recidivism and could in fact increase the risk of re-offending through inducing more shame (e.g. Mann & Barnett, 2012). (ref).

Mother as victim – (women as victims)

Many men blame their mothers for their abuse (Dargis & Koenigs, 2017) and Keith seemed angry that he had never witnessed his mother protect herself or him. We explored their relationship for many months: his feelings of resentment, sexuality, and related his offences to his "fighting back", attacking his mother for not being protector. Witnessing his mother's rape, Keith had also come to view women as victims. The mother-son relationship can play a key role in complex layered patterns of sexualised, and sexually offending behaviour, where men with strong mother fixations can remain "bound" to their (inner) mother, strongly identifying with her, which not only influences their masculinity but has a significantly detrimental impact upon sexual relationships (Freud, 2013).

The "mother-complex" constellation is an active component of the psyche that is influenced by the experience of mother and a result of what he has learnt about how to relate to women. Women are seen as deceitful or over-controlling like their mothers were. Perhaps angry at what he had to "swallow" from his mother: a projective identification of a fear of engulfment underneath his perpetrating rape, may have been an unconscious attempt at transforming his relationship with her, or it became an unconscious matricide phantasy. The death of his daughter was a difficult subject he also illustrated through his newfound expression in painting; this loss was thought about in a much deeper sense where his drawings of his separation from her were also thought about psychologically as representing a part of his feminine psyche that he was far removed from and to which he needed to re-connect. Figure 4.2 expressed an unconscious desire to regress back to the womb (an original state of innocence) where he wanted to be "*looked after*" and protected from harm. Over time, he began to translate women no longer as abuser but as healer.

Breaking and entering 47

FIGURE 4.2 Breaking and Entering, 2010.

Wounded masculinity: fears of impotency and engulfment ("*swallow bitch!*")

After breaking into women's homes, Keith repeatedly forced them to have oral sex and swallow his semen.

Keith's image (Figure 4.2) perhaps related to the fear of engulfment from mother and a re-enactment of the sexual abuse he had encountered. Keith may have emotionally bonded with his mother in a way that shut down his feeling capacity, affecting his masculine identity and sense of separate self. The image perhaps also illustrates his sexuality as a weapon; not only re-enacting the trauma he witnessed, by repetition and copying, but as a psychoanalytic attack on his vulnerable self. In the countertransference, I was aware of what he'd done to women, how he'd made them feel, but also how women could make him feel. Women, or rather mothers, have the power to make men feel impotent and Keith spoke of his conflict-avoidance with his female partners too.

Looking back at his past, Keith described his wish to now "*turn around*" and "*face*" his difficulties. Through confronting the horror of his own violence, and that of others, he is able to locate a more positive relationship and understanding of his personality disorder, and gender. In Figure 4.2, a symbolic and psychological intercourse is seen; his adult masculinity (penis-like) entering his childhood trauma and vulnerable boyhood, with the vulva directly linking his experiences to his mother. His violent sexuality and

vulnerability is exposed as related, and as one. Symbolic of psychological penetration, the libido (source of life), the self, and repression of sexuality, a mirroring of offender-adult-self to childhood-victimisation is illustrated and a dual symbolic meaning entering of both the masculine *and* feminine. Over time, imagery began to relate to both his own experiences of abuse as well as his abusing. Keith's emotional development was made impotent through trauma. He often wanted to reassure me that he "couldn't" re-offend due to having erectile dysfunction, and that, before the act of rape, he would often have difficulties "performing" where both his burglaries and sexual offending were forms of invasion, regaining power and control, and *not* about sexual intercourse.

Keith has confronted his vulnerable inner boy who was neglected by his mother, an act of rape being a symbolic act of vengeance towards her, and also his emotionality. The most threatening territory to enter was the (archetypal) feminine. An over-sized, cave-like vulva (a potential threat that could engulf him); much like his mother relationship and inner "mother-complex". Perhaps Keith was compulsively re-enacting his own abuse; perhaps he'd even been conceived out of rape. This powerful image evokes a confrontation of potential engulfment, re-articulating his command to his female victims to "*Swallow Bitch!*" and is similar to the unconscious, sado-masochistic, master-slave roles and dynamics within personality-disordered relationships where intimacy and vulnerability are threatening. More importantly, however, is that image-making powerfully enabled Keith to openly disclose adverse childhood experiences of abuse, neglect, and trauma, and enabled us to both witness how this had impacted upon his own offending behaviours. Patients' history of violence and whether women have been victims in the past are important factors to also explore in the transference. From a masculine perspective, it is phallic, but instead of a sun-rise, it also made us also think of a sun-set, (symbolising endings, wholeness and completion), where his earlier defences had seemed to calm down, and where Keith could empathically turn towards the feminine and his hidden emotions; symbolic of libido, and wholeness. A confrontation (with regards to emotionality and trauma) and reconciliation to the self takes place, transforming destructive anger, aggression, and re-discovering new meanings:

> *I exposed myself to a different experience; exploring myself, and how my past impacted upon my life.*
>
> ("*Keith*", Interview, 2011)

Joint image-making – *gaining consent*

> *My images had a profound impact upon me, allowing me to express emotions. I particularly enjoyed the relationship I built up with my therapist – the trust I felt in her allowed me to explore what I previously kept hidden from others. . . .*
>
> ("Keith", Interview, 2011)

Eighteen months later, Keith felt ready to re-attempt SOTP. I suggested we try to create joint imagery to express and explore our relationship and to work towards a positive ending over a series of review sessions. We agreed these would be paintings,

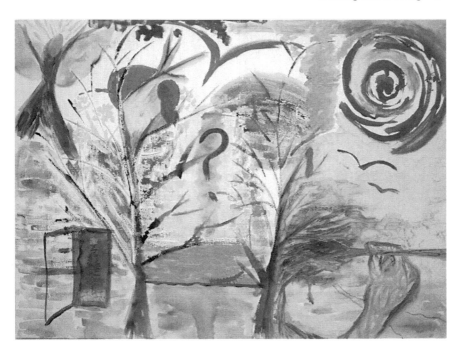

FIGURE 4.3 Breaking Free, 2011.

and on canvas. Joint imagery began with us both image-making separately and then swapping places to continue, and completing each other's work. Keith was encouraged to paint over my marks or to include his images alongside mine, and vice versa. This seemed a useful method in experiencing how he now related to women. In our final joint painting (Figure 4.3), Keith painted two trees to represent us both, and our relationship. Offering a re-modelling of a safe, intimate partnership and a test of being in each other's space. Interactions felt consensual but apologetic due to Keith's uncertainty of mark-making near mine and seemed overly sensitive to my acceptance. Creativity offers the offender a form of reparation to his own destructiveness and our final canvas was described by Keith as "*celebratory*". Sado-masochistic relationships reveal difficulties with separateness and the need to create boundaries between self and other, in which Keith had attempted to domineer and control his female victims. Conversely, in joint image-making, separateness and control is evidenced, and attachment relationships are witnessed. Keith needed encouragement to make marks near mine, and for our images to converge in a creative, not intrusive way. In the co-transference process, I became witness to his way of relating to his mother; intimidated to start, timid, rigid, passive; victim-like. We explored his superficiality and people-pleasing traits where he related this to learning how to please his mother.

Careful to not "rape" his psyche by being controlling mother, I knew our shared space allowed a new way of relating to females. In retrospect, these encounters allowed a new paternal mirroring and attunement also, facilitating safer transferential

experiences and triggering a powerful and emotional countertransference, the therapist as participant-witness. With an emphasis on symbol formation, together, therapist and patient shared an experience of turn-taking, maintaining boundaries, and sharing a safer, more respectful and authentic space. Keith's previous need for control was now more philosophical, adding a question mark in the centre. Our joint images combined an integration of engendered configurations and archetypes; pink and blue angels appeared both feminine, masculine, and in surrender, as a form of openness rather than punishment, and the open door felt hopeful; leading out of therapy. Therapists can make powerful contributions to an offender's image; accompanying the patient into dark inner territories, engaging in a symbolic intercourse, integrating more hopeful imagery into the patient's psyche, and allowing trust to deepen with increased tolerance of uncertainty. Making contributions to the patient's artwork, however, should never be done without consent.

"Embracing the old man"

Gender influences how patients perceive the therapeutic relationship. Keith compared it to *"marriage"*. He described feeling *"exposed"* to a *"new"* experience where he'd been *"challenged"*, that this had felt *"exciting, liberating and surprising"* to have a positive relationship with a woman. Although art was the central focus in therapy, gender was a healing factor. Keith admitted he'd worried he would feel *"dumped like rubbish"* by me, even when he'd decided the ending. This felt important that he hadn't felt controlled by me, the same as he had felt by his mother. He even joked that *"even a marriage doesn't sometimes last this long"* and seemed to imply a discomfort with his attachment. He told me he wanted to *"embrace the old man"*; accepting a more mature and renewed a renewed sense of masculinity and identity, telling me he wished to grow a beard. There appeared to be a more genuine quality to his motivation of feeling ready for SOTP, and his team seemed more confident that he might meaningfully engage. Keith went on to successfully complete treatment (where his relational risk was thought to have reduced), before transferring to a regional secure unit.

Conclusion – renewed masculinity: breaking free

"Breaking and entering" a wounded sense of masculinity takes place where unspeakable, unsafe, territories can be psychologically re-entered through the containing art psychotherapy image and trusting, compassionate, therapeutic relationship. Men who have sexually offended may address their belief system towards women, sexuality and gender, self-perceptions and personality difficulties in a mixed, gender-victim dyad. Trauma, maternal deprivation, poor self-regulation, hostility, grievance, and witnessing domestic violence can all influence violence towards women, where the female art psychotherapist may identify with the victim. Those who have offended have often been offended against; they have been victims too, and are often still victim of their own self-hatred and shame. Installing victim-empathy is therefore not only towards the female victim, but to the victimised, emotional, feminine self that

is avoided through sexual violence, aggression, and hyper-masculinity. Exploring sexual offending and ways to relate to women, mother, and self, can all be compassionately approached in the triangular relationship (patient-image-therapist) and in the non-verbal approach; images can speak and dare to tell the painful truth, along with the therapist providing a voice for the victim. Emotional recognition, however is threatening and can feel exposing, therefore, feelings can feel exposing; feelings sometimes need to be intellectualised, and de-sensitised by both patient and therapist in order to manage explicit, disturbing, gender-attacking material. Keith's assumptions, and perception of art psychotherapy had been offensively sexist, in the same way that he had perceived women to be weak, vulnerable, and victim-like, yet it was his own feminine, emotional aspects of self (and the unconscious) that were wounded, making it difficult to be empathic, or to feel compassion. Engaging meaningfully in a trusting therapeutic relationship in the mixed-gender-dyad was felt to be a significant step forward towards a renewal of intimacy with the feminine, exploring his offence-supportive attitudes, and beginning to take responsibility for his future.

Image-making can lead to acceptance and self-realisation, which may restore self-worth; Keith's images began as rigid, controlled, cautious, and perfectionist but evolved into more free-flowing paintings that felt more genuine and trusting. A reduction of psychopathology, improved emotional states, and re-engagement into offender treatment are also all possible through strengthening a sense of self and gender-identity through self-imagery, positive-risk and perspective-taking. Men like Keith require empathy, compassion, dignity, neutrality, trust, optimism, and hope, not condemnation, ridicule, humiliation, or further exposure to shaming. Keith would not have been able to have explored his violent shadow, and vulnerabilities, should he have felt rejected, disapproved of, punished, or judged. Joint attention, image-making, and improvisation can all evoke an attuned and intimate empathic-mirroring-transference. Joint imagery not only provided a collaborative, authentic enquiry, and approach in "facing" emotional, intimacy deficits, and understanding intentions and risk, but created "live" consent scenarios. These allowed a symbolic "marriage" of conscious and unconscious material to integrate into a psychological intercourse, creating a new relationship to the masculine and feminine through creativity. Psychological development, and schemas, are witnessed in the progression of art psychotherapy imagery: a sacrifice of past self (e.g. Figure 4.1) and an archetypal state of (empathic) Self-confrontation (e.g. Figure 4.2) before integrating an internal balance of the feminine and masculine; expanding consciousness and insight (e.g. Figure 4.3). Confronting emotionality involves surrendering to self-control and superficial attachment, but transforming hyper-masculine aggression and rehabilitating a sense of compassion and redemption in oneself leaves the self no longer hidden with shame.

References

Black, D. W. (1999). *Bad Boy, Bad Men: Confronting Antisocial Personality Disorder*. Oxford: Oxford University Press.

Blagden, N., Pemberton, S., and Breed, C. (2012). Chapter 10: A Psychologist's Casebook of Crime from Arson to Voyeurism. In B. Winder and P. Banyard (Eds.) *Rape of Adults*. London: Palgrave Macmillan.

Blasko, B. L. and Jeglic, E. L. (2016). Sexual Offenders' Perceptions of the Client-Therapist Relationship: The Role of Risk. *Sexual Abuse: A Journal of Research and Treatment*, Sage Publications, Volume 29, Issue 4, pp. 271-290.

Dargis, M. and Koenigs, M. (2017). Witnessing Domestic Violence During Childhood Is Associated with Psychopathic Traits in Adult Male Criminal Offenders. *American Psychological Association, Law and Human Behavior*, Vol. 41, No. 2, pp. 173–179.

Freud, H. C. (2013). *Men and Mothers, the Lifelong Struggle of Sons and Their Mothers*. London: Karnac Books.

Gannon, T. (2015). Treatment of Men Who Have Sexually Abused Adults. In D. T. Wilcox, T. Garrett and L. Harkins (Eds.) *Sex Offender Treatment; A Case Study Approach to Issues and Interventions*. West Sussex: John Wiley & Sons, Ltd.

Gussak, D. and Virshup, E. (Eds.) (1997). *Drawing Time: Art Therapy in Prisons and Other Correctional Settings*, Chicago, IL: Magnolia Street Publishers.

Isserow, J. (2008). Looking Together: Joint Attention in Art Therapy. *International Journal of Art Therapy*, Vol. 13, No. 1, pp. 34–42.

Karr-Morse, R. and Wiley, M. S. (1997). *Ghosts from the Nursery: Tracing the Roots of Violence*. New York: Atlantic Monthly Press.

Keith. (2011). *Post Treatment Interview and End of Therapy Questionnaire*, unpublished and confidential.

Mann, R.E. and Barnett, G.D. (2012). Victim Empathy Intervention With Sexual Offenders: Rehabilitation, Punishment, or Correctional Quackery? Sage Publications, Vol. 25, Issue 3, pp. 282–301.

Mercer, D. and Perkins, E. (2018). Sex, gender and the carceral: Female staff experiences of working in forensic care with sexual offenders, International Journal of Law and Psychiatry, Vol. 59, pp. 38–43.

Moulden, H. M. and Firestone, P. (2007). Firestone Vicarious Traumatization, the Impact on Therapists Who Work with Sexual Offenders. *Trauma, Violence & Abuse*, Vol. 8, No. 1, January, pp. 67–83. Sage Publications.

Pietz, C. A. and Mann, J. P. (1989). Importance of Having a Female Co-Therapist in a Child Molesters' Group. *Professional Psychology: Research and Practice*, Vol. 20, No. 4, pp. 265–268.

Polaschek, D. L. L. and Gannon, T. A. (2004). The Implicit Theories of Rapists: What Our Questionnaires Tell Us. *Sexual Abuse: A Journal of Research and Treatment*, Vol. 16, 299–315. doi:10.1023/B:SEBU.0000043325.94302.40

Schaverien, J. (1997). Men Who Leave Too Soon: Reflections on the Erotic Transference and Countertransference. *British Journal of Psychotherapy*, Vol. 14, No. 1.

Scully, D. (1990). *Understanding Sexual Violence: A Study of Convicted Rapists, Volume 3 of Perspectives on Gender*. Oxford: Psychology Press.

Springham, N., Dunne, K., Noyse, S., and Swearingen, K. (2012). Art Therapy for Personality Disorder: 2012 UK Professional Consensus Guidelines, Development Process and Outcome. *International Journal of Art Therapy*, Vol. 17, No. 3, pp. 130–134, doi:10.1080/17454832.2012.734834

Young, J. E., Klosko, J. S., and Weisharr, M. E. (2003). *Schema Therapy: A Practitioner's Guide*. New York: Guildford Press.

5
BODY POLITICS AND PERFORMANCE OF GENDER IN MUSIC THERAPY

Randi Rolvsjord and Jill Halstead

Introduction: music therapy and music for all

Musical practice in music therapy unfolds in a tangled web of socio-cultural contexts and interrelated identity politics. In this text we will explore the ways bodies in therapeutic contexts do, redo and undo gender in musical performance practice by drawing on critical perspectives from the fields of health humanities, feminist theory and musicology.

Music therapy has long been linked to an agenda, which brings "music to all" (Ruud 1996), by offering spaces for people to engage with music, regardless of disability or cultural marginalization. Usually, to participate in music therapy, there is no requirement for any previous musical experience or musical skills, nor any prerequisite of certain levels of ability. Rather, music therapists seek to foster a mutual space for music making that starts with the basic human capacity of communicative musicality (Pavlicevic and Ansdell 2009; Trevarthen and Malloch 2000), and whatever musical skills, preferences and musical identities that the clients possess. This general "non-judgmental perspective" (Bruscia 2014, 113) towards music fosters music practices that engage broadly across health care contexts, teaching contexts, cultural contexts and community work. Music therapists work with children as well as with elderly, and with a variety of clinical populations (e.g. children with physical and cognitive impairments, elderly with dementia, people with mental health problems, cancer patients), as well as community work. Thus, music therapy practices create spaces for musical interaction for people that otherwise have limited possibilities for musical participation. Ruud's broad definition of music therapy encompasses such an agenda when describing music therapy as "an effort to increase possibilities for action" (Ruud 1998, 3). The definition is implying a cultural politics that moves away from elitist exclusivity towards inclusive and participatory arts practices.

In the current discourse of music therapy, social approaches such as community music therapy have clearly fostered political awareness and agendas (Pavlicevic and Ansdell 2004; Stige and Aaroe 2012; Stige, Ansdell, Elefant, and Pavlicevic 2010). The movement of community music therapy sparked a shift away from music therapy as primarily situated in (clinical) institutional contexts to more broadly engage with community settings and the fostering of participation (Stige and Aaroe 2012). Likewise, anti-oppressive (Baines 2013; Baines and Edwards 2015), and feminist perspectives (Curtis 2006, 2015; Hadley 2006; Hadley and Hahna 2016) have challenged structural barriers for individual's health and recovery. A growing amount of music therapy practices that foster community participation for marginalized groups are documented in the literature (Kim 2013; Krüger and Stige 2014; Schwantes et al. 2011; Stige, Ansdell, Elefant, and Pavlicevic 2010; Tuastad and Stige 2014; Veltre and Hadley 2012).

Despite a focus on developing inclusive and participatory practices, critical exploration that engages with intersectional aspects of body politics in music therapy is rather new. Recently, critical engagement with intersectionality (Hadley 2013a; Whitehead-Pleaux et al. 2013; Whitehead-Pleaux and Tan 2017), gender (Edwards 2006; Rolvsjord and Halstead 2013; Halstead and Rolvsjord 2017; Scrine 2016), race and ethinicity (Comte 2016; Hadley 2013b; Veltre and Hadley 2012), sexuality (Whitehead-Pleaux et al. 2012) and disability (LaCom and Reed 2014; Metell 2014; Metell and Stige 2015; Rickson 2014; Rolvsjord 2014), has identified a need for more awareness of inequality and discrimination, and the challenges related to body politics, identity and participation in music therapy interactions.

Music therapy is not unfolding in an a-political vacuum, but takes place in a web of cultural, social and political contexts. This demands that we explore body politics by engaging with the intersectionality of gender, race/ethnicity, class, age, sexuality and disability, as well as to engage with levels of intertextuality between the discourses of different areas of cultural politics. In previous texts, we explored interaction between the gender politics in popular music cultures. In these previous texts that focused on the gendering of voice (Rolvsjord and Halstead 2013) and on the gendering of musical instruments, specifically the electric guitar (Halstead and Rolvsjord 2017), we exemplified that music therapy mirrored the gender politics of popular music cultures.

Given the inclusive approaches to musical participation in music therapy, this mirroring of gender politics is an apparent paradox in the discourse and practice of music therapy. Our point of departure, when approaching this paradox, will be body politics emerging in the specific landscape of European neo-liberal societies which continually shape bodily ideals and modes of being for women and men. Specifically, we will locate musical practices in therapeutic contexts through their interaction with the broad context of popular musical practices, where performance has been a pervasive site for the performative doing and undoing of gender, and as such constitutes an important source of collective understanding with regards to sex, gender and the body.

The body and difference

Feminists have had a long and complex relationship between the body and how the body may be defined, and the formation and performance of identity (Butler 2011; Grosz 2011; Moi 2008; Young 2009). It is important to point out that for many periods of history the body was seen to determine the identity, characteristics and potentials of particular groups. For example, for women, people of colour, for people with disabilities, children and elders, their bodies were seen as the primary source of their subjugation, and often used as a justification for their lack of equal rights and oppression (Blackman 2008; Hall, 2011). For previous generations the relationship between the body, identity, and the possibilities to participate were firmly drawn. Scholars and activists in the field of feminism, race and disability have consistently challenged the ways bodies have been described, inscribed and defined by the relationship between the body and society across periods of time and culture (Butler 1990; hooks 2010; Lykke 2010).

Our approach to understanding gender and body politics recognizes the complexity of body politics and difference, being influenced by feminist philosophy and theory, whilst acknowledging that feminist thinking on the body is a field of diversity which cannot be characterized by one approach (Collins 2002; Lykke 2010; Mann 2012; Rolvsjord and Hadley 2016). The body continues to be a contested site primarily due to the fact that women have continued to be defined by their relationship to their bodies, a difference that marks them out from men. Images of gender that proliferate in neo-liberal society can be linked to a "sexual contract" fostered by an individualistic consumer mentality (McRobbie 2011). This has sparked a new ideal of "can do girls" or "alpha-girls" who not only present as competitive and achievement-orientated in their careers, but also in terms of their bodily success in relation to achieving idealized femininity (McRobbie 2011; Faludi 2006).

A premise for our discussion of gendered performances of music in music therapy is a concept of gender as performative rather than given (Butler 1990), and a focus on the body as a practical, direct locus of social control (Bordo 1997). We connect with perspectives that situate gender in cultural, political and discursive contexts (Butler 1990, 2004), and at the same time acknowledge the material conditions of corporality (Grosz 2011; Hemmings 2011; Lykke 2010). We connect with key sociological and philosophical discourses that locate ideals of how bodies perform themselves as masculine and feminine as emerging through the mundane organization of the body, primarily through the habits, routines, rituals and practices of the body in everyday life (Bourdieu 2002; Butler 1990; Foucault and Sheridan 1997). It is through the ongoing routine actions and interactions of the body in daily life that identities are habitualized and the performance of gender is done, redone and undone (Butler 2004; Deutsch 2007; Risman 2009; West and Zimmerman 1987, 2009).

In spaces of musical practice, techniques, routines and conventions shape possibilities for action and *vice versa*, whether through the processes of live or recorded

performances, whether on public stages or in private therapy room, bodies enact and perform complex, multiple identities through the macro and micro interactions of sound making and movement, with technologies (instruments and recording devices) and other people (other musicians and audiences). In doing gender in these contexts, people organize and negotiate their actions in relation to cultural expectations as to how particular bodies appear in differentiated musical practices (genres). As such musical practices create possibilities for action, where doing gender might confirm or interrupt social and cultural norms and stereotypes.

Disappearing and dys-appearing bodies in music therapy

Although the body of the client has been a consistent focus around which music therapy practices and research has been developed, the vast majority of traditional music therapy literature evidences a general absence of reference to the body and bodily experiences.

The body appears most commonly in music therapy literature in terms of perceived physical and psychological differences expressed in terms of dysfunction and incapacity, and music therapy´s potential role in increasing functionality and easing discomfort. For example, music therapy may enhance functionality for movement (Thaut 2005), enhance capacity for breathing (Tamplin 2011), soothe pains (Bradt, Dileo, Magill, and Teague 2016; Gallagher, Lagman, and Rybicki 2018), or contribute to body awareness and contact with bodily feelings (Lejonclou and Trondalen 2009; Solli and Rolvsjord 2015). Another aspect of music therapists work with bodily variations is the adaptation and creation of musical instruments that facilitate music making despite physical impairment (Nordoff and Robbins 1983).

Yet, this focus on the body as a site for illness and disability, and a site for the improvement of functionality and healing, makes other cultural and social foundations of bodily experience invisible, leaving the wider politics of participation which are organized around the body unacknowledged and unchallenged. In this way the body in music therapy is in danger of both disappearing and dys-appearing (Ledger 1990), in that the body´s presence as social, cultural and embodied is absent, only appearing when designated as dysfunctional along the lines of medical and psychological diagnosis. This dys-appearing body is very evident in the amount of texts that only describe and define clients in terms of bodies that lack of functionality, or present physical symptoms and impairments. It has been argued that this dys-appearance of the body in literature mirrors an *ableist* culture more generally and the ableist strategy towards the elimination and cure of the dis-abled (Goodley 2014; Shakespeare 2014).

Building on recent work in music therapy which describes bodies through intersectionality (Hadley 2013a; Whitehead-Pleaux et al. 2013), we argue that music therapy as a field needs to engage with the body to pose critical questions which locate it beyond medical definitions and the singular focus on issues of incapacity or impairment. Instead, 21st-century bodies need to be located in terms of age, gender, sexuality, race, ethnicity, dis/ability and socioeconomic class (Collins and

Bilge 2016). So that in asking questions of the body we recognize and account for bodies in ways which acknowledge that they are neither neutral nor natural, but always defined and located in relation to power, inequality and difference, all of which create the possibilities for action and the conditions of health or lack of it. To this end, intersectionality is a crucial tool for music therapy theorists, practitioners and activists in their work providing open, accessible spaces for musical participation (Hancock 2016).

Musicking, performance, personae

Music is a performing art, a bodily practice, yet the body's role in the production of musical culture has been both peripheral and problematic (Leppert 1993; McClary 1991). Traditionally socio-cultural and musicological discourses have circumvented the body focusing instead on music as text-based (scores and recordings) or as sonic abstraction. In recent decades there has been a greater interest in developing terminology that better captures the dynamic, social and performative nature of musical experiences. Most notable is the now widely used term *musicking*, which recasts music as a verb (to musick) rather than a noun (Elliott 2009; Small 1998). Musicking, the way bodies listen, perform and interact in and through sound, is grounded in a complex set of cultural expectations regarding what particular bodies are, and can do, and what they do together in any particular time and place.

To understand the connection between bodies and the enactment of identity in music therapy we need a clearer understanding of the musical practices that routinely form the core of such therapeutic work. Musical practices in music therapy have changed from their traditional format of improvisation (largely removed from the specifics of genre or repertoire) between a therapist and one client playing acoustic instruments. Important for the context of this study, music therapy practices have increasingly appropriate specific musical genres, often from recorded Anglo-American popular music of the last 60 years. Popular musical idioms are now routinely deployed by way of working in groups with amplified instruments (guitars, bass, digital keyboards, drums kits) (i.e. Aigen 2002; McFerran 2011; Solli 2009; Tuastad and Stige 2014) making use of specific forms, techniques and popular idioms (i.e. Aigen 2002, 2013; Hadley and Yancy 2012; Viega 2016) and engaging with various technologies such as recording (i.e. Smith 2012; Solli 2014; Soshensky 2011).

Changes in the format of music therapy sessions have emerged in tandem with the introduction of popular music styles and techniques, shifting from music making which occurs within the closed therapy session, to more open groups and community formats, where those not directly involved in the session feature in the musical interactions and performances. Public performance of various sorts are now part of music therapy practices, whether it be the informal sharing of music with family and friends, to more formal concerts and gigs with recorded material released via CD and video or on the internet (Ansdell 2005; O'Grady, Rolvsjord and McFerran 2015; Solli 2014; Turry 2005). Participation in music therapy is therefore explicitly interlinked to practices, expectations and values of the broader

popular music culture within which the therapy occurs. Moreover, as music therapy practices absorb and modify globally circulated commercial musical sounds, forms, imagery and traditions of performance, the associated politics of such musical genres as a contested space for the doing of various forms of identity also becomes part of the context for music therapy. Music therapists therefore need to engage with the wider set of musical parameters and modes of performance specific to forms of popular music practice.

Auslander (2004, 2006a) suggests that to analyze and better understand popular music performance we must first take into account the wider socio-cultural context through which performed musical behaviour emerges, alongside the context and conventions of specific musical genres and the associated expectations of the audiences and performers (Auslander 2004, 10). In popular music performance practices performers enact a series of relationships, between themselves (the real person), their performance *persona* (star personality, or fictional musical self) and the specific character related to a particular song (song character) (Auslander 2004; Frith 1998). Performance personae are created through the sounds, forms, techniques and lyrical content of specific musical genres, enacted in performative gestures, facial expression, costume, make-up, props, lighting, visual effects and so on. As such enacting a musical role within any performance tradition, by its very nature, requires the cultivation of musical stylization and character created through the sonic qualities, expressive, emotional and narrative flow of any particular performance. Such performing personae should not be seen as an inauthentic or false version of the musical performer, but rather as an essential affordance of the performative quality of musical practices and customs.

Moreover, part of the pleasure of engaging with popular music is to "experience and consume the persona of a favorite artist in all their many forms and this experience is inseparable from the music itself, and of the artists as musicians" (Auslander 2004, 9). Clearly, the performative play with personae is an essential part of musical practices and experiences for musicians and audiences alike. Indeed Auslander points to the fact that "audiences can avail themselves of most of the same means of expression as popular musicians themselves in their responses to them, including playing music" (2004, 13). This supports the idea that a common response for those who engage with popular music of various forms is to play and perform the same music themselves. As music therapy is increasingly a site through which people can gain access to music making, so it is imperative to better understand the mechanisms through which clients engage with popular music culture through their own performances and the construction of musical personae.

Music, body, gender, sexuality

Across history, and in different cultural contexts, music practices have often been segregated along lines of gender and sexual difference, with specific instruments, techniques and performance spaces closely regulated in terms of male and female participation (Doubleday 2008). In this way men have traditionally been associated

with creative work, production and the playing of instruments, whereas women have been associated with singing, dancing and demonstrative emotional expressivity (Doubleday 2008; Dunbar 2015; Pendle 2001). This situation is reflected in music therapy contexts where men tend to play instruments and women sing and dance (Halstead and Rolvsjord 2017; Scrine 2016). Whether as public spectacle or domestic activity these musical roles have emerged as key sites for the reproduction of the ideal relationship between women and femininity and men and masculinity, and the appropriate form of relationship between the two (Green 1997; McClary 1991).

Historically the musical role most often associated with women is singing. Since the Renaissance, customs related to women's singing have emerged, whereby the woman's voice is a proxy of the female body expected to touch the audience through the transfer of emotions, whereas men took roles that demonstrated their mastery of mechanical (and later digital) instruments whilst suppressing or controlling their emotions (Doubleday 2008; Dunbar 2015). Reflecting wider culture, women's roles in musical practices have been often defined by their relationship with their bodies, and indeed the display of the female body, and therefore the delineation of femininity in any era, has been integral to shaping the form and content of the musical practices (Doubleday 2008; Green 1997; McClary 1991).

In European art and folk genres women's singing and song have often been musical enactments of an idealized fusion of the feminine beauty of the body of the singer, and beauty of the voice and song (Dunbar 2015; McClary 1991). As a singer's performance is not mediated by any visible technologies such as instruments, a sense of bodily intimacy is created between the singer and the audience. This intimacy of presentation of the musical body has been described in terms of aesthetic and emotional interactions as well as emotional or affective labour (Alberto 2018; Hofman 2015). Forms of labour where specific emotional display are part of the transaction or service provided have primarily been associated with women (Hochschild 1982) and the role of professional singers has often been framed in this way in line with musicians as a group having an embodied occupational identity (Alberto 2018). In the post-war era, the embodied occupational identity of the singing diva has been one of the most significant models for women and in many ways encapsulates the complexities of performing gender and the politics of representation and participation in contemporary neo-liberal societies. The singing diva figure proliferates in popular culture and in many ways captures the competing expectations of women, being viewed as simultaneously hostile and empowering to ideals of women's independence, economic and cultural self-sufficiency and open sexuality (Tasker and Negra 2007).

Negotiating body politics in music therapy. Gender segregation and gender tourism

Forms of musical practice not only reflect and reproduce dominant norms of gender, but are active spaces of gender formation, where gender is done and undone, and the interaction of gender and sexuality is specifically performed (Alberto 2018;

DeNora 2000). In this sense musical practice is neither entirely constrained by socio-cultural norms of identity but neither is it entirely free of them (Auslander 2004). Music therapy mirrors the broader context of music making situations in that it affords opportunities for doing and undoing gender through gender segregated and mixed musical practices.

Historically popular music practices have often been segregated along lines of gender, race and age among others. For example, women have frequently been excluded or absent from particular musical practices. Historically as musical practices were often associated with religious practices women were often prohibited from performing in particular locations, and excluded from education and training (Halstead 1997). In more recent history women have been absent from some musical practices through lack of opportunities, discouragement and the development of negative relationships with particular instruments or practices (Doubleday 2008; Halstead and Rolvsjord 2017).

Clearly some musical practices offer the potential for men and women to conform to ideals of heterosexual masculinity and femininity. There are numerous examples in music therapy literature where musical practice and performance confirm dominant gender/sexual scripts/roles in the broader culture. It is important to note that these practices are seen to have therapeutic qualities that can contribute to promotion of health and participation for those involved. Pertinent examples of this are found in case studies of all male rock bands that foster experiences of bonding, self-confidence and group reflection (Aigen 2002; Soshensky 2011; Tuastad and Stige 2014, 2018); similarly there are case studies of women gaining self-esteem and increased self-expression through singing practice (Rolvsjord 2010; Turry 2005). Tuastad's work with a rock band of ex-prisoners (Tuastad and Stige 2014, 2018) might help to illuminate aspects of how performances confirm gender norms, in that the all-male rock band has traditionally been a musical practice through which the performance of normative heterosexual masculinity has been central (Cohen 1991; Jarman-Ivens 2013; Reynolds and Press 1996). The rock band idiom has been a key site for the performance of various forms of masculinity and rebellion often focused on heterosexual power relations and sexual freedom. For the band *Me and the BAND'its*, the rock band became a space configured in terms of normative masculinity, but where actions were channeled into a musical practice which allowed members to negotiate normative masculinities in other areas, as when the members of the band made a collective decision not to take revenge for a violent attack on one of the band members (Tuastad and Stige 2014).

Yet at the same time, genres such as rock and pop are perhaps the most widely recognized examples of musical styles associated with practices of *gender tourism* (Reynolds and Press 1996). In some genres like rock and rap, women's very presence as instrumentalists can radically disrupt the gender roles of the genre (Auslander 2004; Coates 1997; McCarthy 2006). In these genres musical practices are an imaginative space for performers and audiences to reaffirm, stretch or even escape ideals of gender and associated heteronormativity (Auslander 2006b; Hawkins 2009). For instance, there are numerous artists that challenge and negotiate

gender, sexuality and ethnicity in their performances such as Madonna, David Bowie, Prince, Michael Jackson, Nina Simone, Björk and Lady Gaga to name a few (Burns and LaFrance 2002; Hawkins 2017; McClary 1991).

In music therapy, such negotiations can sometimes be explicit as part of the musical and verbal interactions, other times they are subtle and inverted responses enacted in the musical participation. For example Veltre and Hadley (2012) discuss how gender roles and personae in popular music can be negotiated through discussion of lyrics and techniques of lyric substitution. Rolvsjord and Halstead (2013) provide a more specific example describing the experiences of a woman singing with a relatively low-pitched voice in music therapy. The woman experienced that her low voice had previously conflicted with feminine norms, where the range of high-pitched and low-pitched voices (and musical sounds in general) are often directly connected with the male and female body and thus ideal connotation of femininity and masculinity. Singing in music therapy became a way for this woman to negotiate her feminine identity.

"Sparkling Divas"

Smith (2012) offers a case study of music therapeutic work with a group of teenage girls that might help us disentangle in more depth how gendered bodies are central to musical practice and performance in the context of music therapy. We chose this case because it is a strong example of a music therapeutic practice that is both respectful and in touch with the young girls' play with musical personae, employing a practice that fosters self-esteem and friendship among the participants, and at the same time is an intriguing example of the complexities and conflicts of identity in the intertextual and intersectional frames.

The music therapy practice is part of the program of the Boys and Girls Clubs of America, a program established in response to the difficult life conditions for children and adolescents living in communities of poverty and social problems described in terms of drugs, crime, racism, gangs and domestic violence. The specific case described is a therapeutic collaboration with a group of seven girls of Hispanic and African American ethnicity aged 10–13. The opening activity is described as a "get-to-know-you game" accompanied to the song *Party in the USA* by Miley Cyrus. The group work engaged the girls in singing and dancing. The girls were then invited into a participatory process of song-creation and a subsequent process of creating a music video. When the music therapist introduced the girls to the songwriting process, the group began to brainstorm ideas for a central message for the song, and as a result quickly came up with a name of the group:

> The group decided to name themselves the "Sparkling Divas." All of the group members quickly agreed to this. As the girls were brainstorming, the main themes that emerged consisted of "pre-teen girl stuff" (lipgloss, dressing up, sparkles, dancing, singing, favorite music artists, boys, performing as divas) and life circumstances (being a member of the Boys and Girls Club,

school, neighborhood, challenges). As the group narrowed down their ideas, it became evident that they wanted to focus on "preteen girls stuff" and to leave out topics related to their life circumstances.

(Smith 2012, 20)

As the work with the girls continued they all had agreed on the lyrics. Assisted by the music therapist they created an instrumental track to accompany the songs, with a Hip Hop track for the chorus, and verses in R & B style. Each of the girls worked on a solo-verse and then together they created the final verse:

> We're not mean, we're a team
> We're never off beat, we always move our feet
> When we are complete
> We're glamorous and adventurous
> We're sparkling and free
> Sparkling Divas.

(Smith 2012, 23)

For the music video the girls recorded the music, and choreographed and performed dance-moves to the song. The music video is described in less depth, but we learn that in advance of the video "All the girls agreed that for each of the filming they would wear pink, and that they would create a dance" (Smith 2012, 23). The young girls clearly identified with an idea of a female singer as diva, invoking a specific persona and bodily practice of performance. The text explicitly makes the connection to female pop-singers by listing the girls' favourite artists, such as Beyoncé, Alicia Keys, Keysha Cole, Miley Cyrus and Rihanna with "the idea of being a Sparkling Diva really became a strong and important concept that the girls embodied when they came to the sessions each week" (Smith 2012, 22). The embodied identity of Sparkling Divas seems to draw on the traditional female pop-singer persona, enacting traditional roles as singers and dancers, through the construction of bodily appearance that emphasizes the value of feminine beauty: "We'll loan you lip gloss, do your hair, paint our nails . . ." (ibid. 22). The case study of the Sparkling Divas might be taken to exemplify a high emphasis on achieving femininity through the musical performance of the body and its gestures, often playing with self-modification through the use of pink clothing, make-up, hairstyling and painted nails. Yet, the Sparkling Divas also negotiate the diva, pop-star persona in several ways, for example with lyrics such as, "We gloss our lips, not shake our hips" (ibid. 22), which suggest a sense of sexual agency, and "all the guys and they say hi. But we only like certain guys" (ibid. 22). Still, there is a strong sense of the girls reflecting the agentic sexual performances of their favourite artists in their own song and video performance.

The deployment of the musical persona of the diva and the negotiations untaken by these young girls as they embody this character point to the conflicted nature of persona, and the conflicting demands placed on girls and women. Enactments of

the singing diva manoeuvre between a strong, famed, gifted and sexually confident woman on the one hand, and a capricious, indulgent, unreasonable harpy on the other. Central is the construction of a specific bodily presentation of hyper-feminine sexuality. Certainly, the wide dissemination of provocative and sexualized musical personae for women has many consequences, with the often unobtainable images of feminine perfection of face, hair and body linked to a rise in eating disorders and low self-esteem among girls (Dunbar 2015). Yet, at the same time, more positively, performances of female artists can be seen as agentic in that they are clearly a negotiation of the sexual objectification of women which has predominated broader culture and commercial music specifically for decades (Dunbar 2015), even if this is complicated by its promotion of the ideal of competitive and individualistic "can-do girls" (McRobbie 2007, 2011; Faludi 2006). Springer (2008), notes that the character of the diva is primarily a negative stereotype used for women of colour, with "divadom" used to describe unreasonable and unpredictable behaviour which amounts to "another form of categorization that classes women according to how they adhere to race, class and sexuality norms" (p. 78). The centrality of this term as a reference point for these young girls of colour may reinforce musical practices as an important site for redoing and positive reclaiming of the intersectional body politics of race, ethnicity, gender and heterosexuality.

In conclusion

The case of the Sparkling Divas demonstrates the importance of gender performances in musical practices, differentiated along age, race and class lines. Examples from music therapy literature illuminate how performative interactions in music therapy may reveal the tendencies towards the organizing function of normative gender narratives. In spite of the clear intentions toward participation and equality expressed in several texts (Baines 2013; Stige and Aaroe 2012; Rolvsjord 2010), the gender politics in the practices, discourses and performances of music therapy have a tendency to conform and confirm gender norms. Furthermore, it seems that stage performances in music therapy are also rather conformist to gender norms and stereotypes in music culture.

In the post-war era musical bodies have proliferated via mass media and as such have been a significant and public site for the doing and undoing of many aspects of identity including gender, sexuality and race. Music as a performative, bodily practice has been an important location linked to the normalization of the female body through the reproduction of femininity (Bordo 1997). From the 1980s the music industry has increasingly merged commercial marketing of music and related products as central to production. Women's bodies and their sexuality have been central to this marketing and indeed the fantasy of the singing diva, a famed, beautiful, talented, and often sexualized female vocalist, is marketed primarily to girls and women. With the example of the Sparkling Divas we have provided a case to demonstrate how the performance of femininity personified in musical practice, and marketed by the music industry, permeates the practices of music therapy. As

the practices of music therapy become more entangled with performances of identity, issues of social justice and the wider implications of social participation and marginalization, music therapy scholars and practitioners must begin to engage with the intersectional musicking body as a dynamic site where socio-cultural differences may emerge, become mapped, performed and transformed.

References

Aigen, K. 2002. *Playing in the Band. A Qualitative Study of Popular Music Styles as Clinical Improvisation*. New York: Nordoff-Robbins Center for Music Therapy.
Aigen, K. 2013. "Social Interaction in Jazz: Implications for Music Therapy." *Nordic Journal of Music Therapy*, 22(3), 180–209, doi:10.1080/08098131.2012.736878
Alberto, R. G. 2018. "Gender Distorting Genre Distorting Gender: Exploring Women's Rock Musicking Practices in Contemporary Portugal." Unpublished Doctor of Philosophy in Sociology thesis. University of Exeter.
Ansdell, G. 2005. "Being Who You Aren't; Doing What You Can't: Community Music Therapy & the Paradoxes of Performance." *Voices: A World Forum for Music Therapy*, 5(3), doi:10.15845/voices.v5i3.229
Auslander, P. 2004. "Performance Analysis and Popular Music: A Manifesto." *Contemporary Theatre Review* 14(1): 1–13.
Auslander, P. 2006a. "Musical Personae." *TDR/The Drama Review*, 50(1), 100–119.
Auslander, P. 2006b. *Performing Glam Rock: Gender and Theatricality in Popular Music*. Ann Arbor: University of Michigan Press.
Baines, S. 2013. "Music Therapy as an Anti-Oppressive Practice." *The Arts in Psychotherapy*, 40, 1–5, doi:10.1016/j.aip.2012.09.003
Baines, S. and J. Edwards. 2015. "Considering the Ways in Which Anti-Oppressive Practice Principles Can Inform Health Research." *The Arts in Psychotherapy*, 42, 28–34, doi.org/10.1016/j.aip.2015.01.001
Blackman, L. 2008. *The Body: The Key Concepts*. Oxford: Berg.
Bordo, S. 1997. "The Body and the Reproduction of Femininity." In *Writing on the Body: Female Embodiment and Feminist Theory*, edited by K. Conboy, N. Medina and S. Stanbury, 90–110. New York: Columbia University Press.
Bourdieu, P. 2002. *Outline of a Theory of Practice*. Cambridge: Cambridge University Press.
Bradt, J., Dileo, C., Magill, L., and Teague, A. 2016. "Music Interventions for Improving Psychological and Physical Outcomes in Cancer Patients." *Cochrane Database of Systematic Reviews*, 8, Art No: CD006911, doi:10.1002/14651858.CD006911.pub3
Bruscia, K. 2014. *Defining Music Therapy*. 3rd ed. Gilsum, NH: Barcelona Publishers.
Burns, L. and M. Lafrance. 2002. *Disruptive Divas. Feminism, Identity & Popular Music*. New York: Routledge.
Butler, J. 1990. *Gender Trouble: Feminism and the Subversion of Identity*. New York: Routledge.
Butler, J. 2004. *Undoing Gender*. New York: Routledge.
Butler, J. 2011. *Bodies That Matter: On the Discursive Limits of "Sex"*. Abingdon and Oxon: Routledge.
Coates, N. 1997. "(R)evolution Now? Rock and the Political Potential of Gender." In *Sexing the Groove: Popular Music and Gender*, edited by S. Whitely, 50–64. London: Routledge.
Cohen, S. 1991. *Rock Culture in Liverpool: Popular Music in the Making*. Oxford: Oxford University Press.
Collins, P. H. 2002. *Black Feminist Thought: Knowledge, Consciousness, and the Politics of Empowerment*. New York: Routledge.

Collins, P. H. and S. Bilge. 2016. *Intersectionality*. Cambridge: Polity Press.
Comte, R. 2016. "Neo-Colonialism In Music Therapy: A Critical Interpretive Synthesis of the Literature Concerning Music Therapy Practice With Refugees". *Voices: A World Forum for Music Therapy* 16(3). https://doi.org/10.15845/voices.v16i3.865.
Curtis, S. L. 2006. "Feminist Music Therapy: Transforming Theory, Transforming Lives." In *Feminist Perspectives in Music Therapy*, edited by Susan Hadley, 227–244. Gilsum, NH: Barcelona Publishers.
Curtis, S. L. 2015. "Feminist Music Therapists in North America: Their Lives and Their Practices." *Voices: A World Forum for Music Therapy*, 15(2), doi:10.15845/voices.v15i2.812
DeNora, T. 2000. *Music in Everyday Life*. Cambridge: Cambridge University Press.
Deutsch, F. M. 2007. "Undoing Gender." *Gender & Society*, 21(1), 106–127.
Doubleday, V. 2008. "'Sounds of Power': An Overview of Musical Instruments and Gender." *Ethnomusicology Forum*, 17(1), 3–39, doi:10.1080/17411910801972909
Dunbar, J. C. 2015. *Women, Music, Culture: An Introduction*. London: Routledge.
Edwards, J. 2006. "Considerations of Potential Informants from Feminist Theory for Music Therapy Practice." In *Feminist Perspectives in Music Therapy*, edited by S. Hadley, 367–388. Gilsum, NH: Barcelona Publishers.
Elliott, D. J. 2009. *Praxial Music Education Reflections and Dialogues*. Oxford: Oxford University Press.
Faludi, S. 2006. *Backlash: The Undeclared War Against American Women*, 15th Anniversary edition. New York: Three Rivers Press.
Foucault, M. and A. Sheridan. 1997. *Discipline and Punish: The Birth of the Prison*. London: Penguin Modern Classics.
Frith, S. 1998. *Performing Rites: On the Value of Popular Music*. Cambridge, MA: Harvard University Press.
Gallagher, L. M., R. Lagman and L. Rybicki. 2018. "Outcomes of Music Therapy Interventions on Symptom Management in Palliative Medicine Patients." *American Journal of Hospice & Palliative Medicine*, 35(2), 250–257, doi:10.1177/1049909117696723
Goodley, D. 2014. *Dis/ability Studies. Theorizing Disablism and Ableism*. London: Routledge.
Green, L. 1997. *Music, Gender, Education*. Cambridge: Cambridge University Press.
Grosz, E. A. 2011. *Volatile Bodies: Toward a Corporeal Feminism*. Bloomington: Indiana University Press.
Hadley, S., ed. 2006. *Feminist Perspectives in Music Therapy*. Gilsum, NH: Barcelona Publishers.
Hadley, S. 2013a. "Dominant Narratives: Complicity and the Need for Vigilance in the Creative Arts Therapies." *The Arts in Psychotherapy*, 40(3), 373–381, doi:10.1016/j.aip.2013.05.007
Hadley, S. 2013b. *Experiencing Race as a Music Therapist: Personal Narratives*. Gilsum, NH: Barcelona Publishers.
Hadley, S. and N. Hahna. 2016. "Feminist Perspectives in Music Therapy." In *Oxford Handbook of Music Therapy*, edited by J. Edwards, 428–447. Oxford: Oxford University Press.
Hadley, S. and G. Yancy. 2012. *Therapeutic Uses of Rap and Hip-Hop*. New York: Routledge.
Hall, K. Q., ed. 2011. *Feminist Disability Studies*. Bloomington: Indiana University Press.
Halstead, J. 1997. *The Woman Composer: Creativity and the Gendered Politics of Musical Composition*. Aldershot: Ashgate Publishing.
Halstead, J. and R. Rolvsjord. 2017. "The Gendering of Musical Instruments: What Is It? Why Does It Matter to Music Therapy?" *Nordic Journal of Music Therapy*, 26(1), 3–24, doi :10.1080/08098131.2015.1088057
Hancock, A. M. 2016. *Intersectionality: An Intellectual History*. Oxford: Oxford University Press.
Hawkins, S. 2009. *The British Pop Dandy: Masculinity, Popular Music and Culture*. Aldershot: Ashgate Publishing.

Hawkins, S., ed. 2017. *The Routledge Research Companion to Popular Music and Gender*. Oxon: Taylor & Francis.

Hemmings, C. 2011. *Why Stories Matter: The Political Grammar of Feminist Theory*. Durham, NC: Duke University Press.

Hochschild, A. 1982. "Emotional Labor in the Friendly Skies." *Psychology Today*, 16(6), 13–15.

Hofman, A. 2015. "Music (as) Labour: Professional Musicianship, Affective Labour and Gender in Socialist Yugoslavia." *Ethnomusicology Forum*, 24(1), 28–50. Routledge.

Hooks, B. 2010. *Feminist Theory: From Margin to Center*. Cambridge, MA: South End Press.

Jarman-Ivens, F., ed. 2013. *Oh Boy!: Masculinities and Popular Music*. New York and London: Routledge.

Kim, S-A. 2013. "Re-Discovering Voice: Korean Immigrant Women in Group Music Therapy." *The Arts in Psychotherapy*, 40, 428–435. doi:10.1016/j.aip.2013.05.005

Krüger, V. and B. Stige. 2014. "Between Rights and Realities – Music as a Structuring Resource in Child Welfare Everyday Life: A Qualitative Study." *Nordic Journal of Music Therapy*, 24(2), 99–122. doi:10.1080/08098131.2014.890242

LaCom, C. and R. Reed. 2014. "Destabilizing Bodies, Destabilizing Disciplines: Practicing Liminality in Music Therapy." *Voices: A World Forum for Music Therapy*, 14(3).

Lejonclou, A. and G. Trondalen. 2009. "'I've Started to Move into My Own Body': Music Therapy with Women Suffering from Eating Disorders." *Nordic Journal of Music Therapy*, 18(1), 79–92, doi:10.1080/08098130802610924

Ledger, D. 1990. *The Absent Body*. Chicago, IL: University of Chicago Press.

Leppert, R. 1993. *The Sight of Sound: Music, Representation, and the History of the Body*. Berkeley and Los Angeles: University of California Press.

Lykke, N. 2010. *Feminist Studies. A Guide to Intersectional Theory, Methodology and Writing*. New York: Routledge.

Mann, S. A. 2012. *Doing Feminist Theory. From Modernity to Postmodernity*. New York: Oxford University Press.

McCarthy, K. 2006. "Not Pretty Girls? Sexuality, Spirituality, and Gender Con-structions in Women's Rock Music." *The Journal of Popular Culture*, 39(1), 69–94.

McClary, S. 1991. *Feminine Endings. Music, Gender, and Sexuality*. Minneapolis, MN: University of Minnesota Press.

McFerran, K. 2011. "Moving out of Your Comfort Zone: Group Music Therapy with Adolescents." In *Developments in Music Therapy Practice: Case Study Perspectives*, edited by T. Meadows, 248–267. Gilsum, NH: Barcelona Publishers.

McRobbie, A. 2007. "Top Girls? Young Women and the Post-feminist Sexual Contract 1." *Cultural Studies*, 21(4–5), 718–737.

McRobbie, A. 2011. "Beyond Post-Feminism." *Public Policy Research*, 18(3), 179–184.

Metell, M. 2014. "Dis/Abling Musicking: Reflections on a Disability Studies Perspective in Music Therapy." *Voices: A World Forum for Music Therapy*, 14(3), doi:10.15845/voices.v14i3.786

Metell, M. and B. Stige. 2015. "Blind Spots in Music Therapy. Toward a Critical Notion of Participation in Context of Children with Visual Impairment." *Nordic Journal of Music Therapy*. doi:10.1080/08098131.2015.1081265

Moi, T. 2008. *What Is a Woman? And Other Essays*. Oxford: Oxford University Press.

Nordoff, P. and C. Robbins. 1983. *Music Therapy in Special Education*. 2nd ed. Saint Louis, MO: Magnamusic-Baton.

O'Grady, L., R. Rolvsjord and K. McFerran. 2015. "Women Performing Music in Prison: An Exploration of the Resources that Come into Play." *Nordic Journal of Music Therapy*, 24(2), 123–142. doi:10.1080/08098131.2013.877518

Pavlicevic, M. and G. Ansdell. 2009. "Between Communicative Musicality and Collaborative Musicking: A Perspective from Community Music Therapy." In *Communicative Musicality*, edited by S. Malloch and C. Trevarthen, 357–376. Oxford: Oxford University Press.

Pavlicevic, M. and G. Ansdell. 2004. *Community Music Therapy*. London: Jessica Kingsley Publishers.

Pendle, K., ed. 2001. *Women & Music: A History*. Bloomington: Indiana University Press.

Reynolds, S. and J. Press. 1996. *The Sex Revolts: Gender, Rebellion, and Rock'n'Roll*. Cambridge, MA: Harvard University Press.

Rickson, D. J. 2014. "The Relevance of Disability Perspectives in Music Therapy Practice with Children and Young People Who Have Intellectual Disability." *Voices: A World Forum for Music Therapy*, 14(3).

Risman, B. J. 2009. "From Doing to Undoing: Gender as We Know It." *Gender & Society*, 23(1), 81–84.

Rolvsjord, R. 2010. *Resource-Oriented Music Therapy in Mental Health Care*. Gilsum, NH: Barcelona Publishers.

Rolvsjord, R. 2014. "The Competent Client and the Complexity of Dis-ability." *Voices: A World Forum for Music Therapy*, 14(3), doi:10.15845/voices.v14i3.787

Rolvsjord, R. and S. Hadley. 2016. "Critical Inquiries: Feminist Perspectives and Transformative Research." In *Music Therapy Research*, edited by B. Wheeler, 477–490. 3rd ed. Gilsum, NH: Barcelona Publishers.

Rolvsjord, R. and J. Halstead. 2013. "A Woman's Voice: The Politics of Gender Identity in Music Therapy and Everyday Life." *The Arts in Psychotherapy*, 40, 420–427, doi:10.1016/j.aip.2013.05.015

Ruud, E. 1996. *Musikk og verdier [Music and Values]*. Oslo: Universitetsforlaget.

Ruud, E. 1998. *Music Therapy, Improvisation, Communication and Culture*. Gilsum, NH: Barcelona Publishers.

Schwantes, M., T. Wigram, C. McKinney, A. Lipscomb and C. Richards. 2011. "The Mexican 'Corrido' and Its Use in a Music Therapy Bereavement Group." *Australian Journal of Music Therapy*, 22, 2–23. url: https://search.informit.com.au/documentSummary;dn=686545754403523;res=IELHE

Scrine, E. 2016. "Enhancing Social Connectedness or Stabilising Oppression: Is Participation in Music Free from Gendered Subjectivity?" *Voices: A World Forum for Music Therapy*, 16(2), doi:10.15845/voices.v16i2.881

Shakespeare, T. 2014. *Disability Rights and Wrongs Revisited*. 2nd ed. London and New York: Routledge.

Small, C. 1998. *Musicking: The Meanings of Performing and Listening*. Middletown, Connecticut: Wesleyan University Press.

Smith, L. 2012. "Sparkling Divas! Therapeutic Music Video Groups with At-risk Youth." *Music Therapy Perspectives*, 30, 17–24.

Solli, H. P. 2009. "Shut Up and Play!" *Nordic Journal of Music Therapy*, 17(1), 67–77, doi:10.1080/08098130809478197

Solli, H. P. 2014. "Battling Illness with Wellness: A Qualitative Case Study of a Young Rapper's Experiences with Music Therapy." *Nordic Journal of Music Therapy*, 24(3), 204–231. doi:10.1080/08098131.2014.907334

Solli, H. P. and R. Rolvsjord. 2015. "'The Opposite of Treatment': A Qualitative Study of How Patients Diagnosed with Psychosis Experience Music Therapy." *Nordic Journal of Music Therapy*, 24(1), 67–92, doi:10.1080/08098131.2014.890639

Soshensky, R. 2011. "Everybody Is a Star: Recording, Performing, and Community Music Therapy." *Music Therapy Perspectives*, 29(1), 23–30, doi:10.1093/mtp/29.1.23

Springer, K. 2008. "Divas, Evil Black Bitches, and Bitter Black Women: African-American Women in Postfeminist and Post-Civil Rights Popular Culture." In *Feminist Television Criticism: A Reader*, edited by C. Brunsdan and L. Spigel, 72–92. Berkshire: Open University Press.

Stige, B. and L. E. Aaroe. 2012. *Invitation to Community Music Therapy*. New York: Routledge.

Stige, B., G. Ansdell, C. Elefant and M. Pavlicevic. 2010. *Where Music Helps. Community Music Therapy in Action and Reflection*. London: Ashgate Publishing.

Tamplin, J. 2011. "Singing for Respiratory Muscle Training: Using Therapeutic Singing and Vocal Interventions to Improve Respiratory Function and Voice Projection for People with a Spinal Cord Injury." In *Voicework in Music Therapy. Research and Practice*, edited by F. Baker and S. Uhlig, 147–170. London: Jessica Kingsley Publishers.

Tasker, Y. and D. Negra, ed. 2007. *Interrogating Postfeminism: Gender and the Politics of Popular Culture*. Durham and London: Duke University Press.

Thaut, M. H. 2005. *Rhythm, Music, and the Brain. Scientific Foundations and Clinical Applications*. New York: Routledge.

Trevarthen, C. and S. N. Malloch. 2000. "The Dance of Wellbeing: Defining the Musical Therapeutic Effect." *Nordic Journal of Music Therapy*, 9(2), 3–17, doi:10.1080/08098130009477996

Tuastad, L. and B. Stige. 2014. "The Revenge of Me and THE BAND'its: A Narrative Inquiry of Identity Constructions in a Rock Band of Ex-inmates." *Nordic Journal of Music Therapy*, 24(3), 252–275, doi:10.1080/08098131.2014.967713

Tuastad, L. and B. Stige. 2018. "Music as a Way Out: How Musicking Helped a Collaborative Rock Band of Ex-inmates." *British Journal of Music Therapy*, 32(1), 27–37, doi:10.1177/1359457

Turry, A. 2005. "Music Psychotherapy and Community Music Therapy: Questions and Considerations." *Voices: A World Forum for Music Therapy*, 5(1), doi:10.15845/voices.v5i1.208

Veltre, V. J. and S. Hadley. 2012. "It's Bigger than Hip-Hop. A Hip-Hop Feminist Approach to Music Therapy with Adolescent Females." In *Therapeutic Uses of Rap and Hip-Hop*, edited by S. Hadley and G. Yancy, 79–98. New York: Routledge.

Viega, M. 2016. "Exploring the Discourse in Hip Hop and Implications for Music Therapy Practice." *Music Therapy Perspectives*, 34(2), 138–146, https://doi.org/10.1093/mtp/miv035

West, C. and D. H. Zimmerman. 1987. "Doing Gender." *Gender and Society*, 1(2), 125–151.

West, C. and D. H. Zimmerman. 2009. "Accounting for Doing Gender." *Gender & Society*, 23(1), 112–122.

Whitehead-Pleaux, A., A. M. Donnenwerth, B. Robinson, S. Hardy, L. G. Oswanski, M. Forinash, M. Hearns, N. Anderson and X. Tan. 2013. "Music Therapists' Attitudes and Actions Regarding the LGBTQ Community: A Preliminary Report." *The Arts in Psychotherapy*, 40(4), 409–414.

Whitehead-Pleaux, A., A. M. Donnenwerth, B. Robinson, S. Hardy, L. G. Oswanski, M. Forinash and E. York. 2012. "Lesbian, Gay Bisexual, Transgender, and Questioning: Best Practices in Music Therapy." *Music Therapy Perspectives*, 30(2), 158–166.

Whitehead-Pleaux, A., and X. Tan (Eds). 2017. *Cultural Intersections in Music Therapy: Music, Health, and the Person*. Gilsum NH: Barcelona Publishers.

Young, I. M. 2009. *On Female Body Experience: "Throwing Like a Girl" and Other Essays*. New York: Oxford University Press.

6

MASK AND GENDER

From concealment to revelation, from pain to relief. Arts therapies with masks. A journey through art therapy

Irina Katz-Mazilu

Prelude

Mask making and playing in arts therapies is an artistic and psychodynamic creative modality addressing individual and social identity issues. I would like to show how arts therapies with masks allow exploring gender issues in both a respectful and deep way. I also wish to enlarge the viewpoint so that the process of *masking/unmasking* or *veiling/unveiling* could include different medias such as painting, drawing, puppets, clown and mime, the understanding of which will be connected with the themes of *hiding/revealing* dynamics. As illustrated by Jean-Luc Nancy in his 2008 work, 'Le masque doit être démasqué. Il dissimule moins qu'il ne révèle, il est moins posé par-dessus qu'il ne surgit d'en dessous'[1] (Nancy, 2008), the mask reveals precisely by hiding.

Several types of masks exist for different goals. The protective mask is a social regulator. Meant to terrify the demons in archaic human communities or scare and thus stop and wave away illness like plague in the Middle Ages, it still is present in daily rituals. Hiding masks are used to conceal and protect identity while being transgressive, as for instance in the Venetian tradition. Ridiculous and caricature masks play a social and moral role in many traditional and contemporary shows and carnivals.

In therapy we have to deal with mask in simulation, lying, concealing secrets and displaying false selves. The neutral white mask is often used as a projective therapeutic screen. In other settings, making a mask is a prelude to playing.

Before studying individual or group arts therapies with masks and equivalents, it would be also important to consider the arts therapy workshop as a living existential and philosophical whole, as an integrated and complex system. Its specific *space and time* is part of the movement of life as raw material for human psyche. Thus men, women and children in the arts therapy setting are referred to as participants and not as patients, clients or users.

Art, mask and therapy

Masks are used in various traditional ways by individuals for social integration and regulation. Most rituals are codified and controlled by specially chosen and trained representatives of a group. The mask carrier has to be entirely covered and hidden by facial and body disguise in order to be protected from ancestors' or demons' spirits whom he or she has to get in touch with. In a large majority of traditional use of masks, only men are allowed to practice. Sometimes specific masks should not be seen by women as this could affect fertility. These masks are symbolic, sacred, ritualized and healing.

The main goal of ancestral rituals is to obtain protection against dangers and sufferings due to human fragility. An example of the therapeutic use of masks is the *Sanni Yakuma* ritual in Sri Lanka, meant to exorcise illness and demons. Each mask is connected to a specific illness or bad temper which are figured by corresponding codified forms and colors, and is used only once within a dance ceremony (Goonatilekka, 2006). Another ritual in Sri Lanka is the *Kolam*, a sacred theater and mask performance connected to birth and fertility (2006).

A second important goal is reinforcing community links and solidarity, so that the group as a whole would grow and get stronger. The individual is meant to accept and forward cultural inheritance. Guy Cogeval, President of the Musée d'Orsay in Paris says, 'Because it reveals by hiding and hides by being exposed, the mask touches to the origins of the human life and community' (Cogeval, 2008, 9). Maybe somehow as in childbearing the mother's body shows the pregnancy but at the same time is hiding and thus protecting the child before giving birth.

In contemporary society being an artist might be the only social role allowing and valuing the subversive and transgressive expression of human living experience. 'Being an artist is the only place where I can be alive' says Phia (Philippe) Ménard, a transgendered dancer, juggler and performer (Saigre, 2013, 119). Sometimes acting-out is performed in specific artistic context. The artist's creative function is to unveil and support deep contradictions and paradoxical feelings and thinking of individuals and groups.

Well-known artists like Orlan or Conchita Wurst use creative playing to point out complex dynamics between human appearance and gender issues. Actual or faked and symbolized, their transgendered appearance is socially provocative but nevertheless accepted because it concerns art and artists. These examples are effective to support arts therapy process for individuals concerned with gender and sexual identity/choice.

In contrast, many artists use their creative skills to hide or mask their inner world, sometimes unconsciously.

> In search of the self, the person may have produced something worthwhile in the arts but an artist can be very successful and yet fail to find the self he is looking for. The self cannot be found derived from the products of the body or mind, as valuable as can be these constructions from the point

of view of beauty, deployed skill or effect produced. If the artist is (...) in search of the self (...) this means (...) already a flaw in his creative life. The finished art work will never be enough to address the underlying lack of the sense of self.

(Winnicott, 1971, 77, tr. IKM)

So in Winnicott's view, the art process itself would not always be helpful with pathological issues. The arts therapist's presence is also central for Jean-Pierre Klein, defining arts therapies as *accompanied symbolism (symbolisation accompagnée)* (Klein, 2012).

This is why personal art and psychotherapy, as well as consistent art practice are basic to the art therapist. Continuous training is to be included all the length of our professional activity. Here are some illustrations of how new work and knowledge helped me go deeper and deeper through twenty years of arts therapies practice with very different individuals and groups. I experienced for myself a white mask workshop (Figure 6.1); I run a training group as a teacher – and also as a member/participant myself – creating paper masks, playing with them and then writing a collective storyboard; I trained in a clown therapy group (Figure 6.2) as well as in many other settings after my arts therapies degree for over twenty years.

Running a puppet art therapy workshop with adult disabled persons, being a member and the leader of the group, creating a mask or a puppet myself and then playing it was effective for exploring identity evolution, role play, dynamic relationships and posture changes. Thus we are able to connect opposite but complementary and equally important processes such as mental flexibility and identity self-assertion (Figure 6.3).

From *art with masks* to *mask in gender aware therapy*

Contemporary studies have many times examined how art and gender are interacting in social and aesthetic fields. Art often shows transgressive symbols for sex and gender issues in visual (art, photo, performance, video and movies) as well as scenic (drama, dance, happenings, music) arts. How can arts therapies with masks help in mental health?

There are different views about the role of masks in art therapy. A detailed presentation on arts therapies with masks is given by Henri Saigre, the author of the theoretical underpinnings and clinical methodology of the *Masco-thérapie analytique* (Analytic Mask Therapy) in France (1986). Later his concept evolved to *L'Opéra des masques* (The Masks' Opera, Saigre, 2013). This formula is in reference to the Latin meaning of the word *Opera*, which is *work*. So the masks are at work. They are created by the participants in a workshop or in therapy in a non-directive or semi-directive way. Then they are played in an *empty setting*.

> By empty setting we mean a scenic setting without script or canvas proposed or developed to serve as a frame for the action. In this the Opera of Masks

moves away from the traditional theater, including improvisation. The project is to start from nothing and to let the mask act us (...). In doing so, the person experiences a phase of possession. To make this accessible ... a breakdown is necessary.

(2013, 185)

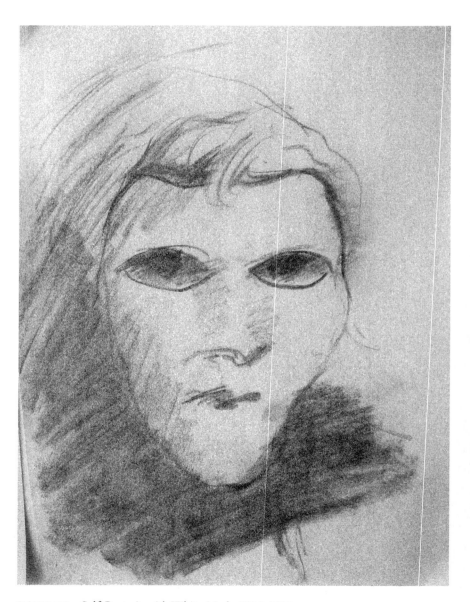

FIGURE 6.1 Self-Portrait with White Mask, IKM, 2011.

Mask and gender 73

FIGURE 6.2 The 'Smallest Mask' in the World, IKM, 2014.

This concept of a *necessary breakdown* is connected with Didier Anzieu's theory of the creative process and its inherent risks of psychotic episodes during art making and its successive stages (Anzieu, 1981, 1996, 133–158). Confused, manic and depressive moments *have* to occur in the artist's creative process alternatively to controlled and rational stages in art work, in order to un-compose the already known and re-compose creatively new forms and esthetics. Many artists have to struggle to go through this process without anxiety and fear – and be able to make sure that these psychotic moments are voluntary and will stay under control. . . . Maybe in art therapy – as in art making – the most subtle is to initiate an authentic creative process without risk of true breakdown for the author? This is why the containing presence of the art therapist is so important.

In contrast, applying Jungian theory, we do not need to be anxious about potential destructiveness because in the creative process as the *individual self* would come in contact with the protecting *Self*, which is the collective unconscious formed by the archetypes. This configuration leads the work with *persona, ego, self* and *shadow* to be safe and therapeutic. We can add that if *persona* is mostly an appearance, sometimes a *mask* and in some cases a *false self*, this means that in therapy making a mask and playing with it might help to go deeper to the self.

Jung was a psychiatrist and a psychoanalyst but also an artist himself and thus a forerunner of arts therapies. His concept of *persona* points to the 'always there' individual and especially to the social appearance of humans, which is in specific relationship to the *ego*, the *shadow* and the *self*. *Persona* and *shadow* as well as *animus* and *anima* are both connected and separate, necessary while conflicting, always part

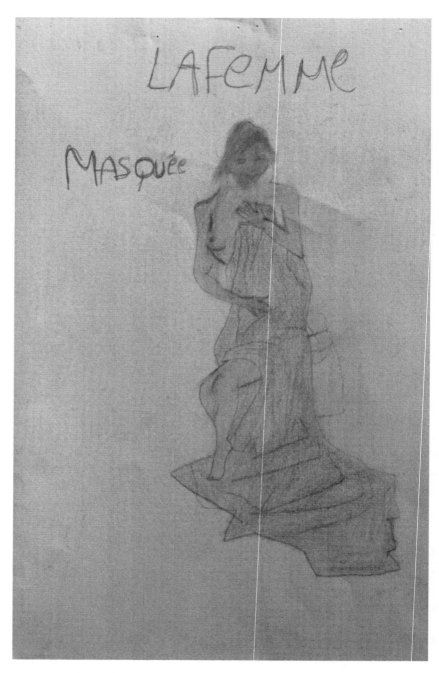

FIGURE 6.3 The Masked Woman, 2005.

of a whole. Jung was a pioneer in art therapy by exploring with himself creative media in connection with his own mental life before starting to apply his discoveries in the treatment of some of his psychiatric patients. He believed that the arts could have a balancing tendency, allowing unacknowledged psychic material to be expressed and assimilated (Hogan, 2016, 40). Thus art making was seen to be intrinsically healing.

Sometimes creating masks will be satisfying in itself, there will be no need for playing and enacting with the mask.

> In the [art therapy] workshop it is not proposed to play with the masks but just to make them, which means to imagine and produce a wearable appearance. This is sufficient for the expressive attempts of participants... [not wishing to undermine the] dramatic value of the mask by [possible exposure to] derision, and to arouse the fear of annihilation too violent to be contained.
> *(Païn and Jarreau, 1994, 232–233,* tr. IKM*)*

In gender studies, biological sexual categories are linked to socio-cultural constructions of masculinity, femininity and androgyny. Individual and collective arts practices provide powerful existential help by offering canvas and support for sharing with the other humans. 'If I live a good life, it will be a good life lived with others, since my dependence with respect to the other, and the essence of this dependence are necessary to live and live well' says Judith Butler (2014, 109). With respect to the idea of struggling for 'a good life in a bad life' (2014), often participants in arts therapies have to cope with chronic symptoms and disabilities, as well as with global and sometimes overwhelming social difficulties. Not always the 'good life' is within reach, so that care will focus on a 'better life' by increasing mental wellness.

These considerations are very often pertinent with respect to post-traumatic syndromes. Surviving trauma may force the individual to repression and denial, implementing a fake appearance based on a false self. In this case, it is like if the mask will stick to the psychic skin and grow consubstantial with it. We can compare this process to some cancerous adherence, which will progressively invade, attack and kill the sane cells and organs of the body. Concerning mental health, someone may seem alive while actually being 'mentally dead' – severely depressed, borderline, psychotic, addictive, suicidal....

The concept of *psychic skin* fostered by Anzieu (1996a, 189–205) is strongly pertinent for arts therapies. The *psychic skin* means the mental equivalent of the body skin, as for Anzieu the psyche and the mental functions are based on our biological reality. The skin provides both exchange with our environment and protection from external dangers, clear limits and containment to our body. It has to be flexible but firm, at the same time sensible and protective. Gently and gradually, the arts therapies process is not just to remove the adherent mask/skin. This might be intrusive, violent and maybe impossible to obtain in the short term, because it could leave

the flesh raw as when tearing the physical skin. Arts therapies have to help evolving by successive stages and transformations until the mask would become removable.

Making and playing a mask in arts therapies means to confront the narrow space behind it and leads to deep queries: is anyone there? Is it *me*? And if *I* am there, who am I? Hopefully, one day this space would grow larger, a fresh breeze will enter and comfort the psyche. The tight mask at risk of suffocating the person behind will become a removable one, the wearer is soothed, the joyful and creative approach helps to surpass suffering. The *detour* by preverbal communication and symbolic expression by art helps the individual to discover, recover and reinforce the self.

In post-traumatic syndrome, arts therapies both prevent violent renewing of the trauma by focusing on the event through the multiplication of the interviews and help to avoid concealing, says Jean-Pierre Klein, psychiatrist and dramatherapist. 'The respectful work (...) as with a badly burnt, will carefully foster the expression (without dictating the content) with various media, within the playful and artistic distance of fiction or form, which is surprisingly easier than expected' (2006, 16, *tr. IKM*). The suffering *badly burnt* victim's destroyed skin and self have to be hidden because they are too horrific and unbearable. The trauma experience will engrave scars in our memory as on our skin and in our flesh. The defensive temptation is strong to deny, trying to forget the unpleasant and unbearable ... but deeply hidden non-solved problems will inevitably show up.

Often in arts therapies through free exchange, stimulating the imagination by discussing and consulting books and images, the theme of the mask will spontaneously arise. Then I would propose drawing, painting or creating one. Materials, media, formal and technical specific arts equipment offer opportunities to contact the body and appeal to its sensuality, to our vital energy, to the management of the control or lack of control dialectics. The imaginative, reflexive and symbolic capacities will gradually develop and grow strong enough to allow and support self-esteem and individuation. One day, the mask would be dropped off and self-assertion will become effective. The carefully accompanied person would find or recover psychic autonomy.

A few clinical examples

In my practice, I used masks with people experiencing post-traumatic syndromes related to gender by specific and respectful creative proposals. Relevant therapy with masks may occur with individuals or groups concerned by sexual abuse, gender issues, exile and immigration. For prisoners and/or prostitutes – which often might be the same, if involved in drugs trafficking or other offenses – shame feelings are overwhelming and block all possibility for psychic work. In this case, masking inner feelings for a while, producing apparently neutral but clearly significant expressive objects, avoiding verbal exchange and interpretation and using powerful non-verbal communication modalities is a good way to initiate further deeper mental work and evolution so that relief will occur.

The conflicting relationship between masculinity and femininity are at their peak in the context of sexual use of human beings. Man, woman or child, the

prostitute must submit to what is imposed, which means being designed as a sexual object. The person is at risk of becoming a victim, the trauma may overcome – and become – the entire identity because of the need for self-protection and defense against annihilation. Being understood then means being destroyed (in the self-defended state), which comes from the resistance to therapy, says Georges Devereux. 'The self-misunderstanding follows automatically and inevitably this waiver of identity; by renouncing, the patient stops understanding the reality, [which] ceases to be understandable. . . . How could he, since he must constantly reassure himself on the fact that he is protected from destruction precisely because he does not exist as an individual?' (2009, 110–111). Obviously, arts therapies are greatly relevant to help surpassing resistance.

I was working as an art therapist for more than ten years in a social shelter with prostitutes trying to escape their situation and struggling to change their lives. Some had to fight to clarify their gender identities, escaping traditional social and cultural deciding factors. This was particularly true for migrants, but also for natives with a sexually abusive, violent and traumatic past. In many countries, male homosexuality is still subject to punishment via prison sentences or death, torture, rapes and murders. Women and children often are sexually abused and exploited in domestic or social life, as well as war victims. Many forms of the so-called deviant sexuality: homo- and bisexuality, transsexuality, transvestism, transgender, which are socially tolerated – if not yet truly accepted – in most democratic countries generate cohorts of victims from all over the world. Often migrants, mostly illegal, can only find survival resources in prostitution or delinquency, or both. Sometimes they previously have had the same destinies in their native countries. Medical and mental care, welcome and social integration is a long and demanding way for migrants as well as for natives and 'welcomers'. As therapists we might suffer vicarious trauma – patients' trauma might induce strong echoes and hard memories in our own psyche.

In my practice with migrants and prostitutes, arts therapies with masks were effective in addressing gender identity. Women often used arts therapies to express violent negative feelings – fear, anger and frustration, while men would take the opportunity to update their feminine side. All were living with an overwhelming feeling of shame; many used to hide their past from relatives and friends or had relationships exclusively with those with similar profiles. As expression of repressed feelings in art was allowed, the forbidden identity was gradually liberated and enhanced in art therapy.

A young man first chose a female model in a book and carefully represented the body and the drapery. Then he drew a mask as a personal contribution to the image – and an original interpretation, as I signified to him. The mask's color was slightly different from the rest of the skin and it was superimposed to the face but slightly put aside, so that a removal was suggested as possible. Big hesitation occurred during this work and the young man needed much support. When finished, he added the inscription 'The Masked Woman' with clear relief and satisfaction (Figure 6.3). A difficult decision was then to expose the drawing to the group and even let it stay on the wall after the workshop, so that all the members of the

professional team and fellows would see it – instead of hiding it in a folder. I never insisted on any choice to do so, it had to be his own. This stage was very important, as for Muslims homosexuality is shameful and criminalized in many countries. This man has been persecuted and tortured in Algeria before escaping to France where he had to live clandestinely for ten years and consent to prostitution in order to survive. Meeting social workers and being admitted to the social service was successful in obtaining a legal migrant position. Psycho- and arts therapies helped to diminish anxiety and enhance self-esteem and self-assertion for this man. He was later able to find a job and recover autonomy in his social life.

Another young homosexual African man, living in France in similar conditions, used mask creation to express gender issues. He alternatively produced male and female masks. Later he created both traditional and fantasy masks, thus exploring different aspects and facets of his personality. He would not play with masks but the same process occurred in his paintings. At the start, not many verbal exchanges were possible as shame feelings related to his past were very strong. After some time, he was able to formulate anger and revolt against persecution by religious fanatics, also inciting submissive Muslim women in the group to rebellion and protest. After a two-year process with the social workers, the psychiatrist and the art therapy, this man was able to find a job and accommodation. Nevertheless, for several years he still came back seeking for support as he frequently relapsed to depression and addictive behavior with money games.

Another setting with mask creating and playing was in a puppet workshop with adult disabled. We performed in a 'no-curtains' open scene space where the actor/author is as visible as his/her 'creature'. Every member of the group, including the arts therapist and the trainees, creates one (or several) characters, presents and plays it to the group, naming, identifying and describing it by its name, age, behavior and habits, family and social context, life environment and relationships. Then the characters would come in touch by short improvisations. From one workshop to the following the presentation and the improvisation would vary and grow more complex. This stage is very important for work on identity, as it shows the degree of mental flexibility, individual mental and body abilities as well as the capacity of each participant to accept exchange, frustrating feelings and negotiation. Sexuality and gender issues arise even if not verbally thoroughly questioned. Sometimes a character would show a clearly female shape straightly defined (Figure. 6.5), at other times hesitation about the character's personality and/or gender would last for several sessions (Figure. 6.6). In other cases, cognitive impairment and psychotic or autistic trends might produce male or female non-specific traits and forms, then naming and playing the character would offer time to diminish confusion and find more identity references. Later on a storyboard will be built including (or not) previous improvisations and sketches. Decorum and accessories will be created, as well as sound and music chosen by the participants from existing records or played in live with varied instruments. A scene presentation is shown to all the members of the families' community running this program, together with the other arts therapies groups (theater, dance, painting, music, clay), at the final meeting closing each school year period from the beginning of October to the end of June. This

Mask and gender **79**

FIGURE 6.4 The Princess Marie, 2013.

community provides several arts therapies workshops with different media and aims to overcome and reduce the social discrimination of disabled persons. Educators, social workers, medical and psychological caregivers as well as friends and relatives are invited to presentations and public exhibitions. Records and books are distributed with participants' and families' authorizations, accordingly to the law. This aims for mentally disabled – as for every other – being the author of one's own self-development even if support is needed and being part of an inclusive and comprehensive social life.

The following illustrations show how two young women created and played big and entirely hiding them masked and costumed characters. While "The Princess Marie" is a well-defined female figure, seeming colorful and joyful even if we can see rather ambivalent feelings being expressed on her face (Figure 6.4), the "Black Witch" is a clearly non-gendered character.

FIGURE 6.5 The Black Witch, 2013.

It is important to point that the initial "Black Witch" progressively evolved to a kind fairytale "Black Sorceress" gently protecting the others, but still without much more definition of male or female characteristics of the face (Figure 6.5).

There is a clear connection between these characters and the respective personalities, sexual/gender identity and orientation of the two authors. Some verbal sharing took place at the final point of the making off:

- I asked if the slightly surprising facial expression of "The Princess Mary" was satisfying to her author. After some hesitation the answer was "yes" which made

sure that the young woman was aware of the ambivalency of her emotions – joy and sadness melted;
- As for the "Black Witch/Black Sorceress", her author stated that "she" was nor a woman neither a man, or maybe both of them. Later on she produced a bi-sexual puppet (girl and boy at the extremities of the same body) asking me if I understood what it meant – my response was "yes" making clear that I was aware of her lesbian orientation.
- I also expressed to both of them my interest and appreciation for such creative and original ways to produce surprising and expressive masks and puppets, allowing complex playing, interactions and plots.

For the puppets workshop, we used to produce a book every year and for every member of the group as well as video records when possible, so that the memory of this collective work will stay long-lastingly available.

Arts therapies are great help in coping with chronic mental (as well as body) disabilities. Specific objective and subjective difficulties in the management and control of sexual, emotional and relational life can be addressed. So little is done by now to help social inclusion for persons with mental disabilities – beyond just providing some work and accommodation. Arts therapies can greatly contribute to less discrimination.

Figure 6.6 shows a final collective production in a workshop with painting, mask and volume, running on a period of one training year in a Social Work College with a group of twenty students. After a long-term individual self-expression, as a final proposal I suggested to produce a group 'totemic' form. Choice was free – it could have been a tree, a home, a bird, a Carnival character, or just an abstract big sculpture in paper and recycled materials. After some discussion, the group decided to create a big human character. Several weekly sessions were needed to go through the process. The result was rather surprising for the group itself. A big discussion occured to understand if the figure was Female giving life to a baby or Male with a funny phallus? The group was entirely composed of female young students and not everybody would agree this representation was socially allowed and accept to let it be exposed at the school year exhibition. Finally, the majority in the group decided that it had to be shown, even if the school board and the mates could be surprised and even possibly shocked (I must say that some discussion about this occurred with a few teachers who thought that transgressive-perceived attitudes were not welcome in a social work school. I replied that this art work was congruent with the deepest concerns of young and active adults . . . moreover, later their professional social work activity would largely have to deal with sexual transgressive attitudes and other offenses; training had to put them at work concerning transference and counter-transference). In the students' group we also discussed how to manage some risks related to self-assertion and need for authenticity in everyday life, in school life and in social work professional life. Being authentic and expressing less masked sentiments helped the students to explore authority issues with teen-agers and young adults in the human community. This workshop led to growth in personal inner life as well as in professional attitudes.

FIGURE 6.6 'Male, Female or Transgendered?', 2004.

Conclusion

In sexual abuse, prostitution, war or other traumatic context the body is mistreated and forced. Experiencing external as well as internal violence induces splitting and a gap might occur between body and psyche. Sometimes we face selective mutism, consciously or unconsciously disguised feelings and acting-out behaviors. Addictive, border-line and psychotic symptoms such as delirium, anxiety, phobia, compulsion, depression and/or suicide attempts are frequent in those with post-traumatic syndromes. Sometimes it might lead to physical or ideological violence. An important issue for psycho- and arts therapies is how to find truth about hidden, secret, shameful life stories without fixing traumatic memories, so that compulsive

and addictive behaviors would be diminished, relapse could be prevented and relief could happen. Mask representation, creation and playing are helpful in enlightening hidden identity and trauma issues.

Let's go back now to the question: Who am I? Self-repair, self-esteem and self-assertion are general human needs. The arts therapist is as human as the participant in the workshop. Personal therapy, art practice, training and supervision help in being authentic, empathic and congruent with the other, as Carl Rogers says. Non-directivity and humility are main postures in humane attitudes and humanistic vision in life and work.

Note

1 'The mask should be unmasked. It conceals less than it reveals, it is less superimposed than it arises from underneath' (Nancy, 2008, 13, *tr. IKM*).

References

Anzieu, D. 1981. *Le corps de l'œuvre [The Body of the Work]*. Paris: Gallimard.
Anzieu, D. 1996a. "Le Moi-Peau" [The Me-Skin]. In *Créer Détruire [Create Destroy]*. Paris: Dunod.
Anzieu, D. 1996b. "Samuel Beckett: de la psychanalyse au décollage créateur" [Samuel Beckett: From Psychoanalysis to Creative Take-Off". In *Créer Détruire [Create Destroy]*. Paris: Dunod.
Butler, J. 2014. *Qu'est-ce qu'une vie bonne? [Can One Lead a Good Life in a Bad Life?]*. Paris: Payot & Rivages.
Cogeval, Guy. 2008. "Préface" [Foreword]. In *Masques – de Carpeaux à Picasso [Masks: From Carpeaux to Picasso]*, edited by Musée d'Orsay. Paris: Hazan.
Devereux, G. 2009. *La renonciation à l'identité: Défense contre l'anéantissement [Waiving from Identity – Defence Against Annihilation]*. Paris: Petite Bibliothèque Payot.
Goonatilekka, M.H. 2006. "Masques du Sri Lanka: catégories, usages et interactions" [Masks from Sri Lanka: Categories, Uses and Interactions]. In *Visages des Dieux, visages des hommes: Masques d'Asie [Gods' Faces, Humans' Faces: Masks of Asia]*, edited by CCAD (Centre Culturel Abbaye de Daoulas), 68–73. Abbaye de Daoulas: Hoëbeke.
Hogan, S. 2016. *Art Therapy Theories*. Oxon: Routledge.
Klein, J-P. 2006. *Violences sexuelles faites à enfant [Sexual Violence Against Children]*. Paris: Pleins Feux.
Klein, J-P. 2012. *Penser l'art-thérapie [Reflexion on Art Therapy]*. Paris: Presses Universitaires de France.
Nancy, J-L. 2008. "Masqué, Démasqué" [Masked, Unmasked]. In *Masques – de Carpeaux à Picasso [Masks: From Carpeaux to Picasso]*, edited by Musée d'Orsay. Paris: Hazan.
Païn, S., and Jarreau, G. 1994. *Sur les traces du sujet: Théorie et techniques d'une approche art-thérapeutique [In the Footsteps of the Self: Theory and Techniques in an Art Therapy Approach]*. Paris: Delachaux et Niestlé.
Saigre, H. 1986. "L'au-delà des masques" [Beyond the Masks]. *Art & Thérapie* no. 20–21: 1–84.
Saigre, H. 2013. "Le mythe subi". In *Survivre: Mythes et transgressions en art-thérapie [Survive: Myths and Transgressions in Art Therapy]*. Paris: L'Harmattan.
Winnicott, D.W. 1971. *Jeu et réalité [Playing and Reality]*. Paris: Gallimard.

7

MEDIATING THE CULTURAL BOUNDARIES

The rise of Lion Rock Spirit in Hong Kong women

Bianca Ling Cheun Lee and Regina Wai Yin Au

In the spirit of the Lion Rock Mountain we, Hong Kong women, rise. Hong Kong is the fast-paced "Pearl of the East". In the past hundred years this city grew from a humble fishing village to the international financial hub of today. Under such strong colonial influence and assuming the identity of a special administrative region, Hong Kong and its people continue to adapt to the changing times. The city's constant negotiations with traditional Chinese family structure, gender roles, socioeconomic values, and policies are all specifically affecting the changing identity of the Hong Kong woman.

This chapter is a synthesis of two native Hong Kong Chinese art therapists utilising the knowledge they gained from Western education and personal backgrounds to localise their learning. Included are observations and art works that explore the intersectional lives of women in Hong Kong and uncover the creative ways these women, including the authors, record, better understand, and change their narratives. Due to the complex nature of the Hong Kong sociopolitical identity, Chinese phrases are interjected in various parts of this chapter. Spaniol and Cattaneo (1994) stated the importance of language usage because it shapes our thoughts, feelings, and actions. "It is the basis for our sense of existence and identity because it is a tool for developing self awareness and self concepts" (Spaniol and Cattaneo 1994, 266). Due to the lack of specificity within the available literature, and for the purpose of references in this chapter, the terms *Hong Kong Chinese*, *Chinese*, and *Asian* will be used.

Historic background

> *Hong Kong, described as a "barren rock" some 150 years ago, is today a world-class financial, trading and business centre and, indeed, a great world city. Hong Kong has no mineral resources, but has one of the finest deep-water ports in the world.*
>
> (HKGOV 2008, 4)

Hong Kong began as a small coastal city and a haven for travellers and pirates in the South China Sea. After the Opium Wars with the United Kingdom from 1842–1898, Britain acquired the New Territories and Kowloon on a 99-year lease in 1898. During World War II, Japanese aircraft bombed Kowloon on December 8, 1941, and forced the British to surrender Hong Kong on December 25, 1941. Following Japan's surrender on August 14, 1945, Britain reclaimed the territory. Hong Kong thereafter slid into gentle decline. The colony was forced to develop internal industries taking advantage of local and regional resources in order to continue to grow. During the 1980s Hong Kong started to work with China on a series of joint projects that brought the two closer together (Welsh 1997).

In 1984, Britain and China signed a joint declaration on the conditions under an agreement that Hong Kong would revert back to Chinese authority. The declaration detailed Hong Kong becoming a Special Administrative Region (SAR) of the People's Republic of China on July 1, 1997, under the "one country, two systems" formula, after a century and a half of British administration. Under Hong Kong's constitutional document, the basic law, the existing economic, legal, and social systems will be maintained for 50 years until 2047, at which time China will be able to exercise its authority (Yang 2006).

The Hong Kong Chinese identity

儒家 or Confucianism has a significant role in influencing the traditional and present structure of the Hong Kong Chinese identity and cultural values despite globalisation. Hong Kong Chinese continue to negotiate the cultural boundaries of collectivism and individualism. According to Wong et al. (2006), the Confucian guidance goes far beyond the Western concept of the nuclear family; the traditional Chinese family or 家 ("jia") includes ties with kinship groups. Kinship groups, also known as 族 ("zu"), include the extended family, family friends, and individuals who share the family name without biological ties. Therefore, one may not fully understand the individual identity of Hong Kong Chinese without learning about the collective identity (Wong et al. 2006).

Since family is seen as top priority, every member bears the responsibility to contribute to the benefit of the larger collective. By fulfilling responsibilities of the family, one gains with it a sense of identity and purpose (Ye het al. 2008). In order to maintain peace in the collective, one must follow certain moral codes. These moral codes emerge from the belief of causing tension in the system as a negative contribution. Hong Kong Chinese are concerned with self-control and self-surveillance rather than control of others or the environment. Therefore, the maintenance of family harmony and extension of social network has become the essence of the Chinese daily life (Nisbette 2003).

百行以孝為先 – "All actions shall begin with filial piety"

The Confucian belief of having respect for the elders in the family is called filial piety, or 孝 ("xiao"). It is one of the fundamental beliefs of the Chinese family system. The

ancient Chinese text, *Book of Rites* mentions, "The root of the world is the nation, the root of the nation is the family" (Tzu 2008, 230). There is some diversity, however, Chinese families stress family order, and it is only through respect and collaboration that the family becomes prosperous (Song and Kim 2009, 319). With such emphasis on the family system, the Chinese concept of "self" is significantly different from the conventional views of self development in Western psychology.

There are various ways of describing "self" in different cultural contexts (Essame 2012). Freud's (1923/1961) idea of ego-strength is used to describe the ability to know, to feel and to understand the self and how it relates to the outside world (Essame 2012). In contrast, the Chinese concept of self refers to the collective; it is believed that the social need to care for others is inevitable for being true to oneself (Tu 1976). There is no Chinese word for individualism, but it is close to the meaning of selfishness (Nisbette 2003). As a result, the Western individualism may contradict the Chinese interdependent collectivist cultures (Lau et al. 2013). Despite the firm belief of causing minimal disturbance to the social collective, the Hong Kong Chinese identity is greatly influenced by the West, which nurtured this population's desire to become increasingly individualistic.

獅子山精神 – "The Lion Rock Spirit"

The Peak district, the highest point on Hong Kong Island, is the landmark financial and political centre of Hong Kong, as well as a tourist attraction, which is minimally associated with the struggle more so representing imperialism, colonialism, and capitalism. Historically, the Peak was resided by British governors or others in positions of power. Moving downhill from the Peak, it is the "mid-levels" district, where real estate is expensive and most of the government agencies are located. As a result, living on the Peak or mid-levels of Hong Kong Island indicates a certain social status; either very rich or in positions of power. The "Peak" is therefore a natural symbol of success (Case 1998).

In contrast, The Lion Rock Mountain is the spiritual representation of Hong Kong Chinese. The term "Lion Rock Spirit" was coined in the late 1950s through 1970s to commensurate the financially, spiritually challenging times experienced by the locals. The Lion Rock Mountain is the physical manifestation of the struggle in the space where East meets West. The Lion Rock Mountain stands in the middle of the Kowloon Peninsula in Hong Kong. Hong Kong Island, the geographical symbol of colonisation, is located in the south, and in the north, is the New Territories, which is also the land that connects to mainland China. The geographical and organisation of Hong Kong subtly alludes to themes of colonisation and classism.

重男輕女 – "Importance placed on males less on females"

Hong Kong women are conditioned to meet the challenges brought on by cultural clashes between traditional Chinese ideals and Western ideas. Themes of patriarchy radiate in Hong Kong culture, such as traditional beliefs that males are more

important as they can carry the family name to future generations while females marry into other families. Importance placed on males is balanced out through the years with increased influence by Western feminism. These Western concepts empower women to strive to reach social-political status that was previously reserved for males and the non-Chinese population. In early 2017, Hong Kong elected the first female chief executive, Carrie Lam; under the social, political, and historic light, the definition of womanhood is about to shift once again.

Traditional ideas of a woman's life, including preparing for marriage, becoming a mother, raising children and growing old as a caretaker, are deeply ingrained in the Hong Kong woman's psyche. As times change with globalisation, the ideals of womanhood shifted dramatically. Women are more empowered to make choices with their lives. Women are starting to make more bold choices that focus heavily on their individual aspirations over fulfilling family or societal expectations. Nowadays, young women are encouraged at a young age to work hard academically owning their identity as writers of their own destiny.

Women are able to take up more space in the socio-political arena since the 1950s. At the end of World War II, Hong Kong was struggling financially to support its growing population, which led women into work, picking up contractual or odd jobs. Painting doll heads, sewing in a factory, or assembling parts of plastic flowers, were a few of the types of jobs that allowed women some flexibility to care for their families while earning an income.

As the generation of Baby Boomers rises, Hong Kong's international status was starting to rise as well. One of the benefits of being a British colony guaranteed free education for all children up to high school graduation. The Baby Boomer generation is more educated than previous generations who experienced war, extreme poverty, and possibly illegal immigration. Equality became increasingly evident as highly educated women had more choices in career paths. Due to Western influences from colonialisation and World War II, the generation of female Baby Boomers became open to new ideas about love, fashion, and the concept of self. An increase in individualistic tendencies began to grow amongst Hong Kong woman (Sun and Wang 2010).

By the time of Generation X and Y, the tension between individualism and collectivism intensified. Women are judged by the Hong Kong society for fulfilling their own desire to pursue their career; contrarily, they are looked down upon by the "modern woman" if they choose to stay home and raise a family. Meanwhile, Hong Kong's policies or infrastructure for women has minimal flexibility for career-oriented women to maintain a family at the same time, for instance, there is a lack of maternity leave or availability of breastfeeding support (Wang 2015). Therefore, a new generation of career women began to emerge.

剩女到盛女 – *"Generation of leftover women"*

剩女 or "leftover women" represents the group of women who voluntarily or involuntarily choose to grow in multiple facets besides the traditional path of

womanhood. As the prominence of these women grows, Cantonese language tradition has developed a series of terms, in most cases derogatory, describing these women. Terms such as 賣剩蔗 meaning unsold sugarcane, and 蘿底橙 meaning oranges left at the bottom of a crate, are often used regularly by society as an attempt to uphold the heavy focus on patriarchal ideals by shaming women. These phrases objectify women by minimising their female identity. The baggage that weighs on Hong Kong Chinese women continues to grow as their ideals begin to move away from traditionalism (Keenlyside 2012).

Intersectionality of Hong Kong women's identity through time

Survivor identity

Due to the effects of the war era (World Wars I and II) and Japanese occupation, many women suffered from the effects of post-traumatic stress. Due to financial reasons and the lack of resources, young women from the war era up till the 1960s were often sold as unpaid servants or brides. These young girls knew little to nothing about their family of origin with minimal chance to return. These young girls and women were trained to become servants to their "new" families. When they reach a marrying age, they are usually sent away through blind marriages. These women sometimes choose to share details of their traumatic past with later generations while others maintain silence in respect of the collectivist "peace".

Surviving war violence, extreme poverty, and hunger are only a few of the shared themes women of the war generations experienced. "Transgenerational transmission is when an older person externalizes their traumatized self onto a developing personality of a child . . . a child becomes a reservoir for the unwanted, troublesome parts for the older generation" (Wolynn 2016, 19). Often times these types of trauma and suffering the grandparents' generation endured are passed on to the later generations. Other studies have also indicated that DNA may carry trauma from earlier generations (Wolynn 2016). Later generations may also be caught in the symptoms of anxiety and depression without a better understanding of embodied trauma. Since many women are bound by social structures and patriarchal tradition in keeping unrest to themselves, therefore they rarely seek help from any mental health professionals (Fonagy 1999). Ultimately the following generations will experience the post-traumatic stress through various situations in family dynamics (Miller 1999).

Colonial influence and political identity

Since the British governed Hong Kong for a hundred years, the after effects of colonisation were still prominent even after the handover to the Chinese government after 1997 (Nisbette 2003). Colonialisation has a tremendous effect on the identity and self-esteem of the colony they once occupied. When Hong Kong was

governed by Great Britain, most of the higher government positions were only open to Westerners, this type of systematic racism created a strong sense of cultural hierarchy. Furthermore, buildings or social venues that British people occupied often had the sign "Asians and dogs not allowed entry" to perpetuate segregation. From such strong undertones of colonial power play, Hong Kong Chinese were raised under the impression with minimal confidence to succeed, hence the start of the concept of 崇洋 or "admiration of the West". From fashion to music taste, Hong Kong people underwent a period of saturation trying to adapt to Western culture and ideals in the 1960s. The fluid negotiation between the two cultures remains today. Politically, similar to the female identity formation in response to socio-political pressures, Hong Kong is always subject to larger governmental policies without much room for self-determination. Politically, Hong Kong continues to struggle with its own dependence and interdependence identity crisis as China grew stronger evidenced by the Umbrella Revolution.[1] In recent political developments in Hong Kong, young Hong Kong Chinese came into the spotlight.

Education from follower to thinker

Hong Kong culture emphasises educating academically successful and competitive young people. In an educational setting, the collectivist mentality heavily discourages students' individual distinctiveness, as well as depersonalises the learning style and needs of each student. Asian cultures emphasise the hierarchal distinction between a student and the teacher, therefore students are rarely encouraged to question information taught by the teacher. Wisdom is mainly derived by obtaining others' knowledge and skipping the process of argumentation. Contrarily, in the Western world, knowledge is gained by learning through personal experience (Case 1998, 253). Western education values personal development as well as critical thinking in the process of learning, especially dialectical thinking and argument. While the Hong Kong educational system rewards those who best follow the strict guidelines of the system, this consideration often overlooks different learning styles and psychological needs among students. Therefore, minimal financial support or government budgeting prioritise psychological and special educational needs. With minimal psychosocial support for students, and stigma associated with seeking help, many students are left with little resources to help them process the stress they experience. Hong Kong student suicide is on a sharp rise in the past 10 years. Psychological support for Hong Kong women is desperately needed in response to the prominent and serious effects of such socioeconomic circumstances (Lee et al. 2006).

Road to decolonise art therapy

Intersectionality (Phoenix 2006) refers to being located within multiple social categories (i.e. race, class, gender, sexuality, disability) concurrently. With these contemporary concepts in mind, focus in the following sections will be placed on

the Hong Kong Chinese in the context of art therapy, as well as resulting implications for the future. As Art Therapy is popularised and becoming its own field in the West, most of the existing knowledge has been Western-oriented. Meanwhile, many Asian countries are starting to accumulate more literature in regards to working with increasingly globalised subjects. However, to better understand and further deconstruct the process of localising traditional art therapy knowledge, one must take a closer look at art therapy in the context of utilising traditional Western methods and modalities working with the Hong Kong Chinese population.

The Chinese population may perceive psychological disturbances as a symptom of a physical ailment (Sue and Sue 1991). Gopaul-McNicol (1995) developed a multicultural/multimodal/multisystem model in working with non-Western families. There is, however, still a strong belief among the Chinese population that only the "mentally disturbed" would seek help through forms of counselling. Sue (1995) mentioned that the perception of mental instability was caused by physical discomfort; for instance, feelings of depression were caused by headaches. It is important for the counsellor to get an adequate understanding of the issues in the context of the family experience at the assessment phase. It may be helpful to inquire with clients about the impact of the health or mental health discomfort on the functions of the individual or family. During following phases of treatment, psychoeducational approaches may be used for families from non-Western cultures. Through the multisystems approach, the family may learn about the systems that they are exposed to and are looking to participate in. According to Tania (1995), as non-Western families learn more about the stressors that they face, they may be able to decrease the anxiety they have in regards towards them as well as providing a sense of universality.

According to Rotter and Hawley (1998), family art therapy may provide context for the art therapist as well as for the family to explore and access the contrasting values between themselves and the larger society. In the therapeutic context, typical Western ways of negotiation and democratic discussion may feel very foreign to many Asian families and their patriarchal structure (Jung 1984; Saner and Yiu 1985). Therefore, it is necessary to alter the traditional forms of therapy. While art utilises many of the non-verbal qualities of expression, it allows for Hong Kong Chinese clients to communicate in a much less direct way that lowers the risk of threatening the traditional roles and values of the culture.

Roland (2005) wrote that such formal hierarchy based on age and gender is deeply internalised as expectations of both the superior and the subordinate, which often plays out within a therapeutic relationship. Rather than voicing their opinions about discomfort, the Asian client might comply with the therapist's request because of the innate sense of respect they have for the therapist. Roland (1996) expressed the existence of the dual self-structure for the subordinate, as they observe the social etiquette expectations of being obedient and polite; they are also keeping many feelings and fantasies within the private self. The lack of experience in identifying, acknowledging, and communicating their emotional states may encourage

the client to suppress their authentic feelings, which in turn may hinder their optimism toward the therapeutic outcome. While it may not be a popular Western concept, it can be very helpful for the counsellor to take the "not-knowing" approach to therapy. Anderson and Goolishian (1992) emphasised that such an approach is not about creating change, but rather, being open towards opportunities to learn. Becoming curious and taking the client's story genuinely enables the therapist and the client to form a therapeutic bond in exploration that leads to a better understanding of the client's experience.

Chinese clients are likely to expect the leader or teacher to provide instructions to resolve difficulties instead of engaging in the self-exploration process, which is the essence of all psychotherapy (Cheng 1993). As a result, clients may expect the images to be interpreted by the therapist rather than self exploration or to reach some thought or feelings through the images. They may tend to focus on the answer instead of the exploration process. This target-oriented goal explains the need of a fortune teller or shamans, because the directive style might be more trustworthy and safer.

Research is suggesting that art therapy is a powerful treatment when engaging with the non-Western population. Emberley (2005) stated that images created from an art therapy session act similarly as an interpreter. Clients may still express themselves through art making and allowing a space for dialogue even without direct verbal communication. Ellis (2007) expressed that art, with a more extensive vocabulary, allows for "ambiguity, subtleties, and complexities more extensively than [is] possible in verbal language" (p. 60), which provides clients with opportunities to express deeper emotions through metaphors. McNiff (1984) supports this sentiment by stating, "The art object becomes a bridge between cultures and languages and a common focal point that provides access to universal qualities of feeling" (p. 129).

In Chinese culture, those who suppress their feelings and resist sharing their emotions are considered mature, wise, and respectable. By reflecting flexibility and tolerance, Chinese are able to demonstrate high levels of self-control. Hence, in contrast to the Western framework, Freudians might define such phenomenon as a repression of oneself (Essame 2012). The consequences of inward self-control over desires and emotions may result in a interpersonal disturbance (Weisz et al. 1984). Art therapy, as a Western practice, not only emphasises individual values, it also encourages the importance of self-expression and individual rights (Case and Dalley 1992) while the Chinese notions are exactly opposite. This phenomenon has brought on a conflict in the cultural adaptation of therapeutic approaches between the East and West.

The two authors of this chapter accumulated a multitude of experiences growing up in the East and receiving their education in the West. Their lives were greatly influenced by the previously mentioned socioeconomic and historic background of Hong Kong. To better synthesise the concept of art therapy in the context of Hong Kong Chinese women, we each now share our personal journey in becoming art therapists in the following sections.

Regina's story

The Lion Rock Mountain witnessed the lives of three generations of Hong Kong women; from World War II and poverty, to colonisation and finally to reunification. We are now able to make our own choices and to live a better life.

FIGURE 7.1 AND FIGURE 7.2 Ar Beng 2007.

After being in therapy for a period of time, I was able to understand how the formation of trauma worked on a whole new level. I can see clearly the ways trauma affected previous generations during World War II and how the trauma was truly passed on to our current generation. My mother spent a lifetime trying to manage the guilt and shame passed down from my grandmother's painful life experiences; when I look at myself, I felt something was missing. This missing piece was passed down from my mother. I recognised that my family was stuck in a vicious cycle.

My grandmother (Figure 7.1) was only 11 years old during World War II. Her father died from a missile launch by the Japanese army, her mother was unable to take care of her as a single mother, therefore, my great-grandmother made the painful decision of selling her to a land-owning family as a 妹仔/童養媳 "younger sister/child bride" ("younger sister" is an unpaid, live-in maid for a rich family; "child bride" is a child that was sold to the host family, when the son in the host family reaches marriage age, the "child bride" would become his wife), in hope of my grandmother's survival. My grandmother (Figure 7.2) and great-grandmother lost the ability to take charge of their lives because of their desire to live. When the right to live becomes so minimal due to the circumstances, their psychological needs were not met, hence the formation of trauma (Figure 7.3).

Due to my education, I had the opportunity to explore my family history and myself. I was able to and continue to uncover parts of the experience that were once silenced by the socioeconomic needs of society. Not only did I enrich my own emotions through therapy, I also contained the family's emotional trauma. Trauma can only begin its healing process when therapy begins.

FIGURE 7.3 Ar Beng 2007.

Bianca's story

The year 2017 marks the 20th anniversary since the transfer of sovereignty over Hong Kong. The theme song of "Under the Lion Rock" TV show comes up in the media more and more frequently reminding us of the best of times and the worst of times through the years. The lyrics remind us all about the fate of coming across all kinds of stories and people despite experiencing the toughest of times, together we write the golden history of Hong Kong. The song accentuated the collective history of people who live here from the past to the present. Under the Lion Rock my family thrived.

On one hand, the Lion Rock represents the majestic nature of the animal, yet it also symbolises all the times the symbolic lion sinks its claws into its victims and makes them fight for their own survival. Generations of superwomen cross my mind as I comb through the narratives of what I know about the lives of the women in my family as I was told. These stories deeply touched me with their humble beginnings and make me reflect on the contrasting upbringing I experienced. Collectively my previous generations experienced the Cultural Revolution, slavery, abuse, immigration, poverty, and a lot more with the historic-socioeconomic background previously mentioned. The women in my family achieved success in many ways, US citizenship, fame, fortune, and beautiful families to name a few. The successes did not come without a cost. The women's psyche in my family suffered.

The dark underpinnings of trauma grip tighter as we take a closer look at family dynamics among mothers and daughters. My grandmother was sold to a different, more well-off family to become their family servant at the age of three. Soon realising her hope to return home to her family of origin was not possible, my grandmother learned to be resilient, generous, and kind. She started her own family through a blind arranged marriage, and then raised her daughters to do what she did best – to suppress our needs in order to serve others in every way possible. My mother's upbringing provided her with minimal tools to be who she is without servitude. Therefore, with the agency of public education under the British Government, my mother figured out a way to gain more independence. She started working part-time since elementary school to provide for her family with money, rather than following the traditional concept of females contributing to the household by

FIGURE 7.4 The Family Machine 2011.

Mediating the cultural boundaries **95**

FIGURE 7.5 Lion Rock 2005.

serving the family (Figure 7.4). My curiosity continues to grow as I notice how each generation seeks new ways to manage the previous generation's deficit.

My parents provided me with a life where academic excellence was my focus. I never needed to think about supporting my family's material needs. Rather, I was left with pieces of the psychological aftershock from my mother's past as well as the way my mother experienced her mother's past. Different elements of our diverging narratives are revealed to me through my mother's angry outbursts when I did not do well in school, or the depressed mood I witnessed through her fluctuating sleeping and eating patterns. Growing up I was left with much guilt and shame with the constant wondering if I was the cause of all her misery. Realising I was following the footsteps of my mother's moodiness, I was determined to leave the cycle. I was drawn to art therapy because of my interest with self-exploration in art, and the counselling dimension was to reassure my family that I will be able to find a job in the future. My decision to become an art therapist validates the family cycle of me doing something I wanted with conditions of satisfying some standards that I thought my mother wanted or needed from me.

My eyes trace the outlines of the Lion Rock Mountain (Figure 7.5) every time I see it. From days of the golden shadows that sunset casts on the mountain peaks to rainy typhoon days when fog hangs so low that I can barely make out the shape of the mountain. We are all seeing different parts of the Lion on any given day. In my journey towards healing, I continue to discover where darkness meets the light.

Future implications

In this chapter we examined in detail the common themes of upbringing that are shared by many Hong Kong Chinese women. Many of them were born and raised in Hong Kong or other Chinese nationals who end up immigrating to other countries. The physical-psychosocial trauma suffered by previous generations continues to be experienced by current generations. In order to manage or even heal the negative effects of the past, we must be committed to utilise, develop, and localise the variety of counselling or arts therapies modalities.

Note

1 The Umbrella Movement (Chinese: 雨傘運動) is a political movement that emerged during the Hong Kong democracy protests of 2014. Its name arose from the use of umbrellas as a tool for passive resistance to the Hong Kong Police during the occupation which was sparked by the decision of the Standing Committee of the National People's Congress (NPCSC) of August 31 of that year that prescribed a selective pre-screening of candidates for election of the region's leader (Chan 2015).

References

Anderson, Harlene and Goolishian, Harold. 1992. "The Client Is the Expert: A Not-Knowing Approach to Therapy". In *Therapy as Social Construction*. Edited by McNamee, Sheila and Gergen, Kenneth J. London: Sage. 25–39.

Bouhours, B., & Broadhurst, R. (2015). Violence Against Women in Hong Kong: Results of the International Violence Against Women Survey. *Violence Against Women*, 21(11), 1311–1329.

Case, Caroline. 1998. "Reaching for the Peak: Art Therapy in Hong Kong". In *Arts Therapies, Refugees and Migrants: Reaching Across Borders*, Edited by Dokter, Ditty. London and Philadelphia: Jessica Kingsley Publishers.

Case, Caroline and Dalley, Tessa. 1992. *The Handbook of Art Therapy*. London and New York: Routledge.

Chan, Shun-Hing. 2015. "The Protestant Community and the Umbrella Movement in Hong Kong". *Inter-Asia Cultural Studies*, vol. 16(3): 380–395.

Cheng, L.Y. (1993) "Introduction". In *Psychotherapy for the Chinese: Selected Conference Papers*. Edited by Cheng, L.Y., Cheng, F., and Chen, C. N. Hong Kong: Chinese University Press.

Ellis, Mary L. 2007. "Images of Sexualities: Language and Embodiment in Art Therapy". *International Journal of Art Therapy: Formerly Inscape*, vol. 12(2): 60.

Emberley, Alexandra. 2005. "Responding to the Crisis of Relocating: Cultural Differeces, Self Psychology and Art Therapy". *Canadian Art Therapy Association Journal*, vol. 18(1): 9–19.

Essame, Caroline. 2012. "Collective Versus Individualist Societies and the Impact of Asian Values on Art Therapy in Singapore". In *Art Therapy in Asia: Tothe Bone or Wrapped in Silk*. Edited by Kalmanowitz, Debra L., Potash, Jordan S., and Chan, Siu M. London and Philadelphia: Jessica Kingsley Publishers, 91–101.

Fonagy, Peter. 1999. "The Transgenerational Transmission of Holocaust Trauma". *Attachment & Human Development*, vol. 1(1): 92–114.

Gopaul-McNicol, S. A. 1995. "Examining Psychotherapeutic and Psychosocial Factors in Working with Immigrant Families". *Journal of Social Distress and the Homeless*, vol. 4: 143–155.

HKGOV. 2008. "Hong Kong in Brief". Hong Kong Special Administrative Region Government, Accessed April 20. www.gov.hk/en/about/abouthk/docs/2008HK_in_brief.pdf

Jung, Marshall. 1984. "Structural Family Therapy: Its Application to Chinese Families". *Family Process*, vol. 23: 365–374.

Keenlyside, Sarah. 2012. "You Do Not Want to Be a Single Lady Over 28 in China". *The Daily Telegraph*, July 20, Accessed March 15, 2017. www.businessinsider.com/you-do-not-want-to-be-a-single-woman-over-28-in-china-2012-7

Lau, Y., Cameron, C., Chieh, K., O'leary, J., Fu, G., & Lee, K. 2013. Cultural Differences in Moral Justifications Enhance Understanding of Chinese and Canadian Children's Moral Decisions. *Journal of Cross-Cultural Psychology*, 44(3), 461–477

Lee, Margaret T.Y., Wong, Betty P., Chow, Bonnie W.Y., and Mcbride-Chang, Catherine. 2006. "Predictors of Suicide Ideation and Depression in Hong Kong Adolescents: Perceptions of Academic and Family Climates". *Suicide and Life-Threatening Behavior*, vol. 36(1): 82–96.

McNiff, Shaun. 1984. "Cross-Cultural Psychotherapy and Art". *Art Therapy: Journal of the American Art Therapy Association*, vol. 1(3): 125–131.

Miller, L. 1999. "Treating Posttraumatic Stress Disorder in Children and Families: Basic Principles and Clinical Considerations". *The American Journal of Family Therapy*, vol. 27: 21–34.

Nisbette, Richard E. 2003. *The Geography of Thought: How Asians and Westerners Think Differently . . . and Why*. New York: Free Press.

Phoenix, A. 2006. "Intersectionality". *European Journal of Womens Studies*, vol. 13(3): 187–192.

Roland, Alan. 1996. *Cultural Pluralism and Psychoanalysis: The Asian and North American Experience*. New York: Psychology Press.

Roland, Alan. 2005. "Between Civilizations: Psychoanalytic Therapy with Asian North Americans". *Counseling Psychology Quarterly*, vol. 18(4): 287–293.

Rotter, Joseph C. and Hawley, Lisa D. 1998. "Therapeutic Approaches with Immigrant Families". *The Family Journal*, vol. 6(3): 219–222.

Sigmund, Freud. 1961. *The Standard Edition of the Complete Psychological Works of Sigmund Freud. The Ego and the Id*. Edited and Translated by J. Strachey. London: Hogarth Press. (Originally published in 1923).

Sŏng, Kyu-T. and Kim, Bum J. 2009. *Filial Piety in Asian Chinese Communities. Respect for the Elderly: Implications for Human Service Providers*. Lanham, MD: University Press of America, 319–323.

Spaniol, Susan and Cattaneo, Mariagnese. 1994. "The Power of Language in the Art Therapeutic Relationship". *Art Therapy: Journal of the American Art Therapy Association*, vol. 11(4): 266–270.

Sue, David and Sue, Derald W. 1991. "Counseling Strategies for Chinese Americans". In *Multicultural Issues in Counseling: New Approaches to Diversity*. Edited by Lee, Courtland C. and Richardson, Bernard L. Alexandria, VA: American Counseling Association.

Sue, Stanley, Sue, Derald W., Sue, Leslie and Takeuchi, David T. 1995. "Psychopathology Among Asian Americans: A Model Minority?" *Cultural Diversity & Mental Health*, vol. 1(1): 39–51.

Sun, Jiaming and Wang, Xun. 2010. "Value Differences Between Generations in China: A Study in Shanghai". *Journal of Youth Studies*, vol. 13(1): 65–81.

Thomas, Tania N. 1995. "Acculturative Stress in the Adjustment of Immigrant Families". *Journal of Social Distress and the Homeless*, vol. 4: 131–143.

Tu, Wei-M. 1976. "The Confucian Perception of Adulthood". *Daedalus*, vol. 105(2): 109–123.

Tzu, K'ung-fu. 2008. "*The Li Chi or Book of Rites, Part I of II*". Beijing: Forgotten Books.

Wang, Jeanette. 2015. "Hong Kong Lags Behind in Support for Breastfeeding Mothers". Accessed August 10. www.scmp.com/lifestyle/health-beauty/article/1847393/hong-kong-lags-behind-support-breastfeeding-mothers

Welsh, Frank. 1997. *A History of Hong Kong*. London: HarperCollins.
Weisz, John R., Rothbaum, Fred M., and Blackburn, Thomas C. 1984. "Standing Out and Standing in: The Psychology of Control in America and Japan". *American Psychologist*, vol. 39: 955–969.
Wolynn, Mark. 2016. *It Didn't Start with You: How Inherited Family Trauma Shapes Who We Are and How to End the Cycle*. New York: Viking Press, 15–24.
Wong, Sabrina T., Yoo, Grace J., and Stewart, Anita L. 2006. "The Changing Meaning of Family Support Among Older Chinese and Korean Immigrants". *The Journals of Gerontology Series B: Psychological Sciences and Social Sciences*, vol. 61(1): 4–9.
Yeh, Christine J., Kim, Angela B., Pituc, Stephanie T., and Atkins, Marc. 2008. "Poverty, Loss, and Resilience: The Story of Asian American Youth". *Journal of Counseling Psychology*, vol. 55: 34–48.
Yip, K. 2006. Psychology of gender identity: An international perspective. New York: Nova Science.
Yiu, Saner L. and Yiu, Saner R. 1985. "Value Dimensions in American Counseling: A Taiwanese-American Dimension". *International Journal for the Advancement of Counseling*, vol. 8: 137–146.

Artist (Regina Au) video in full version:

Ar Beng. 2007. https://drive.google.com/file/d/0ByrlBPpU4pCHMlFCNXMyVGJNM3M/view

8

GENDER DIFFERENCES EXPRESSED IN COSTUMING AND DRAMATIC PLAY

Warrior Cat boy

Jeanne Sutherland

Adam Brite-Star Shard, 2017

Adam is complex. Born a biological girl, but since age fifteen, identifying as part boy, part cat, and part *Simpson* (based on the television series "Simpsons" cartoon characters created by Max Groening); Adam chooses his name as a transgender boy to reflect the Warrior Cats that have been guiding his life since he was ten years old – based on the fiction fantasy series by Erin Hunter (2003). Adam Brite-Star Shard is a morph of a Warrior Cat he created, *Ambershard*, in combination with Brite-Star, the name given to the little girl by her adoptive mother's dear friend.

There are several names and personas that identify this individual, and I will try not to confuse the reader. However, confusing identities is a dominant theme in this story. My role as the primary writer of this chapter is due to the many years I worked with the then *Brite* as she/he expressed herself through costuming and metaphoric play. As an arts therapist, my work includes art, play, mythic costuming, and creative metaphors for empowerment and transformation. And this is how Brite and I fit together. My specialty is *mytho-poetic* creative play based on Art Therapy and "Transformative Education" (see Sutherland 2014, 62–63). My objective is to foster deeper, symbolic knowing through creative exploration and applications based on Jungian and critical theories. In a non-traditional art therapist and community support role, I worked with Brite from age eight to twelve. Or more accurately, I joined Brite on her mythic quest to transform her trauma and to embody a gender identity different from her biological body. The following scenes are based on interviews with Brite, her adoptive mother, Theatre Adventure director, and my own observations. Since I did not observe some of these scenes in actual time, they may contain approximations of dialogue and content to the best of my ability.

Getting ready to go to the hospital, 2003

Four-year-old Brite has a round face with fair skin, freckles, and blue eyes. A clear, wide plastic tube protrudes from a hole in her throat, attached to an oxygen tank that hangs on the back of her wheelchair.

Brite taps her hand on the table to get her mother's attention.

Her adoptive mother Paula has long purple dreadlocks, large blue-green eyes, and a gentle smile. Living in Vermont suits her creative disposition.

Brite uses sign language, "I need Toto. And a basket to carry him in. And I need those too." She points to a pile of assorted costumes.

Paula signs back as she speaks out loud, "I'll see what fits in your suitcase. I don't think we can bring a basket to the hospital; we already have so many things to carry."

Brite is going in for surgery, the first of several, to have her breathing tube removed and to begin the process of having the hole in her throat surgically sewn up.

As her mother gathers some of the costumes, Brite taps her hand on the table again.

Paula looks over to see Brite pointing to a storybook cover, as she signs and points to her mother's sewing machine.

Paula glances at the clock, "I don't have time to make you another costume before we go to the hospital." Paula stops her packing. They both keep their eyes fixed on each other. Paula takes a deep breath, stoops down to kiss Brite on the cheek, then says in a quiet, gentle voice, "I'll be there with you the whole time."

Brite stares into the distance then signs, "I want to wear the Cowardly Lion."

Paula nods, holding back her tears.

From a very young age, Brite spontaneously chooses costumes and fictional characters as a method to express herself. Her adoptive mother believes that she wears costumes to depict characters and stories as a way to find answers, to explore, to gain mastery, and to make sense of her world. At age twelve, when describing her early life, Brite tells me that when she was born, they had to take her in a "baby ambulance" to a special hospital. From the time she is born three months prematurely, her body is cut into and invaded by many and numerous medical procedures. Her paradoxical task is to have these procedures to protect her life even though these invasive intrusions do not "protect" her body boundaries. Because Brite breathes through a tube attached to a hole in her throat for the first four years of her life, she could not talk until much later. Instead, she uses sign language or communication boards, in addition to costumes and props to communicate and embody her emotional state until about six years old.

In Brite's case, embodied creative play becomes a crucial vehicle for her to "voice" her feelings and needs. One of the ways she embodies her voice – to communicate her fears, anxiety, and celebrations – is through creative costuming and narrative play. The *Wizard of Oz* (Garland et al. 1996) movie and characters are a big part of her early life. Because Brite is on oxygen during this time, she has limited

mobility that requires her to stay in bed or stationary for long periods. This stops her from having much access to peers until she is five years old. It may be because of this isolation and restricted accessibility to play with other children that she engages herself deeply in storybooks and with their imaginative characters and adventures.

Summer, 2004

Paula chats with a friend as she wheels five-year-old Brite into the house, then sets her up in the living room with her toys.

"Okay. You two can play while I make some lunch," she tells Brite and her friend's little boy.

Five-year-old Brite looks up at her mother innocently. She has long blonde hair and she is wearing the frilly dress that her mother put on her that morning.

After Paula goes into the kitchen, Brite makes her way over to the sewing table. It takes her just a few moments to find the scissors.

Poised, scissors in hand, she looks over at the little boy.

The six-year-old boy looks back at her questioningly.

Brite smiles.

After about twenty minutes, Paula sticks her head around the corner to check on the children. She freezes, "What did you do?"

Brite's friend looks up, eyes wide, scissors still in his hand.

Brite stands there in her underwear. Her dress, now on the floor, is covered with her recently shorn blonde hair.

Paula shakes her head, retrieves the scissors from the boy's outstretched hand, then goes back into the kitchen with a deep sigh.

Brite grins with satisfaction as she pats her now short hair.

Local fire station, 2005

With still short hair, six-year-old Brite wears a firefighter's hat, big tee-shirt, shorts, and oversized rain boots.

One of the firemen squats down and puts his hand up for a high five, "Hey buddy! You here for the tour?"

Brite nods.

He calls over to one of the other firemen, "Hey Bob, show this little guy around while I finish washing the truck."

Neither Paula nor Brite correct his reference to Brite as a "little guy."

In her too-big rain boots, Brite wobbles off to meet up with Bob.

The firehouse and trucks are filled with all kinds of important firefighting and rescue equipment. Brite and a few other children spend an hour learning about fighting fires. Brite even gets to sit in the driver's seat of one of the trucks and sound the air horn!

After the demonstration, Brite and Paula say their goodbyes and head toward their van.

"See ya, buddy," one of the firemen yells out.

Paula hesitates, furrowing her brow a bit and looking back at the fireman. After just a moment, she moves toward the car.

Brite gets in the back and Paula fastens Brite's seatbelt.

On the drive home, Paula is silent for a little while, but then says in her kindest, most motherly way, "I know you like dressing like a boy."

Brite looks up from the storybook in her hand.

Paula turns her head briefly, "You know I want you to do and be anything that makes you happy." She keeps driving, "But we can't lie and let people believe you're a boy."

"But I'm a Tom-boy!" Brite's tone is insistent.

"I know," Paula says, "But when people refer to you as a boy and we don't correct them, then they may get upset later when they find out the truth. We don't want them to feel deceived."

They sit in silence for a moment as the scenery passes by.

Paula looks into the rear-view mirror at Brite, "Okay?"

Brite keeps her eyes on the pictures in her book, without looking up, she signs, "No."

Playing "dress-up" is a common phenomenon for small children. Unstructured symbolic play typically emerges in the second year when children use imagination, fantasy role playing, and exploratory play (Fisher, Hirsh-Pasek, Golinkoff, and Gryfe 2008, 306). However, atypically developing children may not have independent mobility, manual dexterity, or the cognitive awareness to access such play until much later. Thus, for such children, fantasy role playing and imaginal, exploratory play can occur in late childhood or even into adulthood, perhaps due to never having had occasions for early "natural" play. Brite's childhood does not reflect the developmental norms. In part due to her lack of verbal speech and her developmental anomalies, costumes and fictional characters play an important role in her communication, identity exploration, and development even into late childhood and beyond.

Theatre Adventure Program, 2006

An adolescent boy with Down Syndrome pulls down the long black dress and pointed hat from the costume rack and puts them on over his clothes. With his fingers in front of him like claws, he mimics, "I get you my pretty, and your little dog too!" He then cackles loudly.

I smile, just as many other support staff and troupe members do. I watch as other troupe members come out wearing different costumes.

Seven-year-old Brite is wearing a tan, furry lion suit with a little hood that goes up over her head with ears on top.

One of the directors of the theater program, Laura, starts a simple rhythm on a large doumbek drum as the participants move around the room. This signals to troupe members to join in. Brite and other participants make their way to the

center of the room where chairs form a circle (with some open spaces for wheelchairs or people who choose to sit on the floor). There are little hand drums and other percussion instruments in or next to a basket. Some of the costumed members pick up instruments. There is a clanging and pounding that almost forms a coherent beat.

The boy in the Wicked Witch costume capers into the center of the circle to do a little dance. A girl in a tutu and cowboy hat joins him. They hold hands and bob back and forth to the rhythm.

After about five minutes, Laura drums faster and faster and then ends with a single loud beat.

The dancers go back to their seats and Laura starts another round of drumming.

Brite gets on all fours and pounces into the center on her haunches. She is joined by two support members who growl and swat each other with pretend paws.

This is a typical warm-up session before the troupe gets to the more structured process of learning how to "act" and to planning their show. Theatre Adventure Program (see neyt.org) is described by its creator/directors Laura Lawson Tucker and Darlene Jenson as "inclusive theater" for young people of "mixed abilities." Within a dramatic play framework, Theatre Adventure's directors model and create a culture of respect, encouragement, and unconditional acceptance in a collaborative theater program. Theatre Adventure directors are always asking, "How can we make this work?" What they mean is that every troupe member comes in with different abilities, needs, interests, and ideas about what they want to do. The directors do not draw attention to "dis" abilities or differences. They focus on what is possible, what is imaginable. They look for characters or stories to which the troupe members are drawn or for which participants express interest. At Theatre Adventure, imaginal play through costuming is an opportunity to express aspects of embodied identity and gender difference.

Creating such therapeutic drama environments is echoed in what David Read Johnson and Renee Emunah (2009) referred to as *Developmental Transformations* in the form of drama psychotherapy. Such dramatic transformations are based on the "process and dynamics of free play" and the "transformation of embodied encounters in the playspace" that include the four components of: *transformation, embodiment, encounter,* and *playspace* (89). In their essay on the "body as presence," Johnson and Emunah considered the encountering of another person, actions and roles of play that are story-bound to give order to time through the plot, self through characters and story, and predictability through the ending (97). Though Theatre Adventure Program directors Darlene and Laura do not categorize their theater troupe as "drama therapy," many of these components are active in their program. Within the playspace, troupe members embody characters in stories in different ways depending on their disabilities. Every member is respected and honored for what they have to offer and what they choose to explore through story and character. For example, Brite explores what it is like to be a boy by embodying and playing male characters.

Jack & the Beanstalk, 2008

Nine-year-old Brite is playing *Jack*, the starring role.

Laura announces, "We need to have a scene with the beanstalk. Our prop people have made us a beautiful beanstalk from a ladder."

Support staff roll in a fifteen-foot ladder with "ivy" trailing up its structure. Many oohs and aahhs are heard from everyone but Brite. She will have to climb up to the top for her big scene.

Laura says, "Okay, Brite. Go on up."

In a quiet voice, Brite says, "I'm scared."

Her support person says, "I'll spot you from behind."

Brite hesitates, then climbs slowly up the ladder, stopping often to look down.

"I've got you," her support person reassures her.

When Brite gets halfway up, she stops. She looks down and then up. After a moment she sings, "So-o-me-where over the beanstalk," she takes a breath, "Ski-i-es are blue," imitating the tune from the *Wizard of Oz*'s "Somewhere over the Rainbow."

Laura and Darlene look at each other and smile.

Climbing is a great accomplishment for a child who had been tethered by a breathing tube attached to an oxygen tank for the first years of her life. For Brite, the song from her beloved *Wizard of Oz* is a comfort during her fearful climb. The song's meaning offers a theme of hope for a better reality. Though singing "Somewhere over the Beanstalk" is not part of their original plan, the directors decide to include it in the final production because they interpret Brite's spontaneous song as an expression of her need for support and comfort. "Being heard" is a colloquialism for having one's needs acknowledged. "Being seen" is vernacular for being recognized and validated by others. Because Theatre Adventure creates theater that will be seen, the actors know that they too will be seen. The troupe members have an opportunity to play, and they know that others will *see* their play. This creates occasions to address actors' emotional, cognitive, physical, and developmental challenges, as well as to showcase their abilities and individual talents or unique characteristics.

However, being seen in a public theater production is a vulnerable position for anyone, especially for those who are different from typical peers. In Johnson and Emunah's words, "Encountering another person is an awesome event. Perceiving the gaze of the Other, we can feel our freedom constrained, invaded (Sartre 1943). We can respond by becoming silenced, shamed, or disempowered" (Johnson and Emunah 2009, 96). Though these risks are possible, Theatre Adventure directors use empowering words like *abilities, strengths, interests, learning,* instead of *disabilities, problems,* and *limitations*. They focus on what the actors can do, while also helping them to stretch beyond what the actors thought they were capable of doing. In a different structure, my Mythic Play programs also provide creative, empowered play. Though Theatre Adventure has many improvisational moments, they craft stories and use embodied play in theater productions for the actors *and* the audience. While this is an opportunity for Brite to be witnessed and valued in a public arena,

my Mythic Play programs provide archetypal play and metaphoric enactment for personal exploration and expression in small groups.

Knights & Ninjas Camp, 2008

On the lawn just up from the brook, a Medieval-like mêlée breaks out. Children wearing crowns, tunics, and capes battle each other with small balsa wood swords. Nine-year-old Brite wields her sword fiercely as she fights her opponent. Participants have made their own tunics on which they have depicted images and words that describe their attributes, strengths, and character. Brite wears a green satin cape over her tunic on which her mother has sewn an applique of a king's crown. Her cape has an image of the Welsh dragon in red sewn on the back.

My Mythic Play programs are theme-based. The themes offer children some structured activities in addition to creative exploration and improvised play. In the *Knights & Ninjas Camp*, participants make costumes, engage in sword play, and participate in the "Roundtable Council" to co-create their "Knights' Code" of behavior. Within this themed structure, Brite embodies and enacts traditional masculine characters. The culturally normed "Warrior" and "King" archetypal figures are used in "mythopoetic men's work" as images of masculinity (Moore and Gillette 1991). Based on the work of Carl Jung (1990), archetypes are described as common patterns visible in culturally bound images and narratives. According to Robert Moore and Douglas Gillette (1991), the *King* represents archetypes of power and authority to control resources for the flourishing of the kingdom. The *Warrior* fights under the authority of the King to champion a cause. The Warrior is not characterized as a random killer or murderer for his own objectives. He fights for a greater purpose beyond himself. For Brite, these figures may be helping her to explore cultural norms of masculinity. Embodying the King and Warrior in creative costuming and play may help her to feel powerful. Perhaps she metaphorically uses this power to wield her authority over doctors who stab her with scalpels and nurses who pierce her with needles.

Mother's Day, 2009

Brite's mother and grandmother make a plan for the family to go out to dinner to celebrate Mother's Day. Ten-year-old Brite is playing outside when her mother calls her in to get ready. Brite comes in the back door wearing a big pair of shorts with a big tee-shirt and high-top sneakers.

Paula says, "Sweetheart? Will you put on a dress for Grandma?"

Brite frowns and walks down the hall to her room.

Paula adds cheerily, "It's Mother's Day!" Paula is trying to make her mother happy. But since Brite has refused to wear dresses for a few years now, except for when she plays Dorothy from *Wizard of Oz*, Paula is not expecting Brite to comply with her grandmother's request.

A short while later, Paula calls out, "Okay, let's go!"

Brite comes running out of her room wearing a bright yellow dress that her mother laid out for her. She smiles, "Look Mom; I'm cross-dressing for Grandma!"

[Brite understands this concept because at her school they have "Cross-Dressing Day" once a year for the students and teachers. Also, Paula has a wide array of friends, some with alternative gendered expressions.]

Boys & Girls Club, 2010

I sit at the table in the eating area of the Boys & Girls Club. In addition to Brite participating in my programs, I provide support for her in community activities.

That afternoon, eleven-year-old Brite is involved in a game with some other children. The boxy warehouse-like building has been painted in numerous bright colors and has an open floor plan with different alcoves and levels with various designated spaces like a large, indoor skateboard park. Due to the concrete floors and steel framing, the building is loud with the echoes of yelling and laughing children.

Suddenly, I see the club's director leading Brite to my table. The director has a concerned look on his face.

Two boys trail behind them.

The director says to me, "Brite was in the boy's restroom. She knows she's not allowed to go in there."

The boys add in unison, "Yeah."

Brite looks at me and shrugs.

I respond slowly, "Okay," but I am not sure what to do beyond that. I know that in Brite's mind, she is a boy and I do not want to reprimand her for following a deep-seated impulse. Without knowing what else to do, I nod at the director and say, "Thank you."

Brite reports that she thinks of herself as a boy. She knows that she is biologically a girl, but she says, "I like being a boy." When she wears a dress, she is a boy cross-dressing as a girl. Brite tells me that the reason she likes being a boy is that she always noticed that the boys in stories had the "best and most fun adventures." Though Brite reports this authentically, it seems likely that her gender identification as a boy goes beyond her justification that cultural power norms and narratives are expressed through male characters. From a very early age, she looked like, acted like, and dressed like a (culturally typical) gendered boy. Many people would mistake her for a boy, even those who knew she was a girl would sometimes use the male pronoun when talking about her. In the community, however, she is expected to comply with rules that designate her as a girl. That's why the option for her to play male characters in mytho-poetic play and theater is so important. It allows her to embody her gender identity as a boy within a socially normed venue.

Theatre Adventure, 2011

As is sometimes the case with "seasoned" actors, twelve-year-old Brite wants to play more than one role in a show. They are putting on a play based on an old tale, *The Princess and the Goblin*.

Brite's main role is as a local miner boy who is befriended by the princess, but Brite also wants to play in a prominent scene as a dove.

Laura nods, "That's great. The white dove does a special dance. Are you willing to do that?"

Brite agrees and spends the next couple of weeks learning the dance and her role as the dove.

As it gets closer to the show, they start developing specific costuming instead of just grabbing things off the rack. Brite's mother Paula is the resident costume-designer/maker for the show.

Laura says, "We're going to need a white flowing dress for the dove."

Hearing this, Brite shakes her head, "No. I'm not wearing a dress."

Laura emphasizes, "The dove *really* needs to wear a dress because the motion of the dance moves the fabric so the dove looks like it's flying."

"No. I'm a boy dove."

Laura persists, "To show the dove flying, I really think you need to wear a dress."

After Laura and Brite cannot reach a resolution, Darlene says (and Laura and Paula agree), "Let's find a way to make it work so Brite doesn't need to wear a dress."

Paula makes a costume out of sheer white fabric that includes full flowing pants instead of a dress.

In the show, Brite does her dance as a boy dove.

Warrior Cats Camp, 2011

Since 2010, Brite has been guiding her life by the characters, clans, and codes of the *Warriors* fantasy book series by Erin Hunter (2003).

One day, Brite asks me, "Can I lead a 'Warrior Cats Camp'? I could do an apprentice training for the little kids."

Since Brite has had her own challenges, which often result in her oppositional and noncompliant behaviors, I am hesitant. I reply, "Well, that would mean that you would have to be a mentor. Do you think you have enough experience for that?" At Theatre Adventure, Brite sees mentors who have developmental and behavioral differences so she knows the meaning of this term in this context.

Brite nods emphatically, "I can do it."

I agree to move forward with this idea.

With authentic and thoughtful reflection, Brite spends many weeks planning the form her leadership will take. She and I have a long discussion about her reliance on the "Warrior Cat Code."

Brite argues, "Warrior Cats fight for their clans and territories."

I reason, "My camps already have a *Code* that is not about fighting but about working together, sharing, and expressing care when someone is hurt or upset."

She and I finally agree that her Warrior Code will be applied for their play but not for interpersonal conflicts that might come up.

The camp begins. Cardboard boxes, scissors, markers, tape, all stand at the ready for the creative and utilitarian use of the evolving cats. The children dig through a large bin of fabrics, pulling out what they need to depict their characters.

"Can you pin this?"

"Can you help me cut this out?"

Brite uses tape to attach small, pointed, cut-out cardboard tips on the ends of her fingers. These are claws.

Face-painting also plays an important role for the embodiment of these characters.

With orange, brown, and black face paint to show she's a cat, twelve-year-old Brite stands with her hands as claws, poised in front of her.

"I'm a Warrior Cat!" she declares.

I watch as she hisses, growls, then races across the room followed by a trail of hissing children.

Brite turns to them and hisses to begin their training.

As part of their "apprentice training" to become Warrior Cats or Medicine Cats, Brite leads the small group of children in four activities of her design: *Sky Drop; Lightning Strike; Night Ambush;* and *Rushpaw Splash.* Warrior Cat territory consists of a thirty-foot open studio with thick rubber mats and tall windows that show the grassy yard outside (another training ground). Warrior Cats belong to different clans based on Hunter's series: Thunder Clan; River Clan; Wind Clan; Shadow Clan; and Star Clan.

Several children stand at the ready. They all have faces painted to look like cats and they wear ears, tails, and capes. Though Brite is twelve years old, the rest of the children are ages five to eight. They follow Brite's instructions – running, jumping, pouncing, and fighting.

In a gentle but firm voice I call out a reminder, "Pantomime!" They know that this means not to really hurt each other but to just play-fight.

I watch the magic unfold and capture it with my camera.

When I get back to my computer and open the images, I see what I did not "see" with my mythic eyes. The participants are wearing their everyday clothes – pinks, yellows, blues, in various decorative and stylized flowers, polka dots, stripes – partly covered with fabrics hanging off their bodies in all sorts of disarray and ambiguousness. They are no longer the Warrior Cats I had seen earlier that day. I realize that in these improvisational activities, the embodied play is for the players, not for the audience. It occurs to me that this may reflect the transgender experience; it is how the individual experiences themselves inside, not how they look to others.

From a very early age, Brite has embodied archetypal and mythic characters as her preferred method of exploring her world and framing reality. Through the characters, costuming, and embodied enactment, Brite has tried on gender differences. In the above programs, by exploring and embodying different archetypal identities and genders, individuals can safely experiment with their own identity and gender without too much risk. Brite played Knights and Warrior Cats in the Mythic Play camps to likely express her masculinity and the power and fierceness

to survive and thrive. At Theatre Adventure, Brite was allowed to express gender difference in narrative productions – for herself and to be witnessed by the audience. These creative costuming and narrative experiences helped Brite to express and later become the boy that lives in her.

Epilogue

Coming out as a boy, 2015

I drive up to their house after two years of living overseas.

Paula answers the door and we hug hello and briefly exchange news.

I see in the next room that Brite is on the computer. At almost sixteen years old, she is a bigger version of the twelve-year-old I saw three years ago – same round face, freckles, and short blonde hair.

With a shy smile, she gets up and gives me a light hug then sits back down. After a few customary greeting rituals of "How are you?" "Nice weather," and such, she looks down and says quietly, "Um, I have to tell you something."

I wait for her to continue.

She is still in front of the computer, but turned toward me with eyes on the floor. I wait.

Finally, Brite begins, "This may be confusing." She has an unusually mature, almost parental, explanatory tone. Finally, she finishes, "But I'm a boy now. Transgender."

I raise my eyebrows, "Wow." Then I shrug and add, "But I always knew you were a boy."

He looks up at me, "Really?"

We keep eye contact as I nod my head in affirmation, smiling, "Brite, remember all the times you told me how you felt like a boy and remember how you always pretended to be a boy? Remember when you got in trouble for using the Boys Room at the Boys & Girls Club?"

"Oh yeah." He looks into the distance thoughtfully.

We sit together in silence for a few minutes. It is a comfortable silence.

As he turns back to his computer he asks, again in a mature tone, "Do you want to see what I'm working on?"

He tells me later about how he had been in the car with a family friend who told him about her friend who was transgender.

He explains to me, "As soon as she said it, I knew. I knew that that was me. I had never heard about 'transgender' before, but I knew that was me. That's the day I 'came out' as a boy."

Spring, 2017

Adam Brite-Star Shard is now almost eighteen years old. It has been a little more than two years since he identified as transgender. Though he does not use costuming in the same way, Adam creatively explores his identity through computer

drawing and online role-playing games. He has his own computer server from which he makes accessible his Warrior Cats/Medicine Cats role-playing game for himself and online participants. He also created a version of Warrior Cats Minecraft.

We arrange a visit to work on writing this chapter.

Adam sits in front of his computer and shows me his server. "These are my friends." He names five peers he knows who are now depicted as Warrior Cat/Medicine Cat-Simpson hybrids on his screen.

I nod, "Wow, you draw those on the computer?"

He demonstrates for me: Using his mouse with a computer drawing program, he draws a Simpson face with a cat's snout, ears, and whiskers.

"And these are your friends?"

"Well, they were." He keeps drawing, "I don't really have many friends at school. Ya know, 'cause I'm different." He shrugs then adds, "The only time that I felt like I really fit in was when I was at Theatre Adventure."

There is an awkward silence.

Then I say, "I finally got my PhD," then jokingly add, "You can call me Dr. Jeannie, now." My smile fades when I see him flinch.

Shaking his head, Adam responds flatly, "No." Then, keeping his eyes on his computer screen he explains, "Ya know, because of my PTSD about doctors."

I nod and sigh, reminded of the wounds this Warrior Cat still bears.

This is not the end of the story. Adam has decided to go back to Theatre Adventure for their summer program. Perhaps he will become a mentor. They may decide to create a show based on the Warrior Cats in which Adam can star. Perhaps Warrior Cats have nine lives.

References

Fisher, Kelly R., Kathy Hirsh-Pasek, Roberta Michnick Golinkoff, and Shelly Glick Gryfe. 2008. "Conceptual Split? Parents' and Experts' Perceptions of Play in the 21st Century." *Journal of Applied Developmental Psychology* 29, no. 4: 305–316.

Garland, Judy, Frank Morgan, Ray Bolger, Bert Lahr, Jack Haley, Victor Fleming, Mervyn LeRoy, et al. 1996. *The wizard of Oz*. Universal City, CA: MGM, UA Home Video.

Hunter, Erin. 2003. *Into the wild*. New York: HarperCollins Publishers.

Johnson, David Read, and Renee Emunah. 2009. *Current approaches in drama therapy*. Springfield, IL: Charles C. Thomas.

Jung, C. G., and R. F. C. Hull. 1990. *The archetypes and the collective unconscious*. Princeton, NJ: Princeton University Press.

Moore, Robert L., and Douglas Gillette. 1991. *King, warrior, magician, lover: Rediscovering the archetypes of the mature masculine*. San Francisco: Harper.

Sartre, Jean-Paul. 1943. *Being and nothingness: An essay on phenomenological ontology*. New York: Philosophical Library.

Sutherland, Jeanne Marie. 2014. *Imagining dialogue with other voices as part of indirect, post-heroic leadership development: Writing mytho-poetic narrative as arts practice exploratory inquiry*. Dissertation Abstracts International. 77–81. Thesis (Ph.D.), Union Institute and University.

9
ON BEING A MALE DRAMATHERAPIST

Clive Holmwood

Introduction

Throughout my career I have never really considered the issue of being a male dramatherapist. Like Tavani (2007), whilst training as a male dramatherapist I noticed that I was in a culture in which males were a minority surrounded by female trainees. To an extent this is not to be unexpected in the so-called caring professions. As a dramatherapist in training, out of a group of 12 there were two males including myself. Our main dramatherapy lecturer was male but part of a team of mainly female dramatherapy lecturers at the University of Hertfordshire when I trained in the mid-1990s. Hudson and Jacot argue that:

> The maleness of women and the femaleness of men are assumed to be hidden landscapes, waiting to be discovered. If we are to be personally fulfilled, we are encouraged to believe, we must 'get in touch with' those parts of ourselves that the culture has 'conditioned' us to deny.
>
> *(1991: 2)*

Bearing this in mind, whilst attending many arts therapy conferences since the 1990s, I have often found myself in large groups with only a small proportion being male, I probably gave little attention to this. My experience was not dissimilar to that of Tavani in the United States (2007) who also noticed this disparity between the sexes when he commenced his training as an art therapist in 2001. Now many years later as a practitioner and lecturer in the field of arts therapies, I notice this is still a current theme, a theme I have taken for granted and never fully acknowledged or explored, until now, echoing Hudson and Jacot's idea that I have somehow been 'conditioned' 'to deny' the 'hidden landscapes, waiting to be discovered' (1991: 2).

After a brief look at the limited literature in this area, I will consider my role as a male arts therapist, and specifically dramatherapist, using my experience of working with children and teenagers in a variety of settings since the mid-1990s. I will do this from a phenomenological and pragmatic perspective. I will briefly consider whether male arts therapists should work with: young female survivors of sexual abuse; whether male arts therapists can build a more positive therapeutic relationship with adolescent males who have sexually offended; and consider to what extent male arts therapists create a positive role model for male adolescents with absent fathers. I will consider these ideas from the perspective of the two major theoretical influences upon my dramatherapy practice – attachment theory (Bowlby, 1989) and systemic theory (Burnham, 2002). By revisiting assumptions about maleness in the therapeutic space (Scher, Stevens, Good & Eichenfield, 1987), I hope to begin to delve (albeit briefly) into an area that historically may have been considered taboo, or more accurately in my case at least, just completely ignored. I hope that this will begin to add to the currently meagre debate on this issue.

Literature review

Little consideration has been given to the role of the male arts therapist in the literature and the profession. There is some excellent work that considers working creatively in therapy with boys such as Haen (2011); however to my knowledge nothing specifically has been written on the *role* and *impact* of the male dramatherapist, my own profession. I was able to find a brief discussion by Michael Barham, who in a British Association of Dramatherapy journal questions the impact of gender upon the development of the profession in the UK. He states that a recent survey (1995) suggested 76% of UK dramatherapists were women, implying that 24% were male. Barham references Etzioni (1969) and argues that:

> Professions which are disproportionally staffed by women have greater difficulty being accepted as a profession by other 'higher professions' and by the public; he terms these professions 'lower professions'. So, it could be argued that the marginal status of these groups is regarded partly as a function of the low status attached to women generally.
>
> *(Barham, 1995: 34)*

He appears to suggest that the lack of men in the dramatherapy profession has a potentially negative impact upon how the profession is perceived, and how seriously it is taken. This could be considered a very controversial view from a feminist perspective, and something I have little space to discuss any further here. However, Barham does point out:

> It also seems important to me to be sceptical concerning the argument that the gender balance of a 'lower State' registration provides access to employment in the NHS and in local authority Social Services departments. . . . It

would be quite incorrect to state that women who occupy similar posts to men as dramatherapists or within the BADth exhibit distinctively 'female' patterns of behaviour when it comes to matters of a professional and organizational kind.

(Barham, 1995: 35)

Much more recently, and in a similar way, in the *Drama Therapy Review* in the United States Frydman & Segall (2016) carried out some statistical research into the impact of the professional 'trajectory' of dramatherapists based on their gender. Their results were inconclusive due to size and scale of their study, however, stated that the specific sex of the therapist had an impact upon their career development; 'specifically women were found to advance at a faster rate than men by an average difference of 1.92 years' (2016: 31). They point out that the nonlinear career development, small sample size and much larger female cohort in the profession make it difficult for results to be both accurate and true across the profession and have the potential to slew the results. They concluded that:

> the rationale presented was that other variables played a larger role than gender, including personal initiative, other social locators, location, qualifications and professional identity as a creative arts therapist.

(2016: 36)

However, these discussions address the state of the profession and professional development as opposed to considering the nature of gender and the male gender and its impact upon practice. It does however also seem telling that this general issue has only been addressed twice in 20 years, once in the UK fleetingly, and once again more thoroughly in the US more recently.

There are to my knowledge only two papers about the *role* of the male *art therapist*. It might be considered that the lack of men generally in the profession might be one reason for this. Firstly then, Tavani in the United States reported in 2007 'that 91.3% of all members of the American Art Therapy Association (AATA) were women (6.2% men, 2.5% not specified)' (Tavani, 2007: 22). Thus, confirming what was probably known, but never fully considered, or explored, that only a tiny percentage of men appeared to be art therapists in America in the early part of the 21st century. Tavani goes on to state that in his research he could find no literature 'addressing the state of male practitioners in the field' (2007:22). Tavani offers a very valuable statistical analysis and hypothesis, stating that:

> More than half the respondents were aware of the gender disparity when they entered the field of art therapy but nearly 40% were not aware of this imbalance. Also, the level of awareness was less in younger age brackets; these data could support the possibility of a societal shift in men's expectations about gender in the professional world.

(2007: 26)

He further discusses in the statistical analysis of his survey that men in their 50s were the only ones to consider themselves as 'feminists' but concludes this is due to them reaching maturity during the era of civil rights in the 1960s and early 1970s.

The only other major piece of literature I can find, which incidentally considers the different approaches between male and female art therapists, as opposed to the disparity in numbers, is written by my fellow colleagues at the University of Derby, UK, Hogan and Cornish (2014). They consider the difference in approach between male and female art therapists and the potential impact on their clients. They acknowledge that male therapists overall tend to consider the impact of their gender as more significant than females. Other than Tavani, and Hogan and Cornish there is to my knowledge no other academic writing, theory, or research within art therapy, and none that I can find within dramatherapy, that considers the impact that being a male arts therapist has, especially from a male perspective, bearing in mind that only one of the two studies to date is written by a male.

In a similar way to Tavani, Hogan and Cornish carried out a statistical survey amongst the members of BAAT, the British Association of Art Therapists. However, they themselves acknowledge that the 12% return rate was disappointing and might not be considered statistically significant. They mindfully state:

> . . . it is possible that the overall sample is not representative of the overall population of art therapists, because those with interests or strong views may have been more inclined to complete the questionnaire. Although 12% of a total population would often be viewed as a reasonable sample size, we recommend that a larger proportion of the art therapy population be induced into participation for further work on this topic.
>
> *(Hogan & Cornish, 2014: 123)*

Of the 12% who did respond 13.8 % were male, 84.2% female, and 2% other; 83% of those respondents considered themselves heterosexual and 69.4% of the respondents considered themselves white British (2014: 124). What did seem interesting is in response to the question: How important is your client's sex (gender) to the way you would commence art therapy? Hogan and Cornish state:

> Looking at a breakdown of the same question which analyses how men and women responded, we see a bell-shaped curve again, but we can now see that the highest number of male respondents (37.5%) regard gender as 'very important' whereas the highest number of women (37%) thought it was 'quite important' with a very slight lean towards lack of significance overall for women, with 18% of respondents reporting that it is 'not important'.
>
> *(Hogan & Cornish, 2014: 123)*

Therefore, their research could suggest that male art therapists give more credence and consideration to their gender and its impact upon client work than female therapists. This does seem to offer a different perspective to my own view at the

beginning of this chapter where I suggest it is just ignored. It might not actually be ignored, it just might not be discussed.

Hogan & Cornish (2014) have also considered the difference in approach between male and female therapists and the potential impact on their clients. They acknowledge that male therapists overall tend to consider the impact of their gender more than females. However, despite this there is little academic writing, theory, or research within the arts therapies and none within dramatherapy considering the impact that being a male therapist has, especially from a male perspective.

The male therapist

It could be argued that the historic development of therapy and psychotherapy in general was initially dominated by the male medical profession, formed by Freud and his male colleagues and the 'Vienna Psychoanalytical Society' in the early part of the 20th century (Landy, 2008: 9). The psychotherapies, which were closely aligned to the medical profession, were at the very beginning a male-dominated affair. Some would also argue there was a considerable level of misogyny as men's perspectives of women were coloured by the prejudices of their day. Freud's now-famous 'Fragment of an Analysis of a Case of Hysteria' (Masson, 1997: 84) is a good case in point. Freud's miscalculated belief in this case that the young girl, 'Dora', secretly fantasised about her father's friend's sexual advances, rather than believe, as she genuinely stated, that she found them downright repulsive, could be a good example of setting the tone of early experiences with male therapists, making judgements which could in hindsight be viewed as misogynistic in nature. Of course, this is one historical example and we should be careful not to draw conclusions from this about current perspectives.

Bringing therapeutic work much more up to date in the wider academic and practitioner arena today, there is significant literature on working with men and boys therapeutically and creatively, for example Haen, 2011. Whilst he does consider a plethora of ideas about how to work with males and boys creatively, it does not consider specifically the nature of what it is to be a male *arts* therapist and the unique role they play with their clients. However, the prejudices towards female clients in Freud's day and male clients in our own era do have some connections. Haen (2011: 7) notes that literature of the early 1990s that presents men and boys being in crisis over their masculinity was not in his view accurate:

> I was starting to see more and more boys, both in a clinical context and out in the world at large, who didn't seem to be emotionally vacuous, alexithmic, relationally inept, passive victims of socialisation (as) I was taught to expect.
> *(2011: 7)*

As with Freud, each generation manufactures its own conscious and unconscious societal prejudice about how we should respond to gender: men and boys, girls and women. It could be argued this is difficult for even the most reflective therapist

to escape from. Additionally, do these societal expectations also cross over into the kind of work female and male therapists are supposed to carry out?

As a dramatherapist two of the major influences upon my own work over the last 10 years have been attachment theory (Bowlby, 1989) and systemic theory (Burnham, 2002). This is mainly because of the variety of work I have carried out within the looked after system, supporting both children, foster carers, and birth parents whose children have been removed from them by the courts, and young people (under the age of 18) who have sexually offended.

Systemic approaches (their varying subsidiaries put to one side) (Burnham, 2002), sometimes described as 'family therapy', give greater emphasis to the external stimuli on children and family groups, and therefore the generational, social, and societal context and prejudices within which all therapists work. Having done some initial training in this area I later understood when a systemic therapy colleague of mine once said, 'transference, counter-transference, we don't believe in it, it doesn't exist'. What I now suspect she was trying to say was that she perceived the conscious and unconscious processes between client and therapist from a much more systemic perspective than those who trained within more of a psychodynamic or psychoanalytical perspective. The frames of reference were different. I also wonder whether the frames of reference of a male arts therapist are also different, but as I discussed earlier those frames of reference have not yet been fully explored.

Secondly, the other major influence on my work is that of attachment. Bowlby (1989) and his followers have at times in more recent years had some negative publicity, his work at times being considered white, middle class, and mid-20th century. However, his context of 'The Secure Base' (1988) and what happens when there is a lack of it is something that constantly rings true within my practice, and the various forms of secure or otherwise attachment I have seen on a regular basis in children.

So, taking on board my own background as a male dramatherapist, acknowledging my influences of systemic and attachment-based foci, how do I work or operate, acknowledging my gender, and how does it influence what I should or should not be able to do?

Three examples

I will discuss three generic examples from my practice and the perceived impact as a male arts therapist, and specifically a male dramatherapist. I will reflect on these experiences from an empirical perspective, acknowledging my dramatherapy practice alongside systemic and attachment-based theory.

1 Should male arts therapists work with female victims of sexual abuse?

In the early part of my career I would have accepted that it was a given, it was obvious, that a female victim of sexual abuse needed a female therapist. The perpetrators were almost always male, and the victims almost always young, vulnerable, and often female.

The logic behind this was simple enough, and the anxiety around self-protection for the therapist always present. Male represented 'abuser'; therefore, the therapist could not be male. In hindsight, this represents a form of fuzzy logic (Pillay, 1996), a binary approach within which we can often become stuck; as Dewey, the famous educationalist said 'mankind likes to think in terms of extreme opposites. It is given to formulating its beliefs in terms of Either-Ors. . . .' (1938: 1). Burnham suggests that we consider what he famously came to describe as the social GRRAAAC-CEEESSS (2012: 139) as a way of considering our relationship to Gender, Geography, Race, Religion, Age, Ability, Appearance, Class, Culture, Ethnicity, Education, Employment, Sexuality, Sexual Orientation, Spirituality etc. and all the other wider systemic contexts. Marshall (2011) in relation to male sexual abusers offers a strength-based approach in which he considers we should focus on individuals' strengths rather than their deficits. Therefore, in a similar way, a male therapist working with a young female victim who has been sexually abused has the potential to offer an alternative perspective on what maleness is. That a male therapist can be trusted, can be caring, and can offer a space in which a female victim of sexual abuse could feel safe. It could be argued that a female victim may feel inhibited working with a male therapist. The client first and foremost must make the choice. I wonder how often they would be denied the choice of working with a male therapist and whether fuzzy logic might suggest only ever offering a female therapist.

Additionally, what is it a male dramatherapist can offer as opposed to a female dramatherapist, or another profession for that matter? A dramatherapist can offer a non-directive play-based approach. Role, empathy, and distancing (Jones, 1996) offers a way of looking at situations through distance of story, inanimate object (to create even further distance) or character, that creates safety and a safe distance for the client. The male dramatherapist offers close physical proximity in which the client can be physically close to a male, and feel and be safe. Could the male dramatherapist also offer an additional anchoring in the idea that men can be safe, men can be okay, and that some men care? Does this further assist in developing a more gendered approach that historically has been brought down to a binary (a very crude one, I acknowledge) that women are okay, and men are not okay? What if men also have the possibility of being okay and that as part of the emotional and psychological healing of the young client this can be demonstrated within the therapeutic relationship, using safe distanced play-based approaches in which the client can explore their experience through story, inanimate objects, and play in the presence of a male dramatherapist.

2 Can male arts therapists build a more positive therapeutic relationship with adolescent males who have sexually offended?

I worked for several years with young men (up to the age of 18) who have sexually offended or have been at risk of sexually offending. It is interesting that the fuzzy logic we discussed earlier also appears to work here in reverse. Young men who

sexually offend 'need a male therapist',[1] to again put it crudely, to 'point out the error of their ways'. The natural presumption being that the young male offenders might need a male, who represents strength and masculinity, to show them an alternative. I also must acknowledge the counter argument here; a female therapist may be able to offer a feminine perspective to the work. However, this simple binary argument, either way, and it is simple, could be argued is not a strength-based model but a deficit-based model, looking for the simple maleness or femaleness in the equation, and possibly the male therapist as being punitive and judgemental, without considering the wider application of a male working with the client. Anecdotally, many of the young men I worked with had themselves lacked a male role model in their lives. They lacked a male who could have shared with them their experience of and their understanding of relationships (or conversely did on occasion share their inappropriate understanding of relationships). Hypothetically this could have impacted upon their own secure base (Bowlby, 1988) as an adolescent and their understanding of what relationships are about and what they mean and the practicalities of what should and should not happen within personal and sexual relationships. However, the alternative is also true; many of them also lacked the support of a female care giver who could also offer something similar. Therefore, the simple binary of male or female arts therapist becomes much more nuanced when considering the nature of the work with this specific client group. The additional issue of being able to source a male arts therapist (when males are a minority, in a minority profession) to carry out the work, when felt appropriate, can also be challenging.

Again, what of dramatherapy specifically, and a male dramatherapist? Historically physical games within dramatherapy are a mainstay of the profession. In previous work, unrelated to this directly, the building of dens and even what I have termed 'therapeutic football' have been used as a way of trying to create the beginnings of a therapeutic relationship with the client. What is it that a male dramatherapist can bring to the work that a female dramatherapist might not be able to bring? What is permissible within the context of a male-to-male dramatherapy relationship that might not be within a female-to-male dramatherapy relationship? Is there a greater possibility for the playing of physical games that might involve appropriate touch, or close physical proximity and how does this play out? How does this become explored within the context of the young male offender working with a male dramatherapist?

The concept of embodiment maybe particularly relevant here in the realm of dramatherapy. Milioni (2008) describes embodiment as being central to dramatherapy practice. Embodiment being the connection between the mind and the body, often not considered as central in other non-arts-based therapies. As Milioni describes, 'This view relies on a dualist notion of mind-body separateness' (2008: 3). Touch is also seen as central to in this context of embodiment. Milioni notes: 'Dramatherapy literature also constructs bodywork, including the use of touch, as only appropriate under certain conditions or with certain client groups, through the construction of "vulnerability". . . . The construction of "vulnerability" refers

to the use of the body and touch being represented as threatening and invasive for the client' (2008: 6). This concept creates particular potency within the therapy space when young offenders have often been found guilty of inappropriate touch themselves. Could a young male offender make embodied connections within a mind/body/touch scenario with a male therapist in a way they might not be able to with a female therapist?

The dynamics of the space could be considered to be different when a male therapist and male client explore touch as opposed to female therapist with a male client, as the perceived rules and anxieties on both sides may feel different. Does the male dramatherapist give implicit permission for themselves and the client to explore embodied touch in relation to their offending in a way that a female dramatherapist might not?

Does the nature of two males, or a group of males in a space, open different physical avenues through which the young person's behaviours can be explored – through the rawness of physical energy and games, through the ability to face up to difficult and complex issues a young offender might be expected to face up to? Talking in these cases might not be enough, or conversely in fact talking may be too much, especially in cases where the young offender is in denial of their offence. Therefore, might an arts-based approach with a male therapist and the specific skills of a male dramatherapist allow work to develop in ways it might not with a female dramatherapist?

3 To what extent can the male arts therapist create a positive role model to male adolescents with absent fathers?

Weber and Haen consider attunement, self-regulation, and the concept of 'state regulation'. They suggest that adolescents constantly respond to moments or 'states' within a therapy session, their individual 'self-state' can alter dependent on threats etc. (Weber & Haen, 2016). This might make connections with the ideas I have discussed above of the physical proximity, touch, and energy levels in physical games. Weber and Haen do not consider this from specifically a *male* dramatherapy perspective. They do point out however that the drawback of attachment theory is that 'it primarily used the paradigm of the traditional family, so that families composed of two mothers or fathers are largely invisible within attachment research....' (Weber & Haen, 2016: 218).

It could also be argued that the very nature of a male dramatherapist working physically with a male client does consider the unconscious paternal bond, and echoes the father-son relationship, but that their very maleness allows them to explore physically the subject and subjective nature of their work in a way that might not be possible with a female therapist to male client. In the proximity of the relationship, the physical nature of the practical activity, the physical strength and intensity and closeness of the physicality, impacts upon the building of the relationship. However, as Weber and Haen point out 'when role-play becomes too much like reality, the play space collapses, and attuned connections ceases ... modulating

needed distance fosters brain integration, self-regulation and the ability to take in the therapeutic relationship' (Weber & Haen, 2016: 221).

Haen (2011) considers Super Heroes with adolescent boys in relation to the role of the absent father, suggesting that boys often gravitate towards the role of: 'man of the house' (2011: 165) placing a large burden of responsibility on the child once the father is no longer present. Haen states the child is 'attracted to the role because it allows him to play out fantasises of power and importance but ultimately leaves him feeling inadequate and overwhelmed' (2011: 165). The child does not have the emotional or physical maturity or ability to take on the role of the absent father.

The child should not be in a position where they are unconsciously forced to over-compensate and take on a role they are not prepared for or that they should play. The masculinity and its interplay between the therapist and client has the potential to take on a special and specific meaning here within the dramatic therapeutic play space. The therapists role is to guard against the negative implications of this.

Therefore, it could be argued, from an attachment and systemic perspective the games played between a *male* dramatherapist and a *male* client, as I have played on many occasions, help form and develop neural pathways in adolescents and allow them to begin to think about the impact or effect of both the present *and* absent father. The lack of authoritative or, transversally, emotional connectivity in a young adolescent male may be supplemented, be it briefly, in the male dramatherapist, who could represent some form of male parental figure, who otherwise has unfortunately been absent.

Conclusions

I make no apology for the wider assumptions the three examples above might suggest in this chapter. I fully acknowledge the potential for alternative views and perspective which I have been unable to consider in the space I have here. What it has done is to begin to consider the nature of the role and impact of the male arts therapist, and specifically the male dramatherapist, curiously a position rarely before explored within the profession. This might possibly be due to the lack of male arts therapists, or because the very nature of the consideration of the subject might be considered in itself to be slightly controversial. However, Hogan and Cornish's research did suggest that the male art therapists did attribute greater significance to their gender than females. It is interesting that males have rarely expressed their thoughts on the subject, the assumption being that male and female arts therapists can by and large do very similar if not the same work within a broad cross-section of the community, which of course they can. Male therapists might also be seen to be more sensitive and emotionally tuned than the average male, therefore less reluctant to share their views on maleness?

The examples I have discussed are by their very nature selective, as they are based on my own experience as a male dramatherapist. The lack of discussion about the role of the male arts therapist might as I have said be a crisis of confidence

in maleness, or just a minority group within a minority profession; a place men generally are not used to being in and maybe not sure how they should respond. Therefore, do we (male arts therapists) modulate our thinking, thus preventing us from considering the unique position we are in, and seeing it from a position of positivity and strength, as opposed to a position of perceived negativity in a politically correct world?

Therefore, I seek nothing more than to begin to consider the role of the male arts therapist as 'hidden landscapes, waiting to be discovered' (Hudson & Jacot, 1991: 2). Let the debate continue.

Note

1 Though in my experience they often ended up with a female therapist purely due to the lack of male therapists working in the organisation, as the only male on the team I couldn't work with everyone. Though on the few occasions when I have co-worked cases with female therapists, this has appeared beneficial to the client. Unfortunately, I do not have space to begin to discuss therapy from a parental dyad perspective here.

References

Barham, M. (1995). Dramatherapy: The journey to becoming a profession. *Dramatherapy*, 17(1–2): 33–39. doi:10.1080/02630672.1995.9689390

Bowlby, J. (1988). *The secure base*. London: Routledge.

Bowlby, J. (1989). *The making and breaking of affectionate bonds*. London: Routledge.

Burnham, J. B. (2002). *Family therapy*. London: Routledge.

Burnham, J. B. (2012). Developments in social GRRRAAACCEEESSS:Visible-invisible and voiced-unvoiced. In I. Krause (ed.) *Culture and reflexivity in systemic psychotherapy- mutual perspectives*, pp. 139–162. London: Karnac Books.

Dewey, J. (1938). *Experience and education*. New York: Palgrave Macmillan.

Etzioni, A. (1969). *The semi-professions and their organisation*. New York: Free Press, pp. vi–vii.

Frydman, J. S. and Segall, J. (2016). Investigating the glass escalator effect among registered drama therapists: A gender-based examination of professional trajectory. *Drama Therapy Review*, 2(1): 25–39. doi:10.1386/dtr.2.1.25_1

Haen, C. (ed.) (2011). *Engaging boys in therapy, creative approaches to the therapy process*. London: Routledge.

Hogan, S. and Cornish, S. (2014). Unpacking gender in art therapy: The elephant at the art therapy easel. *International Journal of Art Therapy*, 19(3): 122–134, doi:10.1080/17454832. 2014.961494

Hudson, L. and Jacot, B. (1991). *The way men think, intellect intimacy and the erotic imagination*. New Haven: Yale University Press.

Jones, P. (1996). *Drama as therapy theatre as living*. London: Bruner Routledge.

Landy, R. J. (2008). *The couch and the stage integrating words and action in psychotherapy*. New York: Jason Aronson.

Marshall, W. L. (2011). *Rehabilitating sexual offenders: A strength-based approach*. Washington, DC: American Psychological Association.

Masson, J. (1997). *Against therapy*. London: Harper Collins.

Milioni, D. (2008). Embodiment and metaphor in dramatherapy: A discursive approach to the extra-discursive. *Dramatherapy*, 29(3): 3–8, doi:10.1080/02630672.2008.9689729

Pillay, K. (1996). 'Fuzzy logic – A theoretical perspective for the practice of educational drama and theatre. In J. Somers (ed.) *Drama and theatre in education contemporary research*, pp. 63–74. Canada: Captur Press.

Scher, M., Stevens, M., Good, G., and Eichenfield, G. A. (eds.) (1987). *Handbook of counselling & psychotherapy with men*. London: Sage.

Tavani, R. (2007). Male mail: A survey of men in the field of art therapy. *Art Therapy*, 24(1): 22–28, doi:10.1080/07421656.2007.10129360

Weber, A. E. and Haen, C. (2016). Attachment-informed drama therapy with adolescents. In C. Jennings and C. Holmwood (eds.) *The international handbook of dramatherapy*. London: Routledge.

10
THE PERILOUS HOUSE

Silvia Wyder

Introduction

In the context of my art therapy and cultural studies' PhD research at the University of Derby, UK, I carried out six months of fieldwork at the art and media department in Wil in German-speaking Switzerland in 2016. The topic of my research is how the *house* may be seen as a symbolic representation of the self in adults.

In this chapter I will share a case study where the theme of the *house* allowed a repeatedly battered, 'almost raped', alcohol-dependent, and at times, drug-dependent female patient to create alternative *houses*, which she depicted as spaces of partial withdrawal, and as giving possibility of 'gaining control'.

Clinical context

The clinic's department where my research took place is named Living Museum; it represents an approach which was founded by Dr Marton in New York in 1983. The concept of the Swiss branch of the Living Museum is that it consists of an 'asylum for mentally impaired people and of a museum of modern art. A Living Museum is an open studio and a day-care centre for people with mental disabilities [. . .]. Our mission is to provide mentally ill persons with a stress-free, supportive, and appreciative space, within which concerned persons can pursue a self-determined and meaningful activity [. . .], which may have a healing impact and may positively enhance the artists' identity' (Living Museum, Leitbild, 2015).

Methodology

My adopted research methodology consists of triangulation incorporating phenomenological, qualitative as well as quantitative approaches in order to best

address complex phenomena via multiple sources, such as participants' artworks and narratives, a 27-item semi-structured interview questionnaire (registered and transcribed), observational field notes, two psychometric tests: the Impact of Events-Scale (IES-R) measuring possible Posttraumatic Stress Disorder (PTSD) symptoms, and the Basler Befindlichkeitskala (BBS) measuring wellbeing as well as any available psychiatric diagnoses from Klinik Wil.

According to Petersen (2011, p. 17) art therapy approaches are based on 'at least three fundamental areas: the therapeutic relationship (patient and therapist), the therapeutic process and the aesthetic medium'. Elaborating research in this field is thus a complex undertaking since it includes observing and interacting with various simultaneously occurring phenomena, including social, spatial, temporal, aesthetic, and cultural elements, which can best be approached by using triangulation.[1]

In addition, I adopt a participatory approach to my research, referring to Bergold and Thomas's (2012) definition, where they 'argue in favour of the possibility, the significance, and the usefulness of research involving partners in the knowledge-production process' (Bergold, 2007, p. 57). For the two researchers 'the participatory research process enables co-researchers to step back from familiar routines, forms of interaction, and power relationships in order to fundamentally question and rethink established interpretations of situations and strategies'. In practice they point out the need for a 'safe space' since 'participatory research requires a great willingness on the part of participants to disclose their personal views of the situation, their own opinions (including dissenting and critical ones) and experiences'.

Furthermore, for Hogan[2] (2016, p. 133) participatory methodologies 'are those which situate the locus of power more fully with the recipients of services: though there is a spectrum of activity, consumers of services may fully set the agenda'. The notion of co-production of research with participants has become more widespread since some researchers wish to collaborate with patients on equal terms, rather than considering them solely as 'objects' to be researched for their data collection. This approach helps avoiding a possibly occurring inhibiting hierarchy between the researcher and her participants, which I consider as unhelpful for participants themselves, as well as for the research process and data acquisition.

Hence, I wish to let participants speak in their own voices through registered and transcribed interview narratives, which are whenever possible carried out by myself with the goal to as best as possible efface the researcher's interpretation and bias.

Method

My method regarding my art therapy research involves a closed session focus group format, by putting the emphasis on a safe space. Closed art therapy sessions were rather unfamiliar to the patients, as they are used to big open spaces of the Living Museum Ateliers.

After receiving ethical clearance, a pre-selection of possible workshop participants was made by the Living Museum's two head art therapists. Patients' diagnoses were kept 'blind' so as to best avoid any bias stemming from my side.

During an individual first meeting with interested patients, I introduced the topic of the *house*. Thereupon, after providing written informed consent, the majority started attending my closed art therapy focus group sessions after receiving ethical clearance (two groups, up to four persons per group, with overall equal numbers of women and men).

As a means of visual stimulation, a selection of 31 postcards showing various socially and culturally diverse house images were distributed on a table. These postcards were spread out every week in the same manner, which led to individual and/or group discussions or just silent 'visits' by workshop participants.

The art material consisted of acrylic paints, watercolours, oil, and pastel crayons, graphite pencils of various degrees of softness, Japanese ink, a ruler, a compass, brushes, and palettes. The paper sizes were between A3 and A0, and a large paper roll.

The term *patient* is used for addressing a suffering person without implying any sense of hierarchy.

Patient vignette: Ms L.

Ms L. attended mixed gender art therapy focus group sessions for the duration of four months. Ms L. is a 61-year-old woman who has encountered mutually violent behaviours with her deceased husband and perhaps also with her current partner, including an earlier 'almost rape' occurring. She has two grown-up children and is presently unemployed. Currently, she lives with a male partner whom she had met at the psychiatric clinic. Moreover, Ms L. also attended the clinic's Living Museum Ateliers (ceramic and painting).

Ms L.'s psychiatric diagnosis

In 2008 Ms L. received a diagnosis of 'drug use, besides alcohol and tobacco addiction and personality disorder' (Klinik Wil).

Later in 2015 her main diagnosis was ICD-10-CM F10.2, which is 'grouped within Diagnostic Related Group(s) (MS-DRG v34.0) including alcohol, drug abuse or dependence, with or without rehabilitation therapy'.

Reflections related to received psychiatric diagnosis in contrast to the IES-R PTSD self-evaluation test results

Considering Ms L.'s maximum scores based on her self-evaluation of the Impact of Events Scale-Revised (IES-R) (German version by Maercker & Schützwohl, 1998) testing for possible PTSD-symptoms, it is interesting to note that the levels of her scores may point to PTSD-symptomatology. Some of these include:

- No 5. I avoided letting myself get upset when I thought about it or was reminded of it.
- No 6. I thought about it when I didn't mean to.

- No 9. Images, which are related to the occurrence, suddenly popped into my mind.
- No 16. It happened that the feelings which were linked with the occurrence became suddenly more violent.

Furthermore, my MSc systematic review in mental health (Wyder, 2012) investigating possible correlational links between substance use disorder (SUD) and posttraumatic stress disorder (PTSD) demonstrated that psychiatric diagnostic procedures seem often to focus on consequences of traumatic experiences in form of e.g. alcohol and/or drug dependence rather than on causes, such as trauma, or PTSD. Additionally, this review established a correlation between trauma and SUD. Therefore, alcohol and/or drug misuse can be considered as a possible consequence of trauma, as a coping strategy, and is by some considered self-medication (Khantzian, 1997).

Socio-cultural relevance

According to Ms L.'s own description she considers herself as a 'despair drinker' ('Absturztrinkerin'), which started during her marriage due to on-going issues. According to the clinic's information, Ms L.'s husband was also an alcoholic. Following Ms L.'s narrative, she had 'swallowed' everything for a long time for the sake of their children. This behaviour conforms to Dekel and Andipatin's (2016) study findings where they write that 'women believe it is better to remain in an unsatisfying, conflict-ridden marriage for the sake of their children, than to leave the relationship' (p. 7), and further that women 'believe [they] need to adopt the feminine construction of the "good wife", as a "good wife" should accept a caring role regardless of her partner's abusiveness' (p. 8).

Additionally, Reavey and Gough's (2000, p. 331) findings of a study on repeatedly experienced physical abuse demonstrate that participating women seem to blame themselves for their 'choices' of abusive male partners by putting themselves in 'self-blaming positions'. As they rightly point out, partner violence, as well as, in my view, addictive behaviours, need to be therapeutically addressed not solely on a personal level, but need to also be embedded on a socio-cultural level in order to avoid self-blame; hence, they 'propose an externalisation of problems, a deconstruction of their origins and maintenance [. . .]' (p. 340).

Regarding Ms L.'s alcohol consumption, she said: 'To abandon guilty pleasures is so hard . . . if I don't feel good and I see alcohol . . . one has this thing in one's head, then I become weak. And if I feel fine, I think and I can be well without [alcohol]'.

Ms L.'s house types

The first painting of Ms L. showed a colourful, four-storey sea snail-like upright *house* surrounded by a garden. Further paintings included a woman lying in an open snail-like *house*. Later appeared a country house with a glass 'control tower' (Ms L., 2016) on the rooftop, featuring a multitude of entrance doors. The last painting was of a turtle, in which the *house* can be considered as inseparable from the animal's body.

Ms L.'s narratives and my related observational notes (excerpts)

Ms L. started drawing a *snail-like* organic *form*. Then she added grass on both sides, blue on the sides and on the top of the form. She started talking about the *door* on the ground floor. She said that she doesn't like closed doors. Ms L. continued saying that at her place they [she and her male partner] always have the doors open since she wishes people to come in [into the apartment].

When I came back to her table later on, she was working on *woman in snail house* [Figure 10.1, named by S.W.], painting created with the pastel pencils she likes. She said that she had seen a postcard of *a woman who was lying within a strawberry*.

As she was painting the background, she suddenly started singing an old Swiss German song: 'Hans im Schneckenloch, was er hat, das will er nicht, und was er will, das hat er nicht...'. This song is about Hans who lives in a snail house and it goes as follows: 'What he wishes for he doesn't have, and what he has he doesn't want'. Ms L. seemed to realise that she was singing aloud and said that she often is a bit nervous and that she has repeatedly experienced depression. In this context a discussion started between Ms L. and another patient, Mr F.; she said that sometimes when she feels down she goes to bed and completely curls up under a blanket. One could say that she withdraws and takes on a snail-like body position.

FIGURE 10.1 Ms L.'s Snail House, 3 August 2016.

In terms of her bodily bearing the French philosopher Gaston Bachelard (1957, p. 114) discussed snails and shells in his book *The Poetics of Space* by reason of these animals' forms and materiality. He refers to 'the symbolism of the Ancients, which made the shell the emblem of our body which encloses in an outer envelope the soul which animates the whole being, represented by the mollusc's organism. They said, the body becomes inert when the soul is separated from it, so too the shell becomes unable to move when it separates from the part that animates it'.

Later on, whilst filling out the IES-R PTSD self-rating questionnaire, Ms L. started talking about a man who knew her and caught her in front of her house and wanted to rape her. Upon my question, she said that she tried to defend herself by biting the man in the hand. I asked her whether she could escape. She answered: 'No!' She continued by saying that when there was a trial, this man had said that he did it since he knew her, and that if a young woman would have been there instead of her, he would not have done it. She also said that people had asked her how she was dressed. She was very upset and said that she had met a mental health worker who told her that it does not matter what she wore; nobody can rape anybody, no matter what clothes she or he is wearing.

Interestingly, a common linguistic link has been established between the nouns *house* and *clothes* in German. According to Gabriele Oberreuter, (2006 p. 91), basing herself on Grimm's German language dictionary from 1877, the term *house* is analogous with 'skin and sums up analogy terms such as: cover, salvage, clothing, armor, skin, leather, shelter'.

Clearly, there seems to be an attribution of blame expressed towards Ms L. for her dress style. It remained unclear whether the man who 'almost raped' her was a stranger. According to Reavey and Gough (2000, p. 327) 'seminal feminist texts drew attention to the link between sex and power, thereby attempting to shift responsibility from the individual to the social and from women and femininity' to men and 'masculinity' (e.g. Armstrong, 1978; Brownmiller, 1975; Ward, 1984). Attribution of blame in the present situation partially follows these considerations; as an individual, Ms L. *was* indeed questioned regarding her dress code, but on a more societal level, the health worker's statement hopefully alleviated Ms L.'s sense of self-blame, integrating the question of dress style within a societal context.

Throughout the session, Ms L. kept on mumbling to herself: 'It is not surprising that I am here [in the clinic] with all that I experienced. . . .'. Or, 'I am perhaps a bit strange, and that is why I am here'. As she was talking to herself, other participants sometimes looked at me and we just smiled at each other. It seemed to be a supportive smile, expressing mutual acceptance of difference and the troubles people may experience in their lives.

That day, Ms L. was wearing a summer dress without sleeves. As she took off her red leather jacket, I realised that she had a ten centimetres big bruise on her left upper arm. She told me that a very tall man had attacked her and held her very strongly. She continued saying that he was standing in front of her with his 'Schwanz' ('dick') hanging out and that he had said that he wanted to have sex

with her. She said that she did not know that person. I asked her whether she had gone to the police to denounce the occurrence. She answered: 'Yes I did, and the police officer [male, upon my questioning] asked me if the man had a "hard-on" ("Latte")'. She answered: 'No, it was just hanging!'

Once more, she repeated saying that years ago she had almost been raped; it seemed to me that she was checking whether I too would find rape terrible. Of course, I do and I very clearly let her know that. She seemed relieved, thereafter she added: 'I have tried so many addiction clinics and it never worked. I have tried but then one has these patterns how one deals with stuff. It is my fault', she said.

Country house painting with glass 'control tower'

Ms L. took out her painting (Figure 10.2) that she had started three weeks earlier. She hesitated a bit how to continue. As I stood next to her, she said that there are many (seven) doors, and that the two smaller ones on the right are for the cat and dog. She said that she wonders what she had in mind? I told her that she had many times talked about a 'house with a garden'. Looking at her painting she said that 'this does not really look like a garden, it does more look like paths towards the doors'. Regarding the water on the right, Ms L. stated that first she thought it to be a pond, but then she considered it to be a river, since 'I like water running by and the sound of it'.

FIGURE 10.2 Ms L.'s Country House, 19 July 2016.

Glass 'control tower'

Ms L. wanted to paint a rectangular structure, situated on the rooftop of her house. I asked her about the material and she replied that it would be made out of glass. She wondered how she could paint the glasshouse and tried using white acrylic paint. She pointed out that it is *her* space and that she wishes to have an *overview*. Ms L. painted herself within that glass-space: her depiction included her head with a rather smiling mouth and her upper body reaching down to her shoulders. There were no eyes, nor a nose, or ears.

Thereafter she 'covered' up her portrait with white paint in a translucent manner. After a moment, she decided that she didn't like the [her] face as she painted it, and covered it up in such a way that a figure could only be intuited.

Registered and transcribed interview narrative (excerpts)

Country house and 'control tower' painting

Ms L. had been away for six weeks due to a broken foot based on an accident (according to her). The final session consisted of a 27-item semi-structured interview questionnaire, as well as of looking at, and discussing her artworks.

'A river, a . . . a little door for the dog and for the cat, it should be welcoming, that's why there is light'. I asked if these are all entrance doors, or windows? Ms L.: 'Yes, yes, erm, entrance doors, open, or the like. Windows would be up there. And a nice balcony, erm, so that all people can be comfortable'. S.W.: 'It almost looks southern'. Ms L.: 'Yes, yes!' S.W.: 'I could imagine it to be in the Toscana'. Ms L.: 'YES, yes, but it must have a streamlet. . . . and up there . . . I made a sketch at home, and up here, there is, that's me, that's the *control tower*, and that's made of glass'. S.W.: 'Control tower. . . ?' Ms L.: 'So that I have everything under control!' S.W.: 'I see!' Ms L. laughs . . . S.W.: 'First you had started to paint a face [on the figure, which represents Ms L. as she had said earlier], then you were not satisfied, and. . . '. Ms L.: 'Erm, yes!' S.W.: 'And then you painted it over, made the glass. . . '. Ms L.: 'Erm, yes, yes. . . . it doesn't fit at all, but . . . I would now and then want to go up there, and control everything, if everything is ok, and then I would go down again, I would. . . [she starts to laugh] these are such fantasies, and up there I could watch the sun and the moon'. S.W.: 'And how would you get up there. . . ?' Ms L.: 'I don't know that, such technical problems. . . [we both laugh] I cannot solve. There is certainly a kind of a stairs, but no spiral staircase, that would make me dizzy [giggles like a young girl]'.

Turtle painting (last session)

Ms L. arrived and said that she thought to paint a *turtle*. She then went to her bag and got out some photographic printouts showing me several kinds of turtles. She also showed me a sketch she had already done at home on a piece of A4 paper. The turtle (Figure 10.3) was her last painting during my art therapy research workshops.

The perilous house **131**

FIGURE 10.3 Ms L.'s Turtle Painting, 3 August 2016.

According to Ms L. it was easy for her to work on the topic of the *house*: 'I had many ideas, but because of my . . . stupid . . . thing . . . I didn't have enough time'. Upon my question about how or why she chose certain colours and/or materials: 'I actually have tried everything. . . . how I chose it? Depending on my mood, I am an emotionally driven person'.

Regarding her painting process, she said: 'I cannot paint in a predetermined manner'. Asked about the location of the house on the paper, she said: 'I need "Bodenhaftung" (I need to be earthed, grounded). It is mostly in the upper third [of the paper], always a bit of the sky and beneath, the earth [...] grass, and the house in the middle'.

Gender studies/feminist notions

Ms L.'s life experiences need, in my view, to be seen in a wider, more global context as her abuses are unfortunately shared by too many persons: Young (1980, p. 138) refers to de Beauvoir (1949) by writing 'every human existence is defined by its situation; the particular existence of the female person is no less defined by the historical, cultural, social, and economic limits of her situation. We reduce women's condition simply to unintelligibility if we 'explain' it by appeal to some natural and ahistorical feminine essence' [...]. Further, Young defines 'femininity' as 'rather a set of structures and conditions which delimit the typical situation of being a woman in a particular society, as well as the typical way in which this situation is lived by the women themselves (Young, p. 140) [...]'.

Body memory and trauma

An additional important aspect regarding endured violence is pointed out by Fuchs (2008, p. 111), where he talks about the 'massive violation of human dignity regarding rape and torture'. According to him such 'violence of dignity is particularly humiliating and traumatising since it breaks the barriers of intimacy by reducing the victims to their bare physicality ("Körperlichkeit"), without allowing an opportunity to represent one's dignity'.

This is especially relevant since trauma and violence are inscribed *in* the body. As Summa et al. (2012, p. 424) write: 'The body remembers in a life-long learning history. Even the earliest pattern of how we are held, comforted, guided, and reacted to by your care-givers remains imprinted in the body, in our later actions and our entire habitus...'. [...] She further elaborates referring to Eberhard-Kaechle (2012) and Rothschild (2002): 'A characteristic of traumatic memory is that the explicit, declarative memory is deactivated during the climax of a traumatic event, while the implicit, procedural memory is activated. Therefore, verbal narrative is in a sense a goal and not the starting point for therapy' (p. 432).

Based on my fieldwork in 2016, it seems to me that the arts therapies may allow survivors of trauma to aesthetically, and at times indirectly access their traumatic experiences by expressing these painful life events through a symbolising topic, in this case, the *house*, which may initiate an alleviating, and hopefully transformative, restoring process. Furthermore, according to Levine (2009, p. 20) 'such a [new] form [of life] can be found only in the poetic (or "poïetic") shaping that can encompass the chaos of fragmentation of traumatic experience without promising any harmonious overcoming of contradiction'.

Discussion

For Fuchs (2008, p. 201) 'a picture is a peculiar entity between being and not-being: it shows us something that is not (itself). It presents something absent.... We see the image *as* an image, that is, we see what is depicted *as if* it were real'.

The *house forms* (snail, country house with 'control tower', turtle, shell) depicted by Ms L. seem to have allowed her to distance herself from difficult life issues, as she expressed in the final interview (2016): 'It distracted me from any kind ... of ... problem'. Also, it appears that the topic of the house allowed her to be 'above things', and gave a sense of 'gaining control' via the rectangular glass box, the 'control tower', on the top of the country house. Hence, it seems that her artworks and narratives permitted Ms L. to regain control within a safe art therapy space, which may perhaps be very difficult to achieve in her daily circumstances. Nevertheless, it may have given her a sense of empowerment, and of de-victimisation related to the repeatedly experienced physical aggressions.

Further, Fuchs, referring to art making (2008, p. 203), writes: 'With imagination and fiction, an immense freedom has been gained, an unlimited realm of possibility has been opened...'. The pictorial and artistic production is the realisation of this inner freedom, the re-transmission of the imagination into the material and visible world – an action that always remains a 'trial', an exploration of possibilities ('Probehandeln'), 'since it is within the framework of art' (p. 201).

Ms L.'s last painting, the turtle, is an animal that permanently carries, or rather has incorporated, its own *house* or *roof*. This may be protective but also limiting since it has no choice of leaving it, nor to separate itself from its *house*. The Greek term for carapace is 'carapax', in old Greek 'charpax' meaning fortification (Wikipedia, 2005, 2017). According to the Merriam-Webster's dictionary's definition fortification entails 'the act of building military defences to protect a place against attacks....' (2017). The turtle's armature-house thus is clearly an efficient protection against enemies as the long life expectancy of these animals additionally demonstrates. It also permanently allows a retreat at any moment from the outside world. Additionally, in contrast to Ms L.'s shell, or snail-like house forms, the turtle is able to move through space in a self-protected fashion.

Interestingly, the turtle could thus be considered to be a rather contrasting house representation when compared with earlier paintings where entrance doors were open (country house: nine, not just one), or where there was no door at all in the case of the woman lying (trunk and legs unprotected!) in the snail house. In my view, these houses may be considered as *perilous houses* since they do not seem to allow self-protection. According to McCarter (2016, p. 113) quoting the architect Frank Lloyd Wright referring to materiality:

> 'Glass and light [are] two forms of the same thing', yet the ability to form 'the space within' depended on precisely how glass was used.... The most notable type of all-glass interior space is the Modern all-glass building, which, due to the complete transparency of the bounding walls, may be defined as 'all prospect and no refuge'....

What Wright is suggesting, and this is relevant in the context of Ms L., is that glass structures certainly allow for views, light and walls, but make a real withdrawal, and thus self-protection, rather difficult.

Ms L.'s paintings corresponded to her wish of 'not having closed doors', and relate to an attitude of welcoming people at her house. Considering Ms L.'s repeated exposure to violence, all house forms (if one can generalise) are perhaps 'partial solutions' based on the points mentioned above. Furthermore, if one considers that according to RAINN (Rape, Abuse & Incest National Network) (2016) 'seven out of ten rapes are committed by someone known by the victim', and that these seem to take place close to, or in persons' homes, the usefulness of e.g. having 'closed doors' in order to better protect oneself is also disputable.

In this sense, Ms L.'s artworks and narratives are multi-layered:

- House forms with open doors, or no door, where entrance seems accessible to persons welcomed, but also to allow an easy access to intruders.
- The 'control tower' on top of the country house allows control, and overview, hence protection from others but involves, most likely, separation and isolation as well.
- A turtle house where the 'house', or 'roof' is incorporated in the animal's body offers protection, but may entail also restrictions as no separation is possible; it does however allow movement.

Recommendation

Finally, Reavey and Gough (2000, p. 327) assert 'that therapeutic interventions can focus too eagerly on the "personal" without acknowledging how people make use of culturally available discourses to represent their psychological history and interpret their past and present subjectivity' . . . by pointing out 'ways in which sexual survival is culturally produced and the positions of guilt, shame and victimhood reinforced thereof'. In a similar vein, regarding socio-cultural embedded behaviours and rhetoric, one might additionally consider 'rape culture'. Following Marshall University's definition, 'rape culture'

> is an environment in which rape is prevalent and in which sexual violence against women is normalized and excused in the media and popular culture. Rape culture is perpetuated through the use of misogynistic language, the objectification of women's bodies, and the glamorization of sexual violence, thereby creating a society that disregards women's rights and safety.
>
> *(2017)*

In other words, the topic of the *house* suggested within art therapy settings needs, in this sense, to also integrate its socio- and cross-cultural environments and persons' underlying past and current histories, relating to events and experiences *in* and *outside* the *house*.

Conclusion

The topic of the *house* served Ms L. to aesthetically explore different *house*-related situations; it also allowed her to distance herself from her current painful issues, as well as from past traumatic life events. For Ms L., the topic of the *house* seems to have allowed her to experience an alternative space-time through artistic expressions which provided her with pleasure and joy, as she had expressed several times. Additionally, it consisted of an attempt to regain control for body and mind within a safe art therapy studio, which might hopefully have permitted her to alleviate or to put into perspective her notions of self-blame and feelings of guilt.

Notes

The language of the interview narratives and workshop narratives was Swiss German. The Klinik Wil's notes and diagnosis were in German, as well as some citations. All translations are made by the author, including transcriptions.

1 Qualitative phenomenological, participatory, self-reflective, and quantitative approaches.
2 In her chapter on social art therapy.

References

Armstrong, L. 1978. *Kiss Daddy Goodnight: A Speak Out on Incest*. New York: Hawthorn Books.
Bachelard, G. 1957. *La poétique de l'espace*. Paris: Presses Universitaires de France, p. 114.
Beauvoir, de S. 1949. *Le Deuxième Sexe*. Paris: Ed. Gallimard.
Bergold, J. 2007. Participatory Strategies in Community Psychology Research – A Short Survey. In A. Bokszczanin (Ed.), *Poland Welcomes Community Psychology: Proceedings from the 6th European Conference on Community Psychology*. Opole: Opole University Press, pp. 57–66.
Bergold, J. & Thomas, S. 2012. Participatory Research Methods: A Methodological Approach in Motion. *FQS, Forum Qualitative Sozialforschung*, Vol. 13, No. 1, Art. 30, p. 17.
Brownmiller, S. 1975. *Against Our Will: Men, Women and Rape*. New York: Simon & Schuster.
Dekel, B. & Andipatin, M. 2016. Abused Women's Understanding of Intimate Partner Violence and the Link to Intimate Femicide. *FQS, Forum: Sozialforschung, Qualitative Social Research*, Vol. 17, No. 1, Art. 9, pp. 7–8.
Eberhard-Koechle, M. 2002. Memory, metaphor, and mirroring in movement therapy with trauma patients. In S. C. Koch, T. Fuchs, M. Summa & C. Müller (Eds.), *Body memory, metaphor and movement*. Amsterdam, John Benjamins, p. 432.
Fuchs, T. 2008. *Leib und Lebenswelt. Neue philosophisch-psychiatrische Essays*. Die Graue Edition. Die Graue Reihe 51. Prof. Dr. Alfred Schmid-Stiftung, Zug/Schweiz, pp. 111, 203, 204.
Hogan, S. 2016. *Art Therapy Theories: A Critical Introduction*. London: Routledge, Taylor & Francis Group, p. 133.
International Classification of Diseases, ICD-10. www.icd10data.com/ICD10CM/Codes/F01-F99/F10-F19/F10-/F10.21.
Khantzian, E.J. 1997. The Self-Medication Hypothesis of Substance Use Disorders: A Reconsideration of Recent Applications. *Harvard Review of Psychiatry*, Jan–Feb, Vol. 4, No. 5, pp. 231–244, PMID: 9385000, DOI:10.3109/10673229709030550.
Levine, S.K. 2009. *Trauma, Tragedy, Therapy, the Arts and Human Suffering*. London: Jessica Kingsley Publishers, p. 20.

Living Museum Verein. 2015. *Leitbild*. Wil, Switzerland: Der Vorstand des Living Museum Vereins.

Maercker, A. & Schützwohl, M. 1998. Erfassung von psychischen Belastungssfolgen: Die Impact of Event Skala-revidierte Version. *Diagnostica*, Vol. 44, pp. 130–141.

Marshall University. 2017. *What Is Rape Culture?* www.marshall.edu/wcenter/sexual-assault/rape-culture/.

McCarter, R. 2016. *The Space Within, Interior Experience as the Origin of Architecture*. London: Reaktion Books Ltd, p. 113.

Merriam-Webster. 2017. www.merriam-webster.com/dictionary/fortification.

Oberreuter, G. 2002. *Bilder aus dem Körperhaus. Frühe Räume bei Louise Bourgeois*. Kunstforum International, Band 182, 2006'. Titel: Die dritte Haut: Häuser I, p. 91.

Petersen, P., Gruber, H., & Tüpker, R. 2011. *Forschungsmethoden Künstlerischer Therapien*. Zeitpunkt Musik. Wiesbaden: Reichert Verlag, p. 17.

Reavey, P. & Gough, B. 2000. Dis/Location Blame: Survivors' Construction of Self and Sexual Abuse. *Sage Publications*, Vol. 3, No. 3, pp. 325–346[1363–4607(200008)3:3, 325–346; 013608], pp. 327, 331, 340.

Rothschild, B. 2002. *The body remembers: The psychophysiology of trauma and trauma treatment*. New York: Norton.

Summa, M., Koch, S.C., Fuchs, T., & Müller, C. 2012. Body Memory, an Integration, Chap. 26. In *Body Memory, Metaphor and Movement*. Amsterdam and Philadelphia: John Benjamins Publishing Company, pp. 424, 432.

Ward, E. 1984. *Father-Daughter Rape*. London: Women's Press.

Wikipedia. 2005, 2017. *Carapax*. https://de.wikipedia.org/wiki/Carapax.

Wyder, S. 2012. *A Systematic Review of Possible Causal Links Between Substance Use Disorder and Posttraumatic Stress Disorder*, MSc thesis in Mental Health: Psychological Therapies, Queen Mary University of London.

Young, I.M. 1980. Throwing Like a Girl: A Phenomenology of Feminine Body Comportment Motility and Spatiality. *Human Studies*, Vol. 3, pp. 138, 140.

11
GENDER FLUIDITY THROUGH DANCE MOVEMENT THERAPY

Julia Hall

This chapter will explore how Dance Movement Psychotherapy (DMP) has the potential to facilitate an embodied position of gender fluidity in children and young people. Despite much literature pertaining to the adult lived experience of gender roles in relation to assigned sex, little has been written about the child's experience. Contemporary literature has identified, however, that the act of ascribing gender roles and qualities continues to be the social constructs the child inhabits. Furthermore, within Child and Adolescent Mental Health Services (CAMHS) and Education there is growing evidence of the prevalence of mental health problems in children, associated with living in a rigid binary gender role. Poignant here is the ascribing of movement dynamics to gender roles and how gender stereotypes manifest in gendered self-perception and self in relationship with peers.

DMP affords an approach where the relationship between internal states and external expression are explored through the immediacy of the sensorial body. Moreover, movement expression may illuminate defended emotions and the presence of inner turmoil. Through examples of clinical work and approaches used, this chapter will seek to demonstrate a way of working: one that includes formation of an *embodied neutrality* within a spectrum of gender fluidity. A position of *embodied neutrality* offers a space where polarities of movement alongside arousal/energy levels can be explored, towards the ownership of a flexible movement repertoire that embraces anima and animus.[1] Moreover, this profits congruence between inner psychological and regulatory states, with external movement expression.

DMPs have forged a relationship with neurobiology, one that elucidates the notion that body movement can create changes in the brain. The neuroplasticity of the brain creates a potential for children to embody a *chosen* way of being and promotes a deeper body-based understanding of the *choices* available to them throughout their lives. Furthermore, this *embodied understanding* of shared attitudes towards gender could be transgenerational.

Shaping a body

Despite much literature pertaining to the adult lived experience of gender roles in relation to assigned sex, little has been written about the child's experience. Contemporary literature, however, has identified that the act of ascribing gender roles and qualities continues to be the social constructs the child inhabits. Research conducted within the education sector has illuminated the presence of perceived gender stereotypes held by boys and girls (see 'Breaking The Mould', National Union of Teachers, 2016). As children navigate their role in the world external influences can shape the child's everyday performance expression of self that has the potential to become incongruous with their inner feeling state over time as they develop. Through the child's engagement with society and exposure to the many codes it holds, the child's presence in the world may become an embodied 'stylised pattern of repetition' (Butler, 1990) or as Nayak and Kehily (2001) describe a 'choreography of gender' one that melds 'a set of culturally patterned activities' (p. 177). Furthermore, this repetitive performance of gender is an embodied practice (Allegranti, 2011) and as such could be described as transgenerational (Corbett, 2009). This gendered template can be passed on to the next generation as Orbach highlights in *Bodies* (2009):

> It is not just biology but physical handling, physical expectation and the physical relationship between parent and child that shape girls' and boys' experience of their bodies.
>
> *(2009, pp. 56–57)*

Furthermore:

> From a more physical perspective, it is clear that the historical training of girls to be demure and boys to be adventurous affected their bodies' structures.
>
> *(ibid. p. 56)*

Contemporary research has revealed the role of the sensing body and movement on the construction of the brain (Perry, 2014; Stern, 1998) and how 'Our bodies are made both in a literal physical sense and in a feeling sense' (Orbach, 2009, p. 57). This suggests that such crafting or construction in the early foundation years imprints a plethora of images with undertones of emotion and meanings that builds up over time towards a stylized gendered way of being. This suggests that over time a form of a feedback loop is created where external influences surreptitiously imprint codes and notions of censorship on and through the body to be organized by the brain and expressed in body and movement, in turn sculpting a way of being: one that engenders a binary norm. Poignant here and the concern of this chapter is the *ascribing of movement dynamics and postures* to gender roles and how gendered stereotypes manifest in gendered self-perception and self in relationship with peers.

McKenzie (2006) posits that 'the relationship to one's own body that we call gender is an individual body/mind experience felt at a very early age. It is expandable over a lifetime and not necessarily related to one's sexual anatomy' (p. 403). The child's journey through the process towards development of a core sense of self (Stern, 1998) can be imbued with curiosities and perceived incongruences as they explore meanings associated with notions of gender identity, sexual orientation and expression of sexuality. In the historian Jan Morris's (1974) book *Conundrum*, she recalls her journey of gender transition, and how as a child a 'not feeling quite right' was an embodied way of being. The dance movement psychotherapist Unkovich (2018) illuminates through autoethnographic description his lived experiences from infancy to *coming out* as a gay man in adulthood and how he often felt 'not worthy in the hetero-normative society of my child, teenage and younger adult years' (Unkovich, 2018). Furthermore, how the navigation of socio-political systems and relationships have shaped his: movements, spatial configuration and caused him to consider the place of touch in everyday relationships and in therapeutic work. Within Child and Adolescent Mental Health Services and Education there is growing evidence of the prevalence of mental health problems in children (Holt et al., 2014; Guasp, 2012), associated with living in a binary gender role of male or female. There has also been an increase in referrals of children to Gender Identity Clinics and the diagnosis of children with Gender Dysphoria (GD)[2] (Fisk, 1974; Knudson et al., 2010).

Children and young people with GD experience a greater risk of prejudice, stigma, transphobia, individual and socio-political discrimination and violence (Hendricks & Testa, 2012). This highlights the importance of work in schools and local mental health services in supporting children at risk. Moreover, movement expression may illuminate defended emotions and the presence of inner turmoil. Each child brings a unique palimpsest of their experiences and body stories that have become embodied over time. To protect confidentiality and prevent detection the children's stories presented here will be a culmination of reoccurring themes, statements and movement styles.

Dance Movement Psychotherapy: an embodied practice

Dance Movement Psychotherapy (DMP) is a relational practice and works with multi-sensory embodied processes, one that facilitates a person's expression of self and their experience of being in the world, conveyed through the vehicle of the body and the body in movement (Payne, 1992; Tortora, 2006). The field of DMP is based on the assumption that there exists a fundamental connection between body and mind, motion and emotion. Furthermore, that the primary language of the body can give us a clue to the person's inner feeling state (Kornblum & Halsten, 2006). Moreover, psychological struggles may be transformed through movement and dance where expression and realization of an inner life become interweaved and new insights made (Levy, 2005; Schoop, 2000). The psychotherapeutic use of movement facilitates the integration of bodily sensations, improves body awareness,

and supports the development of emotional, cognitive and social skills towards a more cohesive sense of self (Levy, 2005; Pylvanainen, 2003; Payne, 1992).

DMPs have forged a relationship with neurobiology, one that elucidates the notion that body movement can create changes in the brain due to the presence of neuroplasticity (Berrol, 1992, 2006; Homann, 2010; Schmais, 1974). The body becomes the medium to engage the brain, profiting a reciprocal relationship that affects physical and psychological well-being (Galagher, 2005; Homann, 2010).

Contemporary research indicates that neuroplasticity of the brain continues beyond childhood furthermore, it is the dynamic relationship between the sensorial body and the firing of neural synapses that contribute to the lifelong development of *new pathways* and *connections*. Poignant here is the potential for lifelong learning through and within the sensorial moving body, one that can produce physiological changes in the brain (Schmais, 1974) and ultimately growth in the physical and psychological self. This collective knowledge underlines the importance of *in-action modalities* within the therapeutic and learning process.

As a DMP my starting place towards understanding comes from kinaesthetic awareness (Rova, 2017; Sheets-Johnstone, 2010), one that illuminates inner feeling states and sensations rooted on a somatic level. The immediacy of the sensorial body has the potential to engage with the palimpsest of personal history and to explore the embodied ways of navigating the world that have become a default position for the person. The therapeutic relationship engenders an environment of trust and safety, one that affords a place to *come out*: a safe space from which to emerge.

Becoming and shaping: a process of negotiation

Contemporary literature has witnessed the amplification of the intersubjective lived experiences of some celebrities such as the artist Grayson Perry (2007), and actor, presenter, comedian Stephen Fry (2004) who journeyed through their formative years wrangling with the notions of how to be or not to be a boy. Comedian and actor Robert Webb in his book *How Not to Be a Boy* (2017) gives a compassionate and humorous account of his childhood and how the imprint of the perceptions of others influenced his navigation in the world, one that stipulates a codified way of being a boy. The chapter titles in Webb's book underline his experiences of being a boy: 'Boys Aren't Shy; Boys Love Sport; Boys Don't Cry; Boys Don't Fall in Love (with other boys); Men Don't Need Therapy; Men Don't Take Themselves Too Seriously'. Webb illuminates how these perceptions provoked feelings of marginalization that were further endorsed with labels that described assumptions, qualities and dynamics that were dismissive and belonged to another community, one of a feminine bias, and one that is not part of being a boy. Comedian/actor David Walliams has also written a fictional children's book *The Boy in a Dress* (2013), this has also been released as a film. The story should instill hope to demonstrate the possibility of a different way of being, in my experience however, work within schools has illuminated that notions of gendered stereotypes are prevalent and animated in

the school environment and the child's lived experience. The markers of being a boy or girl are imbued with behavioural codes. Moreover, the ways in which the world is negotiated become embodied habits (Gilbert, 2012), and void of authenticity to prevent marginalization.

Nayak and Kehily (2001) highlight that education is pivotal and that 'one of the most formative arenas in which young people experience and contribute to the production and reproduction of gender is through the institution of schooling' (p. 109). Furthermore, Carrie Paechter (2007) highlights that

> [t]he masculinities and femininities collectively constructed by children in schools are formed in relation to the school-based peer group; older children; school as a disciplinary institution and spatial site producing and purveying knowledge; and children's individual and collective understanding of the other inhabitants of that site.
>
> *(p. 77)*

The National Union of Teachers (NUT) conducted research titled *Breaking the Mould* to explore children's perceptions of gender identity. Year Six children of single sexed groups (ten to eleven years of age) were asked to suggest words associated with characteristics that they ascribed to their own and opposite gender. Generally, girls' views of boys were much more positive than that from boys' perceptions of girls. Girls tended to be ascribed with softer, less assertive qualities, including creativity and calmness and physical beauty. Boys tended to be ascribed with words that denoted strength, humour and masculine features. The adjectives used appeared to engender a code with censorship that promotes a way inhabiting the world or as Butler posits a 'stylised repetition of acts' (1990, pp. 190–192). Poignantly here is how these *acts* become 'embodied performances' (Allegranti, 2011) in everyday life. The dance movement psychotherapist Beatrice Allegranti (2011) posits that as humans we embody both nature (biological body and neurological processes) and nurture (socially constructed body). Moreover, how this knowledge may contribute to an understanding of being in our bodies that is embodiment. Allegranti argues that through dance and movement, psychological, social and biological processes we can develop a relationship with our bodies and understanding of human agency towards embodiment (. . .). Poignantly, Nayak and Kehily (2001) assert that a 'choreography of gender' has the potential to be 'resisted, transgressed and reconfigured in new routines' (p. 177) as there is a shift in attitudes.

'I am not this way and I am not that way'

Within the context described here children are generally referred for DMP due to difficulties with emotional and/or sensory regulation, poor self-esteem, poor self-confidence, self-harm and low mood. However, this is not an exhaustive list. The referrals related to gender ratio is generally higher in boys than girls. This chapter is

concerned with children of primary school age, ranging from five to eleven years of age. Each child brings a unique palimpsest of their experiences and body stories that have become embodied over time. To protect confidentiality and prevent detection the children's stories presented here will be a culmination of reoccurring themes, statements and movement styles.

Prior to or at the beginning of therapy verbal statements made by the children are often concerned with descriptions of 'not feeling quite right' or 'I feel uncomfortable'. There may be subtle nuances along a continuum in the child's expression of self that suggest a dislike of body parts or qualities of self that could be attributed to the feminine or masculine or anima and animus. The ultimate of this continuum is one of self-hatred. The actor and author Aleshia Brevard (2006) described how as a child she perceived herself as having too many legs and as an adult said her male genitals she was born with were 'an embarrassing often life-threatening birth defect' (p. 64).

Themes of rejection of self or part of self may also be seen in-action as the child attempts to hide or exaggerate body parts and/or movement qualities and dynamics. Within this context the lived experience of some boys who inhabit the qualitative parameters attributed to the masculine, including the engagement in combative and competitive sports was one, that they embraced but felt like something was missing or not quite right, not whole. For some boys however, they had already been identified by their peers and wider social circle as not fitting in with a masculine code of conduct: they have described being a victim of words that could be aligned with feminine qualities used in a derogatory tone. I witnessed boys who wanted to express more feminine qualities despite or in spite of being bullied for these specific attributes. The lived experience of these children may be one of victim, including bullying, isolation, alienation and stigma by peers, family and the wider society (Stonewall, 2012). Hendricks and Testa (2012) highlight that children with Gender Dysphoria are at greater risk of stigma, prejudice, transphobia, individual, institutional and societal discrimination and hostility.

Ken Corbett, psychoanalyst (2009) posits that normative codes of masculinity are present from an early age. Furthermore, that becoming a boy is a continual process and is shaped by 'culture and cultural symbols, society and social orders, what we might call "backstories", build a boy' (p. 11). In feminist theory much has been written about the codes and censorship that have the potential to shape a girl's narrative and how the imprint of a gendered stereotype on the body influences the navigation and discourse with and in the world (Allegranti, 2011; de Beauvoir,1949; Butler, 1990, 2004; Orbach, 2009).

The child comes with a backstory including their experience of the early attachment relationship. When working with this group of children I am mindful of the possible over-identification with an attachment figure that is absent, or the adoption of a way of being in order to survive or access a relationship with a parent creating a mini-me way of being. However, whether the child has been referred due to possible gender identity or attachment problems, the result may manifest in an embodied false self (Winnicott, 1971).

The following statements represent a collective voice of both boys and girls referred for DMP:

- *My body has two lives*
- *I don't recognize parts of me*
- *I'm an alien*
- *I see, but I don't feel that parts of my body are me*
- *Others see me one way, but I'm not the same inside*
- *I hate what I see. When I close my eyes I can be me*

A starting place

As children wrangle with the parameters of normative codes created by social construction, self-censorship has the potential to create a gendered 'embodied performance' (Allegranti, 2011), one that includes a choreography with ascribed movement dynamics and postures that engenders a feeling of 'not quite right' or other. Furthermore, how the child experiences, understands and interprets socio-political codes may be incongruous to their body felt internal processes and sensations, ranging from feelings of being in the wrong body to subtle nuances that encompass a denial of parts, qualities of self or curiosities regarding sexual orientation. For the child the presence of this spectrum of feeling states appears to suggest an incongruity between internal sensations and external expression that is further shaped by normative codes and self-surveillance. The children helped me understand that for some, the default position is one that inhabits a false self (Winnicott, 1971) to protect themselves and in order to be accepted by peers and fit in with wider society rules. However, this is to the detriment of self-acceptance.

Nayak and Kehily (2001) posit that a 'choreography of gender' is not necessarily static, rather it can be 'resisted, transgressed and reconfigured in new routines' (177) as attitudes shift over time. Furthermore, the Dance Movement Psychotherapist Allegranti's groundbreaking work demonstrated a potential for deconstruction and reconstruction of gender expression through explorations of embodied performance. Collectively this knowledge engenders hope and scope for change and attitudinal shifts that have the potential to become transgenerational.

The frame for therapeutic work presented here is not a definitive model, however, the children guided the process towards a way of working that seemed to offer a space for the expression of many selves, with a plethora of qualities and dynamics of body and movement along a *continuum*. Furthermore, this *continuum* holds binary poles of distinct qualities of feminine and masculine with a potential to privilege, experience and integrate both. Integral within the therapeutic space is to work with fluidity along the continuum: between masculine and feminine, anima and animus, towards integration, positive self-image, development of core self and crucially self-acceptance. This approach provides a space to explore and support the emergence of parts or qualities of self or qualities that are already formed or being formed in the process of child development. The privilege of

age in this client group affords potential for transformation and to facilitate the shaping and growth of new formations in the expression of self. Furthermore, the exploration and embodiment of novel body and movement dynamics in-action has potential to influence synaptic connections in the brain to create new pathways (Homann, 2010) due to lifelong neuroplasticity. The psychotherapist Susie Orbach (2009) highlights that in the early parent-infant relationship we are 'being formed in the process of being related to' (2009, p. 37); this can be applied to the relational space in psychotherapy, and facilitates the development of a true self (Winnicott, 1971). Poignant here is how the therapeutic relationship can be a present at the beginning of some areas of childhood development where an attitude of curiosity is present for the child rather than a wearing of a well-worn embodied choreography of being.

My role as a DMP is not to interpret, but rather attempt to gain an understanding of the child's narrative and how sexuality and gender are embodied, whilst seeking to support the child to develop a more cohesive and integrated sense of self. Furthermore, a cohesive body, and the authorship of a movement style informed by sensation, contributes to a 'body-self' (Pylvanainen, 2003, p. 41).

I use an integrative psychotherapy approach framed by developmental and attachment theory (Bowlby, 1988; Stern, 1998), Sensory Integration (Ayres, 1979) and Sensorimotor approach to psychotherapy (Ogden et al., 2006). In my approach, I encourage exploration of gender roles to ensure that options are open for the child, before self-labelling or categorizing. The process-orientated approach of DMP affords a position to 'watch, wait and see', and support the child in the development of a cohesive core self with the capacity for fluidity to draw from resources along a continuum of feminine and masculine qualities.

As a female DMP, I am subject to socially constructed perceptions and gendered notions of how I should be or perform and how as Doug Risner describes 'Western European paradigm situates dance as primarily a "female" art form' (2009, p. 58). Moreover, that the process of becoming a boy may include perceptions and behaviour to avoid 'all that is feminine, homosexual or unmasculine to any degree' (Risner, 2009, p. 62). I have witnessed however, that children are open to engaging in a modality that offers support and help, moreover, one that uses the primary language of the child: body in movement.

Moving stories

The structure of the sessions provides space to warm up to non-gender-specific movement qualities, one that offers a starting place to facilitate working with fluidity along a continuum. Resources in the therapy room include a tunnel and a mock stage/draped area from which to emerge. A dressing-up box, masks and narrating resources, for example *Story Cubes:* these are employed to facilitate the trying on of movement, rhythms and spatial configurations.

In DMP there is a focus on the 'how' of movement, moreover how expression of self is manifested through body and movement. The child develops a palette

of movement qualities informed by developmental and psychosocial processes creating a personal signature of postures, gestures and movement (the movement equivalent of idiolect, which is the particular speech habits of a person). The repetition of a moving expression imprints within the body musculature: the signature or repertoire of movement becomes the embodied way of inhabiting the world (Bloom, 2006; Sheets-Johnstone, 2010). Furthermore, the processes of motion and emotion are intertwined and influences expression of self (Levy, 2005; Payne, 1992; Schmais, 1974). Movement dynamics and rhythmic patterns contain qualities along a continuum: one that holds expressions of polarity, synergy and integration. The DMP will be concerned with the movement qualities that may be present or missing for the child and the possible implications for emotional development and well-being.

Within the clinical work described here the child's personal repertoire of movement is explored and developed with attention to the use of personal kinesphere, Laban Effort [3]qualities of movement and expression including: *weight, flow, time and space*[4] (Laban, 1971) *and rhythm* patterns (see Kestenberg Amighi et al., 1999) associated with child development, including the Tension-Flow Rhythms (ibid.) of fighting and indulging rhythms.[5] Janet Kaylo (2009), Dance Movement Psychotherapist and Jungian Psychoanalyst, explains that 'Laban [...] referred to some movement as "masculine" and "feminine", although LMA's [Laban Movement Analysis] fluctuating, interdependent binary system can (and should) serve as a movement palette for *either* gender' (p. 173).

The children may be encouraged to develop a body map or landscape, to offer something tangible that can be referred to over time. Some children have also found the use of an iPad or tablet helpful in recording their process.

The following is a summary of a collective of experiences and movement repertoires observed and therefore are not to be generalized. The observations however, offer some insight into ascribed movement repertoires that may be present for boys and girls and could guide a way of working with this group.

Some of the boys referred for DMP appeared to show a preference for movement that included effort qualities (Laban, 1960, 1971) of fast time, heavy weight, fragmented use of space, indirect with all body limbs, with some bound flow in body parts, accompanied with an urgency of speech and thoughts. However, some boys appear constrained within their kinesphere and hesitant with use of light weight, and considered time. The former group appeared to use more fighting rhythms compared to the latter group who engaged in more indulging rhythms. Girls were more often observed to fall in the latter repertoire of movement, creating a hesitant, demure way of being, however, this should not be generalized to all girls.

A space from which to emerge

The children are invited to choose from a selection of props and resources but dressing up and/or making masks that represent an animal or human are often the activity of choice. The children engage in a form of hatching (Mahler, 1975) or

rebirthing: utilizing the mock stage and/or tunnel to enter, add the layers of clothes or mask, then re-emerging into the space: this act was repeated many times with individual children exploring a range of movements and spatial configurations. The full expression of movement becomes available to the child for example, fast movement may become sustained with free flow movement. The child is able to explore and work with polarities (Schoop, 1992, Chaiklin, 1975), and rhythmic patterns, each movement carrying with it an inner sensorial feeling (Sheets-Johnstone, 2010) and an emotional undertone. Moreover, it facilitates the capacity to work with the in-between space along a continuum: a form of embodied neutrality that provides a starting place for fluidity, one of movement as opposed to one that is static or binary in nature. This offers the child choice and freedom to access qualities that can be attributed to anima and/or animus, or an integration of both, and supports the emergence of novel ways of moving, finding gestures and spatial formations. Kaylo (2009) poignantly states that:

> What is important in the discussion of movement qualities and gender, is not only which movement qualities 'belong' to whom in socio-cultural inscription, but to recognize that holding access to *all* qualities of movement is important for integration – especially when split off parts of the self are oriented in a gendered 'opposite'.
>
> *(Kaylo, 2009, p. 180)*

Over time, I have witnessed a shedding of masks and clothes, but the new movement remains. As some of the children emerged from the tunnel or from behind the drape, a change in movement style appeared to offer the opportunity to also try out different vocal textures: volume, tone and amplification. This influenced their use of breath: breath became expansive or calm. The teachers' feedback suggested that the children appeared more confident in their body movements and vocal communication.

'I see you'

During the process of exploring old and new movement, the therapeutic use of mirroring[6] as developed by one of the pioneers of DMP, Marion Chace, is employed to reflect back what is witnessed in the moment. Winnicott (1971) posits that the first act of mirroring can be seen in the early relationship between parent and infant and explains that when the infant looks at the mother's face:

> what the baby sees is himself or herself. In other words the mother is looking at the baby and *what she looks like is related to what she sees there.*
>
> *(Winnicott, 1971, p. 131)*

Furthermore, Chace demonstrated that the act of mirroring 'elicits more movement, and promotes movement dialogue' (Stanton-Jones, 2008). This is relevant to

the current context and can facilitate the emergence of a more integrated sense of self, one that enables the child:

> to exist and feel real. [moreover] Feeling real is more than existing: it is a way to exist as oneself, and to relate to objects as oneself, and to have a self into which to retreat for relaxation.
>
> *(Winnicott, 1971, p. 138)*

Both mirroring and recording of self on a tablet appears to be significant in validation and the development of congruity between inner feeling states and expression of self. The place of repetition and rephrasing, of movement sequences, dynamics and rhythmic patterns appear to support the child in re-presenting themselves, and integrating experiences. Following movement exploration the use of body mapping and/or opportunity to produce a sculpture appears to concretize the experiences. Narration of the child's body and movement experience in this way appears to promote authenticity, one that is not othered, but accepted as part of the physical and psychological self towards integration, a foundation for *becoming*. The sensorial experiences of the body in action become imprinted on the body memory (Bloom, 2006). Moreover, the sensorial body offers a benchmark for making sense of relational and environmental events, affording a secure base from which to experience the world (Bowlby, 1988; Rumble, 2010).

Moving from the binary towards fluidity

Much has been written about the influences of socio-political constructs on gender formation and the normative codes that are applied to expression of sexuality and sexual orientation in adulthood. The exploration of gender formation in childhood is currently an area of research for academics and educationalists. Working with children engenders hope and the potential to support the development of an integrated self from the beginning of their developmental journey. The modality of Dance Movement Psychotherapy offers a way of exploring embodied or stylized performances: employing the sensual body and movement expression. The sensual moving body has the potential to shape the brain (Schmais, 1974) and therefore offer changes to inner feeling states and external expression. This relationship is pivotal in the development of a cohesive body, and the authorship of a movement style that contributes to a 'body-self' (Pylvanainen, 2003, p. 41). The framework posited here suggests a starting place of embodied neutrality that has the possibility of gender fluidity rather than a static binary position. Moreover, an embodied choreography that holds qualities of both feminine and masculine, anima and animus, and are integrated as part of the core self. The oscillation between modes of *seeing* self and *feeling* self in movement repetitively appears to support an ongoing organization of body schema, one that facilitates the emergence and ownership of new and a more integrated movement style. Poignantly, Kaylo suggests that:

The ability to express physical qualities of both genders may in fact strengthen identification with the other, and thus delimit experience of envy, or fear, of qualities present in the physical representation of the opposite sex.

(Kaylo, 2009, p. 183)

Working with the movement qualities of children, with the aim of accessing equally all expressions has the potential to strengthen self-identity and the relationship with the other. Moreover, this way of working supports the development of a self identity with a healthy fluidity that engenders choice to access all qualities along the continuum of feminine, masculine and anima/animus. Resources for a life journey that hold a potential to be transgenerational: one that imprints and positively resonates through the generations, over time becoming an embodied way of inhabiting the world, and forming relationships.

Notes

1 Carl Jung's theory of Anima and Animus describes polarized or binary masculine and feminine qualities and behavioural traits. Anima can be viewed as the male's internal other and Animus as the female's internal other (see Kaylo, 2009; Lewis, 1993).
2 Gender Dysphoria (GD) describes the distress caused by the discrepancy between a person's gender identity and their assigned sex (sex classified at birth, based on the appearance of the genitals).
3 Laban's Effort/Shape System refers to Effort as representing 'motion factors toward which performers of movement can have different attitudes depending on temperament, situation, environment, and many other variables' (Bartenieff & Lewis, 1980, p. 51).
4 Flow denotes the constraint or ease of movement, with elements of Free Flow and Bound Flow; **Space** describes the attention of movement, with elements of Directness and Indirectness; **Weight or Force** describes elements of lightness/weight and strength; **Time** describes elements of Quickness, Sustainment (ibid.).
5 Kestenberg et al. (1999) described child development as progressing along a sequence of developmental stages, corresponding to Tension-Flow Rhythms. The child's quality of movement changes over time depending on the needs of each developmental stage. There are ten rhythmic patterns identified that correspond in pairs and are sympathetic to the developmental stages of: oral, anal, urethral, inner-genital and outer-genital. The ten rhythms include: sucking, snapping/biting, twisting, straining/release, running/drifting, starting/stopping, swaying, surging/birthing, jumping and spurting/ramming.
6 Kristina Stanton-Jones (2008) explains that Marion Chace, one of the pioneers of Dance Movement Psycho/therapy, 'developed the technique of mirroring the pateints' movement which became useful in achieving many goals of DMT, including establishing an empathetic relationship, engendering an interaction, and extending an unconscious theme in movement. Mirroring is not simply imitating or mimicking the patients' movement; it is sympathetic reflection, and a structure in which interaction can take place' (p. 16). Furthermore, 'Mirroring [...] elicits more movement, and promotes movement dialogue' (ibid.).

References

Allegranti, B. (2011) *Embodied Performances: Sexuality, Gender, Bodies*, London: Palgrave Macmillan.
Ayres, A.J. (1979) *Sensory Integration and the Child*, Los Angeles, CA: Western Psychological Services.
Bartenieff, I., & Lewis, D. (1980) *Body Movement: Coping with the Environment*, New York, NY: Gordon and Breach Science Publishers.

Berrol, C.F. (1992) 'The Neurophysiologic Basis of the Mind-Body Connection in Dance Therapy', *American Journal of Dance Therapy Association*, 14, no. 1, 19–29.

Bloom, K. (2006) *The Embodied Self*, London: Karnac (Books) Limited.

Bowlby, J. (1988) *A Secure Base*, London: Basic Books.

Butler, J. (1990) *Gender Trouble: Feminism and the Subversion of Identity*, London: Routledge.

Butler, J. (2004) *Undoing Gender*, New York: Routledge.

Chaiklin, H. (ed.) (1975) *Marion Chace: Her Papers*, New York, NY: American Dance Therapy Association.

Chen, N., & Moglen, H. (eds.) (2006) *Bodies in the Making: Transgressions and Transformations*, Santa Cruz, CA: New Pacific Press.

Corbett, K. (2009) *Boyhoods: Rethinking Masculinities*, New Haven: Yale University Press.

de Beauvoir, S. ([1949] 1988) *The Second Sex*, trans. H.M. Parshley, London: Picador.

Fisk, N.M. (1974) 'Gender Dysphoria Syndrome – The Conceptualization That Liberalizes Indications for Total Gender Reorientation and Implies a Broadly Based Multi-Dimensional Rehabilitative Regimen', *West Journal Medical*, 120, 386–391.

Fry, S. (2004 reissue) *Moab Is My Washpot*, London: Arrow.

Galagher, S. (2005) *How the Body Shapes the Mind*, Oxford: Oxford University Press.

Gilbert, P. (2012) 'The Embodiment of Cultural Identity', in Gonzalez-Arnal, S., Jagger, G., & Lennon, K. (eds.), *Embodied Selves*, Basingstoke: Palgrave Macmillan.

Guasp, A. (2012) *The School Report: The Experiences of Gay Young People in Britain's Schools in 2012*. University of Cambridge Centre for Family Research. Available at www.stonewall.org.uk/atschool

Hendricks, M.L., & Testa, R.J. (2012) 'A Conceptual Framework for Clinical Work with Transgender and Gender Nonconforming Clients: An Adaptation of the Minority Stress Model', *Professional Psychology: Research and Practice*, 43, no. 5, 460–467.

Holt, V., Skagerberg, E., & Dunsford, M. (2014) 'Young People with Features of Gender Dysphoria: Demographics and Associated Difficulties', *Clinical Child Psychology*, 21, no. 1, 108–118.

Homann, K.B. (2010) 'Embodied Concepts of Neurobiology in American Dance/Movement Therapy Practice', *American Journal of Dance Therapy Association*, 32, 80–99.

Kaylo, J. (2009) 'Anima and Animus Embodied: Jungian Gender and Laban Movement Analysis', *Body, Movement and Dance in Psychotherapy*, 4, no. 3, 173–185.

Kestenberg Amighi, J.S., Loman, S., Lewis, P., & Sossin, K.M. (1999) *The Meaning of Developmental and Clinical Perspectives of the Kestenberg Movement Profile*. New York: Routledge.

Knudson, G., De Cuypere, G., & Bockting, W. (2010) 'Response of the World Professional Association for Transgender Health to the Proposed DSM5 Criteria for Gender Incongruence', *International Journal of Transgenderism*, 12, no. 2, 119–123.

Kornblum, R. & Halsten, R.L. (2006) 'In School Dance Movement Therapy for Traumatised Children', in Brooke, S. (ed.), *Creative Arts Therapies Manual: A Guide to the History, Theoretical Approaches, Assessment, and Work with Special Populations of Art, Play, Dance, Music, Drama, and Poetry Therapies* (pp. 144–155), Springfield, IL: Charles C. Thomas.

Laban, R. (1971) *The Mastery of Movement*, London: MacDonald & Evans.

Levy, F. (2005) *Dance/Movement Therapy: A Healing Art*. Reston, VA: National Dance Association, American Alliance for Health, Physical Education. Recreation, and Dance.

Lewis, P. (1993) *Creative Transformation: The Healing Power of the Arts*, Wilmette, IL: Chiron Publications.

Mahler, M., Pine, F., & Bergman, A. (1975) *The Psychological Birth of the Human Infant, Symbiosis and Individuation*, London: Karnac Books Ltd.

McKenzie, S. (2006) 'Queering Gender: Anima/Animus and the Paradigm of Emergence', *Journal of Analytical Psychology*, 51, 401–421.

Morris, J. (2001) *Conundrum* (1974), London: Faber & Faber Limited.

Nayak, A. & Kehily, M.J. (2001) 'Learning to Laugh': A Study of Schoolboy Humour', in Martino, W., & Meyenn, B. (eds.), *What About the Boys? Issues of Masculinity in Schools*, Buckinghamshire: Open University Press.

Ogden, P., Minton, K., & Pain, C. (2006) *Trauma and the Body*, New York: W.W. Norton & Company, Inc.

Orbach, S. (2009) *Bodies*, London: Profile Books Ltd.

Paechter, C. (2007) *Being Boys, Being Girls: Learning Masculinities and Femininities*, Maidenhead, UK: Open University Press.

Payne, H. (ed.) (1992) *Dance Movement Therapy: Theory and Practice*, London: Routledge.

Perry, B.D. (2014) *The Moving Child: Supporting Early Development Through Movement* [Film], Vancouver, Canada. Available at www.themovingchild.com

Perry, G. (2007) *Grayson Perry: Portrait of the Artist as a Young Girl*, London: Vintage.

Pylvanainen, P. (2003) 'Body Image: A Tripartite Model for Use in Dance/Movement Therapy', *American Journal of Dance Therapy Association*, no. 25, 39–56.

Risner, D. (2009) *When Boys Dance: Moving Masculinities and Cultural Resistance in Dance Training and Education*, Conference Proceedings (daCi) Kingston, Jamaica.

Rova, M. (2017) 'Embodying Kinaesthetic Empathy Through Interdisciplinary Practice-Based Research', *The Arts in Psychotherapy*, 55, 164–173.

Rumble, B. (2010) 'The Body as Hypothesis and as Question: Towards a Concept of Therapist Embodiment', *Body, Movement and Dance in Psychotherapy*, 5, no. 2, 129–140.

Segal, L. (2010) 'Genders: Deconstructed, Reconstructed, Still on the Move', in Weatherell, M., & Mohanty, T.C. (eds.), *The Sage Handbook of Identities*, London: Sage.

Schmais, C. (1974) 'Dance in Perspective', in Mason, K.C. (ed.), *Dance Therapy: Focus on Dance VII* (pp. 7–12), Washington, DC: AAHPER American Alliance for Health, Physical Education and Recreation.

Schoop, T. (2000) 'Motion and Emotion', *American Journal of Dance Therapy*, 22, no. 2, 91–101.

Sheets-Johnstone, M. (2010) 'Kinesthetic Experience: Understanding Movement Inside and Out', *Body, Movement and Dance in Psychotherapy*, 5, no. 2, 111–127.

Stanton-Jones, K. (2008) *An Introduction to Dance Movement Therapy in Psychiatry*, London and New York: Tavistock, Routledge.

Stern, D. (1998) *The Interpersonal World of the Infant: A View from Psychoanalysis and Developmental Psychology*, London: Karnac (Books) Ltd (first published in 1985)

Tortora, S. (2006) *The Dancing Dialogue*, Baltimore, MD: Brookes.

Unkovich, G.I. (2018) 'Orientating Myself: A Gay Dance Movement Psychotherapist's Gender Experience in Training and Practice', *Body Movement and Dance in Psychotherapy*, DOI :10.1080/17432979.2018.1491415.

Walliams, D. (2013) *The Boy in the Dress*, London: HarperCollins Books.

Webb, R. (2017) *How Not to Be a Boy*, Edinburgh: Cannongate Books Ltd.

Winnicott, D. (1971) *Playing and Reality*, London: Tavistock Publications.

Internet Sources

Brevard, A. (1997) @ www.glbthistory.org Interview One, conducted by Susan Stryker

Killermann, S. The Genderrbread Person, accessible at: www.gingerbreadperson.com

Stonewall at www.youngstonewall.org.uk Tel: 08000 502020

Stereotypes Stop You Doing Stuff, National Union of Teachers, 2016

'Boys will be girls will be boys' (12th September 2016) The Guardian Weekend

12
GENDER RESEARCH IN DANCE MOVEMENT THERAPY

Katharina Forstreuter and Sabine C. Koch

Introduction

Dance Movement Therapy (DMT), a creative body-psychotherapy method with focus on experiencing the subjective body in the here and now (Trautmann-Voigt, 2003), is effective in reducing stress (Martin et al., 2018; Wiedenhofer and Koch, 2016) and improving quality of life (Bräuninger, 2012). Given the reportedly small proportion of men who have participated in such evidence-based studies (21% in Wiedenhofer and Koch, 2016; and 9% in Bräuninger, 2012), one might conclude that there is strong evidence primarily for female clients. What are the reasons for this asymmetrical distribution of the sexes in DMT studies? Do men profit in a similar way from DMT? To answer these questions, this chapter provides an overview of the current state of research on gender in DMT, reports empirical findings on gender differences and similarities, and covers results from focus group discussions with DMT participants in an empirical study. The focus group was conducted with eight participants (4 women, 4 men) in a DMT intervention for stress reduction, led by a male and a female therapist to equal parts. Results suggest that the preference for the leader seemed rather a question of the personality of leader or a personality-fit choice, than a gender choice, and that wording for DMT intervention announcements/advertising is critical in order for men or women to feel equally addressed by the offer.

Current state of research

The German gender discourse in DMT has been initiated in the professional journal *körper – tanz – bewegung* (body – dance – movement; e.g., Kehr, 2016; Reichel, 2013), but there is very little empirical research on this subject. The numeric dominance of women in DMT and body psychotherapies is striking, and is valid for patients as well as for therapists. In a research project on *Integrative Movement Therapy* (IBT),

study participants were in the majority female (87%): 47% of IBT therapists stated that they primarily work with female clients (Höfner, 2008; Koschier, 2009). Similar numbers are reported in a review of empirical findings for *Concentrative Movement Therapy* (KBT) (Seidler, 2016; in Germany, both IBT and KBT are two other historical lines of movement therapy, similar to DMT, with a slightly more functional approach). Moreover, there were significantly more female KBT therapists (approximately 85%) as well as female clients in outpatient settings (approximately 86%). According to Seidler (2016), only about 23% of the patients were male in the inpatient setting. Evidently, mainly women seek therapeutic help through KBT, while a clinical trial found no significant differences in the efficacy of KBT for men and women (Schreiber-Willnow and Seidler, 2002). There were, however, indications of gender-specific active factors varying with age. While younger men benefited from the group experience and the therapeutic relationship, older men focused on access to physical sensation. Older women benefited mostly in physical well-being.

These studies provide initial information on gender relations and issues in KBT and IBT. However, since KBT and IBT are not primarily creative therapy approaches, there is a difference to DMT treatment and interventions. Comparable empirical data from DMT does not yet exist. For an initial analysis, we examined existing efficacy studies on DMT regarding the gender ratios and other gender-related information.

In a large-scale efficacy study of DMT on reducing stress and improving the quality of life, 15 out of 162 participants (9%) were men (Bräuninger, 2012). Apart from the gender distribution, the study reported significant results in terms of stress reduction and improvement of quality of life (QoL). Significant short-term improvements were noted in mental health, social relations, global value of functioning, and physical health. Mental health, spirituality, and general life also was reported to have improved significantly in the long term (6-month follow-up). In their meta-analysis on efficacy of dance and DMT interventions, Koch, Kunz, Lykou and Cruz (2014) evaluated 23 studies ($N = 1,023$) regarding the outcome variables quality of life, body image, well-being, interpersonal skills, depression, and anxiety. The results indicate a significant effect of DMT in improving quality of life and reducing depression and anxiety. Positive effects were also reported for subjective well-being, positive mood, affect, and body image. The information that can be taken from the primary studies indicates that gender distribution was between 0% and 75% of participating women. If we exclude the studies on breast cancer (no men included) and autism and schizophrenia – where the gender ratio in prevalence of men to women is 4:1 – results yield between 5% and 15% of participating men in the DMT studies.

Kiepe, Stöckigt and Keil (2012) compiled a review of studies on the effects of DMT and ballroom dancing on physical and mental illnesses. A total of 11 studies were included in the meta-analysis, five of these studies had a 100% female sample (two of them studies on DMT for patients with breast cancer, Sandel et al., 2005, Dibbell-Hope, 2000; the other on mild depression, Jeong, 2005; on fibromyalgia, Bojner-Horwitz, 2003, 2006 and on diabetes Type 2, Murrock, 2009), three further studies had a larger proportion of female participants (76% in Hokkanen et al.,

2008 on dementia; 63% in Hackney, Kantorovich and Earhart, 2007 on Parkinson's disease; 67% in Haboush et al., 2006 on mild depression) and three studies had a larger proportion of male participants (58% in Koch, Morlinghaus and Fuchs, 2007 on depressed inpatients; 74% in Hackney and Earhart, 2009, on Parkinson patients; and 82% in Belardinelli et al., 2008, on chronic heart failure). DMT significantly reduced stress in patients with depression and significantly improved the quality of life of breast cancer patients. Overall DMT and ballroom dancing proved beneficial to patients with breast cancer, depression, Parkinson's disease, diabetes, and heart disease.

Pinniger, Brown and McKinley (2012) compared the results of tango dance versus mindfulness meditation on reduction of stress, anxiety and depression symptoms and improvement of well-being. They found significant reduction of depression symptoms in both interventions, however, reduction of stress levels was only demonstrated in the tango group. In this study, male participation was also low with 24%. Quiroga-Murcia, Bongard and Kreutz (2009) also examined the effects of tango dance on psychophysiological emotion and stress measurements, however, they were able to recruit patients with a balanced gender ratio. They found significant reduction of negative and significant improvement of positive affect.

West et al. (2004) compared African Dance to Hatha Yoga studying the influence on well-being. Significant reduction of perceived stress was demonstrated in both interventions. In their study, the gender ratio of participants was 31% male to 69% female. In a further study on the effects of DMT, Wiedenhofer and Koch (2016) reported significant results of non-goal-oriented movement on reducing subjective stress, improving mood, body self-efficacy, and self-efficacy; in that study, the proportion of male participants was 20%.

Thus, the evidence suggests a promising efficacy of DMT in reducing stress and improving quality of life, investigating mainly female participants. At this point, we would like to mention that the quality of the primary studies needs improvement in almost all cases; many case studies are underpowered in sample size, the intervention is not described in a replicable way, or non-standardized test procedures are employed. Additionally, the aspect of gender inequality must be emphasized: In about 80% of the studies mentioned, there was a larger proportion of female participants, implying that the effect of DMT on men is often not sufficiently investigated. In order to explore the female overrepresentation in the DMT samples and possible gender-specific needs, common characteristics and differences between the sexes need to be discussed. Important questions are: what might be the reasons for gender differences – if they exist – and what are those potential differences in terms of psyche, body, and therapy relevant to DMT?

Similarities and differences of the sexes

In addition to biological traits, social categories are associated with biological sex, which represents an important factor in social interaction (Bem, 1974; West and Zimmermann, 1987), and accordingly has far-reaching consequences. The social

categorization of gender shapes individual gender stereotypes; this happens partly unconsciously (Jost and Kay, 2005) and cements already at the age of 11 years (Tobin et al., 2010). Normative social role expectations depending on the individual and cultural socialization lead to the gender role self-concept of a person (Athenstaedt, 2003, Sieverding and Alfermann, 1992). The entire gender construct encourages different lifestyle choices in the everyday life of men and women (Courtenay, 2000, Sieverding, 2005, Verbrugge, 1989).

According to social role theory, an attractive appearance is an important predictor of success in life for women, for men on the other hand, professional success and social status are more important (Eagly, Wood and Johannesen-Schmidt, 2004). Women are more likely to be dissatisfied with their bodies, diet more often, and suffer more frequently from eating disorders than men (Smolak and Murnen, 2001). Female body norms in Western culture that emerge from gender-specific stereotypes (cf. Williams and Best, 1990) are *pretty, tender, graceful*, and *slender*, and related feminine activities are aesthetic-compositional individual sports such as dancing, gymnastics, and aerobics, that appear to be aesthetically pleasing and graceful. Male body standards on the other hand, are *tall, muscular, athletic, rough, strong*, and *assertive*. Masculine activities include martial arts, high-risk sports, and direct physical engagement (such as in competitions) that show strength, speed, fighting spirit, courage, and rigour (Athenstaedt and Alfermann, 2011).

The body norms mentioned above are partially reflected in the preferences of the sexes for different forms of movement or sports. While boys and young men tend to compete in sports, girls and young women tend to select more aesthetic-compositional sports. In middle-aged adults (34–64 years), individual sports continue to dominate among women and participation from men increases as well (fitness, running, and cycling). After age 60, both sexes prefer health-enhancing sports such as walking, cycling, and aerobics. Men are more frequently active in sports up to the age of 34 than women, this ratio is similar in middle adulthood until in later adulthood (after age 60) when hardly any differences are reported (Breuer, 2004). The motivations for physical activity have been demonstrated to be different for both sexes, men attribute sport to strengthening their physical and mental strength while women focus on relaxation, as well as body- and movement experience (Rulofs, Combrink and Borchers, 2002). This fits in with women's greater attention to body signals and complaints (Sieverding, 2005) and the resulting greater motivation to maintain health. Overall women are twice as likely as men to participate in exercise and relaxation classes (Jordan and Von der Lippe, 2013).

In summary, women are more critical with regard to their body image than men. A connection to this body image surveillance might exist with the societal body norms that are *slender* and *delicate* for women, while *tall* and *vigorous* for men. Women are more likely to pursue calmer, aesthetic-compositional sports while men pursue more competitive and power-focused activities. The motivation for exercise in women is more often relaxation and health, they often pay more attention to their body signals and turn to health-oriented physical activities earlier than men.

What are the consequences of gender-specific similarities and differences for DMT?

The characterization of the gender-specific similarities and differences reported above lead to further questions regarding DMT and gender research. The gender similarities hypothesis (Janet Hyde, 2005) states that between-subject differences (e.g., differences between women) are greater than sex differences (i.e., differences between men and women); this suggests that the efficacy of DMT may be the same in men as it is in women. Alternatively, it could mean that between-subject needs must be taken into account for an optimal implementation of DMT. Nevertheless, gender-stereotyped differences in behaviour between men and women can be demonstrated: women identify more with expressive (feminine), men with instrumental (masculine) personality traits (Feingold, 1994). Women are more open to express feelings (Wood, Rhodes and Whelan, 1989), both positive and negative, and are more likely to seek help (Knopf and Grams, 2013). So, is the inhibition threshold for men greater to seek help and participate in DMT? If so, how can it be reduced?

Men often have higher self-esteem (Whitley, 1983; Athenstaedt and Alfermann, 2011, p. 123) and are less critical with their bodies, does that mean they have less need to turn to DMT? Would men be more likely to accept therapeutic help, if the stereotype of the "strong man" was not as prevalent? Can DMT do anything to resolve this stereotype or is this a more global societal task?

If women are more likely to pursue aesthetic-compositional forms of exercise, while men more frequently participate in competitive and power-driven forms of exercise, does that mean DMT is "not" for men? Or could DMT also attract male participants with a focus on different content? So, do women benefit from DMT more through the artistic, aesthetic aspect and could men benefit more from the functional content of DMT?

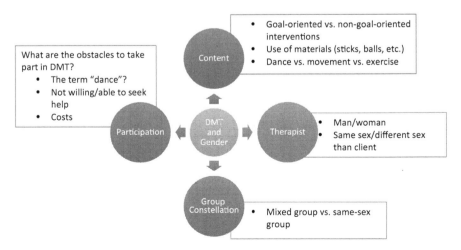

FIGURE 12.1 Questions arising from female overrepresentation in DMT.

Moreover, the female overrepresentation in DMT is worthy of discussion. Does the feminine nature of DMT scare men off? What about the relationship between the therapist and the patient/client? Do men want a male therapist and women a female therapist? Do men and women want gender-mixed or gender-separated groups?

A multitude of questions arise (see Figure 12.1) from these considerations that could unravel the unequal gender relationship in DMT, and we are hoping to receive answers in future DMT research. We asked some of these questions in the focus group discussions reported in the following paragraph.

What do DMT participants say?

In a study on the effects of mindfulness-based DMT on stress-burdened adults (Bauer, 2017; Wolter, 2017), eight participants (four female participants, mean age 33.5 years; four male participants, mean age 25 years) were interviewed separately in gender-specific focus group discussions. Participants categorized as "burdened by stress" after self-assessment joined eight DMT sessions in mixed-sex groups – four sessions with a male and four sessions with a female therapist. In order to avoid anticipatory effects, the interventions were entitled *"Mindfulness-Moves!"* and not Dance Movement Therapy. The focus group discussions took place after the eight DMT sessions and were led by a neutral person (a study colleague who held a BA in psychology and was familiar with the method) during the absence of both therapists. The selection of statements of the focus group discussions here is exemplary and was done by the first author KF.

When asked whether the participants were able to perceive gender differences and effects by the therapist, both women and men were in agreement, no gender differences were found. Rather, both sexes agreed that they could perceive differences between the male therapist who was described as calm and relaxed, and the female therapist who was considered more active and motivating. One male participant commented, *"I cannot attribute the differences directly to gender, but I felt better off with the female instructor. She was more open in the feedback sessions and showed more of herself"*. One male participant stated, *"I felt more comfortable with the female therapist. With her I was better able to get involved in the exercises"*. Another male participant said, *"I found the male therapist to be quieter, so I was better able to get involved with him. The calm nature suited me more"*. Other female participants reported that the female therapist was more in contact with the group, while the instructions of the male therapist were more direct and clear.

When questioned about the preference of the gender ratio in the group (gender-separate vs. mixed-gender), the female interviewees were unanimously in favour of mixed-gender groups. The arguments in favour were that the coming together of both sexes was enriching, involving more diverse movements and thus making the group more interesting. The male respondents commented in a more differentiated way: *"Moving only with other men would certainly have been interesting. But I also find it exciting to move with women, because it brings a different energy"*, one male

participant said. In the same vein, another participant commented: "*I think the movements would have been different in a same-sex group. There is a different dynamic and more flow, when women and men come together*". Another male participant reported: "*I felt even more comfortable in my group where there were more female participants*". Other participating men, however, uttered a preference for same-sex groups: "*A pure men's group can be relieving. I know that from men's yoga. In mixed groups with multiple female participants, I always have to think about where to put my mat so that no woman feels watched*".

Another question was about openness to specific issues and whether or not participants could imagine a change, if same-sex groups had been involved. The female interviewees could not imagine any differences here: "*There was a great deal of openness, everything could be expressed and was expressed – by the man and the woman*". It was observed, however, that in the group with a higher proportion of women, the men spoke less in general. The men answered these questions in a more differentiated way, one participant commented: "*I have found that I can speak well or less well about different topics with different genders. In general, I can discuss emotional issues better with women, because they commiserate more. Then again there are issues that I only want to discuss with men*". Another participant partially agreed with that point: "*For me it depends on the interest of the other person for my concerns. Women are interested in different topics than men. I can discuss emotional issues better with women than with men. Not that I would not like to do so with men, but that's not what interests them*".

As to the content of the interventions and whether expectations were met, no gender differences were found. Both women and men reported positively about their experiences. Regarding the preference of the approach to the dance and the movement interventions – the guided and functional versus the free and artistic aspects – no gender-specific preferences were found. A male participant commented: "*I found it increasingly difficult to engage in the free movement or the free dance. It was easier to do the guided exercises, where the instructor said exactly what to do, so I neither needed to self-initiate my movements, nor could I do something wrong. But I imagine that I benefited a lot, or even more, from the free movement, even if it was not so pleasant. Simply because I then learned other qualities and had to take more ownership and thus get more certainty in my own actions*". Several participants reported that they benefited from both the functional, guided and the free, creative parts of the sessions. A female participant commented: "*The question of the definition of free or artistic and guided or functional interventions arises for me. For me personally, the silent exercise (meditation) was completely free and without guidance while in 'free' dance, I felt more guided by hearing the voice of the therapist. During meditation, my subconscious mind could fully expand. I did not like dancing so much because I cannot dance*".

An important question in these focus group discussions was, whether the participants would have also joined the sessions if they had been declared as DMT? Two male interviewees stated: "*I would not have participated (then), because I would have thought that it requires knowledge of certain dance techniques*". A female interviewee expressed her doubts as well: "*I would have felt much more inhibited, if the intervention would have been called Dance Movement Therapy*".

Results and discussion

Looking at all the information gathered here, there is no conclusiveness regarding the question as to why women might be more interested in DMT than men.

As evidenced by the focus group discussions, no significant gender differences in terms of needs, preferences, attitudes, and benefits from the DMT were found in stress-burdened adults. Rather than between-sex differences, there were clear inter-individual differences (see Hyde, 2005). While all female respondents agreed to be comfortable in a mixed-gender setting, one male respondent commented that there could also be benefits from same-sex DMT groups. Part of the participating men felt more comfortable with the male instructor, another part with the female instructor, a similar picture emerged amongst the participating women. Regarding the ability to speak openly about emotions, there was a tendency for both, men and women, to feel better able to do so with women (Wood, Rhodes and Whelan, 1989). Also in this study, the participants reported that the female instructor seemed to radiate a greater openness towards the group. For the free and artistic versus the guided and functional movement there was, contrary to the stereotypes (male = functional, direct; female = aesthetic, artistic), no gender-specific preference. The overarching view was that both approaches are meaningful and have their raison d'être in DMT. The term *Dance Movement Therapy* led to different associations and provided an idea of concrete requirements from both male and female participants: "*having to master a dance style, dancing with a partner, waving esoterically with cloths, etc.*", but also "*expressing one's own feelings through movement*".

The results of the focus group discussions show that both men and women reported positively about their experiences in DMT. Both female and male participants benefited from the free creative movement in dance, but in individual cases, it was more difficult to get involved in these types of movements compared to the more structured interventions. Therefore, the focus group discussions did not support the empirical data on typical male/female movement preferences.

We would like to mention again that the resulting data from the focus group interviews with only eight participants does not yield conclusive results, but rather constitute exploratory findings which help specify hypotheses to be tested in future studies. Many unanswered questions remain (see below). The only resulting certainty is that gender research and gender issues have so far received very little attention in DMT.

Conclusion and outlook

As a result from the analysis and discussion, it seems that taking socially constructed roles and stereotypes into account and paying attention to determining social factors can establish a gender-sensitive DMT that can counteract differences in gender participation.

A possible framework for more male participation in DMT could be to shift the emphasis, particularly in advertising DMT, from *dance* to *movement* in an effort to appeal more to men (and women) who are deterred by the gender stereotypic attribution of dance to femininity (Athenstaedt and Alfermann, 2011). Broga (yoga aimed at men) is a good example where nomenclature has an impact.

Furthermore, announcements need to communicate that DMT does not require the skill of a particular (dance) technique. The use of alternative props such as sticks (as in Escrima stick fighting, widely used in DMT; Schäberle, Hofinger and Koch, 2018) or balls (as in ballistic sports games) could also help to reduce prejudice against DMT and make it more accessible to men as well as women. Therapeutic offerings that take these aspects into account can certainly expect more men to participate. These are initial suggestions that require a closer look and much more empirical research. Further insights into gender-specific needs could provide more qualitative as well as quantitative research on gender issues in DMT. Resulting questions include: how do men benefit from the male therapist, and how do women benefit from the female therapist and vice versa? Does the sex of the facilitator have an impact, or is it rather their facilitation style that counts, as our study suggests? How beneficial are mixed-sex versus same-sex groups for therapy success? And can possible benefits be related to certain "gender issues"? All these questions provide a basis for future research in this area.

Quantitative studies are also a desirable addition to qualitative research, especially with acceptably powered samples of balanced sex ratio, adequate control groups, and the use of physiological measures (such as hormone levels, heart-rate-variability, etc.). A follow-up with a time interval of, for example, six months to the post-test of the study intervention would additionally provide information about long-term effects. Better transfer of results into the clinical field is warranted and according studies would be beneficial.

An article by the German Federal Agency for Civic Education on gender mainstreaming states that there is "*no progress without movement*" (Neusüß and Chojecka, 2012), it is about gender equality policies in political organizations and institutions. This includes the health-care system, which is threatened by an increase of chronic stress levels in our fast-paced, highly engineered and performance-oriented modern times, times that cry for balance and rest, and for body-mind integration that could help reduce this threat. A gender-sensitive Dance Movement Therapy can – in line with gender mainstreaming – be a useful tool to combat this threat. It promises progress through movement – for both men and women!

Acknowledgements

We would like to thank Dominik Wolter for collaborating in the empirical investigation, and him as well as Anna Mastrominico for conducting the focus groups on the topic; we would like to thank Catherine Stephenson and Frank Melchior for language smoothing and constructive comments on this chapter.

References

Athenstaedt, U. 2003. On the Content and Structure of the Gender Role Self-Concept: Including Gender Stereotypical Behaviors in Addition to Attributes. *Psychology of Women Quarterly*, 27: 309–318.

Athenstaedt, U., and Alfermann, D. 2011. *Geschlechterrollen und ihre Folgen. Eine sozialpsychologische Betrachtung [Gender Roles and Their Consequences. A Socio-Psychological View]*, 1st ed. Stuttgart: Kohlhammer.

Bauer, K. 2017. *Tanz- und Bewegungstherapie wirkt auch bei Männern! Einfluss von Geschlecht und Gender auf Wirkung und Wirkfaktoren von achtsamkeitsbasierter Tanz- und Bewegungstherapie: eine Pilotstudie [Dance Movement Therapy Also Works for Men! Influence of Sex and Gender on the Efficacy and Active Factors of Mindfulness-Based Dance Movement Therapy: A Pilot Study.]* Unpublished Master thesis, SRH Hochschule Heidelberg.

Belardinelli, R., Lacalaprice, F., Ventrella, C., Volpe, L., and Faccenda, E. 2008. Waltz Dancing in Patients with Chronic Heart Failure: New Form of Exercise Training. *Circulation: Heart Failure*, 1(2): 107–114. https://doi.org/10.1161/CIRCHEARTFAILURE.108.765727

Bem, S. L. 1974. The Measurement of Psychological Androgyny. *Journal of Consulting and Clinical Psychology*, 42: 155–162.

Bojner Horwitz, E., Theorell, T., & Anderberg, U. 2003. Dance/movement therapy and changes in stress-related hormones: A study of fibromyalgia patients with video-interpretation (Bd. 30). https://doi.org/10.1016/j.aip.2003.07.001

Bojner Horwitz, E., Kowalski, J., Theorell, T., & Anderberg, U. 2006. Dance/movement therapy in fibromyalgia patients: Changes in self-figure drawings and their relation to verbal self-rating scales (Bd. 33). https://doi.org/10.1016/j.aip.2005.05.004

Bräuninger, I. 2012 Dance Movement Therapy Group Intervention in Stress Treatment. 271 A Randomized Controlled Trial (RCT). *The Arts in Psychotherapy*, 39(5): 443–450. doi:10.1016/j.aip.2012.07.002

Breuer, C. 2004. Zur Dynamik der Sportnachfrage im Lebenslauf [To the Dynamics of Sports Demand in the Life Course]. *Sport und Gesellschaft – Sport and Society*, 1: 50–72.

Courtenay, W. H. 2000. Constructions of Masculinity and their Influence on Men's Wellbeing: A Theory of Gender and Health. *Social Sciences and Medicine*, 50: 1385–1401.

Dibbell-Hope, S. 2000. The Use of Dance/Movement Therapy in Psychological Adaptation to Breast Cancer. *The Arts in Psychotherapy*, 27(1): 51–68.

Eagly, A. H., Wood, W., and Johannesen-Schmidt, M. C. 2004. Social Role Theory of Sex Differences and Similarities: Implications for the Partner Preferences of Women and Men. *The Psychology of Gender*: 269–295.

Feingold, A. 1994. Gender Differences in Personality: A Meta-Analysis. *Psychological Bulletin*, 116: 429–456.

Haboush, A., Floyd, M., Caron, J., LaSota, M., and Alvarez, K. 2006. Ballroom Dance Lessons for Geriatric Depression: An Exploratory Study. *The Arts in Psychotherapy*, 33(2): 89–97.

Hackney, M. E., and Earhart, G. M. 2009. Health-Related Quality of Life and Alternative Forms of Exercise in Parkinson Disease. *Parkinsonism and Related Disorders*, 15(9): 644–648.

Hackney, M. E., Kantorovich, S., and Earhart, G. M. 2007. A Study on the Effects of Argentine Tango as a Form of Partnered Dance for Those with Parkinson Disease and the Healthy Elderly. *American Journal of Dance Therapy*, 29(2): 109–127.

Höfner, C. 2008. *Der Berufsalltag integrativer Bewegungstherapeutinnen. Ergebnisse der Fragebogenerhebung mit AbsolventInnen und Studierenden der IBT-Weiterbildung [The Professional Routine of Integrative Movement Therapists. Results of the Questionnaire Survey with Graduates and Students of IBT Continuous Education]*. Accessed 7 October 2017. www.oegit.at/oegit_hp/dokumente/Endbericht_Berufsalltag_IBT.pdf

Hokkanen, L., Rantala, L., Remes, A. M., Härkönen, B., Viramo, P., and Winblad, I. 2008. Dance and Movement Therapeutic Methods in Management of Dementia: A Randomized, Controlled Study. *Journal of the American Geriatrics Society*, 56(4): 771–772.

Hyde, J. 2005. The Gender Similarities Hypothesis. *American Psychologist*, (2): 581–592.

Jeong, Y.-J., Hong, S.-C., Lee, M. S., Park, M.-C., KIM, Y.-K., & Suh, C.-M. 2005. Dance Movement Therapy Improves Emotional Responses and Modulates Neurohormones in Adolescents with Mild Depression. International Journal of Neuroscience, 115(12), 1711–1720. https://doi.org/10.1080/00207450590958574

Jordan, S., and Von der Lippe, E. 2013. Teilnahme an verhaltenspräventiven Maßnahmen. Ergebnisse der Studie zur Gesundheit in Deutschland (DEGS1) [Participation in Behavioral Preventive Trainings. Results of the Study on Health in Germany]. *Bundesgesundheitsblatt*, 56: 878–884.

Jost, J. T., and Kay, A. C. 2005. Exposure to Benevolent Sexism and Complementary Gender Stereotypes: Consequences for Specific and Diffuse Forms of System Justification. *Journal of Personality and Social Psychology*, 88: 498–509.

Kehr, J. 2016. Männer und Körperpsychotherapie. Wie geht das zusammen? [Men and Body-Oriented Psychotherapy. How Does That Work?] *körper – tanz – bewegung*, 4: 79–88.

Kiepe, M-S., Stöckigt, B., and Keil, T. 2012. Effects of Dance Therapy and Ballroom Dances on Physical and Mental Illnesses: A Systematic Review. *The Arts in Psychotherapy*, 39: 404–411.

Knopf, H., & Grams, D. 2013. Arzneimittelanwendung von Erwachsenen in Deutschland. Ergebnisse der Studie zur Gesundheit in Deutschland (GEGS1) [Use of Pharmaceuticals of Adults in Germany. Results of the Study on Health in Germany]. *Bundesgesundheitsblatt*, 56, 868–877.

Koch, S. C., Kunz, T., Lykou, S., and Cruz, R. 2014. Effects of Dance Movement Therapy and Dance on Health-Related Psychological Outcomes: A Meta-Analysis. *The Arts in Psychotherapy*, 41: 46–64.

Koch, S. C., Morlinghaus, K., and Fuchs, T. 2007. The Joy Dance: Specific Effects of a single Dance Intervention on Psychiatric Patients with Depression. *The Arts in Psychotherapy*, 34(4): 340–349.

Koschier, A. 2009. *Effektivität Integrativer Bewegungstherapie. Ergebnisse der TherapeutInnen und KlientInnenbefragung [Effectiveness of Integrative Exercise Therapy. Results of the Therapists and Client Survey]*. Accessed 7 October 2017. www.oegit.at/oegit_hp/dokumente/Endbericht_Klientenbefragung.pdf

Martin, L., Oepen, R., Bauer, K., Nottensteiner, A., Mergheim, K., Gruber, H., and Koch, S. C. 2018. Creative Arts Therapies for Stress Prevention and Management. A Systematic Review. *Behavioral Sciences*, 8(2): 28. https://doi.org/10.3390/bs8020028

Murrock, C. J., Higgins, P. A., & Killion, C. 2009. Dance and Peer Support to Improve Diabetes Outcomes in African American Women. The Diabetes Educator, 35(6), 995–1003. https://doi.org/10.1177/0145721709343322

Neusüß, C., and Chojecka, J. 2012. Kein Fortschritt ohne Bewegung. Soviel Gender wie heute war noch nie [No Progress Without Movement. We Never Had as Much Gender as Today]. *Bundeszentrale für politische Bildung*. Accessed 18 July 2017. www.bpb.de/gesellschaft/gender/gender-mainstreaming/147263/kein-fortschritt-ohne-bewegung

Pinniger, R., Brown, R. F., Thorsteinsson, E. B., and McKinley, P. 2012. Argentine Tango Dance Compared to Mindfulness Meditation and a Waiting-List Control: A Randomised Trial for Treating Depression. *Complementary Therapies in Medicine*, 1156: 1–8.

Quiroga Murcia, C., Bongard, S., and Kreutz, G. 2009. Emotional and Neurohumoral Responses to Dancing Tango Argentino: The Effects of Music and Partner. *Music and Medicine*, 1: 14–21.

Reichel, A. 2013. Moving Gender – Gendersensible Bewegungs- und Tanztherapie. Ein Anstoß [Moving Gender – Gender Sensitive Movement and Dance Therapy. An Impulse]. *körper – tanz – bewegung*, 1, 111–119.

Rulofs, B., Combrink, C., and Borchers, I. 2002. Sportengagement im Lebenslauf von Frauen und Männern [Sportengagement in the Life Course of Women and Men]. *Sportengagement im Lebenslauf – Brennpunkte der Sportwissenschaft*, 39–59.

Sandel, S. L., Judge, J. O., Landry, N., Faria, L., Quellette, R., and Majczak, M. 2005. Dance and Movement Program Improves Quality-of-Life Measures in Breast Cancer Survivors. *Cancer Nursing*, 28(4): 301–309.

Schäberle, W., Hofinger, S., and Koch, S. C. 2018. Escrima in der Therapie. Philippinische Stockkampfkunst in Tanz- und Physiotherapie [Escrima in Therapy. Filipino Stick Martial Arts in Dance- and Physiotherapy]. *körper – tanz – bewegung*, 1, 6(1), 11–17.

Schreiber-Willnow, K., and Seidler, K.-P. 2002. Ist körperorientierte Psychotherapie Frauensache? Eine klinische Prozess-Ergebnis-Studie zur Konzentrativen Bewegungstherapie [Is Body-Oriented Psychotherapy a Woman's Business? A Clinical Process Outcome Study on Concentrative Movement Therapy]. *Psychotherapie, Psychosomatik, Medizinische Psychologie*, 52: 343–347.

Seidler, K-P. 2016. Männer und Frauen in der körperorientierten Psychotherapie. Eine Sichtung der empirischen Befunde am Beispiel der Konzentrativen Bewegungstherapie [Men and Women in Body-Oriented Psychotherapy. A Review of Empirical Findings Using the Example of Concentrative Movement Therapy]. *körper – tanz – bewegung*, 4, 182–192.

Sieverding, M. 2005. Geschlecht und Gesundheit [Gender and Health]. In *Gesundheitspsychologie, Enzyklopädie der Psychologie*, ed. by R. Schwarzer, 55–70. Göttingen: Hogrefe.

Sieverding, M., and Alfermann, D. 1992. Instrumentelles (maskulines) und expressives (feminines) Selbstkonzept: Ihre Bedeutung für die Geschlechtsrollenforschung [Instrumental (Masculine) and Expressive (Feminine) Self-Concept: Their Significance for Gender Role Research]. *Zeitschrift für Sozialpsychologie*, 23: 6–15.

Smolak, L., and Murnen, S. K. 2001. Gender and Eating Problems. In *Eating Disorders: Innovative Direction in Research and Practice*, ed. by R. H. Striegel-Moore and L. Smolak, 91–110. Washington, DC: American Psychological Association.

Tobin, D. D., Menon, M., Menon, M., Spatta, B. C., Hodges, E. V. E., and Perry, D. G. 2010. The Intrapsychics of Gender: A Model of Self-Socialization. *Psychological Review*, 117(2): 601–611.

Trautmann-Voigt, S. 2003. Tanztherapie. Zum aktuellen Diskussionsstand in Deutschland [Dance and Movement Therapy. The Current State of Discussion in Germany]. *Psychotherapeut*, 48: 215–229.

Verbrugge, L. M. 1989. The Twain Meet: Empirical Explanations of Sex Differences in Health and Mortality. *Journal of Health and Behavior*, 30: 282–304.

West, C., and Zimmermann, D. 1987. Doing Gender. *Gender and Society*, 1: 125–151.

West, J., Otte, C., Geher, K., Johnson, J., and Mohr, D. C. 2004. Effects of Hatha Yoga and African Dance on Perceived Stress, Affect, and Salivary Cortisol. *Annals of Behavioral Medicine*, 28(2): 114–118.

Whitley, B. E. 1983. Sex Role Orientation and Self-Esteem: A Critical Meta-Analytic Review. *Journal of Personality and Social Psychology*, 44: 765–778.

Wiedenhofer, S., and Koch, S. C. 2016. Active Factors in Dance/Movement Therapy: Specifying Health Effects of Non-Goal-Orientation Movement. *The Arts in Psychotherapy*, 52: 10–23.

Williams, J. E., and Best, D. L. 1990. *Measuring Sex Stereotype: A Multination Study*. Newbury Park: Sage.

Wolter, D. 2017. "Achtsamkeit – Bewegt!2" – Ein Unterschied für Männer und Frauen: Eine randomisierte Studie [*Mindfulness – Moves!2 – A Difference to Men and Women: A Randomized Trial*]. Unpublished Masterthesis, SRH Hochschule Heidelberg.

Wood, W., Rhodes, N., and Whelan, M. 1989. Sex Differences in Positive Well-Being: A Consideration of Emotional Style and Marital Status. *Psychological Bulletin*, 106(2): 249–264.

13

ART THERAPY AND MOTHERHOOD AS A RITE OF PASSAGE

Evelina Jagminaite

Introduction

I consider myself a feminist who has ridden herself of many paternalistically pre-scribed stereotypes about womanhood. But when I became pregnant, I realized that I had a very impoverished view of a birthing woman. My subconscious was filled with many scary and disempowering images of women's experiences while giving birth. I was quite distressed when thinking of what was coming. I had heard about epidurals and C-sections and about women having their babies in sterile hospital environments surrendered into a lithotomy position (which places a woman's feet above her hip – often in stirrups) – while taking precise instruction from the medical staff in how to push out their babies. This chilling picture of forced surrender did not inspire me in any way. The voice of medical authority in my subconscious was prompting me to remain ignorant, as I would not have a say in it anyway. I tried to ignore my fears and thought when the time comes, I will surrender completely to the medical knowledge as a 'good' woman should, and get it over with as quickly as possible.

However, several images that I had seen years before, while living in Barcelona, kept creeping into my memory, sparking my curiosity and hope for a different way to welcome my son into this world. These images were a series of self-portraits by the artist Ana Alvarez-Errecalde just after she had given birth (Figure 13.1). She was holding her newborn in her arms with a big smile; next to her was her placenta with an umbilical cord. She was full of light and energy. I wondered how this was possible right after giving birth. These images shook me to the core and collided with my ignorant ideas about birthing women. The images showed me that a woman can be an active agent in birthing and even derive pleasure from the experience. Mothers could be capable of expressing themselves artistically right after birth. I thought this type of image would be impossible to obtain because giving birth is so exhausting and

164 Evelina Jagminaite

FIGURE 13.1 Ana Alvarez-Errecalde, *The Birth of My Daughter*, silver print (2005).

incapacitating. I wondered how a woman could look the way Ana did – happy, strong, capable, and enlightened. Now after having had my son, going through the process myself, and learning about the natural birth movement, I know that Ana's images are not some strange anomaly or a rare exception. Her images embodied and validated a birthing woman's power and centrality that years of patriarchal domination has attempted to take away from our collective awareness.

My own experience of becoming a mother has led me to wonder about societal pressures during the pre and postnatal periods in women's lives and how practices of art therapy could help to address them. Therefore, this chapter analyzes how art therapy, which contextualizes women's experiences within a contemporary artistic practice, can challenge the initial simplicity with which women might view themselves and help create deeper visual narratives. To achieve this, I examine how patriarchal assumptions in Western culture influence the current practice of obstetrics and conducted several semi-structured interviews to identify cultural norms and assumptions that shape the care that women receive in pre and postnatal periods of their lives; review social support and art therapy literature related to motherhood; explore birth art by women artists; discuss my art work produced in response to this study, and propose how birth art by women artists could be incorporated into art therapy practice. I hope that the fusion of birth art by contemporary women artists with pre and postnatal art therapy practice can help resist cultural misogyny, provide alternative constructs of motherhood, and strengthen sense of unity among mothers.

Method

According to Kapitan (2010), the purpose of qualitative studies is 'discovery or understanding of the phenomenon rather than testing' (p. 212). To conduct this study, I used the following methods to gather information: reviewing literature that highlights problems encountered by women in the transition to motherhood;

Art therapy and motherhood **165**

conducting semi-structured open-ended interviews with individuals who provide services to women in pre and postnatal care; outlining studies in art therapy that helped women to address this transition; reviewing examples of birth art by women artists; and creating art work as an aesthetic synthesis of the ideas discussed. Due to chapter word-count restrictions a full account of the qualitative data is not possible, but it summarized in brief at the end.

Background

Western medicine developed and grew within a patriarchal context. The medical model is based on a fragmented view of an individual, rooted in Descartian notions of science. This philosophy focuses on diagnosing and isolating symptoms of disease and then targeting aggressive treatment to alleviate the condition (Davis-Floyd and Sargent, 1997). Under the medical model the physician is viewed as the sole expert and patients are expected to comply to his authority (Davis-Floyd and Sargent, 1997). The authority in the process of birth is relegated to the biomedical ways of knowing where a woman's knowledge about her own body is regarded as less accurate or relevant (Davis-Floyd and Sargent, 1997). The assumptions of the medical model are based on seeing pathology and trying to alleviate it. Therefore, when faced with a natural process such as birth, medical procedures are often interventionist.

Gynaecology and obstetrics developed by treating female reproductive pathology (McGregor, 1998). In the US, obstetrics grew in the historical context of doctors experimenting and developing untried medical techniques on poor or slave women patients (McGregor, 1998). Surgery techniques were perfected on non-anesthetized slave women of the South and poor immigrant women of the North. Obstetricians were trained as surgeons, and when it came to childbirth they were prepared to manage birth using the newest medical inventions such as episiotomies, forceps, and surgery. Even though obstetricians have participated in many births, few of them had much experience with natural birth. In the medical context women's knowledge, self-awareness, and intuition were regularly disregarded, ignored, and submitted to the patriarchal authority of male doctors (Davis-Floyd and Sargent, 1997). In hospitals, women were giving birth in a lithotomy position under the influence of heavy medications that could often lead to more severe medical interventions. Today, these historical undertones have resulted in hugely contested ideological debates and practices related to the management of childbirth within the medical science of obstetrics (Hogan, 2003, 2016).

There have been attempts to include more holistic approaches to birth in hospital settings by introducing midwifery services. However, natural birth, meaning no medical intervention, is much less likely to occur in a hospital setting. Though the medical model of birthing can greatly benefit when birth becomes complicated and abnormal, it is overused. For instance, Epstein and Lake (2008), in a documentary on birthing practices in the US, highlight a trend demonstrating that the more technology is developed to address a few severe cases, the more it is used in situations that do not require it. In the US in 2002, 93% of mothers were connected to

166 Evelina Jagminaite

an electronic foetal monitor; 63% received an epidural for pain management; 55% had their membranes ruptured to speed labour; 53% receive oxytocin to stimulate labour; and 52% received episiotomies to speed deliveries within hospital care (Declercq et al., 2002). Cesarean rates have increased over the years. In 1970s the rate of Cesarean births was 5.5%; by 2012 it grew to 30% (US National Center for Health Statistics, 2012) and is now around 31.9%. Obviously, this increase cannot be solely attributed to a sudden increase in birthing complications. Instead, it is likely the result of the overmedicalization of birth: 'in childbirth, one experiences all the natural power of a woman's body, and in the practice of institutionalized childbirth one experiences all the faces of woman's oppression' (Griffin, 1982, p. 150).

Therefore, many women who have been forced into unwanted medical procedures, such as episiotomies or Cesarean births, feel cheated out of their birthing experience (Kitzinger, 2002). Artist Nalleke Nix in her work *Midnight in the Sterile Tent* powerfully illustrates the possibly incapacitating birth experience as a woman is surrendered to medical procedures (Figure 13.2).

FIGURE 13.2 Nalleke Nix, *Midnight in the Sterile Tent*, drawing (2008).

The empowerment possible in the act of birthing is taken away from many women's consciousness by authoritative notions of the medical establishment (Davis-Floyd and Sargent, 1997). Instead birth has been made into something that should be feared, avoided, and pushed into passivity and paralysis, rather than being comprehended as an active and empowering experience revered for the making of life.

Art therapy for pre and postnatal women

As women in Western culture are bombarded with disempowering and objectifying images, self-awareness that critically reflects upon one's cultural context can help improve self-esteem and gain a sense of control, often identified as lacking by the new mothers (Hogan, 2008, 2013; Swan-Foster, 1989). Art therapy groups have been used to assist women in deepening their self-concept upon entering motherhood and improving their relationships with newborns (Hall, 2008; Hocking, 2007; Hogan, 2012; Hosea, 2006; Proulx, 2002; Swan-Foster, 1989). This helps women to feel less isolated with their 'unacceptable' feelings towards their newborns and counteracts destructive and simplistic cultural stereotypes about motherhood.

Swan-Foster (1989), in her study using art therapy with four pregnant women, provided concrete examples of how art therapy can be used to help women express their concerns and gain a deeper sense of self during pregnancy. In this study, each of the four women completed four images of themselves that represented their self-portrait, their fear, their transformation of that fear, and a closing mandala. Self-portraits helped women to prepare for labour and motherhood as well as were useful in diagnosing adaptation to pregnancy. The results of the study indicate that through the artistic process, first-time mothers were able to gain 'creative introspection, maturation, and self-empowerment' (Swan-Foster, 1989, p. 292).

Another art therapy example that sheds light on women's narrative formation of themselves as new mothers is a study by Hocking (2007). In this study, Hocking (2007) explored artistic pregnancy narratives of three women, noting changes in women's self-concept during the progression of their pregnancies. The author analyzed symbols within the women's drawings using Jungian theory of archetypes (Hocking, 2007). The findings suggested that mother-identity is formed during the early stages of pregnancy and progresses in the woman's self-concept through the pregnancy.

Art therapist Susan Hogan (1997, 2003, 2012, 2013, 2015, 2016), in her research related to motherhood, offers critical and insightful observations into the art therapy process with new mothers. Hogan has conducted qualitative research using art therapy with women in pre and postnatal periods of their lives. Women in these art therapy groups produced images expressing their feelings about motherhood. Reactions of women to their pregnancy were complex. Themes that arose and needed to be addressed were: anxiety and anger due to inhibited grief of self loss that could not be expressed due to idealized expectations of motherhood; postbirth trauma caused by medical interventions and hospital protocols; and exploration of the unprecedented amount of imposed control, judgement, contradictory advice, and monitoring imposed by multiple institutions (Hogan, 2012). Furthermore, the

author challenged implicit cultural assumptions promoted by psychological theories based on Winnicott's (1965, p. 215) object relations theory of 'good-enough mother,' but not 'too-good mother,' pointing out how these types of theories promote maternal guilt and are examples of 'mother-blaming' psychological paradigms that should be correctly identified as 'cultural misogyny' (Hogan, 2012, p. 79).

Hogan in her research highlights the theme of grief experienced by many mothers due to post-traumatic birth experiences. Therefore, insights from art therapy on grief can be applied in work with women in the transition to motherhood. Seftel (2006), in her book on art therapy and grief due to miscarriage, highlights the potential of art making as a ritual in the healing process. Seftel gave examples of how in traditional communities – unlike the Western world where art is often perceived as an object made for the museum – 'art is rooted in rituals' and 'integrated into the life of the community' (Seftel, 2006, p. 95). According to Seftel, 'the visual and performing arts incorporate rituals to invoke the gods, remove obstacles, celebrate the rites of passage, and mark the turning points in the cycle of death and renewal' (Seftel, 2006, p. 95).

Seftel invites her readers to create rituals in the therapeutic process and to seek participation in the community to promote public discourse and healing. *The Secret Club* project, a curated exhibition by Seftel, included works on pregnancy loss by multiple women artists. This project is an example of socially engaged art and a transformative ritualized public event that sparked community dialogue on the painful topic of miscarriage that is rarely acknowledged by our society (Seftel, 2001).

Hogan (2015) provided another innovative example of art therapy as a participatory art practice in the project *Mothers Make Art*. In this project, artist Lisa Watts facilitated a group process for mothers that explored the potential of a performing body interacting with everyday objects to encourage exploration of self-reflective subjectivity and to raise feminist consciousness among project's participants and their audience (Hogan, 2015). The group went through a series of workshops, where women practiced 'self-declaration via art making tasks' (Hogan, 2015, p. 27). The work was publicly presented and performed. Just as in the traditional language of ritual, where symbolic transformation of objects takes place (Gantt, 1991, p. 16) such as a doll taking on magic qualities to aid in conception and birth of a baby amongst Lulua people of Congo or a milagros charm in Mexico (Seftel, 2006, p. 127). In Hogan and Watts's project, the transformation of everyday objects into installation art works opened up a critical space for transfiguration of dominant discourses. This example of community engaged art making could be viewed as a modern-day ritualized art practice having transformative, spiritual, and therapeutic potential not just for the group members involved in performance but for the larger audiences as well. Both *The Secret Club* project and the *Mothers Make Art* project are examples of how the art therapy process can be transformed into a socially engaged participatory art practice.

Insights gained from the studies reviewed suggest that 'pictorial space provided by the use of art therapy' gives much needed room to grieve the loss of an old self while helping reconstruct more empowered and aware identities (Hogan, 2003, p. 169).

Therefore, art therapy practice could be enhanced by inclusion and analysis of visual images that challenge patriarchal values rooted in our cultural subconscious. Inclusion of art works by contemporary artists in art therapy practice has an enormous potential to imprint alternative narratives and challenge the medical model of giving birth.

Birth art by women artists and my art response

To further art therapy applications and to name a few concrete ways which may enhance art therapy's critical potential in reflecting upon Western cultural norms surrounding motherhood, I reviewed birth art created by several contemporary women artists. As a response to this process, I created an art piece that is one example of how to incorporate these images into the art therapy process. A few examples of contemporary artists who powerfully activate the birthing female body and visually challenge cultural misogyny towards birthing woman are Carolee Schneeman's *Interior Scroll*; Judy Chicago's *The Birth Project*; Canan Senol's *Kybele*; and Marni Kotak's birth performance *The Birth of Baby X*. These women artists reveal how a female body can be seen as an active force in its own right that rejects the traditional representations of a passive female body subjugated to the controlling male gaze (Chicago and Lucie-Smith, 1999). These works of art are examples of activating the woman's body in profound and challenging ways, where a woman giving birth is seen to be deeply engaged in the process of creation.

In *Interior Scroll*, Schneeman entered the performance space covered with a sheet. She disrobed, climbed upon a table, outlined her body in mud, exhibited her body in 'action poses' often practiced in life-drawing classes, and read from her book *Cezanne, She Was a Great Painter*. She then extracted a paper scroll from her vagina and read from it out loud – giving birth to her finished work of art (Chicago and Lucie-Smith, 1999).

About this performance Schneeman wrote:

> I thought of the vagina in many ways – physically, conceptually: as a sculptural form, an architectural referent, the source of sacred knowledge, ecstasy, birth passage, transformation. I saw the vagina as a translucent chamber of which the serpent was an outward model: enlivened by its passage from the visible to the invisible, a spiraled coil ringed with the shape of desire and generative mysteries, attributes of both female and male sexual powers. This source of 'interior knowledge' would be symbolised as the primary index unifying spirit and flesh in goddess worship.... I assumed the carved figurines and incised female shapes of Paleolithic, Mesolithic artifacts were carved by women – the visual-mythic transmutation of self-knowledge to its integral connection with a cosmic Mother – that the experience and complexity of her personal body was the source of conceptualizing, of inter-acting with materials, of imagining the world and composing its image.
>
> *(Schneeman and McPherson, 1979, pp. 234–235)*

Schneeman's art work is strongly influenced by the feminist movement of the 1970s. Her work revolves around active expressions of a female body and the reclamation of her erotic power. In an interview about her artistic practice, the artist stated: 'In some sense I made a gift of my body to other women; giving our bodies back to ourselves' (Lippard, 1976, p. 126). I included this work in my review because it is an important representation of female resistance to the misogynistic attitudes of our society. It is an image that claims back the feminine erotic power, while giving birth – an act of female creation in and of itself.

In *The Birth Project*, Judy Chicago teamed up with more than 150 needleworkers over the period of five years to create 'images combining painting and needlework that celebrate various aspects of the birth process; from the painful to the mythical' (Chicago, 1985, p. 17). As Judy Chicago approached the topic of birth she was struck to find out that there were almost no images of birth in Western art, especially from a woman's perspective (Chicago, 1985). Therefore, to explore the theme of birthing Judy Chicago decided to go to the women themselves and ask them to tell about their birth experiences. She used these stories to produce images that captured the process and strenuous effort of labour. The images produced by Judy were then executed in the homes of women needleworkers in the United States, Canada, and New Zealand. 'Chicago incorporated the traditional use of needlework into radical feminist art and drew attention to the intense technical skill of the undervalued workers and the impressive creative potential of this neglected medium' (DeBiaso, 2013, p. 3). This project was a potent undertaking that drew attention to one of the most important and neglected events of human existence, birth, which has been shunned to the corners and ignored just like many other aspects of women's efforts and labour.

The work of art in Figure 13.3 is based on the cult of Anatolian Cybele, known as the 'the great mother' or 'the mother of the gods.' Her possible precursor was the Neolithic goddess of Çatalhöyük, from a region occupied between 6200 and 5400 BC in south-central Turkey. The statue pictured in Figure 13.4 represents a corpulent goddess sitting on a lion throne while appearing to be giving birth (Roller, 1999).

Performance artist Marni Kotak transformed a New York art gallery into a home birth site (Figure 13.5), where she gave birth in front of an open audience, action that she called the 'highest form of art' (Block, 2011).

This performance struck me as an intimate invitation to take part in a sacred event. Although at first I was a bit perplexed by its exhibitionist tendencies, I believe this sensation of mine is indicative of my own conditioning to want to shun the birth experience to the private quarters of women's lives. I think with this performance the artist made an efficacious statement to do exactly the opposite.

Overall these works of art have an important role to play in art therapy. They are gifts from women to women that can give back to us the ownership of the birthing woman's body and inspire reverence, action, and resistance. Therefore, visual synthesis of the material reviewed inspired me to create an art work, culminating in a 140-by-140 centimetre mixed media painting. The painting reflects upon my

Art therapy and motherhood 171

FIGURE 13.3 Canan Senol, *Kybele*, silver print (2000).

desire to incorporate traditional female craft into the painting process. I researched many anonymous doily designs and created a design referencing one of my favourite painters from Pattern and Decoration Movement, Robert Zakanich. I created my painted doily through repetitive and controlled hand motions of pouring red acrylic paint onto a surface. Inside of its design, I weaved six images by contemporary women artists; two images by Ana Erecalde, *The Birth of My Daughter*; one

172 Evelina Jagminaite

FIGURE 13.4 *Seated Woman of Çatalhöyük*, The Museum of Anatolian Civilizations, Ankara, Turkey (6000 BCE).

Photograph by Nevit Dilmen.

image by Carolee Schneeman, *Vagina Scroll*; one image by Alison Saar, *Study for Sea of Fecundity*; one image by Canan Senol, *Kybele*; and two images by me, *Tribute to Georgia O'Keeffe* and *Interlacing Birth*. Images included in this visual mind map challenge existing stereotypes and highlight the strength of a birthing woman.

FIGURE 13.5 Marni Kotak, *The Birth of Baby X*, durational performance and installation (2011).

Image courtesy of the artist and Microscope Gallery.

Intricate doily tablecloths have long been used by women to adorn their tables for a meal, making it more special, while they feed and nurture their families and guests. My painted doily is a metaphor with which I want to draw attention to women's craft and invite women to celebrate and to nurture themselves and each other. I believe that this type of art work can decorate and inform the space where art therapy with pre and postnatal women would take place. It can serve as a reminder of a birthing woman's power and be used as source imagery for creation of visual mind maps in art therapy providing an opportunity to critically examine sources of women's oppression, resistance, and power.

Discussion

The key finding from my interviews supported my initial claim that hospital environments are often stressful and are not set up in a way to empower and support birthing women. Hospital births can be traumatic. In the medical model of birth, white, male-centric, and Puritan values structure women's experiences. The care that most women receive throughout pre and postnatal periods is fragmented and focused on biological processes. Psychological aspects of birth are often not addressed. Care such

FIGURE 13.6 Evelina Jagminaite, *Interlacing Birth*, mixed media, 140 x 140 cm (2015).

as birthing classes, doulas, or psychological support are services that for the most part are paid for by individual women themselves. If income is a consideration, it is hard to get any support that is outside of a medical treatment model.

The need to support women in this tender period of their lives is not acknowledged. For the most part women's emotional states are ignored and they are left to deal with post-traumatic experiences on their own. Women are expected to give birth and go back to 'normal' in a short amount of time. In the US, in a 'good' case scenario women get three months of *un*paid maternity leave. After this term women are expected to go back to work, to further compete in a job market that is defined by male-centric cultural norms; meanwhile, they must also be wonderful mothers fully present for their children. Women experience much financial as well as psychological pressure upon entering motherhood. American society does not allocate financial nor institutional resources to support their mothers in ways that address more than basic biological needs defined by the medical establishment.

I believe that this societal backdrop is important to consider in provision of psychological support to women during pre and postnatal periods of their lives. It is important to remember that the experience of illness is not only a biological aberration but is also socially 'sanctioned' and culturally experienced (Hogan, 2012, p. 80). Societies have a tendency to become deeply embedded in their own familiar discourses, which predisposes its members to lose their ability to decipher those messages. 'Whether we are aware of a discourse or not, it can powerfully shape the stories we can tell and the stories we can hear' and the stories we can live (Weingarten, 1995, p. 11).

Art allows us to create the necessary critical distance to reflect and evaluate one's choices, opinions, roles, and expectations. Artistic process facilitates multimodal and somatic engagement with emotional parts of the brain before verbal equivalents can be found for naming one's experiences (Klorer, 2005). Art therapy through its symbolic language can create a space to process complex feelings and possible trauma related to motherhood (Hogan, 2003). It can also provide the necessary social support. The art therapists interviewed indicated that exploration of visual narratives with their clients have deepened their clients' understanding of their shifting roles upon entering motherhood. Although for the most part art therapists interviewed did not employ source imagery from contemporary women artists in their practice, I believe that women's experiences of motherhood can be strengthened and enhanced by contextualizing their experiences within contemporary artistic discourse. For example, Stiles and Mermer-Welly (1998) used art therapy with teenage mothers and incorporated interactive museum visits to enhance the art therapy experience.

Contemporary women artists within their artistic practices are provoking us to critically evaluate and challenge society's stereotypes and dormant assumptions about birthing women's bodies. An image can imprint the subconscious with the power of resistance against cultural misogyny and covert symbolism of the medical model. It can also help women to situate themselves within a broader cultural context, offering a sense of belonging to a community of women and their struggles. Art works by contemporary women artists who address issues related to motherhood used as source imagery in art therapy can provide concrete means of how to include postmodernist feminist ideas into art therapy. According to Hogan (2013), a postmodern feminist approach in art therapy 'enables a sophisticated response to new mothers, rather than a reductive biologically medical one which sees the "problem" of depression entirely located in the individual' (p. 80).

Art therapy projects such as *Mothers Make Art* (Hogan, 2015) carried out by art therapist Hogan and performance artist Watts and the *Secret Club* (Seftel, 2001) exhibition organized by art therapist Seftel are examples of socially engaged participatory art practices that contextualize women's experiences within a contemporary artistic practice. These examples challenge and inspire reflection upon prescriptive societal norms surrounding motherhood allowing to engage in a deeper dialogue with oneself and the other.

176 Evelina Jagminaite

As an art therapist I hope to be able to offer a space for women that allows for a construction of a more empowering narrative about birth. I imagine creating an educational and supportive program for mothers to be. Where educational material about the medical birthing model would be complemented by historical feminist analysis and source imagery by contemporary women artists that challenges cultural norms. The program would combine educational material with artistic community-oriented projects such as public exhibitions and presentations. This form of art therapy practice would incorporate a multitude of empowering images of a birthing woman, which could serve as a source of inspiration in developing one's own imagery and enhancing personal narrative.

Conclusion

The birth of my son was a rite of passage through which I entered into motherhood. It allowed me to experience both home and hospital birthing environments and to see how my role and sense of self were experienced differently at home and in the hospital. I planned to have my baby in a hospital, but due to emergency circumstance he was born at home. Later I was taken to the hospital by an ambulance. Thus, I was able to experience both environments during the same birth.

I was a woman who was set on having a natural birth. I was one who read and studied extensively about the birthing process. I also had hired a doula to help me navigate the medical environment and to have support. Upon arriving to the hospital and being turned into a patient, I felt disempowered. Although I did decline several medical procedures, which were repeatedly forcefully offered to me, in a state of exhaustion I was coerced into medical procedures that I did not want. I went to the hospital feeling like a healthy, strong, and happy mother who on the cold winter night minutes after giving birth was able to walk from her third-floor apartment and step into the ambulance. From the hospital, I came back with severely bruised arms; I was exhausted by the bright florescent lights switching on and off in the middle of the night and the early hours where I was woken to answer many questions from the various medical staff. While at the hospital, I was forced to abide by the procedures that were structured to fill hospital's requirements; my needs for rest, peace, and quiet were repeatedly disregarded. I had a minimal stay at the hospital and minimal medical interventions; however, I still felt confused and angry about my experience.

Working on this chapter was an opportunity to process the changes that took place in my life as I entered motherhood. Through this process, I was able to negotiate important identities: my identities as a woman, a mother, a feminist, an art therapist, and an artist. Interviews that I conducted gave me a better view of the problems often encountered by women in pre and postnatal periods of their lives. Exploration of art works by other women artists deepened my understanding of contemporary artistic practices and offered a sense of belonging to a community of mothers. Their images inspired a belief in me that I as well can be in tune with my body while giving birth and mothering.

I don't believe birth is a private matter. Just as I don't believe that prenatal anxiety or postpartum depression are individual problems that have nothing to do with the cultural norms and expectations surrounding motherhood. Birth is a community event. It is the time when women need support, tenderness, and understanding from the ones closest to them and society at large. However, American society is far from being one that offers such support. Therefore, connecting to one's community through art and developing critical ability to analyze and reflect upon one's condition are important in preparation to enter motherhood and to withstand its harsh realities. My art response that was born out of the process of writing is meant to offer and share my inspiration with other women. I hope that ideas nurtured and born during the writing process is a humble beginning in my attempts to practice art therapy that resists cultural misogyny and strengthens mothers' sense of unity between each other and their communities.

APPENDIX A

Shared questions for all service providers:

1 What services do you provide for pre and postnatal women?
2 Could you describe the racial, socio-economic identities of the women you primarily serve?
3 From your experience, what do you see as the biggest needs of pre and postnatal women that are being met? What needs are not being met?
4 How have you observed art making as useful to women at this point in their lives?
5 What is your conceptual understanding of pre and postnatal care?
6 How do you think cultural constructs of motherhood shape the pre and postnatal care that women receive in the US?
7 How do you think cultural constructs of birth shape what women expect of themselves in the birthing process?
8 How do you think cultural constructs of motherhood shape women's conceptions of themselves?

Additional questions for the midwife and doula:

A Do you see art making as beneficial to women in pre and postnatal care? Why or why not?
B What types of art making practices do you offer or wish you could offer in your practice?
C What are the barriers for women to be able to access pre and postnatal care services?
D What needs are not being met in the field of pre and postnatal care?
E What types of services do you wish could be offered to women in this period of their lives?

Additional questions for art therapists:

9 Under what circumstances have you provided group or individual art therapy to pre and postnatal women?
10 What other art therapy services do you know of that are available to women in this period of their lives?
11 What types of art making practices have you offered to support the transition to motherhood?
12 What are the barriers for women to be able to access pre and postnatal art therapy services?
13 What types of art therapy services do you wish could be offered to women in this period of their lives?

References

Block, J. (2011, December 17). Birth as performance art. *The Daily Beast*. Retrieved from www.thedailybeast.com/articles/2011/10/17/birth-performance-art-marni-kotak-other-moms-who-share-all.html
Chicago, J. (1985). *The birth project*. Los Angeles, CA: Doubleday.
Chicago, J., and Lucie-Smith, E. (1999). *Women and art: Contested territory*. New York: Watson-Guptill.
Comstock, D. (2005). *Diversity and development: Critical contexts that shape our lives and relationships*. Belmont, CA: Brooks and Cole.
Davis-Floyd, R. E., and Sargent, C. (1997). *Childbirth and authoritative knowledge: Cross-cultural perspectives*. Los Angeles, CA: University of California Press.
DeBiaso, F. S. (2013). *Judy Chicago: The birth project*. Schmucker Art Catalogs, Book 3. Retrieved from http://cupola.gettysburg.edu/artcatalogs/3
Declercq, E. R., Sakala, C., Corry, M. P., Applebaum, S., and Harris, P. R. (2002). *Listening to mothers*. Retrieved from www.childbirthconnection.org/article.asp? ck=10072
Epstein, A. (Director), and Lake, R. (Producer). (2008). *The business of being born* (Documentary). Berkeley, CA: Red Envelope Entertainment.
Gantt, L. (1991). Discussion. In K. Boegel and L. Van Marissing (Eds.), *The Healing Qualities of Art. Art Therapy: Journal of the American Art Therapy Association*, 8(1), 12–16.
Griffin, S. (1982). *Made from this earth*. New York: Harper and Row.
Hall, P. (2008). Painting together — an art therapy approach to mother infant relationship. W: Case C., Dalley T. (ed.). Art therapy with children: From infancy to adolescence. Routledge, New York. 2008; 20–23.
Hocking, K. L. (2007). Artistic narratives of self-concept during pregnancy. *Arts in Psychotherapy*, 34(2), 163–178.
Hogan, S. (1997). Feminist Approaches to Art Therapy. New York: Routledge.
Hogan, S. (Ed.). (2003). *Gender issues in art therapy*. Philadelphia, PA: Jessica Kingsley Publishers.
Hogan, S. (2008). Healing Arts: The History of Art Therapy. London: Jessica Kingsley Publishers.
Hogan, S. (2012). Postmodernist but not post-feminist! A feminist postmodernist approach to working with new mothers. In H. Burt (Ed.), *Art therapy and postmodernism: Creative healing through a prism* (pp. 70–83). Philadelphia, PA: Jessica Kingsley Publishers.
Hogan, S. (2013). Your body is a battleground: Women and art therapy. *The Arts in Psychotherapy. Special Issue: Gender and the Creative Arts Therapies*, 40(4), 415–419.

Hogan, S. (2015). Mothers make art: Using participatory art to explore the transition to motherhood. *Journal of Applied Arts and Health*, 6(1), 23–32.

Hogan, S. (2016). *Gender Issues in Art Therapy*. London: Jessica Kingsley Publishers.

Hosea, H. (2006). "The Brush's Footmarks": Parents and infants paint together in a small community art therapy group. International Journal of Art Therapy, 11(2), 69–78.

Kapitan, L. (2010). *Introduction to Art Therapy Research*. New York: Routledge.

Kitzinger, S. (2002). *Birth your way: Choosing birth at home or in a birth center*. London: Dorling Kindersley.

Klorer, P. G. (2005). Expressive therapy with severely maltreated children: Neuroscience contributions. *Art Therapy*, 22(4), 213–220.

Lippard, L. R. (1976). *From the center: Feminist essays on women's art*. New York: Dutton.

McGregor, D. K. (1998). *From midwives to medicine: The birth of American gynecology*. New Brunswick, NJ: Rutgers University.

Misner, S. J. T. (2012). *The influence of social environment characteristics on depressive symptoms of low-income urban mothers*. (Order No. 3556488, University of Illinois at Chicago), ProQuest Dissertations and Theses, 225-n/a.

Proulx, L. (2002) *Strengthening Emotional Ties through Parent-Child-Dyad Art Therapy*. London: Jessica Kingsley Publishers.

Rauenhorst, J. M. (2001). *Factors influencing mother-infant attachment during pregnancy: A qualitative investigation*. (Order No. 3017931, University of Minnesota), ProQuest Dissertations and Theses, 200.

Roller, L. E. (1999). *In search of God the mother: The cult of Anatolian Cybele*. Berkeley, CA: University of California Press.

Schetter, D. C. (2010). Psychological science on pregnancy: Stress processes, biopsychosocial models, and emerging research issues. *Annual Review of Psychology*, 62, 531–558.

Schneemann, C., and McPherson, B. R. (1979). *More than meat joy: Complete performance works and selected writings*. New Paltz, NY: Documentext.

Seftel, L. (2001). The secret club project: Exploring miscarriage through the visual arts. *Art Therapy*, 18(2), 96–99.

Seftel, L. (2006). *Grief unseen: Healing pregnancy loss through the arts*. London: Jessica Kingsley Publishers.

Stiles, G., and Mermer-Welly, M. (1998). Children having children: Art therapy in a community-based early adolescent pregnancy program. *Art Therapy*, 15(3), 165–176.

Swan-Foster, N. (1989). Images of pregnant women: Art therapy as a tool for transformation. *Arts in Psychotherapy*, 16(4), 283–292.

U.S. National Center for Health Statistics. Rates for Total Cesarean Section, Primary Cesarean Section, and Vaginal Birth After Cesarean (VBAC), United States. (1989–2013). Retrieved from www.childbirthconnection.org/article.asp? ck=10554

Weingarten, K. (1995). Radical listening: Challenging cultural beliefs for and about mothers. *Journal of Feminist Family Therapy*, 7(1–2), 7–22.

Winnicott, D. W. (1965). *The maturational processes and the facilitating environment: Studies in the theory of emotional development*. London: Hogarth Press.

14
GENDER IDENTITY, SEXUAL IDENTITY AND SEXUAL ORIENTATION IN A DRAMA-THERAPEUTIC CONTEXT

An attachment perspective

Craig Flickinger

Sexual/gender identity and sexual orientation

The intention of this chapter is to synthesize three fields of research: drama therapy, sexual and gender identity and sexual orientation, and attachment theory. Because of limitations of space, a full exploration of attachment theory is not possible. The primary research question asked is:

> How can having a LGBTQ (Lesbian, Gay, Bisexual, Transgender, Queer) sexual orientation or sexual or gender identity affect one's attachment style in adulthood? Secondly, how can drama therapists work with these issues?

This chapter offers suggestions for addressing issues experienced by drama therapists who may be working with both attachment-related difficulties in adulthood and gender identity, sexual identity and sexual orientation issues in their practice. Suggestions include drama therapy exercises, theories, and weaving together possible intersections of these three fields of research. Areas for further study are briefly addressed.

Attachment theory and adult attachment

Berman and Sperling (1994) define adult attachment as 'the stable tendency of an individual to make substantial efforts to seek and maintain proximity to and contact with one or a few specific individuals who provide the subjective potential for physical and/or psychological safety and security' (8). Bartholomew and Horowitz (1991) break down the four-group model of attachment styles created by Bartholomew (1990) to conceptualize four combinations based on image of self and image of other: *secure, preoccupied, fearful-avoidant,* and *dismissing-avoidant* (Figure 14.1).

These are measured on two axes, *dependence* and *avoidance*.

	MODEL OF SELF (Dependence)	
	Positive (Low)	**Negative** (High)
Positive (Low) **MODEL OF OTHER** (Avoidance)	CELL I **SECURE** Comfortable with intimacy and autonomy	CELL II **PREOCCUPIED** Preoccupied with relationships
Negative (High)	CELL IV **DISMISSING** Dismissing of intimacy Counter-dependent	CELL III **FEARFUL** Fearful of intimacy Socially avoidant

FIGURE 14.1 From Bartholomew and Horowitz (1991).

Someone securely attached tends to have a high opinion of themselves and is trustful of the world, allowing themselves to be intimate with others. If someone is preoccupied, they tend to have a low opinion of themselves but still seek intimacy and closeness from others, thereafter described as needy or pushy. Fearful-avoidant individuals would typically have both a low opinion of themselves and a distrust of others, opting to push them away and avoid intimacy. Lastly, dismissing-avoidant individuals may have high opinion of themselves but are mistrusting of others, avoiding intimacy.

Cassidy (2001) highlights ways that secure attachment can be connected to the ability to have intimate relationships, with four components: a) ability to seek care, b) ability to give care, c) ability to feel comfortable with an autonomous self, and d) ability to negotiate. She also proposes that the capacity for intimacy can be elevated if a person has not had secure attachments throughout their life, but has been able to forge such connections later in life.

Identity formation and social identity theory

There is a series of circumstances in a gay male's life that can contribute to over-attachment or over-separation: relationship with parents, especially concerning the father, gender conformity or nonconformity, and problems dealing with male-bonding as adult relationships develop (Colgan 1987). Colgan (1987) mentions a coming-out model, Coleman (1982), listing five stages: *pre-coming out, coming out, exploration, first relationships, and integration.* All of these stages are important in maintaining a balance between separation and attachment. Should there be disturbances or negative experiences, be that in childhood or adulthood, there can be negative

effects such as over-attachment or over-separation. Positive experiences, such as support from family and friends, can lead to not just positive identity, but the balance between attachment and separation. The same results of which can be argued and linked to both Troiden (1989) and Cass (1984). Though these models were fixated to the gay, cisgendered male's life, one can make the argument that formation of the identity would also translate to lesbian, bisexual, transgender, and queer individuals (Kuper et al. 2012, 251; Pedersen and Kristiansen 2008).

Attachment, sex, and gender and sexual identity and orientation

There have been numerous research studies on attachment and sex or romantic connections (Feeney 1996, 1999a, 1999b; Feeney and Noller 1990, 1991; Levy and Davis 1988; Mohr and Fassinger 2003; Hazan and Shaver 1987; Shaver and Hazan 1988), however, most of this research focuses on heterosexual relationships. The research on same-sex attachments is considerably smaller (Mohr 2008).

Cooper et al. (2006) report that securely attached individuals seem comfortable in their own skin and their sexuality, which enables them to derive pleasure from multiple sexual activities. While they are seemingly comfortable with their sexualities, secure individuals are more likely to have such sexual activities in a committed relationship than in casual and uncommitted sex. This differs from avoidant-attached individuals. Mikulincer and Shaver (2016) reported multiple studies indicating that the attitude towards casual sex is more positive in avoidant-attached individuals. Ridge and Feeney (1998) similarly found that there is a connection between avoidant attachment and sexual permissiveness amongst gay men and lesbians. Anxious attachment has been associated with confusing sex with love, vulnerability to pressure of sex, initiation of sex at a younger age, more sexual partners, and less likelihood of using precautionary measures when engaging in sex (Cooper et al. 2006). Anxiously attached individuals may also worry about their sexual attractiveness (Gillath and Schachner 2006). According to Mikulincer and Shaver (2016) LGBTQ individuals are found to use sex in place of stability or love. One can argue that the insecure LGBTQ individual does this out of fear, self-hate, or due to rejection from partners or parents.

Landolt et al. (2004) found that amongst gay men, paternal and peer rejection independently predicted attachment anxiety, though maternal rejection did not. Additionally, peer rejection mediated the association between paternal rejection and attachment avoidance. Mohr (2008) found that both external manifestations of anti-LGBT prejudice and internalization of negative views of same-sex attraction can lead to diminished satisfaction and greater conflict in same-sex couples.

Research on LGBTQ and attachment focuses primarily on the anxiety dimension. Ridge and Feeney (1998) and Mohr and Fassinger (2007) found amongst subjects that there were higher levels of attachment anxiety in gay and bisexual men than in lesbian and bisexual women. Zakalik and Wei (2006) found that attachment

anxiety had a strong positive connection with perceived discrimination. This suggests that people who are more anxiously attached are more likely to notice others' rejection as a result of their sexual orientation and that gay males with attachment anxiety are susceptible to depression through the detection of discrimination signals. Wang et al. (2010, 42) conducted a study and found that anxiously attached LGB individuals were likely to seek support from:

> both heterosexual and non-heterosexual peers when dealing with struggles related to their sexual orientations; however, because of the fear of being rejected by either group and a strong desire to please others, they may feel a need to hide their innermost thoughts and feelings to maintain the approval of all people, which results in a difficult identity process.

In the identity formation process, Mohr and Fassinger (2003, 483) found that 'attachment insecurity may increase susceptibility to fear with regard to the tasks of identity development and curtail the exploration that is often critical in forging a positive LGB identity,' meaning that individuals with low self-esteem might forsake vital components towards creating a positive LGB identity out of fear for what that might entail, or the consequences that could follow. Another concept within attachment research and the LGBTQ community that could lead to less secure attachment and more fearful or dismissing attachment is shame. Wells and Hansen (2003) found amongst a lesbian sample that the more securely attached one was, the less shame they tended to feel, and that higher levels of shame were felt by lesbians with fearful and preoccupied attachment styles. More recently, Mohr, Selterman, and Fassinger may be one of the first studies to replicate findings from previous work on same-sex attachment and couples functioning. Past research has found that 'attachment avoidance is typically associated with less relationship commitment in heterosexual couples; yet, in the present sample commitment was uniquely associated only with anxiety' (2013, 79). Anxiety may be more prevalent for same-sex couples in comparison to heterosexual couples, potentially because of 'exposure to negative societal beliefs questioning the sustainability of same-sex relationships, fewer social structures designed to encourage stability in same-sex couples, and greater exposure to norms for negotiating non-monogamy' (79). Two different components that I believe affect the attachment bonds of adults with an LGBTQ identity concern perception and support.

Perception. The perception that people hold over LGBTQ individuals can affect attachment bonds, either reinforcing a secure attachment or contributing to preoccupied, dismissing, or fearful attachment. Regarding *familial perception,* ease or tension can be created when LGBTQ individuals disclose their sexual identity or orientation. Mohr and Fassinger (2003) state that when one comes out that person runs the risk of rejection, physical harm, or censure amongst colleagues, friends, and family. Given these risks, the perceived notion that one's family may not be accepting or supportive can put strain on the attachment relationship, through a manifestation of avoidant or dismissive tactics. Mohr and Fassinger

(2003) also state that LGB individuals with insecure attachments may avoid partaking in aspects of identity development, such as experimentation, coming out to friends, or getting involved with the community. The fear or perceived negative reaction of family members should they find out about the LGBTQ individual could contribute to this avoidance of a homosexual identity development. Henderson (1998) points out that perception of a parent's reaction to coming out is important and it is not to be done in haste, as the dependence on support, food and clothing, and shelter can be brought in jeopardy if LGBTQ youth misjudge their parents, yet such youth have the tendency to overestimate the knowledge that parents have about homosexuality. Jellison and McConnell (2003) found evidence to suggest that one's attitudes and perceptions about homosexuality and towards one's own homosexuality acts as a mediator in connecting strong secure attachment and greater self-disclosure.

Armesto and Weisman (2001) found that when parents perceive homosexual behavior as something the child should control there was a higher degree of negative emotional responses. Also to be found was a higher degree of positive emotional responses when parents perceive homosexual behavior as something the child cannot control. If parents perceive homosexuality as something their child should control, this could create big rifts in the parent-child relationship, and as such the child's attachment to their parental relationships or other ones could become less secure. Ben-Ari found that lesbian and gay youths 'who perceived their parents as not having friends from the gay community, not being involved in civil rights efforts, or not expressing social awareness or sensitivity, were more likely to indicate shame, denial, guilt, and anger' (1995, 105). Ben-Ari also found their perceptions of fears on disclosure, which included fears such as being blamed, losing their parents and confronting homosexuality, amongst other items. The parental style may also impact the LGBTQ individual's perception of acceptance and flexibility. Willoughby, Malink, and Lindahl found that 'men who, prior to coming out, perceive their families as close and flexible, with authoritative or indulgent parents, may be more likely to perceive their parents' reactions less negatively than men perceiving their families as disengaged, rigid, and authoritarian' (2006, 26).

Murphy (1989) conducted a study involving lesbian couples and the effects of perceived parental attitudes on the couple. Findings indicate that perception of parental disapproval may result in secrecy of the relationship, could hinder growth of the relationship, or could even bring the relationship closer than before. All three of these results could potentially impact the attachment bond with parents, seemingly in a negative way. Carnelley et al. (2011) conducted a cross-sectional study of over 300 LGB individuals, finding that the perception of an accepting mother during childhood increased the likelihood of coming out to them. In addition, both mothers and fathers perceived in childhood to be more accepting were reported to have an overall more positive reaction to the sexual orientation of their child. All of these studies appear to indicate that perception is important and can lead to denial of the homosexual identity, physical or emotional harm, or disturbances in attachment.

Religious perception. The values and viewpoints of different religions can affect the LGBTQ individual's attachment style. Worthington (2004, 741) states that:

> sexual identity development is likely to vary depending on the moral convictions learned, adopted, and/or rejected by individuals regarding sexual orientations, values, needs, and behaviors. As a result, some same-sex attracted (SSA) individuals may experience intense internal conflicts between experiences of sexual attraction and their internalized sense of morality arising from religion.

Support. Perhaps another vital element in maintaining a secure attachment and a positive homosexual identity is through support, either through ***social support*** and/or ***familial support***, including heterosexual supportive friends (Smith and Brown 1997). *Social support* is the help and supportive nurturing from one's friends that can help foster growth and a positive identity. This is especially pertinent to those identifying with a homosexual identity, because the opinions of one's social peers can influence their evaluation of their sexuality (Jellison and McConnell 2003). The support offered from friends and social groups can play a part in fostering healthy gay-romantic relationships. If the individual or the relationship a LGBTQ individual has is supported, they may strengthen their pride in a non-heterosexual identity and thusly reinforce secure attachment with peers. Research such as Elizur and Mintzer (2003) found that attached security provided a link between relationship quality and perceived friends' support and self-acceptance.

Regarding *familial support,* research shows having familial support is not only a contributor to secure attachment, but can solidify a positive gay identity (Mohr and Fassinger 2003). One of the results affecting attachment due to a lack of support from family can be internalized homophobia. Not having parents, siblings, or other relatives accept the LGBTQ individual for all that they are can create separation and distance amongst the family. Jellison and McConnell (2003) report that internalized homophobia can lead to problems like the forsaking of goals towards education or career, unsafe sexual practice, domestic violence, or even over-eating and alcoholism. Mohr and Fassinger (2003) reported that individuals who had trouble coming to terms with their sexual orientation were more likely to exhibit high avoidance and high anxiety attachment patterns.

A lack of support from family members can also provide certain dangers to the LGBTQ individual. D'Augelli et al. (1998) reported that lesbians were more frequently than gay males to receive threats of physical violence from family members, specifically mothers, if disapproving of their child's sexual orientation. Other dangers might include rejection, or even the act of being financially cut off. Such fears that these events could occur due to a perceived lack of support can prevent the individual from disclosing their sexual orientation to family.

Elizur and Mintzer (2001) found in their study though that support from family and friends predicted disclosure and Holtzen, Kenny, and Mahalik found that disclosure was 'positively associated with characteristics of secure attachment

[and] . . . attachment security is positively associated with length of time since disclosure' (1995, 353). Some individuals may not have support from their families, though research has indicated that they also seek support from friends (D'Augelli et al. 1998; Elizur and Mintzer 2003; Jellison and McConnell 2003; Smith and Brown 1997).

Drama therapy

According to the North American Drama Therapy Association (NADTA 2017), drama therapy is:

> the intentional use of drama and/or theater processes to achieve therapeutic goals. Drama therapy is active and experiential. This approach can provide the context for participants to tell their stories, set goals and solve problems, express feelings, or achieve catharsis. Through drama, the depth and breadth of inner experience can be actively explored and interpersonal relationship skills can be enhanced. Participants can expand their repertoire of dramatic roles to find that their own life roles have been strengthened.

Drama therapy and attachment theory

Meldrum suggests that the stories we tell of our lives are key to identity formation, speaking of how her clients and herself go through 'narratives of attachment in gesture and actions, in words and in play and through the drama of [their] relationship' (2006, 10). She also argues that in attached relationships, such as the parent-child bond, a child learns to regulate their emotions through play. Though she does not specifically address drama-therapeutic exercises in the article, Meldrum does make note that the professional working with attachment theory aims to provide the secure base for clients, through which they can explore, restructure, and gain insight through play.

Jennings wrote a book called *Healthy Attachments and Neuro-Dramatic-Play* (NDP). This book, while not specifically drama therapy, is written by a prominent drama therapist. With NDP she synthesizes several areas of child development, including attachment theory, play therapy, drama therapy, and neuroscience. In regard to attachment, Jennings states that it 'consists of sensory, rhythmic, and dramatic play that forms the basis of the playful attachment relationship. . . . NDP and attachment empower the continuing story' (2011, 61). Jennings also says that this form is appropriate for youths with attachment difficulties and also when there is a lack of play in the primary attachment bonds. Moore and Peacock discuss 'Life Story Work,' which aims to help children with attachment difficulties further develop a positive sense of identity and not blame themselves for events in their lives that they were not in control of. This is done in such a way as to embody the child's life story, in which 'fictional representations of the children's history using drama gave privacy to experience other perspectives, and reframed their story so that traumatic

events become re-stored as "ordinary" memory' (2007, 20). Though not specifically mentioned as drama therapy, Cassidy (2001) speaks towards the use of dolls and/or puppets to demonstrate a child's self-view in the attachment relationship to the mother. The use of such tools could be considered as utilizing dramatic projection, which Jones (2007, 84) defines as 'the process by which clients project aspects of themselves or their experience into theatrical or dramatic materials or into enactment, and thereby externalize inner conflicts.' If the child or adult client were to use projective techniques such as through work with puppets or dolls, it may be possible to see the attachment relationships in their lives.

Jewers-Dailley (2008) developed a program that combined attachment theory, playback theater, and adult attachment narratives. It proposes a 20-week program that involves utilization of the AAI and has the facilitator act as both conductor and therapist. The program was established in five stages: a) *assessment and formulation*, b) *establishing a secure base*, c) *playback theater and attachment narratives*, d) *making meaning, integration, and saying goodbye*, and e) *re-assessment and evaluation*. It is likened to Renée Emunah's Five Phase Model in Drama Therapy, as the stages are not set in stone and can be adapted to each group's pacing. Jewers-Dailley states the intention of the program is to foster growth and change in attachment narratives, increase empathy, and to expand knowledge and insight to one's attachment experiences and the experiences of others. New articles concerning attachment theory and drama therapy, or the creative arts therapies, include the following: Feniger-Schaal and Lotan (2017), Haen and Lee (2017), Weber and Haen (2016), Henson and Fitzpatrick (2016), Versaci (2016).

Drama therapy and sexual identity/orientation

Research collected on drama therapy and gender and sexual identity and orientation was just as equally small as attachment and drama therapy. Bayley (1999) addresses the transformative aspect in drama therapy and makes connections to *Alice in Wonderland* and queer sexual gender/identity and the theory behind it. He makes note that in drama therapy the question 'who am I?' is significant to self-identity and the work the therapist does with their clients, as through these transformative elements – through the roles we play -- we can help flesh out answers to the question.

Wilson (2011) incorporates narrative therapy and playback theater for a drama-therapeutic intervention for LGBT-identified youth. Wilson speaks about 'narra-drama,' arguing his case for its effectiveness with LGBT youth in stating that:

> the client and therapist can explore dominant stories, unique outcomes and alternate stories through drama and through other expressive arts. Problems can be externalized and deconstructed through the use of objects, puppets, artwork and scene work. Role-play involving unique outcome scenes helps to model more adaptive behaviors and alternate stories can be enacted to

restructure identity apart from the problem. Narrative talk therapy only uses language for the same purposes. Then, a narrative approach to drama therapy with LGBT adolescents could have a powerful effect for externalizing and deconstructing heterosexism and for re-authoring preferred narratives through embodied role-play.

(15–16)

Regarding playback theater, which takes true and told stories which are then retold through performance, Wilson points out that in working with LGBT youth that:

> the power of this method to connect people, validate experiences, and illuminate shared themes could address LGBT needs for a safe, supportive environment where reduced isolation and universality of experience could be promoted. Suffering that has occurred due to sexual orientation or gender identity could achieve meaning in aesthetic presentation and tellers could gain senses of mastery over these difficult experiences.
>
> *(2011, 18–19)*

This intervention has incorporated both narradrama and playback theater. Neither are specifically drama therapy, but both contain qualities and techniques that can be useful to the drama therapist attempting to work with LGBTQ individuals, and even those with attachment difficulties.

Halverson (2010) wrote about a dramaturgical process, which told, adapted, and performed true stories of LGBTQ (Lesbian, Gay, Bisexual, Transgender, and Questioning) youths in the construction and showing of their identities, working with About Face Youth Theatre to develop and adapt participants' stories for performance.

Rousseau et al. (2005) developed a drama therapy program for adolescent immigrants and refugees that are dealing with identity issues as they adjust to new surroundings. Like Wilson (2011), Rousseau et al. (2005) utilized playback theater in their program, but also incorporated aspects of Augusto Boal's forum theater. The program aimed to promote four objectives:

(a) construction of meaning (after trauma and separation);
(b) the grieving process (loss of loved ones, country, expectations, or dreams);
(c) appreciation of difference and construction of creative resistance (that does not lock them into even wider circles of exclusion); and
(d) development of multiple affinities that employ a range of possible strategies.

(p. 16)

While the program was designated for identity issues amongst refugee and immigrant adolescents, the program could translate very well to someone with a LGBTQ identity because they too have experiences that affect their identities.

Possible intersections

Adapting the program of Rousseau et al. (2005) could be one way to help LGBTQ individuals that have their attachment bonds affected. This may potentially be done through identifying the issue(s), grieving, strengthening their self-esteem, and providing a secure base as indicated by Meldrum (2006). The drama therapist could also expand upon and retool the program developed by Wilson (2011), in which not only could the LGBTQ identity be explored, but also the clients' reported attachment bonds. Drama therapy has an inherent playful aspect to it, so it could be useful to play with the roles that can be associated with the LGBTQ community and the roles within the different attachments. Emunah (1994, 12) states that 'the playing out of a multitude of roles serves to expand one's role repertoire, fosters an examination of the many aspects of one's being, and increased one's sense of connectedness with others.' Such role playing could be done in scene work, likely first with similar but not exact circumstances to the participating clients, and then move on to employing drama as a rehearsal for life. Psychodrama techniques, such as role reversal or doubling (the former, switching roles in order to have clients gain perspective, and the latter, acting as a second voice in order to draw out multiple perspectives or say what is perhaps not being said by the client), could also help enhance the scenes and get towards the deeper emotions when an individual does not have a positive LGBTQ identity or secure attachment and is either affected by lack of support or perception that there will be no support.

Some of the roles regarding sexual and gender identity that can be explored could be: gay, lesbian, bisexual, transgendered, queer, bi-curious, or even straight, to list a few. Roles regarding attachment could be: secure, insecure, anxious, avoidant, dismissing, ambivalent, or fearful. Both attachment and sexual identity roles could be combined with the role types and archetypes that Landy (1993) lists. It is stated that there are six domains of roles: a) somatic, b), cognitive, c) affective, d) social/cultural, e) spiritual, and f) aesthetic. Some of these roles have subtypes, an example being family roles (son, mother, sibling, etc.) within social/cultural roles. These roles within attachment and sexual and gender identity can potentially be expanded upon through Landy's taxonomy of roles. Clients can explore to their own devices.

A few examples of these combined roles might be the gay son, the dismissing politician, the bi-curious beauty, the fearful trans-woman, the Christian lesbian, etc. Once these roles are tried on they can be further explored and aimed to strengthen or master them either for acceptance or reparative purposes. They could even be explored to help in preparation for any future hardships that might accompany the label of the role and its associations. These are just a few potential ways to address attachment and sexual identity/orientation within drama therapy.

Areas for future research

One area that could benefit from more research is in regards to bisexuality, queerness, and transgenderism in relation to drama therapy. Many of the studies with

attachment and LGBTQ issues have largely covered the experiences of lesbians and gay men. This is not to say that the -BTQ individuals are excluded within the sample sizes, but they are a very small part or often are grouped together with gay and lesbian categorization. Another area of collected research to be further studied is the ethnicities of the samples. Most of the samples or participants within the LGBTQ-related articles (Armesto and Weisman 2001; D'Augelli et al. 1998; Holtzen et al. 1995; Jellison et al. 2003; Mohr and Fassinger 2003; Murphy 1989; Smith and Brown 1997; Wells and Hansen 2003; Zakalik and Wei 2006) were Caucasian. Though Caucasians are the dominant ethnic group of these samples, they are not indicative or representative of the overall LGBTQ experience. Most of these studies also had more samples of gay males than lesbian females, bisexual males or females, or transgendered and queer individuals.

In this chapter I have explored the ways that social and familial support is of importance to identity formulation and developing secure attachments. In drama therapy we can create a community in the group work, and this community can have a profound effect in creating a supporting and 'holding' environment for people who have attachment issues, bridging gaps in clients' lives and enabling them to reach out and try new ways of being more connected with others in this safe and accepting environment. When LGBTQ identities are not supported by their communities, drama therapy can give an opportunity for figures of acceptance to be envisaged and this is an area requiring further investigation in the literature. I have suggested that explicitly exploring roles regarding attachment could be of benefit, including secure, insecure, anxious, avoidant, dismissing, ambivalent, or fearful. Perhaps in combination with the plethora of roles the LGBTQ community engages in, these attachment difficulties can be worked through in a safe and productive manner.

Further studies looking into the formation of a positive LGBTQ identity or the desire to come out in relation to drama therapy are needed. I also think that there should be more research about the kinds of substitute figures and bonds that LGBTQ individuals make when their identities are not supported, either socially or with family. Additionally, I wonder how the use of pronouns (he/him, she/her, they/them, ze, etc.) amongst LGBTQ individuals might affect one's identity and how that might translate to attachment-related difficulties.

Other areas in need of further research are drama therapy and attachment, and drama therapy and gender and sexual identity and orientation. Bayley (1999, 8) recollects his training as a drama therapist and how there was not one 'official mention of Queer gender or sexual identity in the curriculum . . . except where it emerged within a group or as a function of some other activity.' This would seem to indicate that there needs to be more research done within this field and it should be addressed in training, per findings of Beauregard et al. (2016). Attachment bonds – especially of the primary caregiver – can constitute the basis of how we interact with others, so I find that it is important to further expand knowledge of how one can address attachment difficulties in a drama-therapeutic context, especially if those bonds are disrupted because of an individual's gender or sexual identity or orientation.

References

Armesto, Jorge C., and Amy G. Weisman. 2001. "Attributions and Emotional Reactions to the Identity Disclosure ("Coming Out") of a Homosexual Child." *Family Process* 40(2): 145–161. doi:10.1111/j.1545-5300.2001.4020100145.x

Bartholomew, Kim. 1990. "Avoidance of Intimacy: An Attachment Perspective." *Journal of Social and Personal Relationships* 7: 147–178. doi:10.1177/0265407590072001

Bartholomew, Kim, and Leonard M. Horowitz. 1991. "Attachment Styles Among Young Adults: A Test of a Four-Category Model." *Journal of Personality and Social Psychology* 61(2): 226–244. doi:10.1037/0022-3514.61.2.226

Bayley, Bruce Howard. 1999. "Feeling Queer in Dramatherapy: Transformation, Alice, & the Caterpillar." *Dramatherapy* 21(1): 3–9. doi:10.1080/02630672.1999.9689502

Beauregard, Mark, Ross Stone, Nadya Trytan, and Nisha Sajnani. 2016. "Drama Therapists' Attitudes and Actions Regarding LGBTQI and Gender Noncomforming Communities." *Drama Therapy Review* 2(1): 41–63. doi:10.1386/dtr.2.1.41_1

Ben-Ari, Adital. 1995. "The Discovery That an Offspring Is Gay: Parents', Gay Men's, and Lesbians' Perspectives." *Journal of Homosexuality* 30(1): 89–112. doi:10.1300/J082v30n01_05

Berman, William H., and Michael B. Sperling. 1994. "The Structure and Function of Adult Attachment." In *Attachment in Adults*, edited by Michael B. Sperling and William H. Berman, 3–28. New York: Guilford Press.

Carnelley, Katherine B., Erica G. Hepper, Colin Hicks, and William Turner. 2011. "Perceived Parental Reactions to Coming Out, Attachment, and Romantic Relationship Views." *Attachment & Human Development* 13(3): 217–236. doi:10.1080/14616734.2011.563828

Cass, Vivienne. 1984. "Homosexual Identity Formation: Testing a Theoretical Model." *The Journal of Sex Research* 20: 143–167. doi:10.1080/00224498409551214

Cassidy, Jude. 2001. "Truth, Lies, and Intimacy: An Attachment Perspective." *Attachment and Human Development* 3(2): 121–155. doi:10.1080/14616730110058999

Coleman, Eli. 1982. "Developmental Stages of the Coming Out Process." In *Homosexuality and Psychotherapy: A Practitioner's Handbook of Affirmative Models*, edited by John Gonsiorek, 31–42. New York: Haworth Press.

Colgan, Phillip. 1987. "Treatment of Identity and Intimacy Issues in Gay Males." *Journal of Homosexuality* 14(1–2): 103–123. doi:10.1300/J082v14n01_09

Cooper, Mary Lynne, Mark Pioli, Ash Levitt, Amelia Talley, Lada Micheas, and Nancy L. Collins. 2006. "Attachment Styles, Sex Motives, and Sexual Behavior: Evidence for Gender-Specific Expressions of Attachment Dynamics." In *Dynamics of Romantic Love: Attachment, Caregiving, and Sex*, edited by Mario Mikulincer and Gail S. Goodman, 243–274. New York: Guilford Press.

D'Augelli, Anthony R., Scott L. Hershberger, and Neil W. Pilkington. 1998. "Lesbian, Gay, and Bisexual Youth and Their Families: Disclosure of Sexual Orientation and Its Consequences." *American Journal of Orthopsychiatry* 68(3): 361–371. doi:10.1037/h0080345

Elizur, Yoel, and Arlette Mintzer. 2001. "A Framework for the Formation of Gay Male Identity: Processes Associated with Adult Attachment Style and Support from Family and Friends." *Archives of Sexual Behavior* 30(2): 143–167. doi:10.1023/A1002725217345

Elizur, Yoel, and Arlette Mintzer. 2003. "Gay Males' Intimate Relationship Quality: The Roles of Attachment Security, Gay Identity, Social Support, and Income." *Personal Relationships* 10: 411–435. doi:10.1111/1475-6811.00057

Emunah, Renée. 1994. *Acting for Real: Drama Therapy Process, Technique, and Performance*. New York: Routledge.

Feeney, Judith A. 1996. "Attachment, Caregiving, and Marital Satisfaction." *Personality Psychology* 3: 401–416. doi: 10.1111/j.1475-6811.1996.tb00124.x

Feeney, Judith A. 1999a. "Adult Attachment, Emotional Control, and Marital Satisfaction." *Personal Relationships 6:* 169–185. doi:10.1111/j.1475-6811.1999.tb00185.x

Feeney, Judith A. 1999b. "Issues of Closeness and Distance in Dating Relationships: Effects of Sex and Attachment Style." *Journal of Social and Personal Relationships 16:* 571–590. doi:10.1177/0265407599165002

Feeney, Judith A., and Patricia Noller. 1990. "Attachment Style as a Predictor of Adult Romantic Relationships." *Journal of Personality and Social Psychology 58:* 281–291. doi:10.1037/0022-3514.58.2.281

Feeney, Judith A., and Noller, Patricia. (1991). "Attachment styles and verbal descriptions of romantic partners." *Journal of Social and Personal Relationships, 8,* 187–215. doi:10.1177/0265407591082003

Feniger-Schaal, Rinat, and Nava Lotan. 2017. "The Embodiment of Attachment: Directional and Shaping Movements in Adults' Mirror Game." *The Arts in Psychotherapy 53*: 55–63. doi:10.1016/j.aip.2017.01.006

Gillath, Omri, and Dory A. Schachner. 2006. "How Do Sexuality and Attachment Interrelate? Goals, Motives, and Strategies." In *Dynamics of Romantic Love: Attachment, Caregiving, and Sex,* edited by Mario Mikulincer and Gail S. Goodman, 337–358. New York: Guilford Press.

Haen, Craig, and Kat Lee. 2017. "Placing Landy and Bowlby in Dialogue: Role and Distancing Through the Lens of Attachment." *Drama Therapy Review 3*(1): 45–62. doi:10.1386/dtr.3.1.45_1

Halverson, Erica Rosenfeld. 2010. "The Dramaturgical Process as a Mechanism for Identity Development of LGBTQ Youth and Its Relationship to Detypification." *Journal of Adolescent Research 25*(5): 635–668. doi:10.1177/0743558409357237

Hazan, Cindy, and Phillip R. Shaver. 1987. "Romantic Love Conceptualized as an Attachment Process." *Journal of Personality and Social Psychology 52*(3): 511–524. doi:10.1037/0022-3514.52.3.511

Henderson, Mitzi G. 1998. "Disclosure on Sexual Orientation: Comments from a Parental Perspective." *American Journal of Orthopsychiatry 68*(3): 372–375. doi:10.1037/h0080346

Henson, Alisha M., and Marilyn Fitzpatrick. 2016. "Attachment, Distancing, and the Working Alliance in Drama Therapy." *Drama Therapy Review 2*(2): 239–255. doi:10.1386/dtr.2.2.239_1

Holtzen, David W., Maureen E. Kenny, and James R. Mahalik. 1995. "Contributions of Parental Attachment to Gay or Lesbian Disclosure to Parents and Dysfunctional Cognitive Processes." *Journal of Counseling Psychology 42*(3): 350–355. doi:10.1037/0022-0167.42.3.350

Jellison, William A., and Allen R. McConnell. 2003. "The Mediating Effects of Attitudes Toward Homosexuality Between Secure Attachment and Disclosure Outcomes Among Gay Men." *Journal of Homosexuality 46*(1–2): 159–177. doi:10.1300/J082v46n01_05

Jennings, Sue. 2011. *Healthy Attachments and Neuro-Dramatic-Play.* London, UK: Jessica Kingsley Publishers.

Jewers-Dailley, Kimberly. 2008. *Attachment Re'story'ation Through Playback Theatre: Construction of a Program Guide for Mothers with Insecure Attachment Narratives.* Master's thesis, Concordia University.

Jones, Phil. 2007. *Drama as Therapy,* 2nd ed. Hove, East Sussex: Routledge.

Kuper, Laura E., Robin Nussbaum, and Brian Mustanski. 2012. "Exploring the Diversity of Gender and Sexual Orientation Identities in an Online Sample of Transgender Individuals." *Journal of Sex Research 49*(2–3): 244–254. doi:10.1080/00224499.2011.596954

Landolt, Monica A., Kim Bartholomew, Colleen Saffrey, Doug Oram, and Daniel Perlman. 2004. "Gender Nonconformity, Childhood Rejection, and Adult Attachment: A Study of Gay Men." *Archives of Sexual Behavior 33*(2): 117–128. doi:10.1023/B:ASEB.0000014326.64934.50

Landy, Robert J. 1993. *Persona and Performance: The Meaning of Role in Drama, Therapy, and Everyday Life.* New York: d Press.

Levy, Marc B., and Davis, Keith E. (1988). "Love styles and attachment styles compared: Their relations to each other and to various relationship characteristics." *Journal of Social and Personal Relationships,* 5, 439–471. doi:10.1177/0265407588054004.

Meldrum, Brenda. 2006. "The Drama of Attachment." *Dramatherapy* 28(3): 10–20. doi:10.1080/02630672.2006-2007.9689702.

Mikulincer, Mario, and Phillip R. Shaver. 2016. *Attachment in Adulthood: Structure, Dynamics, and Change,* 2nd ed. New York: Guilford Press.

Mohr, Jonathan J. 2008. "Same-Sex Romantic Attachment." In *Handbook of Attachment: Theory, Research, and Clinical Applications,* edited by Jude Cassidy and Phillip R. Shaver, 2nd ed., 482–502. New York: Guilford Press.

Mohr, Jonathan J., and Ruth E. Fassinger. 2003. "Self-Acceptance and Self-Disclosure of Sexual Orientation in Lesbian, Gay, and Bisexual Adults: An Attachment Perspective." *Journal of Counseling Psychology* 50(4): 482–495. doi:10.1037/0022-0167.50.4.482

Mohr, Jonathan J., and Ruth E. Fassinger. 2007. "Attachment in Same-Sex Couples: Basic Processes and Minority Stress Effects." In *Attachment and Caregiving in Same-Sex Romantic Relationships.* Symposium conducted at the meeting of the American Psychological Association, San Francisco.

Mohr, Jonathan J., Dylan Selterman, and Ruth E. Fassinger. 2013. "Romantic Attachment and Relationship Functioning in Same-Sex Couples." *Journal of Counseling Psychology* 60(1): 72–82. doi:10.1037/a0030994

Moore, Joan, and Fiona Peacock. 2007. "Being Before Doing: Life Story Work for Children with Attachment Difficulties." *Dramatherapy* 29(1): 19–21. doi:10.1080/02630672.2007.9689712

Murphy, Bianca Cody. 1989. "Lesbian Couples and Their Parents: The Effects of Perceived Attitudes on the Couple." *Journal of Counseling and Development* 68: 46–51. doi:10.1002/j.1556-6676.1989.tb02492.x

North American Drama Therapy Association. 2017. *What Is Drama Therapy?* North American Drama Therapy Association. Accessed April 13. www.nadta.org/what-is-drama-therapy.html

Pedersen, Willy, and Hans W. Kristiansen. 2008. "Homosexual Experience, Desire and Identity Among Young Adults." *Journal of Homosexuality* 54(1–2): 68–102. doi:10.1080/00918360801951962

Ridge, Stacey R., and Judith A. Feeney. 1998. "Relationship History and Relationship Attitudes in Gay Males and Lesbians: Attachment Style and Gender Differences." *Australian and New Zealand Journal of Psychiatry* 32: 848–859. doi:10.3109/00048679809073875

Rousseau, Cécile, Marie-France Gauthier, Louise Lacroix, Néomée Alain, Maryse Benoit, Alejandro Moran, Musuk V. Rojas, and Dominique Bourassa. 2005. "Playing With Identities and Transforming Shared Realities: Drama Therapy Workshops for Adolescent Immigrants and Refugees." *The Arts in Psychotherapy* 32: 13–27. doi:10.1016/j.aip.2004.12.002

Shaver, Phillip R., and Cindy Hazan. 1988. "A Biased Overview of the Study of Love." *Journal of Social and Personal Relationships* 5: 473–501. doi:10.1177/0265407588054005

Smith, Richard B., and Robert A. Brown. 1997. "The Impact of Social Support on Gay Male Couples." *Journal of Homosexuality* 33(2): 39–61. doi:10.1300/J082v33n02_03

Troiden, Richard R. 1989. "The Formation of Homosexual Identities." *Journal of Homosexuality* 17(1–2): 43–74. doi:10.1300/J082v17n01_02

Versaci, Rebecca. 2016. "Attachment Performs: Framing Attachment Theory Within the Dramatic Worldview." *Drama Therapy Review* 2(2): 223–237. doi:10.1386/dtr.2.2.223_1

Wang, Chia C., Codi Schale, and Kristina K. Broz. 2010. "Adult Attachment: Lesbian, Gay and Bisexual Identity and Sexual Attitudes of Nonheterosexual Individuals." *Journal of College & Counseling* 13: 31–49. doi:10.1002/j.2161-1882.2010.tb00046.x

Weber, Anna Marie, and Craig Haen. 2016. "Attachment-Informed Drama Therapy with Adolescents." In *International Handbook of Dramatherapy*, edited by Sue Jennings and Clive Holmwood. Hove, East Sussex: Routledge.

Wells, G. B., and Nancy D. Hansen. 2003. "Lesbian Shame: Its Relationship to Identity Integration and Attachment." *Journal of Homosexuality* 45(1): 93–110. doi:10.1300/J082v45n01_05

Willoughby, Brian L. B., Neena M. Malink, and Kristin M. Lindahl. 2006. "Parental Reactions to Their Sons' Sexual Orientation Disclosures: The Roles of Family Cohesion, Adaptability, and Parenting Style." *Psychology of Men & Masculinity* 7(1): 14–26. doi:10.1037/1524-9220.7.1.14

Wilson, Carlos. 2011. *Integrating Narrative Therapy and Playback Theatre Into a Drama Therapy Intervention for LGBT Adolescents*. Master's thesis, Concordia University.

Worthington, Roger. 2004. "Sexual Identity, Sexual Orientation, Religious Identity, and Change: Is It Possible to Depolarize the Debate?" *The Counseling Psychologist* 32(5): 741–749. doi:10.1177/0011000004267566

Zakalik, Robyn, and Meifen Wei. 2006. "Adult Attachment, Perceived Discrimination Based on Sexual Orientation, and Depression in Gay Males: Examining the Mediation and Moderation Effects." *Journal of Counseling Psychology* 53(3): 302–313. doi:10.1037/0022-0167.53.3.302

15
DISMANTLING THE GENDER BINARY IN ELDER CARE
Creativity instead of craft

Erin Partridge

On the surface, an art studio in an assisted living or senior center does not seem as entrenched in the gender binary as a hair salon or mechanic shop. However, ageist beliefs (Applewhite 2016; Kennedy 2017) often intersect with the more rigid gender binary (Johnson 2013) of previous generations in creative arts therapy spaces. Assumptions about gender and preference dictate older adults' participation in art-related pursuits. It may also impact the types of materials client use, the projects they create, and the design space itself. Work in elder care settings requires the arts therapist to advocate for the creative potential of older adults and to empower through non-traditional media and approaches (Houpt et al. 2016; Maidment and Macfarlane 2011; HP Development Company 2016; Partridge 2016, 2019). For the feminist art therapist, work with older adults creates a frequently intense interplay between personally held beliefs and identity and the life experiences of the elders. Our work, if it is to be inclusive, must consider the intersectional identities of ourselves as well as our clients (Talwar 2010).

Some research suggests older adults become more socio-culturally conservative as a way to increase self-esteem (Van Hiel and Brebels 2011). Beliefs, particularly about life values, are expressed out of habit and as a way to resolve anxieties in the later stages of life. Changing one's deeply held beliefs can threaten sense of self, or suggest past mistakes in judgment; conservatism preserves a sense of internal and social stability. Conservatism, particularly around identity, can come from external forces as well. Popular culture's depictions of older adults stereotype and segregate based on gender; the movie *Grumpy Old Men* (Petrie 1993) is one example. The protagonists play out exaggerated male stereotypes and gender roles. Though played for humor in the film, the implications of this strict gender binary are oppressive (Talwar 2010; Moi 1989). Those who work in elder care settings may reinforce or assign aspects of identity (Powell and Gilbert 2009) dismissing or downplaying the complex nature of human lives. These externally assigned identities and roles make

assumptions about elders' ability to change and grow. Gender is a "life issue" (Norris 2006, 62) not necessarily linked to any life stage.

Gender is an important consideration in the art studio. Artists and art therapists write about the importance of materials to the meaning of work (Lusebrink 1990, 2004, 2010; Hinz 2009), but less often about the gendered nature of materials. The artist Rachel Lachowicz (2013) described the impact of makeup as a material in fine art as viewed through "a culture that desires bodies to be gendered and sexualized" (p. 31). Certain craft practices have been traditionally gendered as discussed in the context of Native American cultures (Senior 2000) and in research about craft in educational settings in Finland (Kokko 2009, 2012) where interactions to teach an art form also instruct gender norms and social behavior. Even when these craft practices and materials are removed from their traditional contexts or intentionally used in alternative or subversive ways (Betsy Hosegood 2009), they retain some gendered elements.

Creative arts therapy professionals work with older adults in a wide range of settings; the history of craft, material use, and approach to arts influence who participates in the experience. This chapter will cover what I observed when entering the elder care field and the work I undertook to pivot the art programming in two communities toward shared creative engagement. The creative practices effectively dismantled, piece by piece, the existing binary between activities for men and for women.

Business as usual

When I began working in an assisted living community, I observed a heavily gendered art program, reinforced by ageist stereotypes and an emphasis on product over process; even the pale pink art room walls signaled it was a female-only space. Prior to my arrival, residents were ushered through step-by-step craft projects without any room for personal expression.

In my first week in the community, a member of the resident council approached me in the hallway: "What will you do for the men here?" She told me about her husband, who died several years earlier, longed for companionship, and did not see anything of interest on the calendar. Prior to the conversation with this elder, I had not considered that participation in my groups would be impacted by gender – the participants or mine. Her question caught me off guard. Having come from a larger hospital setting, where the client population in art therapy groups was predominantly male-identified, I needed to do an assessment of the existing art practices in the community as well as an investigation into my own practices; to "become more skilled in confronting, challenging, and contesting hegemonic ways of seeing and representing others" (Talwar 2010, 16).

The existing art practices were predominantly passive, from the programming to the work hung on walls. Museum trips, when they happened, utilized outside experts or docents and did little to encourage critical thinking or imaginative feedback. Business as usual in this community, like many I have encountered since, seemed to be craft-based or focused on how the art practice appeared from the outside rather than on the elders' experiences. Attendees to the art class were given a

preselected image and often heavily coaxed or assisted in rendering the image. The previous facilitator offered limited materials (black permanent markers, watercolor paper, and watercolor paint) and the focus seemed to be more about pleasing the art teacher than satisfying an internal creative drive.

After assessing the program in its current state, it was clear something needed to change. Male-identified residents assumed the space and therefore my services were not for them. I questioned whether older adulthood is necessarily a gendered experience or if elder care itself was a gendered setting. I also thought deeply and created art about what it meant to be a younger woman working in this context. When I took over, I did so with the intention to transform the entire approach, while working with each elder as an individual.

Creative culture change

Changing the philosophical underpinnings of the groups and the titles on the calendar was only the first step. The difficult work came with shifting the practices towards creativity. Elders had adapted to the old way of doing things; I described it as artistic learned helplessness. The elders relied on the identified expert to provide stimulus and external motivation. They also behaved as though art and craft was a gender-segregated practice, assuming the solution was to add men's groups with some kind of stereotypical male focus. Solving the problem could not be accomplished through increased gender segregation, nor was it in the best interests of staffing the community. The association between craft and gender may be linked to survival; social hobbies were correlated with longer survival for women while participation in independent hobbies was most supportive for men (Agahi and Parker 2008), a creative open studio model can support both needs simultaneously. Older adults in an open studio session can follow their own goals or work in close connection to others.

The creative culture change took almost a year. I structured the groups based on materials offered; in the first assisted living, we had two open studio sessions, a fiber art group (weaving/knitting etc.) and a jewelry group. In the second community, we had three open studio groups and a jewelry group. Elders would enter the space and see the materials set out and the room ready for creating. If they regularly used specific materials or preferred a certain spot in the room, I prepared the space for their arrival. Entering a prepared room reduced reported anxieties about what to create. It also signaled stepping into a new area, crossing the threshold into a space with different possibilities. Our art studio in the first community had a wall-sized bulletin board where we posted inspiring images, postcards from exhibits we attended, and quotes from artists. The second community did not have this option, but I brought art books, images, and ideas in for each session.

I asked several residents to define creativity; each one had a different idea, often relating it back to their occupations and other life experiences. Anne's medical training was evident in her definition: "There's different kinds of creativities, sometimes it is hard to decide because they're all good! You have to decide which one you like. You just analyse which one you are more inclined to." Anne's time in the open art studio was one of the few times she was able to sit quietly, outside the studio space

she fixated on the location of her children and alienated her peers with her constant invasive questions. The art studio became a space for quiet, but also a place where her peers could have a different type of interaction with her. She compared her experiences in the studio to her early life experiences; as a young woman growing up in the Philippines, she was discouraged from pursuing creative work and pushed into studying medicine. Her first nameplate from her early days as a doctor has her name with the title "lady physician" in bold type underneath. She described hating medical school, but feeling like "as a woman" she had no right to make her own choices. The studio setting not only allowed, but encouraged her to make choices. Another elder defined creativity as an active, iterative process: "Creativity is the action taken by an individual to show the meaning of creativity." He attended the art studio weekly, often working for several sessions on one idea. He was inspired by minimalism and creative meaning-making. His painting *Black Is Black* (Figure 15.1) was inspired by two monochromatic minimalist pieces he saw on museum trips. He created the image through layering a variety of black materials on black canvas.

FIGURE 15.1 *Black Is Black.* Acrylic, oil pastel, graphite, paper, and vinyl on canvas. The finished composition was mounted on board with the title stamped in ink below.

He enjoyed instructing people to look at his piece from different angles, in order to get his intended effect. Creativity looked different for each elder, and that was the important point – they were empowered to explore and self-define. Case examples from work with male-identified residents illustrate the different ways gender and creativity interacted in the art studio space.

Robert paints the universe

Robert was a mathematician and science enthusiast. He worked for NASA and the military on complex early computer programming and navigation system implementation. When I asked him to define creativity, he connected it directly to science: "I like science, so you have to include that. Without creativity, science would be boring. We'd be back a thousand years making dots in the sand." Prior to a stroke, he did not engage in any art making as part of a creative practice. When he moved into our assisted living, he began attending the art studio sessions. He told me in one of his first sessions that he wanted to "paint the universe" and he brought scholarly articles to share about Mars and black holes. As his artistic confidence expanded, he became known in the community as an artist. His *Oval Guys And Gals* piece (Figure 15.2) shows both parts of this elder – the systematic exploration of a single topic with remarkable variation.

FIGURE 15.2 *Oval Guys And Gals*. Robert used watercolor, colored pencil, and ink to explore different facial expressions and gender presentations. He liked to show this image to peers and staff and ask, "Which one do you like best? Which one is you?"

The stroke that precipitated Robert's move to assisted living left him unable to use his left arm or hand. He grew adept at using paint bottles to weigh down paper so he could cut items for collage, regularly put his canvas on the floor next to his wheelchair so he could paint at arms' distance and splatter paint, and enjoyed using non-traditional materials and techniques. His enthusiasm for non-art materials mirrored what I observed among many of my male-identified elders; using toothbrushes, masking tape, and other items seemed to encourage greater levels of participation. These materials were a visual vocabulary they were comfortable with. Items from the kitchen or garage invite participation from people for whom paint or yarn is read as "off-limits" or too gendered.

Michael and the power tools

When Michael walked into the art studio, he did so only as a last resort. He had a goal, and was told his path to meeting that goal necessitated speaking with me. He towered in the doorway, keeping his walker (walking frame) defensively between the pink art studio and his large frame. He was imposing, with a booming voice and sarcastic attitude. Michael had lived most of his later life in a cabin he built by hand for him and his wife, on the bank of a river surrounded by trees. He discovered a passion for woodcarving in retirement; the cabin had a woodshop fully stocked with power tools and large equipment. When he and his wife accepted their advancing age and declining health necessitated a move to a continuing care retirement community, they sold his tools and decorated the new apartment with his finished sculptures. He wanted to set up a woodshop somewhere in the community, but heart problems, a residential stay in skilled nursing care, and a subsequent prescription for blood thinning medication made everyone wary about allowing him to use any sharp tools. After approaching the maintenance director and several other male staff members, he reluctantly came to the door of the art studio – a place where, in his words, "the ladies are doing all their pretty little things."

The first few interactions we had were terse. He was sizing me up, determining my competencies in operating power tools and ability to help him toward his goal. These interactions necessitated some restraint and soul-searching on my part; beneath the art therapist is a strong farm girl with a long history with chainsaws and power tools. Though the feminist rancher in me wanted to prove my worthiness through comparing woodcarving scars and describing recent adventures with a chainsaw, I knew doing so was not therapeutically appropriate. Additionally, his paternalistic tone stirred a countertransferential response. I needed to understand my reactions in order to work with Michael. Interacting with older adults often requires bracketing one's own life experiences; an art therapist working in this context needs to maintain an awareness about expectations of deference, to keep potentially ageist behavior in check, and to acknowledge the often-vast differences between the elder's life experience and that of the therapist.

Michael and I made progress when he invited me to his apartment to see his sculptures. I could see him relax as I remarked over the different types of wood he

used, asked about his process, and admired the sturdy frames he built for each piece. His carvings, bas relief sculptures of birds and mammals of North America, covered the walls of the apartment he and his wife shared in the independent living building. Michael used layers of wood to build up the form of each animal, glued the rough shapes together, and carved the details with both handheld chisels and power tools. Each piece had a well-built frame and a grid of monofilament line suspending the animal figure in the center of the frame. The pieces had a curious visual tension between natural and synthetic, solid and ephemeral. He was proud of the artistic execution of the animals and the workmanship of the frames. After he gave me a tour, I reaffirmed my interest in helping him continue to create sculptures. He shook my hand and said he would be in touch. The handshake signaled two things: me promising he did not have to make "pretty little things" and him accepting me as an ally.

After we established a partnership, Michael often waved me over in the dining room, to show me the latest carving tool catalogue or the sale pages for the local hardware stores. He flipped through earmarked pages, debating the merits of various tools. He measured the seat on his walker and called the manufacturer to determine whether he could transport a heavy chop saw between his apartment and the art studio. As his enthusiasm grew, his wife and the care staff continued to voice concerns about bleeding risks; they were opposed to any tools in his apartment. Out of desperation, Michael started coming all the way into the pink art studio, pulling up a chair, and sitting with us. Once he sat down, he saw the art studio was not the heavily gendered crafting corner he imagined it would be. He observed as one woman taught herself how to make Viking Knit wire cable and as a man with limited vision created clay sculptures. He heard the conversations: personal stories, aesthetic discussion, and lively debates of current events. As he grew more comfortable in the space, he connected with others in the room, particularly those who were using non-traditional materials. One woman, an accomplished basket-weaver, described her search for gnarled hardwood for basket handles. He listened with fascination as she described her non-adhesive and non-mechanical joinery techniques. Each time he came to the art studio he stayed longer, and eventually started asking for materials.

Michael offered to teach some of the studio "regulars" his methods for creating wooden sculptures. I obtained tracing paper for his pattern-making and gave him a folder to hold his pages of animal examples. We talked about options – having a day in the studio just for wood work or writing a petition to the leadership to allow him to order tools, if he used them with my assistance. My interactions with him were not leading him on; I was prepared to make a woodshop happen for him, if that was the route he wanted to follow. Reflecting back on several months of his behavior, I was left wondering if he actually wanted to set up a woodshop, or if he just needed a conspirator in the process – someone who saw his potential as a maker rather than just his diagnosis as a heart patient on blood thinners. He continued to create paper patterns and even explored some non-wood sculpture options like cardboard and specialty carving foam. Michael's health and energy level

ultimately precluded the woodshop plan; he had to return to the skilled nursing and was in his bed for most of each day. However, instead of escalating frustration, he expressed excitement about providing patterns for others and his own continued creativity. Over the course of several months, he went from writing off the studio – and by extension, me – as a space not for him, to entering the space willing to collaborate and accepting any of the other participants as collaborators.

Creativity outside the studio

Michael was able to go beyond the threshold and enter the art therapy space. However, other elders never got over the art space as a place for "the ladies." Bill, a retired naval officer, spent most of his days knotting macramé key chains. He had limited mobility; neuropathy in his feet made him unsteady, so he preferred to stay in his room. When he was referred to me, first in assisted living and later when he was transferred to the skilled nursing, he boomed out "come aboard" every time I knocked at his door. He conducted business in his room as though it was a naval ship. Not interested in an ally or a collaborator, he did pursue interactions with me around obtaining materials and finding an outlet for his making. When he expressed interest in creating key chains for the residents in our dementia care program, I got a list of initials for him and delivered the finished pieces to each person. As with Michael, working with Bill required me to shift my behavior and way of thinking. His demeanor came across as dismissive, his tone condescending, but when I approached him as a creative maker, we were able to interact.

Still alive and still creating

James had a booming voice like Bill, a voice he used to run the show in his career as an architect as well as interpersonally. He interacted with me from an adversarial and aggressive standpoint at first, questioning everything I said, disrupting the space of the group, and introducing provocative or inappropriate content to discussions. He was fixated on sexual behaviors and relationship status. When he felt seen and heard, he proposed marriage, when he felt ignored, slighted, or belittled, he lashed out with anger; his anger often took on a misogynistic tone. This very assertive man, a self-declared "survivor of many things" and successful architect, was not coping well with decreased physical mobility. He required a wheelchair and his medical providers declined his repeated request for a motorized wheelchair due to his assessed cognitive status. "I am at their mercy," he would tell me, rolling his eyes upward and gesturing over his shoulder at the private caregiver hired by his wife. Because he was unable to self-propel his wheelchair, well-meaning private caregivers often brought him to groups he was not interested in, or kept him from groups he wanted to attend. After several weeks of encouragement, I convinced a caregiver that the art studio would be of interest to him. During one of his first sessions, he created a simple self-portrait and wrote across the bottom in bold charcoal lettering "I am still alive." Our interactions in the art studio were not framed by our genders

and his patriarchal assumptions; in the creative space, we were peers. He felt seen as a vital and generative individual. Over several years of interactions, we came to a mutual respect for each other. I learned how to interact with him in ways to minimize his angry outbursts. When he lashed out, our rapport enabled me to gently chide him about voicing frustration without resorting to gendered slurs. He gave the art studio a name that sums up his experiences and remains to date the highest compliment I have received. In his bold handwriting, he wrote "Erin's House of Indulgence" and instructed me to hang it on the studio door. The inclusivity and permissiveness felt like an indulgence to him, an experience I reinforced.

Inclusive art space

Shifting the philosophy toward creativity and exploration resulted in a more inclusive art therapy program; elders and those who provided care began to see the participants as artists. Our art spaces became hubs for exploration, community, and research instead of step-by-step crafting (Partridge 2019). The change was evident in the participation demographics as well as the quality and subject matter of the work. They explored their lives and connected to community through creative pursuits and political activism. Two women created powerful work about their thoughts about gender and sexuality as breast cancer survivors who did not get reconstructive surgery. Other elders explored their body image and gender identities through a community photography project (Rosenfield, n.d.); one participant talked about his lifelong curiosity about wearing women's clothing and said aloud for the first time in his life, "I wish I was born a woman." He was not the only older adult who confessed or came out in the art studio, an elder with androgynous gender presentation felt safe to read a story aloud about growing up in the rural southern United States where she experienced extreme prejudice; her story described interactions leading to a decision to stay in the closet for the duration of her adult life. The art studio became a place for social, political, and philosophical discourse.

Some assisted living residents I work with do not create any physical art when they attend sessions. Instead, they engage in conversations and watch their peers create. One elder volunteered to hold a stencil for a peer; after seeing the stenciled image unveiled, she exclaimed, "I want to cut open your mind and see inside!" Another brought the coloring book her son gave her, but preferred to watch as the man across the table from her brushed expressive swaths of bright color across a dark background. As she watched, they discovered a shared love of travel and language. Creativity became a valuable skill in the community, a form of social currency.

As our creative work dismantled the gender binary piece by piece, we were able reassemble a world with more inclusive practices; we used adaptive techniques to facilitate expression and became a site for intergenerational and community connection. The implications of this creative work extend beyond the walls of the art studio as evidenced by the call for inclusive elder care (Johnson 2013) and feminist critiques of formal and informal care practices (Parks 2010; Poo and Conrad 2015).

Heavily gendered activity programming signals to LGBT elders an old-fashioned philosophy and may be symptomatic of other discriminatory or heteronormative practices. Creative rule-breaking signals possibilities for inclusion (Doyle and Getsy 2013). Elders identified this work as a form of wellness. One elder described her increasing fatigue and acceptance of her ageing body along with gratitude for the ways she is able to find growth and healing in art: "Creativity, that's taking care of ourselves! Art from the gut is what cures you." A creative, inclusive approach also supports openness to exploring beyond paternalistic medical model thinking or infantilizing care provision; when elders are treated as autonomous creative individuals, they can contribute to their communities and society. To return to the question asked in my first week of work, what I did and continue to do "for the men" and for all the elders in our communities is to facilitate non-binary spaces focused on creativity.

References

Agahi, N., and M. G. Parker. 2008. "Leisure Activities and Mortality: Does Gender Matter?" *Journal of Aging and Health* 20 (7): 855–871.

Applewhite, Ashton. 2016. *This Chair Rocks: A Manifesto against Ageism*. Farmington Hills, MI: Thorndike Press, A Part of Gale, Cengage Learning.

Doyle, Jennifer, and David Getsy. 2013. "Queer Formalisms: Jennifer Doyle and David Getsy in Conversation." *Art Journal* 72 (4): 58–71. doi:10.1080/00043249.2013.10792864.

Hinz, Lisa. 2009. *Expressive Therapies Continuum: A Framework for Using Art in Therapy*. New York: Routledge.

Hosegood, Betsy. 2009. "Not Tonight." *Textile: The Journal of Cloth and Culture* 7 (2): 148–163. doi:10.2752/175183509X460065.

Houpt, Katharine, Linda "Ariella" Balkin, Rubye Hunt Broom, Allen G. Roth, and Jessica Drass Selma. 2016. "Anti-Memoir: Creating Alternate Nursing Home Narratives Through Zine Making." *Art Therapy* 33 (3): 128–137. doi:10.1080/07421656.2016.1199243.

HP Development Company. 2016. "Dr. Erin Partridge: Sprout by HP Offers New Possibilities." http://h20195.www2.hp.com/v2/GetDocument.aspx?docname=4AA6-8503ENW.

Johnson, Iain. 2013. "Gay and Gray: The Need for Federal Regulation of Assisted Living Facilities and the Inclusion of LGBT Individuals." *The Journal of Gender, Race & Justice* 16: 293–321.

Kennedy, Pagan. 2017. "To Be a Genius, Think Like a 94-Year-Old." *The New York Times*, April.

Kokko, Sirpa. 2009. "Learning Practices of Femininity Through Gendered Craft Education in Finland." *Gender and Education* 21 (6): 721–734. doi:10.1080/09540250903117090.

Kokko, Sirpa. 2012. "Learning Crafts as Practices of Masculinity. Finnish Male Trainee Teachers' Reflections and Experiences." *Gender and Education* 24 (March 2015): 177–193. doi:10.1080/09540253.2011.602331.

Lachowicz, Rachel. 2013. "Portfolio: Material Specificity and the Index of the Feminine." *Art Journal* 72 (4): 30–33.

Lusebrink, Vija B. 1990. *Imagery and Visual Expression in Therapy*. New York: Plenum Press.

Lusebrink, Vija B. 2004. "Art Therapy and the Brain: An Attempt to Understand the Underlying Processes of Art Expression in Therapy." *Art Therapy* 21 (3): 125–135. doi:10.1080/07421656.2004.10129496.

Lusebrink, Vija B. 2010. "Assessment and Therapeutic Application of the Expressive Therapies Continuum: Implications for Brain Structures and Functions." *Art Therapy* 27 (4): 168–177. doi:10.1080/07421656.2010.10129380.

Maidment, Jane, and Selma Macfarlane. 2011. "Crafting Communities: Promoting Inclusion, Empowerment, and Learning between Older Women." *Australian Social Work* 64 (3): 283–298. doi:10.1080/0312407X.2010.520087.

Moi, Toril. 1989. "Feminist, Female, Feminine." *The Feminist Reader*, 117–132.

Norris, E. 2006. "Age Matters in a Feminist Classroom." *NWSA Journal* 18 (1). http://muse.jhu.edu/journals/nwsa_journal/v018/18.1norris.html.

Parks, Jennifer A. 2010. "Lifting the Burden of Women's Care Work: Should Robots Replace the 'Human Touch'?" *Hypatia* 25 (1): 100–120. doi:10.1111/j.1527-2001.2009.01086.x.

Partridge, Erin Elizabeth. 2016. "Amplified Voices: Art-Based Inquiry into Elder Communication." Ph.D. diss., Notre Dame de Namur University.

Partridge, Erin Elizabeth. 2019. *Art therapy with older adults: Connected and empowered*. Philadelphia, PA: Jessica Kingsley Publishers.

Petrie, Donald. 1993. *Grumpy Old Men*. Warner Brothers.

Poo, Ai-jen, and Ariane Conrad. 2015. *The Age of Dignity: Preparing for the Elder Boom in a Changing America*. New York: The New Press.

Powell, Jason L., and Tony Gilbert. 2009. "Introduction: Postmodernism and Aging Identity." In *Aging Identity*, edited by Jason L. Powell and Tony Gilbert, 1–3. Hauppauge, NY: Nova Science Publishers, Inc.

Rosenfield, S. n.d. "I Am Not My Identity." www.whatibeproject.com/portfolio-item/i-am-not-my-sexuality-11/.

Senior, Louise M. 2000. "Gender and Craft Innovation: Proposal of a Model." In *Gender and Material Culture in Archeological Perspective*, edited by Moira Donald and Linda Hurcombe, 71–87. New York: Palgrave Macmillan.

Talwar, Savneet. 2010. "An Intersectional Framework for Race, Class, Gender, and Sexuality in Art Therapy." *Art Therapy* 27 (1): 11–17. doi:10.1080/07421656.2010.10129567.

Van Hiel, Alain, and Lieven Brebels. 2011. "Conservatism Is Good for You: Cultural Conservatism Protects Self-Esteem in Older Adults." *Personality And Individual Differences* 50 (1): 120–123. doi:10.1016/j.paid.2010.09.002.

16
BEYOND MASCULINE AND FEMININE

Responding to real expressions of gender identity and the effect on our own gender identity in psychotherapy practice[1]

Mark Wheeler

The arts therapies are in the business of finding meaning and engendering change. The representation of gender in the arts, from selfies, through children's paintings and fine art, to the daily onslaught in public media, affects our internalised self-images. The arts therapies aim to be a safe context to explore or challenge received messages. This chapter is based on learning from young people and their families, from adults who have struggled for years and from the author's own direct experience.

I have learned more directly from people, especially my patients, about gender and sexuality than from any other source. After 30 years' practice with young people, the insights I have witnessed emerging from young people, in the last decade, have enabled me to recognise how our language and our gender expression and our sexual identities tend to be forged unnecessarily into immutable binary positions.

Among the patients we meet, the increasing popularity of communication whose primary mode is manipulated and photographic (social media apps with filters) renders them comfortably familiar with the syntax of *Photo-Art-Therapy* (Fryrear & Corbit, 1992). The potentially constant gaze of one's own phone-camera, and those of friends and strangers alike, increases reports of image self-consciousness among digital native generations. This might increase people's awareness of the incongruence between their internal, experienced gender, and outward signifiers of gender difference. This also offers early opportunities for conversations beyond words between them and art psychotherapists.

Traditional Western Abrahamic ideas about gender and psychotherapy are breaking down in the 21st century as the structures of analytic practice encounter feminist critique while traditional notions of binary gender identities crumble. Ideas will be drawn from social constructionism (McNamee & Gergen, 1992), feminist theory (Goldner, 1989; Goldner et al., 1990; Sontag, 2002), and art criticism as much as from psychotherapy practice.

Our practice is both our laboratory for research and our principal instrument of research. Whether working directly with clients or in the context of clinical supervision, at times the practice of art psychotherapy is slightly ahead of society's rhythm and at times is responding to cultural shifts. How does the gaze of the apparently male therapist affect the gender identity of those coming to therapy?

Our practice may also be a cauldron fomenting revolution in the lives of individuals and how they position themselves. Whilst some aspects of our practice may be built on the foundation stones of psychoanalysis, object relations, and analytical psychology, I propose that we draw on social constructionism because 'Psychoanalysis is . . . in urgent need of a new and simpler paradigm to replace the present hotchpotch of incompatible theory systems' (Rycroft, 1995). This has resulted in critiques of psychotherapy, feminist or otherwise (Goldner, 1989, Goldner et al., 1991; Goldner et al., 1990; Mitchell, 1975; Sontag, 2002, 2009; Masson, 1992) to be, of necessity equally diverse and varied. Conventional medicine and psychoanalysis have been limited by prevailing Cartesian notions of duality and a conceit (argued by its adherents, of utility) of a locus of 'illness' within individual organisms. This conceptualisation can be of even less utility in mental health. In terms of gender identity and sexual orientation a social constructionist position emerges as more useful in art psychotherapy practice with young people. In recent years young people in the consulting room have been directly challenging binary ideas of gender.

In the author's experience, two decades ago, one or two patients every year would invest therapy time considering their sexual orientation if they were not already confident about it. Overall, the service received fewer than 1% of referrals that included aspects of gender identity before 2008 (a cut-off point dictated by easily interrogatable electronic records). At that time the service was not identified and commissioned purely as a mental health service, but would accept self-referrals from and for anyone who wanted therapeutic input. Therefore, we used to be open to referrals where gender identity or sexuality was a prime concern of the young person. Now referrals only come from other areas of health, education, and social care for young people with diagnosable mental health disorders.

At the end of the last century, young people would explore, in the context of the consulting room, binary notions of gender and then struggle with the idea that Western society demands that they identify with their genital gender or have to identify as trans, with an ultimate implication of gender reassignment surgery. Helping clients contemplate ideas beyond or between these apparently biological (but actually socially constructed) imperatives would be continually undermined by the embedded contextual forces of fixed language and culture.

Without requiring a mental health diagnosis, nor goal-led treatment imperatives, our young clients could explore, at their own pace, using images before words, their own ideas about themselves. These might grow into a self-labelled chosen identity for gender and sexuality. However, in the prevailing social context of their provincial towns and villages, these would distil towards gay, lesbian, hetero, and bi. Concepts of gender remained predominantly male or female even when 'trans'

was appended. The term 'trans' is deemed non-binary by some, and binary but-in-transition by others (UK trans 2019).

The service is now defined as Child & Adolescent Mental Health Service (CAMHS) for which a primary mental health diagnosis (F00-F99, ICD 10, 2004, p. 5) is an essential requirement for acceptance; diagnosis has numerous functions including signposting treatment (Rose, 2013). The ICD 10 (WHO, 1992, 2004) cluster F64 defines gender identity as 'disorder'. Learning from patients, this author takes a social constructionist position regarding many mental health diagnoses; diagnoses are usually created in conversations between 'patients' and 'clinicians' (Law's, 1997 description of ADHD is a good description of how mental health diagnoses are social constructs). The F64.0 and F64.2 labels might only be applicable to those people who have a clear and developed understanding that their body does not match their identity as one of two distinct gender positions and for whom hormone and surgery reassignment treatment is to be funded by a public health services or insurance companies.

In a county-wide CAMHS, in the subsequent decade there have been year-on-year increases. The author's own case-load of 20 to 25 patients receiving 6 to 26 sessions each has included over the last 3 years at least one patient at any time where gender and sexuality issues have been primary or significant. Other young people who will have explored their gender identity safely elsewhere, perhaps through thoughtful discussion with friends, family, or counselling services, do not arrive at our service. Our service has evolved to become a mental health service accessed only by young people with a primary mental health diagnosis, often a mood disorder like depression. Those young people presenting with mental health issues that include anxieties about their gender or sexual identity rarely arrive at our door primarily because of those factors. Therefore, we might offer a hypothesis that those having difficulty might sometimes be characterised as those not fitting into neat cultural pigeon-holes (male, female, hetero, gay, bi, trans) or whose local culture is intolerant of all but the first three labels. Much of mental health diagnosis is socially constructed, as are binary gender and sexual identities. One's gender or sexual identity only becomes a 'problem' in the context of other people.

Even where notions of gender are not fixed, they tend to be binary in our established culture. ICD-10 (2004) defines what it names 'Gender Identity Disorder of Childhood' (F64.2):

> *A disorder, usually first manifest during early childhood (and always well before puberty), characterized by a persistent and intense distress about assigned sex, together with a desire to be (or insistence that one is) of the other sex. There is a persistent preoccupation with the dress and activities of the opposite sex and repudiation of the individual's own sex. The diagnosis requires a profound disturbance of the normal gender identity; mere tomboyishness in girls or girlish behaviour in boys is not sufficient.*

The traditional binary stereotypes of gender, and even of mainstream gender politics, can be embedded in the conversational language of those people who entered secondary school before the mid-1990s, those who might be defined as the digital

immigrant generation. The digital native generation has opportunities to be less linguistically constrained.

> *I wish I was a woman now; it feels like we're at the start of an exciting time for women who soon should have more choices than men. After all, they can do everything else we can, but we can't give birth.*
>
> (Tony Boddinar, photographer and community arts facilitator, to the author 1986)

> *What's happened to feminism? We used to think it was supposed to liberate both of us, but what's going on recently in public images?*
>
> (Conversation between the author and Ellen Fisher Turk, photographer, in 2008)

It would be difficult to imagine either of these statements being made by people under 25 in 2020. Notions of what constitutes cultural gender or sexual identity differ between societies and change over time. Perhaps the written word has narrowed the range of ideas for a few hundred years, but as writing's cultural dominance becomes eroded by easier, more direct communication (internationally interconnected social media dominated by pictures, emoticons, and emojis), this may wane. We might infer from the Abrahamic tenet 'In the beginning was the word' a supremacy of meaning enshrined in language, and the limitations this brings to the modern Abrahamic cultures. Before any evidence for words, we have images, from cup marks on rocks to cave paintings. Our clients might therefore struggle to find language to consider their identity, which forms of artistic creation can encompass.

Young people arrive in the consulting room primed with a disparate collection of ideas found by the algorithms of search engines primarily concerned with the needs of Internet trade. These algorithms are not designed for pre-adolescent exploration or self-understanding. For example, there was a socially conservative imperative to institutionalise gay weddings; the institution of marriage and the traditional stability it represents not only helps society retain its structures, but the performance of ceremony is fuelled by high spending in the service industries. The conventional marriage offer has been extended because it can be understood in conventional binary terms. It can be seen as a part of the existing understanding of society, of couples setting up homes together in socially defined economic units. Other cultures, with an evolving oral narrative tradition of identity and history, have held different ideas about gender and sexuality. Representing the transition between a predominantly oral and a developing written English narrative, Geoffrey Chaucer, commonly used the gender-neutral pronoun 'they'. Words are limiting, merely subjective transient signposts, at best mutually agreed packets of meaning.

Images, particularly metaphors spread more rapidly through the minds (Wilkinson, 2006, 2010) of maker and viewer. Cultures less beholden to written words, like those of native North and South Americans, also enable less restrictive notions of gender and sexuality.

> *Of all of the foreign life ways Indians held, one of the first the Europeans targeted for elimination was the Two Spirit tradition among Native American cultures. At the point of contact, all Native American societies acknowledged three to five gender roles: Female, Male, Two Spirit Female, Two Spirit Male and Transgendered.*
>
> (Brayboy, 2016)

These five gender identity terms attempt to approach universal terms, in English, for the more specific terms of each Nation, for example the Navaho term '*Nádleehí*' means one who is transformed. The invasions by Europeans brought an intolerance of ideas that did not fit the prevailing Roman Catholic norms.

> *Spanish Catholic monks destroyed most of the Aztec codices to eradicate traditional Native beliefs and history, including those that told of the Two Spirit tradition ... In the 20th century, as neurotic prejudices, instigated by Christian influences, increased among Native Americans, acceptance of gender diversity and androgynous persons sharply declined. Two Spirits were commonly forced by government officials, Christian representatives or even their assimilated Native communities to conform to standardized gender roles. Those who felt they could not make this transition either went underground or committed suicide.*
>
> (Brayboy, 2016)

As recently as 1988 in the UK, Section 28 of the Local Government Act (1988), passed into law by Margaret Thatcher's government, prohibited local authorities from 'promoting' homosexuality or gay 'pretended family relationships'. This national law prevented local government bodies spending money on educational materials and projects perceived to 'promote' gay equality. In 2002 the UK Prime Minister, Teresa May, voted against adoption of children by gay couples. Homophobia and intolerance of difference is still rife, even in a government that legalised gay marriage.

The encounters with patients in CAMHS, from primary school age up to adulthood, who struggle to conform to society's demands to identify as male, female, or trans (itself a binary identity), include similar stories of contemplated or attempted suicide.

> *Traditional Native Americans closely associate Two Spirited people with having a high functioning intellect (possibly from a life of self-questioning), keen artistic skills and an exceptional capacity for compassion.*
>
> (Brayboy, 2016)

This skill mix might look familiar to the art therapist. Gender identity influences, affects, or even determines, the way people experience their gender, which in the presence of another, affects their experience of the other's gender. Hence when working with those whose gender is not as explicit as we are structured to expect in daily life, our own gender experience too becomes particularly significant. When

we encounter clients who appear to come from an obviously different cultural background, we can foreground our respectful curiosity about their experience, which helps our understanding. When people look and sound superficially similar to us, the therapist has to work harder not to make assumptions. Cultural secondary sexual characteristics, like clothing and language, may not alert us to the degree of difference between our own lived experience and that a client may live.

Examples

Presentation of gender is more challenging for a young person than for many adults. Institutions like schools have dress codes that, even where there is no official school uniform, dictate what is worn by pupils in clearly delineated gender stereotypical forms. This binary admonition arrives in children's lives long before puberty or any visual sexual characteristics develop. Young persons who have begun to examine their own position about gender may share their thoughts and feelings with their carers. If fortunate, their carers will acknowledge the young person's position and their own position, no matter how equivocal or oppositional. Only at this point does the young person have any opportunities to express their gender identity in a social context.

The clothes chosen by a young person to attend their art psychotherapy sessions are therefore as much objects of conscious creation as art works created in the session itself. A young person, aged 16, Riley Cavanaugh who identifies as pangender and asexual, understood this implicitly and attended from the first session wearing elements from, or redolent of, Cosplay costumes (Cosplay being the activity of wearing often elaborate costumes to represent or adopt a specific character). The masquerade dimension of the Cosplay concept resonates with mask making in art therapy. These are represented more thoroughly and elaborately in Cosplay outfits worn by Riley at social events, including Comic Con and Cosplay conventions. Riley would deconstruct the outfits in conversation as thoroughly as any art work created. Beneath these costumes Riley could engage in a social life, which their Asperger's syndrome and Social Anxiety Disorder would otherwise preclude. Riley's lively intelligence had enabled them to think past many emotional blocks long before entering therapy.

Riley volunteered that they had no desire to contemplate their sexuality, finding physical intimacy undesirable. The fetishistic connotation that might be inferred by the superficial resemblance of some Cosplay to BDSM outfits is contradicted by the performance of gender as an act in Cosplay, creating a paradox. This might be explicit, critical, or ironic, in the choice of an opposite gendered character, known as crossplaying. Hence, there is a thread in Cosplay, however unconscious, challenging socially constructed gender position.

Riley had a difficult early history and was accommodated with grandparents. It would be wrong to ascribe causality to their early experiences with this present expression of Asperger's syndrome and gender identity. While Riley's early life experiences would be typical for those later being diagnosed with attachment

disorders, this does not mean Asperger's syndrome is not present. There is a higher prevalence of non-binary gender expressions among those with diagnoses of Asperger's syndrome (Van Schalkwyk et al., 2015) but little understanding of what the relationship is. Riley Cavanaugh has a deep attachment with their grandparents, including expressing strong disagreements, which was manifested in some review sessions. The safety of this relationship is such that sometimes a transference episode might be observed where a grandparent was identified with anger or distress that might typically be seen for a parent.

During an 18-month intervention of 19 sessions Riley was able to take an expert position on their own experience (Anderson & Goolishian, 1992) enabling their therapist to use their/clinical expertise to be positioned by Riley. Riley became able to explore the meaning of their Asperger's syndrome to their own life and identify the importance and the meaning of gender identity more than most of us do in a lifetime.

Images brought to sessions were often of costumes and costumed characters. These gradually became more playful and less stereotyped. Riley's high-quality draughtsmanship meant the therapist needed to remain alert to seductive aesthetic countertransference (Schaverien, 1992). Riley had apparently concrete ideas and a low frustration tolerance of those who did not remember the Riley position on issues, or who might suggest other ideas. Offering psychodynamic interpretation is challenging when working with someone who combines remarkable insight with apparently insouciant inflexibility quickly turning to anger.

Riley did not need to differentiate between the sensory discomforts that are sequelae to Asperger's syndrome, from discomfort with bodily sensations and drives connected with biological femininity and sexual orientation. Riley knew, with confidence, enough of their gender identity from their own research to know what not to be. Riley needed help in therapy to consider identity in social contexts and how this might be possible to express in life and in relationships.

Asperger's syndrome, combined with high intellectual ability, meant that Riley could only think rationally about relationships, but could do this at a very high level. Riley was able to think coherently about meanings where other, more neurotypical folk would simply jump to conclusions. Riley had to show themself their working out, as maths teachers would say. Riley did exude considerable warmth as Riley learned to trust me. This also meant Riley learning to forgive my shortcomings as a human being and as a psychotherapist. Riley would remember off-the-cuff phrases I had used in previous sessions and repeat them in another context when Riley knew I would recognise the contradiction between the two episodes. Riley would not have to state that explicitly, expecting me to recognise and remember where the phrase came from.

Unfortunately, the random cut-off between CAMHS and adult mental health means that the therapy was interrupted at a time when it could very usefully have continued. There is no longer any Art Psychotherapy provision anywhere in adult mental health services in Nottinghamshire (neither inpatient nor outpatient). Riley has struggled to engage with adult mental health services, telling me that they

seemed to have a poor understanding of how Asperger's syndrome affects communication and how this means it would be helpful for professionals to adapt their interactions when appropriate. It had taken several meetings together for our relationship to fit constructively.

Riley could have been considered, had they expressed these views before puberty, for childhood sexual identity disorder. When a child expresses strong discomfort with the physical gender characteristics of their own body, from 4 years old to puberty, they might be referred for this assessment; in a medical model (GIDS, 2017), identifying this experience is thought to be associated with the hypothalamus. Riley's experience of gender differs from Gender Dysphoria in children, (contradiction between the gender a person feels or is able to express and the one biologically assigned by genitalia, hence the concept of gender reassignment). This feeling must exceed 6 months before diagnosis, and treatment consists of psychotherapy, hormone treatment, and surgery. Sadly, gendered brain differences do not appear until early adulthood (Capetillo-Ventura, 2015). Hence, they are not useful in early diagnosis and we are reliant on the erudition and confidence of the young patient.

Andy (named Andrea at birth) was 10 years old when referred to CAMHS. Andy's parents had accepted Andy's identity and supported treatment by local CAMHS and by the Tavistock Clinic Gender Identity Disorder Service (GIDS, 2017). Andy's parents accepted who Andy is and organise their lives around their children, including Andy's younger sibling who has a diagnosis of Asperger's syndrome. Andy was referred for individual art psychotherapy after an assessment by multi-disciplinary team colleagues.

Andy played with ideas about gender and stereotyping in a succession of images of children playing and of children looking. Each image would have multiple images of Andy's friends occupying their own spaces on the page. Andy enjoyed the narrative reinforcement of the idea of acceptance that could be inferred from these images. Andy played with identity, drawing faces, many from cartoons, which serve as archetypes for young people. Such figures, as well as the conscious range of powers or talents, also have relational qualities as secondary themes in the stories, that can form a useful unconscious archetypal role.

Andy used foam shapes to construct figures, and then began using them with poster paint to print groups of figures. These could be thought of as literally playing with stereotypes. *Stereo* is Greek for 'solid' and the term 'stereotype' comes from the hot metal newspaper printing industry. A 'stereotype' refers to commonly used words (like 'and', 'what', 'how') being created in a single block of white-metal instead of having to assemble them every time. Pronouns 'he' and 'she' will be among the most used 'stereotypes'.

There is a lack in common English of any useful gender-neutral pronouns, 'they' and 'their' being also plural, becomes as ambiguous as 'you' in English, which is why a plural is often coined as 'you all' or 'you lot'. I offered the idea to Andy that the sponge shapes were traditionally gendered, like the stereotype gender pronouns. Andy found this useful to help think about gender, and spent several subsequent

sessions, either directly using the sponge shapes, or mentioning them, or checking where they were in the room before using something else.

As the start of hormone treatment approached, the family informed me that they were told by the Gender Clinic that hormone treatment must be made by injections given either by them or from their family doctor. They had been unaware of this and informed me that Andy has a needle phobia. We used a desensitisation programme using images as graded exposure. Andy's participation in making the images connected deeply and were accompanied by our conversation about what Andy wanted to happen next, the hormone treatment. We have used this art therapy technique in our service before, when patients have not responded to verbal CBT, but in this instance it was to avoid a change of therapist. Three sessions were sufficient. Andy began by follow copying a drawing being made by the therapist that gradually revealed its identity as a needle and syringe, which was then coloured. The final session involved playing with syringes and needles (sheathed) as might be done with found objects in art psychotherapy.

The emotional implications of the start of hormone treatment were explored together, symbolically and metaphorically in image making. There are neurobiological implications to early hormone treatment as well as the primary objectives of pausing development of sexual characteristics. The few differences identified between men's and women's brains in adulthood, where thought to be genetic in origin, are activated in puberty.

Kruiver et al. (2000) building on Zhou et al. (1995) found that trans men–women have similar neuronal numbers as women in the relevant brain area (central bed nucleus of the stria terminalis) and the trans women–men are likewise similar to men. Hence, there is evidence that brain differences accord with identified gender, not with biological genitalia. In psychotherapy we are altering both our brains as we help make difference possible (Cozolino, 2002; Wilkinson, 2010). Andy's primary feeling was one of relief that he was not going to develop the wrong sexual characteristics.

Conclusions

Ideas about gender, among the public and professionals alike, are socially constructed. Psychiatric diagnoses are primarily socially constructed. Dominant narratives currently include those of binary gender identities or transition between them. In popular cultural discourse the predominant gender stories concern these binary gender identity questions arising among a population portrayed as young.

We are reliant on the expertise of our patients in matters of gender. The young person who recognises themselves as trans from an early age may face considerable challenges to the truth of what they know about themselves. If we are the first person who hears this from a patient, we have to feel confident enough to accept their expertise about themselves. This demands a position of safe uncertainty (Mason, 1993) where we can create a space where anything is possible safely.

Such a position also applies to be able to offer our patients the opportunity to be the expert in the room when they are trying to communicate to us a gender

identity which does not match the neat descriptors that their society has created so far, to communicate gender in language. Art psychotherapists, like the Two Spirit Native Americans, are already familiar with gender roles expressed in transference that do not match our outward biological gender. With the added dimensions of image making, for when words are not yet coined, art psychotherapists can be in those positions where we can facilitate the safe processing of our clients' experiences of gender.

Note

1 *All names have been changed for anonymity.*

References

Anderson, T. and Goolishian, H. (1992) The client is the expert: A not-knowing approach to therapy. In S. McNamee and K. Gergen (eds) *Therapy as Social Construction*. London: Sage.

Capetillo-Ventura, N.C., Jalil-Pérez, S.I., and Motilla-Negrete, K. (2015) Gender dysphoria: An overview, *Medicina Universitaria* 17, 66 (January–March), 53–58. www.sciencedirect.com/science/article/pii/S1665579615000071

Cozolino, L. (2002) *The Neuroscience of Psychotherapy: Building and Rebuilding the Human Brain*. New York: W.W. Norton & Company, Inc.

Duane Brayboy. (2016) *Two Spirits, One Heart, Source*. https://indiancountrymedianetwork.com/news/opinions/two-spirits-one-heart-five-genders/ accessed 04–05–2017 at 16:15

Fryrear, J.L. and Corbit, I.E. (1992) *Photo Art Therapy: A Jungian Perspective*. Springfield, IL: Charles C. Thomas.

Gender Identity Development Service (GIDS). (2017) http://gids.nhs.uk/

Goldner, V. (1989) Generation and gender: Normative and covert hierarchies. In Monica McGoldrick, Carol M. Anderson and Froma Walsh (eds) *Women in Families: A Framework for Family Therapy*. New York: W.W. Norton & Company, Inc.

Goldner, V., Penn, P., Sheinberg, M., and Walker, G. (1990) Love and violence: Gender paradoxes in volatile attachments. *Family Process*, 29, 343–364.

Goldner, V. et al. (1991) Feminism and systemic practice: Two critical traditions in transition. *Journal of Family Therapy*, 13, 95–104.

Kruiver, F.P.M., Zhou, J-N., Pool, C.W., Hofman, M.A., Gooren, L.J.G. and Swaab, D.F. (2000) Male-to-Female Transsexuals Have Female Neuron Numbers in a Limbic Nucleus. *The Journal of Clinical Endocrinology and Metabolism*, 85(5):2034–2041.

Law, I. (1997) Attention deficit disorder: Therapy with a shoddily built construct. In C. Smith and D. Nylund (eds) *Narrative Therapies with Children and Adolescents*. London: Guilford.

Mason, B. (1993) Towards positions of safe uncertainty. *Human Systems: The Journal of Systemic Consultation and Management*, 4, 189–200.

Masson, J. (1992) *Against Therapy*. London: Harper Collins.

McNamee, S. and Gergen, K.J. (eds) (1992) *Therapy as Social Construction*. London: Sage.

Mitchell, J. (1975) *Psychoanalysis and Feminism*. Harmonsdsworth: Penguin Modern Classics.

Rose, N. (2013) *What Is Diagnosis For?* Talk given at the Institute of Psychiatry Conference on *DSM*-5 and the Future of Diagnosis, 4 June.

Rycroft, C. (1995) *A Critical Dictionary of Psychoanalysis*, 2nd ed. London: Penguin Modern Classics.

Schaverien, J. (1992) *The Revealing Image*. London: Routledge.

Sontag, S. (2002) *Illness as Metaphor and AIDS and Its Metaphors*. London: Penguin Modern Classics.
Sontag, S. (2009) *Against Interpretation and Other Essays*. London: Penguin Modern Classics.
UK trans. (2019) http://uktransinfo.eu/ accessed 11–04–2019.
Van Schalkwyk, G.I., Klingensmith, K. and Volkmar, F.R. (2015) Gender identity and autism spectrum disorders. *Yale Journal of Biological Medicine*, 1, 81–83.
Wilkinson, M. (2006) *Coming Into Mind, the Mind-Brain Relationship: A Jungian Clinical Perspective*. London: Routledge.
Wilkinson, M. (2010) *Changing Minds in Therapy: Emotion, Attachment, Trauma and Neurobiology*. New York and London: W.W. Norton & Company, Inc.
World Health Organisation. (1992) *The ICD-10 Classification of Mental and Behavioural Disorders Diagnostic Criteria for Research*. www.who.int/classifications/icd/en/GRNBOOK.pdf. accessed 21–03–2015
World Health Organisation. (2004) *ICD-10: International Classification of Diseases, Volume 2*, 2nd ed., 10th revision. www.who.int/classifications/icd/ICD-10_2nd_ed_volume2.pdf accessed 12–05–2017 at 14:40
Zhou, J.-N., Hofman, M.A., Gooren, L.J.G. and Swaab, D.F. (1995) A sex difference in the human brain and its relation to transsexuality. *Nature* 378, 6552, 68–70.

17
BEYOND THE BINARIES

Negotiating gender and sex in music therapy

Susan Hadley and Maevon Gumble

> *The conception of politics at work here is centrally concerned with the question of survival, of how to create a world in which those who understand [or question] their gender and their desire to be [or who are] nonnormative can live and thrive not only without the threat of violence from the outside but without the pervasive sense of their own unreality.*
>
> (Butler, 2004, p. 219)

Location of our selves

Maevon: This topic is particularly important to me as I am a white, nonbinary, female-assigned queer adult who uses they/them/their pronouns and who is nondisabled. I must note that claiming my nonbinary gender has been difficult at times because it can be said that my connection to a "masculine" or "feminine" presence further perpetuates the binary itself. I've come to accept that an individual can express themself and their gender in whatever way feels most authentic to them and that this means accepting that gender can be fluid and shifting and thereby outside of a binary. Before my first semester of graduate school, Susan had known me by a different name and different set of pronouns. This change in presentation and identification sparked a critical examination of the ways in which the therapy and counselling literature we were engaging with in courses was (un)representative of myself and other trans and nonbinary individuals. This examination turned into the realisation that a more complex dialogue around gender within the field of music therapy was needed.

Susan: My work for the past fifteen years has focused on issues of social justice within the field of music therapy. I define myself as an intersectional feminist who is a white cisgender heterosexual nondisabled woman who uses she/her/hers pronouns. During the last twelve months, I have been challenged to confront the

ways in which my thinking continues to fall within binaries which marginalise the experiences of many. This has become heightened in my consciousness as I continue to slip into old habits in terms of both gender and sexuality. For example, I found myself being humbled by assumptions based on binary thinking that I made about the sexuality of one of my queer students who talked about her boyfriend, and I was also humbled by how many times I failed to refer to Maevon with correct pronouns. It was really troubling to notice how their change of name was easier to master than their change of pronouns. Thus began a collaborative journey, with me committed to learning new habits, and Maevon committed to calling me, and other students, out when we made missteps. I believe that it is this mutual commitment and responsibility which has led to transformation for all of us.

Fixed gender and sex binaries

The narratives in which we all live are written, spoken, and performed from within binaries of man/woman, boy/girl, male/female, masculine/feminine. These binaries link together gender and sex, defining men as those with male bodies and women as those with female bodies, thereby making gender an inherent "secondary characteristic" of simply being born into a particular kind of body (Butler, 1999). In an effort to disentangle and complicate both sex and gender, throughout this chapter we intentionally use the terms "male," "female," and "intersex" when referring to an individual's sex. And we use "man/boy," "woman/girl," and "nonbinary" when referring to gender. Butler (1999) notes that there is a "radical discontinuity between sexed bodies and culturally constructed genders" (p. 9), and this separation denounces the ties that are assumed of sex equalling gender.

Gender is performative. That is, gender is not something that someone inherently *has*, but rather something that someone is always *doing*, whether intentionally or unintentionally (Butler, 1990, 1993, 1999, 2004; West & Zimmerman, 1987). This means that we are constantly negotiating and renegotiating gender within our daily lives. Just as bodies are gendered, actions, behaviours, thoughts, and expressions are perceived by others in gendered ways. With every action and interaction, individuals are placed into gender and sex categories, with "feminine" becoming female/woman/girl and "masculine" becoming male/man/boy (Butler, 1999; Gilbert, 2009). These performances of gender reproduce and maintain binary understandings, providing specific rules and norms that communicate to us how to exist (Bornstein, 1994; Gilbert, 2009). As Butler (2004) noted, "the conflation of gender with masculine/feminine, man/woman, boy/girl, male/female, thus performs the very naturalization that the notion of gender is meant to forestall" (p. 42). These understandings of gender and sex position individuals within a fixed binary system that is restrictive and that sets limits on the ways in which individuals can authentically exist (Butler, 2004). To be recognised as a person – to be *real* and *intelligible* – one must exist within these binaries (Butler, 1990).

Existing outside of binaries

Despite these fixed understandings, both gender and sex exist outside of binaries as evidenced by transgender, nonbinary, and intersex individuals.

Transgender (trans) refers to someone who identifies with a gender that is different from the sex that he/she/they were assigned at birth. Cisgender (cis) is used in contrast to trans and refers to a person who identifies with the gender that "matches" their assigned sex at birth. Furthermore, trans is understood as an umbrella term under which a larger variety of identities lie – trans men and trans women and also those who are nonbinary. Nonbinary serves as another umbrella term to represent any gender that exists outside of a binary understanding, meaning that they identify as both, neither, somewhere in between, or even altogether outside of man or woman. This can include individuals who are genderqueer, agender, bigender, pangender, third gender, two spirit, genderfluid, and so on.[1] It is important to note that how one person defines his/her/their gender may not be representative of how another does.

In a study exploring individuals and their gender, it was found that many "normative" individuals (i.e. those who are cis) also experience and express their gender outside of a binary, whether through behaviours, expressions, or their sense of self (Joel et al., 2013). Despite pervasive narratives of man/boy/male/masculine and woman/girl/female/feminine, most individuals do not strictly experience and express their gender within these limits. In addition, the very existence of trans and nonbinary individuals challenges and confounds gender and sex binaries (Butler, 2004; Gilbert, 2009). However, as Butler (2004) discusses, while individuals do live outside of gender norms – whether that be through the expressions of their gender or through their gender itself – it is truly an impossibility to be untouched by them (see p. 41). Regardless of how a person identifies and lives, that individual is still being understood from within those norms and still existing within systems of gender and sex binaries.

Intersex individuals, those born with anatomy that does not fit into the definitions for male or female (Intersex Society of North America, 2008), further challenge gender and sex binaries (Butler, 2004; Hird, 2000). Intersex individuals can go through life unaware that they are intersex because, at birth, these individuals are often "fixed" through corrective surgeries as their bodies are understood as "unruly" and at odds with the "natural" order (Hird, 2000). Butler (2004) notes that intersex children can become "maimed for life, traumatized, and physically limited in their sexual functions and pleasures" (p. 54). Intersex individuals attest to the fact that sex is not as clear-cut as is often assumed (Hird, 2000). As such, "intersex activists work to rectify the erroneous assumption that every body has an inborn 'truth' of sex that medical professionals can discern and bring to light on their own" (Butler, 2004, p. 6).

Cisgenderism

Although gender and sex clearly go beyond the binary, the oppressive ideology of cisgenderism has been maintained. Ansara (2010) defines cisgenderism as:

the individual, social, and institutional attitudes, policies, and practices that assume people with [trans or nonbinary] gender identities are inferior, "unnatural" or disordered and which construct people with [trans or nonbinary] gender identities as the "effect to be explained".

(p. 168)

In essence, this means that even as these individuals exist, their genders are not recognised by the dominant group as real and legitimate. There is a pervasive assumption that a person is cisgender. Gilbert (2009) describes bigenderism (essentially meaning cisgenderism) as "the view that accepts the rules of gender and does not permit or allow for variations, exceptions, and/or deviations from the norm" (p. 95). Bornstein (1994) describes these rules of gender as:

1 There are two and only two genders.
2 One's gender is invariant.
3 Genitals are essential signs of gender.
4 Any exceptions are not serious.
5 There are no transfers from one gender to another except ceremonial ones.
6 Everyone is one gender or the other.
7 The [male/female] dichotomy is a "natural" one.
8 Membership in one gender or the other is "natural."

(p. 46)

These rules maintain that both gender and sex exist within strict and fixed binaries. Furthermore, cisgenderism permeates our social environments. As noted by Gilbert (2009):

. . . governments, schools, hospitals, the professions, the arts, and virtually all social institutions rely on [cisgenderism] as a way of classifying and categorising those who avail themselves of or come into contact with their services or necessities.

(p. 95)

Thus, cisgenderism marginalises and is harmful to those who are trans and nonbinary. And this marginalisation is differentially experienced as gender intersects with other identities such as race, socioeconomic status, disability, etc.

Campbell (2011) notes how oppressive structures cause psychological harm to those who are marginalised. These individuals are negated, silenced, diminished, limited, invalidated, attacked, and denied, and this can lead to a negative self-image and mental health concerns. Although Campbell did not specifically consider those who are trans and nonbinary, Butler (2004) has acknowledged that gendered norms make life "livable" only for some and that people who critique, challenge, or reject binary gendered norms are met with "violence," physical or psychological. Further, Butler (2004) notes that trans and nonbinary individuals' very existence is

associated with being "ill, sick, wrong, out of order, abnormal" (p. 76), and that these individuals "suffer from stigmatization" (p. 76). Stigmatisation can lead to mental health concerns, including depression, anxiety, and even suicide. This is particularly relevant to those who are intersex, as they are given medical diagnoses that pathologise their bodies as "different" and "unnatural."

Trans and nonbinary individuals often must negotiate the experience of being misgendered. As Langer (2011) notes, due to a "visual vocabulary" of gender, these individuals are "often being read as something they are not" (p. 303) and this can lead to a sense of feeling invisible, which in turn impacts their self-image. In addition to a visual vocabulary of gender, it may be said that the voice is an auditory vocabulary of gender, serving as an indicator for listeners of what gender a person "should" be. In line with this, Azul (2013) has discussed that once a sound leaves the speaker, the way in which that sound is sensed, perceived, and interpreted is out of the control of the speaker. Thus, our bodies *and* our voices are recognised as performances of gender.

Performing gender in the voice and body

As noted above, the voice is linked with the body in terms of performance of gender (Azul, 2013; Bonenfant, 2010; Jarman-Ivens, 2011; Rolvsjord & Halstead, 2013). Azul (2013) states that the "voice's gender is the result of a behavior or a *doing* rather than a person's biological characteristic ... [and therefore] not only the speaker or singer but also the listener is seen as actively involved in the gendering of the human voice" (p. 82). We "attach meanings to ... high-pitched, melodious, and gentle sounds [as] 'female' and low-pitched, monotonous, and forceful sounds [as] 'male'" (Azul, 2013, p. 82). Similarly, Bonenfant (2010) notes that a person's timbre is what allows us to make these gendered connections.

Azul (2013) notes that people's understanding of "masculine" or "feminine" voices is rooted in culture. Drawing insights from arguments developed by Delph-Janiurek (1999) and Rascow (1986), Azul states that these understandings are "neither governed by biological forces nor under the conscious control of the individuals in a conversation, but instead formed by stories (or 'discourses') about bodies, sex, gender, identity, and communication that are circulated among human beings" (p. 83). These narratives lie within binaries of male/man/boy and female/woman/girl that position individuals as having "appropriately" or "inappropriately" gendered voices. In relation to this, Rolvsjord and Halstead (2013) note that the voice is understood within "highly restrictive notions of normative gender" (p. 422). Thus, how a voice is classified is not always correct (Andrew & Schmidt, 1997; Azul, 2013; Jarman-Ivens, 2011). Azul (2013) acknowledges that:

> ... the results of these social doings may prove unproblematic (in [the] case [that] speaker and listener agree in their gender attribution) or entail calls for strategies to repair misunderstandings that occur when speaker and listener diverge in their constructions of the voice's gender.
>
> *(p. 83)*

Gender in music therapy

Within the music therapy literature, beyond examining gender differences in clinical practice and clinical research (Bruscia, 1995; Brooks, 1998; Körlin & Wrangjö, 2001; Meadows, 2002; Baker et al., 2005), gender has been explored in in terms of gender inequities (James, 1985; Curtis, 2000; Edwards & Hadley, 2007); gender role socialisation and sex-role stereotypes (Heineman, 1982; Curtis, 1990); gender bias (Curtis, 1990; Baines, 1992); gender oppression (Baines, 1992; Kim, 2006); empowerment (Baines, 1992; Curtis, 2000; Jones, 2006); body image (Trondolon, 2003); ways in which discourse frames our understandings of gender and sexuality (Edwards, 2006; Rolvsjord, 2006); representations of women in music (Edwards, 2006; Jones, 2006); and the gendering of musical instruments (Halstead & Rolvsjord, 2017).

Of particular relevance to our current work, Rolvsjord and Halstead (2013) have explored the politics of gender in relationship to its performative dimensions which are in constant negotiation in social relationships, and how gender may be confirmed or disrupted in musical performances. In addition, Bain et al. (2016) have introduced the concept of cisgenderism into the music therapy literature (p. 23). In line with Rolvsjord and Halstead in terms of understanding gender as performative and not static, and Bain et al. (2016) in terms of queering music therapy, our aim is to move beyond a discussion of stereotypical and restrictive gender roles, to a discussion of moving beyond the binaries of gender and sex in music therapy.

Anti-oppressive practice

Anti-oppressive practice in music therapy, as articulated by Baines (2013), is a way of working with clients that recognises that "the power imbalances in our society affect us all" (p. 4). Baines describes anti-oppressive practice as "a way of addressing the 'problems' that our clients present within the context of their socio-political reality and resourcing both ourselves, and persons we serve to address social inequity toward the goal of creating a socially just future" (p. 4). Similarly, Hadley (2013) discusses ways in which we are shaped and positioned by dominant/subjugating narratives including patriarchy, Eurocentricism, heterosexism, capitalism, psychiatry/psychology, and medicine (regrettably failing to include cisgenderism). Hadley addresses ways in which our understandings of ourselves and others are fundamentally shaped by these dominant sociocultural narratives and that this in turn has shaped our educational, clinical, and research practices in the creative and expressive arts therapies. This participation in dominant narratives means that we are, in essence, complicit in the subjugation of those who are marginalised by these narratives. Thus, she calls for constant vigilance against such dominant/subjugating narratives in order to work towards anti-oppressive practice and social justice. It is imperative to explore how our identities are situated socioculturally, as well as in relationship to the sociocultural situatedness of our clients. However, to engage in this level of self-awareness, we must first see a need for such awareness and commit

to it. This requires agency and the will to be fundamentally changed in the process. We must understand that if we are not actively working toward social change, we are implicated in a system which is unjust and that is disempowering and oppressive for various groups of people. Furthermore, this process of gaining greater sociocultural self-awareness is only part of the process and one for which there is no point of arrival. That is, sociocultural self-awareness is something we must continue to work on throughout our lives.

The oppressive system of cisgenderism exists in and is maintained by our social institutions, which obviously holds true when considering the various therapeutic spaces in which we practice. Given the violence that trans and nonbinary individuals experience, therapists must be attentive to the ways in which this system of oppression can impact a client's life (Blumer et al., 2013). Since our gender and understanding of another's gender is in constant negotiation, it is imperative we interrogate the ways in which cisgenderism lives on through our clinical practice, research projects, and everyday lives. If we are to create a world in which people of all genders and all sexes can live and thrive authentically, we must consider how cisgenderism is being maintained and reproduced.

In adopting an anti-oppressive practice, we must explore our identities in terms of intrapersonal dynamics (that are shaped by our values and biases) within the context of our interpersonal and sociocultural relationships (Hadley & Norris, 2016). Becoming aware of the values and biases that shape our thinking is a long and difficult process, which requires help from others, those who are often negatively impacted by what is hidden from our awareness as members of the dominant group. Often these values and biases are demonstrated in the form of cisgenderist microaggressions. As Bain et al. (2016) state, "Many LGBTQ [individuals] battle pervasive stigma in a multitude of settings, including mental health institutions, which indicates a need for anti-oppressive music therapy techniques grounded in queer theoretical perspective" (p. 28). In music therapy, and in the arts therapies more generally, to engage in anti-oppressive practice, we must commit to challenge gender and sex binaries within therapeutic spaces and within our everyday lives.

Queering gender and sex

One way to challenge cisgenderism within therapeutic spaces is to queer our understandings of gender and sex. That is, rather than depicting trans and nonbinary individuals as a cohesive "other" group, a portrayal that "condenses individual variations into oversimplified, formulaic notions that bear little resemblance to the lived experiences of thousands of individuals, morphing them into a conceptually cohesive theoretical unit presumed to share membership in some secret and mysterious 'community'" (Ansara, 2010, p. 190), we must adopt a new conceptualisation of gender which "emphasizes and celebrates multiplicity and fluidity in the experience of gender" and sex (Joel et al., 2013, p. 315). Joel et al. (2013) found that over 30% of cisgender individuals "experience themselves in ways that transcend the either/or logic of the gender binary system" which is a statistic similar to

those reported by trans and nonbinary subjects (p. 310). Their findings suggest that "dichotomous gender categorisation does not reflect the complexity and multiplicity of gender experience" (p. 312) for all human beings, not just trans and nonbinary individuals. Thus, it seems imperative that we queer our discourse as well as our visual and auditory practices.

Queering discourse

Discourse shapes the way that we understand our world in that it conveys meanings, beliefs, and values. Queering our discourse means intentionally using language that is inclusive rather than exclusive – speaking, writing, documenting, etc., in ways that clearly communicate and validate gender and sex outside of a binary, thereby acknowledging their complexity. Thus, rather than assuming an individual's pronouns, a queer language practice involves intentionally providing the pronouns you use and providing opportunities for a person to share the pronouns they use (not prefer). There are no preferred pronouns, only pronouns. When truly engaging in this queer practice, this would mean sharing in every new encounter, adopting a mindset that does not assume gender but that challenges the binary. Furthermore, if an individual is unsure of what you mean when you share your pronouns, it serves as opportunity to challenge cisgenderist understandings.

Another way to queer language practices is to avoid gendering the way we refer to or group people; that is, not addressing or grouping people as "men and women," but instead utilising words like "everyone" and using other ways to divide groups, other than by gender. Gendered divisions reinforce the binary and forces individuals to choose one or the other, demonstrating to some that the space is not "safe." We see this in choirs when instead of asking to hear the sopranos and altos, we ask the women to sing. Gendering voice parts can lead to misgendering of individuals who may be singing a voice part that is typically not associated with their gender. Furthermore, gendering voice parts perpetuates a binary which completely excludes nonbinary individuals.

Queer listening and looking

Another way to queer our practice is to challenge the perceptions that we individually are making in regards to the voice and body. Bonenfant (2010) argues for *queer listening*, redefining the ways that we listen to and perceive voices by paying very close attention to which voices we are drawn to or away from. By engaging in queer listening, a person does not see a body and expect a certain kind of voice or hear a voice and expect a certain kind of body, thereby also making this a practice of *queer looking*. This means challenging the way we perceive bodies and developing a "sensitivity to certain qualities of timbre" (p. 78). Some individuals may experience not wanting to feel queerness (i.e. voices and bodies that move beyond binary norms) touching them. These voices may cause a pulling away from rather than a moving towards. Bonenfant encourages us to begin to appreciate voices and

bodies that are different from us or that challenge gendered norms. As a way of approaching this, one might adopt what Krell (2014) describes as *transvocality*,[2] a vocal practice that allows for the *embodied* voices of trans and nonbinary individuals, particularly within music spaces, to move the individuals who listen both physically and emotionally. Similar to queer listening, transvocality:

> ... is also a *listening practice* by which [the] encultured ways we hear gender, sex, and race in the voice are opened, unsettled, and potentially reconfigured. Rather than assigning gender, race, etc. to vocal sound, a [queer] listening practice asks how and why we hear sound as sexed, gendered, sexualized, raced, and so on....
>
> *(p. 13)*

By engaging in practices of queer listening and queer looking, we complicate gender and sex, allowing for understandings of the voice that move beyond binary conceptions and further challenge cisgenderism.

Gender affirming music therapy

In music therapy spaces, when we work with verbal clients, the voice is often an integral component to this work, not only through speech, but also in the ways we use the voice as a musical instrument. By engaging in queer language practices and queer listening and looking practices, music therapy can be transformed into a space to affirm and validate people's genders and expressions by challenging cisgenderism. As Rolvsjord and Halstead (2013) note, "musical practices can be seen to delineate and interrupt gender in a way that ... create[s] a space for the destabilizing of normative constructions of gender" (p. 423). Further, Jarman-Ivens (2011) suggests that "a voice that does not comply with the visible signs of gender is as disruptive to the performance of gender as any other silent sign could be" (p. 20).

In considering what the presence of trans and nonbinary voices might mean in creating a more just world, Krell (2014) argues that trans and nonbinary musical performances are works of trans activism and that when other trans and nonbinary individuals witness these performances, their own identities are affirmed. Krell (2014) notes that "when trans [and nonbinary] voices sing into a space, they sing that space into being – changing the feeling of the space and making it harder for negative comments or gestures to counter it" (p. 17). In this way, it is argued that the "voice becomes a verb – not (only) in the sense of giving voice to something, but an intransitive sense where [the] voice transgresses borders of bodies" (2014, p. 24). By providing a space for these voices to be heard and by validating the existence of these individuals, we challenge cisgenderist practices which deny trans and nonbinary individuals their authentic existence within the world. By engaging in this kind of anti-oppressive practice, music therapists embrace an aspirational ethics, a commitment to social justice, by becoming allies for trans and nonbinary individuals.

Notes

1 For more information regarding this and the above terminology please refer to http://ejce.berkeley.edu/geneq/resources/lgbtq-resources/definition-terms and https://plato.stanford.edu/entries/feminism-trans/
2 This term has been used by Constansis (2008) to refer to the voices of trans individuals in medical transition. Goldin-Perschbacher (2008) has more generally used it to refer to the voices of trans individuals.

References

Andrew, M. L., & Schmidt, C. P. (1997). Gender presentation: Perceptual and acoustical analyses of voice. Journal of Voice, *11*(3), 307–13.
Ansara, Y. G. (2010). Beyond cisgenderism: Counseling people with non-assigned gender identities. In L. Moon (ed.), *Counseling ideologies: Queer challenges to heteronormativity*, pp. 167–200. Surrey: Ashgate Publishing Limited.
Azul, D. (2013). How do voices become gendered? A critical examination of everyday and medical constructions of the relationship between voice, sex, and gender identity. In M. ah-King (ed.), *Challenging popular myths of sex, gender and biology*, pp. 77–88. New York: Springer.
Bain, C. L., Grzanka, P. R., & Crowe, B. J. (2016). Toward a queer music therapy: The implications of queer theory for radically inclusive music therapy. *The Arts in Psychotherapy, 50*, 22–33.
Baines, S. (1992). *The sociological and political contexts of music therapy: A question of ethics.* (Unpublished master's thesis). New York University, New York.
Baines, S. (2013). Music therapy as an anti-oppressive practice. *Arts in Psychotherapy, 40*, 1–5.
Baker, F., Kennelly, J., & Tamplin, J. (2005). Themes within songs written by people with traumatic brain injury: Gender differences. *Journal of Music Therapy, 42*(2), 111–122.
Blumer, M. L. C., Ansara, Y. G., & Watson, C. M. (2013). Cisgenderism in family therapy: How everyday clinical practices can delegitimize people's gender self-designations. *Journal of Family Psychotherapy, 24*(4), 267–285.
Bonenfant, Y. (2010). Queer listening to queer vocal timbres. *Performance Research, 15*(3), 74–80.
Bornstein, K. (1994). *Gender outlaw: On men, women, and the rest of us.* New York: Vintage Books.
Brooks, D. (1998). Anima experiences of men in Guided Imagery and Music (GIM). *Dissertation Abstracts International-A*, (6), 1957.
Bruscia, K. E. (1995). Modes of consciousness in guided imagery and music: A therapist's experience of the guiding process, In C. Kenny (ed.), *Listening, playing, creating: Essays on the power of sound*. New York: Suny Press.
Butler, J. (1990). *Gender trouble: Feminism and the subversion of identity*. New York: Routledge.
Butler, J. (1993). Imitation and gender insubordination. In H. Abelove, M. A. Barale, & D. M. Halperin (eds.), *Lesbian and gay studies reader*, pp. 307–320. New York: Routledge.
Butler, J. (1999). *Gender trouble: Feminism and the subversion of identity*. New York: Routledge.
Butler, J. (2004). *Undoing gender*. New York: Routledge.
Campbell, D. B. (2011). Oppression of the different: Impact and treatment. *International Journal of Applied Psychoanalytic Studies, 8*(1), 28–47.
Constansis, A. N. (2008). The changing female-to-male (FTM) voice. *Radical Musicology, 3*, 1–32. Retrieved from www.radicalmusicology.org.uk
Curtis, S. L. (1990). Women's issues in music therapy. *Music Therapy Perspectives, 8*, 61–66.
Curtis, S. L. (2000). Singing subversion, singing soul: Women's voices in feminist music therapy. (Doctoral dissertation, Concordia University, 1997). *Dissertation Abstracts International, Section A: Humanities and Social Sciences, 60*(12), 4240.

Delph-Janiurek, T. (1999). Sounding gender(ed): Vocal performances in English university teaching spaces. *Gender, Place and Culture, 6*, 137–153.

Edwards, J. (2006). A reflection on the role of informants from feminist theory in the field of music therapy. In S. Hadley (ed.), *Feminist perspectives in music therapy*, pp. 367–388. Gilsum, NH: Barcelona Publishers.

Edwards, J., & Hadley, S. (2007). Expanding music therapy practice: Incorporating the feminist frame. *The Arts in Psychotherapy, 34*, 199–207.

Gilbert, M. A. (2009). Defeating bigenderism: Changing gender assumptions in the twenty-first century. *Hypatia, 24*(3), 93–112.

Goldin-Perschbacher, S. (2008). *Sexuality, intimacy, and listening: Gender transgression in popular music 1993–2008*. Dissertation.

Hadley, S. (2013). Dominant narratives: Complicity and the need for vigilance in the creative arts therapies. *The Arts in Psychotherapy, 40*(3), 373–381.

Hadley, S., & Norris, M. (2016). Musical multicultural competency in music therapy: The first step. *Music Therapy Perspectives, 34*(2), 129–137.

Halstead, J., & Rolvsjord, R. (2017). The gendering of musical instruments: What is it? Why does it matter to music therapy? *Nordic Journal of Music Therapy, 26*(1), 3–24.

Heineman, M. (1982). *A study of career aspirations and perceived career success in female and male registered music therapists*. Unpublished master's thesis, Florida State University, Tallahassee, FL.

Hird, M. J. (2000). Gender's nature: Intersexuality, transsexualism and the 'sex'/'gender' binary. *Feminist Theory, 1*(3), 347–364.

Intersex Society of North America. (2008). *What is intersex?* Retrieved from www.isna.org/faq/what_is_intersex

James, M. R. (1985). Sources of articles published in the *Journal of Music Therapy:* The first twenty years, 1964–1983. *Journal of Music Therapy, 22*(2), 87–94.

Jarman-Ivens, F. (2011). *Queer voices: Technologies, vocalities, and the musical flaw*. New York: Palgrave Macmillan.

Joel, D., Tarrasch, R., Berman, Z., Mukamel, M., & Ziv, E. (2013). Queering gender: Studying gender identity in 'normative' individuals. *Psychology & Sexuality, 5*(4), 291–321.

Jones, L. (2006). Critical reflections on song selections for women's empowerment in music therapy. In S. Hadley (ed.), *Feminist perspectives in music therapy*, pp. 329–354. Gilsum, NH: Barcelona Publishers.

Kim, S-A. (2006). Feminism and music therapy in Korea. In S. Hadley (ed.), *Feminist perspectives in music therapy*, pp. 127–155. Gilsum, NH: Barcelona Publishers.

Krell, E. D. (2014). *Singing strange: Transvocality in North American music performance*. Dissertation.

Körlin, D., & Wrangjö, B. (2001). Gender differences in outcomes of guided imagery and music (GIM) therapy. *Nordic Journal of Music Therapy, 10*, 132–143.

Langer, S. L. (2011). Gender (dis)agreement: A dialogue on the clinical implications of gendered language. *Journal of Gay & Lesbian Mental Health, 15*(3), 300–307.

Meadows, A. (2002). Gender implications in therapists' constructs of their clients. *Nordic Journal of Music Therapy, 11*, 127–141.

Rascow, L. F. (1986). Rethinking gender research in communication. *Journal of Communication, 36*, 11–26.

Rolvsjord, R., & Halstead, J. (2013). A woman's voice: The politics of gender identity in music therapy and everyday live. *The Arts in Psychotherapy, 40*(4), 420–427.

Rolvsjord, R. (2006). Gender politics in music therapy discourse. In S. Hadley (ed.), *Feminist perspectives in music therapy*, pp. 311–327. Gilsum, NH: Barcelona Publishers.

Trondolon, G. (2003). 'Self-Listening' in music therapy with a young woman suffering from anorexia nervosa. *Nordic Journal of Music Therapy, 12*, 3–17.

West, C., & Zimmerman, D. H. (1987). Doing gender. *Gender & Society, 1*(2), 125–151.

INDEX

abuse 12, 36–52, 76–77, 82, 94, 112, 116–117, 125–126, 132, 134
ageing xi, 205
analytical 149, 208
androgynous 204, 211; *see also* sexual ambiguity
anthropology xvii, 12, 34
asexual 33, 212
authoritarianism 185

beauty 59, 62, 71, 141, 190
biological determinism 6, 8
biological sex 75, 153
biphobia 31
black feminist 19
body image 26, 152, 154–155, 204, 223

CBT 215
childbirth 5, 165–166
children 5, 7, 30, 38, 40, 46, 55, 69, 87, 101–103, 105–106, 108, 112, 116, 126, 137–148, 211; and gender dysphoria 139, 214; in poverty 61; sexually abused 77; stereotyping 214–215
cisgender/ism 220–226
coming out 26, 29, 139, 182, 185
cross-dressing 106

death 45, 46, 77, 168; of a child 45; due to gender inequality 5
depression 19, 21, 37, 45, 82, 88, 90, 127, 152–153, 175, 177, 184, 209, 222; critique of 19

domestic violence 20, 32, 40, 50, 61, 82, 126, 132, 139, 186, 224; against transsexuals 6; *see also* sexual violence
DSM 19

empowerment 5, 17–21, 99, 133, 167, 223
equality *see* inequality
existentialism 75
expressionism 14

femininity xviii, xx, 2, 4, 5, 45, 59–63, 75–76, 128, 132, 159, 213
feminism 15, 17, 19, 21, 33, 55, 210; and consciousness raising 19; pedagogy 9, 18–20; theory 9, 13, 15–16, 54–55, 142, 163, 168, 170, 175–176, 201, 204, 207–208, 218; *see also* black feminist

gender fluidity 138–139, 141, 143, 145, 147, 149
gender queer 220
grief 167–168

heterosexism 189, 223
homophobia 5; internalized 31, 186
homosexuality 5, 11–78, 185–186, 211; *see also* coming out
hope 17, 31, 50–51, 76, 93–94, 132, 135, 140, 143, 147, 163, 177

ideology 4, 8, 220
inequality 4–6, 5, 9–10, 54, 57, 153

intersectionality 3, 54, 57, 63–64, 84, 88–89, 196, 218
intersex 219–222

Jungian 73, 99, 145, 167

lesbian 181, 183–186, 189–191
LGBT(Q) 181–186, 189–192
love 21, 30–32, 39, 42, 46, 87, 140, 183, 189

masculinity 2, 4, 36, 38–39, 42–47, 50–51, 60–61, 75–76, 105, 118, 120, 142
migration 76, 87, 94
mindfulness 153, 156
motherhood 3, 163–167, 169, 171, 173–175, 177–179

non-binary 218–227
non-directive 71, 117

participatory 18, 54, 61, 124
photography 204
phototherapy 16
poverty 5–6, 61, 87–88, 92, 94
psychoanalysis 9, 115, 116, 208; analytical psychology 208; Jungian 73, 99, 145, 167; *see also* analytical

psychoanalytic 9, 10, 14, 47, 97, 115, 116
psychodynamic 69, 116, 213

questioning 189

sexism 5, 161; *see also* heterosexism
sexual ambiguity 2, 6
sexual orientation 3, 24–27, 31–32, 117, 139, 147, 181–185, 189, 208, 213
sexual violence 5, 36–37, 42, 50–51, 134
social justice 9, 14–15, 20–21, 64, 218, 223, 226
stereotypes 31, 63, 137–138, 142, 150, 154–155, 158, 163, 172, 196, 209, 213–214, 158, 163, 172, 196, 209, 213–214
symbolism 43–44, 128, 175

third gender 220
transgender 24, 26, 32–33, 70, 77, 82, 108–109, 220
transphobia 139, 142
transsexual 6, 77; *see also* non-binary

violence 20, 32, 45, 82, 126, 132, 139, 186, 224; *see also* domestic violence; sexual violence

women's issues 227; *see also* inequality
women's oppression 173